BOLLINGEN SERIES LXXXIX

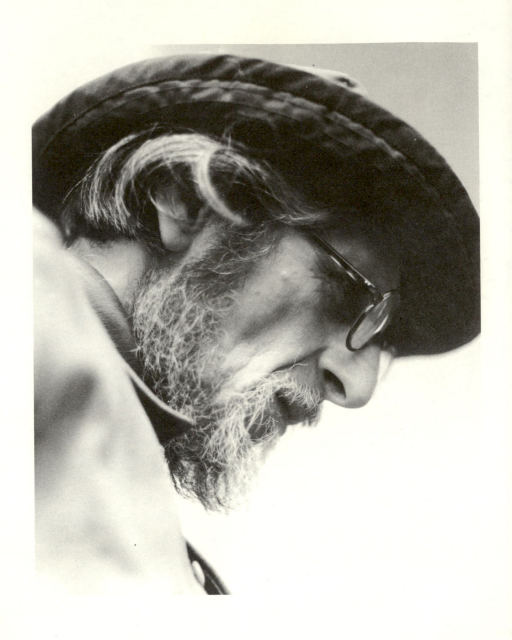

Coomaraswamy

3: HIS LIFE AND WORK

By Roger Lipsey

BOLLINGEN SERIES LXXXIX

PRINCETON UNIVERSITY PRESS

Copyright © 1977 by Princeton University Press

Published by Princeton University Press,
Princeton, New Jersey
In the United Kingdom: Princeton University Press,
Guildford, Surrey

THIS THREE-VOLUME WORK IS THE EIGHTY-NINTH
IN A SERIES SPONSORED BY BOLLINGEN FOUNDATION

Library of Congress Cataloging in Publication Data will
be found on the last printed page of this book

This book has been composed in Linotype Granjon

Printed in the United States of America
by Princeton University Press, Princeton, New Jersey

For my Father and Mother

Contents of Volume 3

List of Illustrations

Preface

Some consider Ananda K. Coomaraswamy to have been a very great man; others, often with less knowledge of him but not necessarily weaker powers of judgment, consider him to have been odd, doctrinaire, mystical where pure reason should prevail, and ultimately of little significance. This book is intended to overwhelm both categories of opinion: those who revere Coomaraswamy's writings and the example of his life should find much that obliges a review of their opinions, although by no means a reverse; those who have never taken a whole view of Coomaraswamy will find it finally possible.

The history of scholarship and opinion concerning Coomaraswamy can be briefly outlined. During his life time he clearly made his mark on the United States, where he lived after 1917, and he was at least as well known in Europe, India, and Sri Lanka. The bibliography of his writings on visual art, aesthetics, literature, religion, metaphysics, and sociology comprises some one thousand items, including many books.[1] In earlier years, he was a pioneer and authority in the field of Indian art, and also a careful but popular writer on Hinduism and Buddhism. In later years, when his thought had ramified, he was known to some as a Sanskrit and Pāli scholar; to others as an art historian, mythographer, folklorist, or social critic; to still others as a metaphysician and expositor of the complexities of Indian thought. He was loved and detested; he was doubtless lovable and detestable. He conquered by scholarship, eloquence, and a completely uncompromising set of values, but where he failed to conquer he made enemies. For him, the study of ancient cultures went hand in hand with severe criticism of modern culture. He was

[1] A select bibliography, listing all works by Coomaraswamy mentioned here, will be found at the end of this volume. References will frequently be made to *A Working Bibliography of Ananda K. Coomaraswamy*, ed. R. P. Coomaraswamy, a forthcoming publication of Books from India, Ltd. (London), which will stand for some years as the best available. The reader will be referred wherever possible to articles as published in *Ananda K. Coomaraswamy: Selected Papers*, two volumes, edited with an introduction by Roger Lipsey, Bollingen Series, Princeton University Press, 1977; these volumes will be identified henceforth as SP I, SP II.

Coomaraswamy will be designated by his initials, AKC, throughout the notes. His articles are identified by title and date when first cited; for books, the place of publication is included. Further bibliographical information will be found in the select bibliography at the end of this book.

partly a prophet, and at worst a preacher, but at best a seer—an unexcited, inecstatic one, a clear and cultured intelligence that thought it dishonest to comment enthusiastically on ideas and works of art that can only be understood slowly.

After Coomaraswamy's death in 1947, a project to republish his essays was initiated about 1950 by the Bollingen Foundation, whose Bollingen Series ranges from the official English-language edition of C. G. Jung's works to editions of Plato and other ancient sources. Bollingen Series constituted nearly a family of like-minded scholars and authors in various fields, and Coomaraswamy was obviously a member of the family. His widow, Doña Luisa Coomaraswamy, was asked to prepare a selection of her late husband's essays and monographs, incorporating the revisions and additions that he had made since their original publication. An extraordinary perfectionist, Mrs. Coomaraswamy worked at her task for almost two decades; she had decided to establish definitive versions of the entire corpus of writings and wished to postpone republication until the riches of Dr. Coomaraswamy's revisions had been transferred into the texts. Praiseworthy in the extreme, her intention nonetheless narrowed the circle of those who could know Coomaraswamy's writings, particularly among younger people. It had always been difficult to read him *en entier* because he published in an enormous variety of Eastern and Western journals, and had made only four collections in book form of his later essays. Mrs. Coomaraswamy died in 1970, before bringing her project to term. It is certain that the times are riper now for the republication of her husband's writings than at any period since she undertook her editorial work; the delay fortuitously allowed time for the growth of a much wider interest in Eastern art and thought, particularly in the United States.

There have been a few scholarly publications concerning Coomaraswamy since 1947, among the most complete and noteworthy being *The Traditional Theory of Literature* (Minneapolis, 1962), by Ray Livingston; *Ananda K. Coomaraswamy* (New Delhi, 1974), by P. S. Sastri; and, in another vein, the annotated bibliography of Coomaraswamy's early writings by James Crouch, "Ananda Coomaraswamy in Ceylon: A Bibliography."[2] In Malaysia, S. Durai Raja Singam has from time to time brought out books, pamphlets, and small selections of Coomaraswamy's

[2] *The Ceylon Journal of Historical and Social Studies*, New Series, III:2 (1973), 54–66.

writings—these, with other writings on Coomaraswamy, will be fully identified in later notes. Mr. Singam, in addition to editing the *Memorial Volume* of tributes and memoirs concerning Coomaraswamy, has also composed a biography of Coomaraswamy's noted father, *The Life and Writings of Sir Mutu Coomaraswamy* (Singapore, 1973) and is preparing a biography of the son. During the years of my research I was privileged to see an early draft of the study of Sir Mutu and am indebted to it. Mr. Singam has been kind enough to welcome the present work very warmly; and because Coomaraswamy lived the last thirty years of his life, the most creative years, in the United States, it was inevitable that an American to whom Coomaraswamy's papers and library could be available would undertake a study of them. Furthermore, the scholar's family and friends live in the United States and have offered unstinting aid during the research and writing of this work.

The problem of writing an accurate biography was one, and the problem of gathering and analyzing the writings another. The biography completes the analysis, and vice versa; it is no accident that *The Life and Works of* . . . is a standard formula for approaching the works of notable authors. The biography should speak for itself: it was a rich life, and it led somewhere. Coomaraswamy passed through many milieus on his way "upwards" toward the person that he was in his last fifteen years: through late Victorian England, through the Victorian East, where nationalism was just becoming a serious word in India and Ceylon, through the first violent years of nationalist uprisings in Bengal. He knew England in the splendid prewar days of Arts and Crafts idealists, fanatical anti-industrialists, and literary men of the caliber of Shaw and Orage. He knew the America of the 1920s and made a name for himself then as a scholar and scholar-about-town. In the 1930s and 1940s, he "became himself," or very nearly: his works from this period on art, culture, and metaphysics, written while living an austere although not unsociable life, are considered by some to be of great and very general significance. Coomaraswamy's oeuvre and unpublished papers have never been read as a whole for the purpose of a published study; they proliferate so widely that the reader who intends to do so must be part butterfly catcher, part beast of burden. Nonetheless, his work has stood in need of a general presentation—and still more must be done.

What is it that primarily characterized Coomaraswamy? Was it his wit? "Some people seem to regard whatever is universal as 'strange,'—are

they themselves so 'particular' that the universal 'annoys' them?"[3] Was it his powerful conscience, which entered into his writings like a flood tide? "Our environment relatively *ineloquent* by restriction of *meaning* to verbal images. Our works of art really and literally *insignificant*. . . ."[4] Was it his sharp critique of Western ethnocentrism and his high regard for traditional cultures? "The Amerindian sand-paintings, considered intellectually, are superior in kind to any painting that has been done in Europe or white America within the last several centuries."[5] It may well have been, above all, his conviction that scholarship and education are intended to ask fundamental questions and to nourish the invisible part of each man, the spirit. Coomaraswamy's question, before the wealth of learning and experience that is possible for modern man, resounds in a passage from the *Shepherd of Hermas*, an early Christian text[6] that he often quoted in later years:

What does it profit me to have seen these things,
If I know not what they mean?

(Vision, III.3.1)

[3] From an informal note written to Eric Schroeder, found among Coomaraswamy's papers in the Princeton Collection.

[4] AKC, notes for a lecture at Yale University (1942), Princeton Collection.

[5] AKC, "Sir Gawain and the Green Knight: Indra and Namuci" (1944), 124–125.

[6] Cf. K. Lake, tr., *The Apostolic Fathers*, II (Cambridge, Mass., 1913, Loeb Classical Library).

Acknowledgments

I wish to thank all those who graciously helped me to complete this work: Dr. Rama P. Coomaraswamy and his wife Bernadette, Rohini Coomara, Stella Eliscu, Peter Bunnell, Joseph Campbell, Margaret Case, Colin Eisler, Richard Ettinghausen, Jan Fontein and the staff of the Asiatic Department, Museum of Fine Arts, Boston, Stella Kramrisch, William McGuire, Pratapaditya Pal, Meyer Schapiro, Craig Smyth, Alexander Soper, and William S. Wilson III.

Thanks are due to Princeton University Press, with which a large portion of Coomaraswamy's papers and library were on deposit during the time of writing, for making this unique material available. I am grateful to the staff of Firestone Library, Princeton University, for permission to reproduce some of these documents, now in their care.

Every effort has been made to secure permission from individuals whose correspondence with Coomaraswamy has been quoted; in some cases, I have not been able to locate the correspondents or their families and must take the opportunity here to thank them for the use of these often invaluable spontaneous guides to Coomaraswamy's life, friends, and ideas.

For reading parts of the manuscript, I would like to thank Mircea Eliade, Walter Muir Whitehill, and S. Durai Raja Singam. Mr. Singam, long a student of Coomaraswamy's life and writings, has been able to correct and amplify points in the biography; he has also generously permitted the reprinting of Eric Schroeder's memoir on Coomaraswamy, originally published in Mr. Singam's invaluable *Memorial Volume*.

Mary Haught, Linda Bacon, and Sara Nicoll-Marx deserve warm thanks for research assistance and typing. Among the students whom I have come to know at the University of Texas, Austin, David Iglehart reviewed Sanskrit, while Lee and Barbara Calaway, Virginia Gaines, and Steven Kotter helped with the final stages of indexing.

A grant from the Spears Fund, administered by the Department of Art and Archaeology, Princeton University, defrayed some of the material costs of completing this work.

Doña Luisa Coomaraswamy and Eric Schroeder, exceptional persons, passed away during the time of writing but left their imprint on my work.

COOMARASWAMY

HIS LIFE AND WORK

Introduction

Coomaraswamy once described the only sort of portrait that he could respect:

> if an ancestral image or tomb effigy is to be set up for reasons bound up with what is rather loosely called "ancestor worship," this image has two peculiarities, (1) it is identified as the image of the deceased by the insignia and costume of his vocation and the inscription of his name, and (2) for the rest, it is an individually indeterminate type, or what is called an "ideal" likeness. In this way both selves of the man are represented; the one that is to be inherited, and that which corresponds to an intrinsic and regenerated form that he should have built up for himself in the course of life itself, considered as a sacrificial operation terminating at death. The whole purpose of life has been that this man should realize himself in this other and essential form.[1]

We too need to make an "ancestral image," not for worship but because Coomaraswamy's life is intrinsically interesting and sheds remarkable light on his work. He himself was adamantly opposed to biographies and autobiographies. He was touched once and for all time by the attitude toward idiosyncratic personality implied by the above passage, an attitude that recurs in the Neoplatonic and Gnostic, Christian and Asiatic writings to which he constantly turned for illumination both as a scholar and as a man. Plotinus, whose works deeply influenced Coomaraswamy, is described in Porphyry's life of the philosopher as

> ashamed of being in the body.
> So deeply rooted was this feeling that he could never be induced to tell of his ancestry, his parentage, or his birthplace.
> He showed, too, an unconquerable reluctance to sit to a painter

[1] AKC, "Why Exhibit Works of Art?" (1941). References to this article will be made in the most accessible place of publication, the collection of essays published as *Why Exhibit Works of Art?* (London, 1943), where this passage appears on p. 43.

or a sculptor, and when Amelius persisted in urging him to allow of a portrait being made he asked him, "is it not enough to carry about this image in which nature has enclosed us? Do you really think I must also consent to leave, as a desirable spectacle to posterity, an image of the image?"[2]

In his maturity, Coomaraswamy shared not only this reluctance but also the quest for intensity of inner life that gave rise to it. His indefatigable reading had brought him to a similar passage in the apocryphal *Acts of John*, the Greek text attributed to a Gnostic Christian community of the second century, which he often quoted in art-historical and philosophical writings. John discovers that one of his disciples, without his consent, has had a portrait made of him; when he manages to accompany this disciple to his living quarters and finds the portrait, he makes a compassionate reprimand, but concludes in the unyielding attitude of Plotinus: "This that thou hast now done is childish and imperfect: thou hast drawn a dead likeness of the dead" (vv. 26–29). In the light of these texts, Coomaraswamy's reply to a colleague who urged him to write an autobiography appears as simple obedience to what he held to be true: "I would not think of writing my autobiography. . . . There are only a very few autobiographies that I think have been necessary and fully justified. I myself am not interested in my personal history and could not make it of interest or value to anyone else. The task before us all is to 'become no one'; for He, as the *Kaṭha Upaniṣad* says, 'never became any one.' "[3] Yet the man who maintained this extreme position received, as a token of homage on his seventieth birthday, not only a Festschrift[4] such as is frequently offered to outstanding senior scholars, but also a much rarer kind of tribute: a book of memoirs and personal appreciations written by friends, colleagues, and admirers, containing a great deal of biographical material. In the second edition, published several years after his death, it ran to more than three hundred pages, with contributions by something more than one hundred authors.[5] The fact is that Coomaraswamy

[2] Porphyry, *On the Life of Plotinus and the Arrangement of His Work*, in Plotinus, *The Enneads*, tr. Stephen MacKenna (London, 1962), p. 1.

[3] AKC, letter to K. Bharata Iyer, quoted in K. Bharata Iyer, ed., *Art and Thought: A Volume in Honour of the Late Dr. Ananda K. Coomaraswamy* (London, 1947), p. xiii.

[4] *Ibid.*

[5] S. Durai Raja Singam, ed., *Homage to Ananda K. Coomaraswamy: A Garland of Tributes* (Kuala Lumpur, 1948); 2nd ed., *Homage to Ananda K. Coomaraswamy (A Memorial Volume)* (Kuala Lumpur, 1952). Quotations from this work will be

through much of his life was engaged in the world, not only as a scholarly expositor of Indian culture, but as a critic of politics and society, a partisan of reform, an Indian nationalist who paid dearly for his views, an art historian and philosopher whose ideas ran counter to the majority view and kept him contentedly mired in controversy. Only in his last two decades did he simplify his life, partly, of course, because of advancing years, but also because the nature of the work that he undertook during these years required simplicity. Looking back on the earlier part of his life, he did on one recorded occasion not simply reject it as a negligible preface to the philosophical way of life of his maturity, but recognized its necessity: "if you must say something, do not try to white-wash me. I have lived in very confused times, I have played the game as thoroughly and completely as necessity demanded. . . . Where is the man who has not made mistakes? To have lived in any other way would have been to evade the issue—had this not been required of me it would not have happened. . . . I am not a Victorian. By meeting the conflict one comes to know the better from the worse and learns to discriminate."[6] The manly but balanced tone of this conversational excerpt takes us far from the ancestral image characterized by vocational insignia and "ideal" likeness only, the type of portrait that Coomaraswamy especially admired. It alerts us that his biography is not a serene movement toward still more serenity in later years, but punctuated—it might be truer to say punctured—by conflicts and resolutions of a thoroughly human kind.

Because of his aversion to biography, until now no one has tried in more than summary fashion to describe his life. Coomaraswamy's life and works fall into three major periods: the early years in England, Ceylon, and India, running from the year of his birth, 1877, to 1917, when he accepted a curatorial post at the Boston Museum of Fine Arts; the first ten or twelve years in America, when he was occupied with very exacting scholarly publications, on the one hand, and an agreeably unsettled personal life, on the other; and the last sixteen years of his life, during which his most memorable writings on art, religion, metaphysics, and culture were produced. Throughout the first period his writings were intertwined with his life pursuits, and these in turn were largely a response to conditions

from the second edition, henceforth referred to as *Memorial Volume*. A third and larger edition, under the title *Remembering and Remembering Again and Again*, was published in 1974.

[6] Cited in Doña Luisa Coomaraswamy, "Some Recollections and References to Dr. Ananda Coomaraswamy," *Kalāmanjari*, I:1 (1950-1951), 20.

of cultural deterioration in Ceylon and India that accompanied British dominion in each country. In order to understand the early writings, not only Anglo-Indian relations, but the state of art-historical knowledge in the late nineteenth and early twentieth centuries regarding India and its sister island must be taken into account. Late Victorian England, quite apart from its relations with India and Ceylon, must also be considered. The line of Coomaraswamy's life until 1917 moves through and is for the most part directed by a complex array of influences and historical conditions; what the early writings lack in intrinsic interest is made up for by the interest of the latter. Biography is necessary for this period; and I cannot erect a wall at any point in time, after which it would no longer be necessary. But to the extent that Coomaraswamy achieved that "other" and more essential form of himself, which he mentioned in the passage on portraiture, his portrait in later years will naturally, without forcing, become a more "ideal" likeness.

In the course of this biography, there will also be found a fairly continuous account of his writings, a selective *bibliographie raisonnée*. Given the great number of his books, articles, and reviews, this is necessary in order to know his mind.

In a manner of speaking, there does exist an "icon" of Coomaraswamy: it is the photograph of him in the late 1930s taken while he worked in his garden (Frontispiece). Bearded and grey, with an old canvas hat pulled down to his ears, he leans over his work. His thin cheeks and gnarled hair bespeak fragility, but the weight and dignity of his movement say something of his strength. The photographer (his wife) caught him mid-way between vertical and horizontal, higher and lower, detachment and involvement.

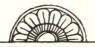

I. An Eminent Ceylonese Family,
an English Boyhood

Ananda Kentish Coomaraswamy was born in Colombo, Ceylon, August 22, 1877.[1] His father, Sir Mutu Coomaraswamy (Figure 1), was one of the foremost men of his country; his mother, the former Elizabeth Clay Beeby, was an Englishwoman of a wealthy Kent family that had engaged in the "India trade" and the civil service, and knew India and Ceylon quite well. The family name, Coomaraswamy, derives from the Hindu deity *Skanda Kumāra*, to whom a temple exists in Ceylon at Katargama. Coomaraswamy said of the name that its suffix "swami" was common in Ceylon and India because of a misunderstanding on the part of the British at the time they were registering names: the honorific title "swami," meaning teacher, lord, or possessor, was taken to be an integral part of family names—of many others in addition to Coomaraswamy. The name is characteristic of a middle caste, not the highest but far from the lowest, known as the Mudaliyars, assistants at the old Ceylonese court and still prominent in public life under British rule.

Sir Mutu Coomaraswamy, although he died when Ananda was not quite two, exercised an enormous influence on his son, not only by his example but through the milieus to which his talents and energies had integrated him, both in Ceylon and in England. Born in 1833 to a family engaged in Ceylonese government at the highest level (his father was a

[1] Biographical data concerning AKC's family is largely drawn from unpublished and informally published (mimeographed) accounts by S. Durai Raja Singam, to whom the Coomaraswamy family made much information available in the years after AKC's death. Mr. Singam's valuable mimeographed papers are: "A New Planet in My Ken: Introduction to Kala-Yogi Ananda K. Coomaraswamy" (Kuantan, Malaya, 1951); "Coomaraswamiana: A Coomaraswamy Chronicle" (Kuantan, 1951?); and "Great Thoughts of Gurudev Ananda K. Coomaraswamy" (Kuantan, 1951). There is an untitled, unpublished family history in the Coomaraswamy family's possession, also the work of Mr. Singam, which proved very useful; it will be referred to as *Unpublished History*. It is an early draft of Mr. Singam's biography of Sir Mutu, mentioned in the introduction to this work.

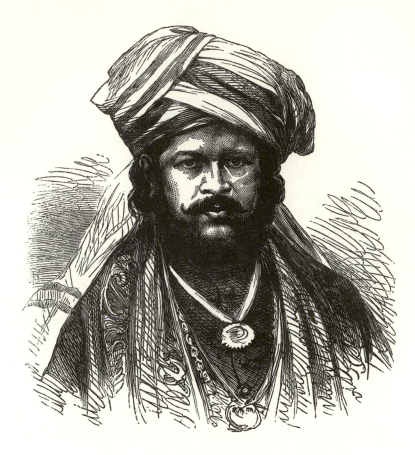

Figure 1. Sir Mutu Coomaraswamy in 1863.

member of the newly created Legislative Council), he practiced law as a young man and achieved recognition as "the lion of the metropolitan Bar," in the words of his biographer.[2] Avocationally a student of the classical literatures, religions, and philosophical systems of East and West, in later years he published English translations of Pāli Buddhist texts and Tamil drama. In 1861 he became a member of the Legislative Council as the representative of the Tamil-speaking people of Ceylon, replacing his uncle, the Hon. Mr. Ethirmanasingham, who had taken the succession to the same post from Sir Mutu's father some years earlier.[3] His speeches in the Council reveal an excellent command of English: his mode of expression was crisp and colorful, his penchant for irony and rich vocabulary was that of an English statesman. He could be tellingly ironic when arguing, for example, the injustice of using tax monies gathered from non-Christians to support the Church of England in Ceylon.[4]

In 1863, Sir Mutu made his first voyage to Europe and Great Britain, spending nearly three years away from Ceylon. He was welcomed in high circles of English society and apparently much appreciated. Professionally, he made a great advance through being called to the Bar at Lincoln's Inn; he was the first Asian accredited for the practice of law in Great Britain. On his second trip to Great Britain, in 1874, his legislative acumen in Ceylon as well as the trust and personal esteem he enjoyed in ministerial and royal circles in London won for him the title of Knight Bachelor, identified by his biographer as "the highest honour with which a British sovereign could reward a colonial subject."[5] A friend of Disraeli, Sir Mutu served as the model for Kusinara, the Ceylonese hero of a novel that Disraeli did not live to finish (an installment appeared in the London Times).[6] It was during this second trip that Sir Mutu met Elizabeth Beeby; already in his forties, he had not until then met a woman whom he thought thoroughly capable of following him in the international, cultured world that he frequented. Elizabeth was of good family; she seems already to have had an interest in India and in Eastern philosophy,

[2] *Unpublished History*, p. 2.

[3] The people of Ceylon are divided into two main ethnic and language groups: the Sinhalese, who came to the island from India ca. 550 B.C.; and the Tamils, who came from South India some four hundred years later. The Sinhalese are for the most part Buddhist, the Tamils Hindu.

[4] *Unpublished History*, pp. 6–7. [5] *Ibid.*, p. 9.

[6] Cf. W. F. Monypenny and G. E. Buckle, *The Life of Benjamin Disraeli*, VI (London, 1920), Appendix, where the existing fragment of Disraeli's novel is reprinted.

which Sir Mutu never abandoned in spite of his adaptation to English society. Marriage between an English lady and an Asian gentleman was rare at the time; nonetheless the marriage was solemnized by the Archbishop of Canterbury, and the couple left for Ceylon in 1876, taking up residence in the Colombo mansion known as "Rheinland," where Ananda was born the following year. Elizabeth and her child returned to England in 1879, expecting to be followed soon after by Sir Mutu, who had been encouraged by Disraeli and others to enter Parliament; but on the 4th of May 1879, the day of his intended departure for England, he died.

Looking back in 1906 on his father's life and his mother's marriage, Coomaraswamy said to a Ceylonese audience that had gathered to discuss the revival of national ideals:

> Thirty years ago my father was the leading Tamil in Ceylon, and it will recur to most of you that he himself had become exceedingly westernized. At that time it was necessary both that we should in some measure adapt ourselves to a changed environment and also prove ourselves capable of equalling the attainments of Western men on their own lines. Had he lived, I cannot doubt that (like my cousins, Messrs. Arunachalam and Ramanathan, who also at one time trod the same path) he would have seen that we were liable to overshoot the mark and he would have been the first to preserve and protect the national ideals and Eastern traditions, with which our lives and those of our forefathers are inextricably bound up. It is therefore fitting that his son should carry on such work. Of my mother I may say that it was her hope that her marriage with my father would contribute to a better understanding and sympathy between English and Tamils for whom she felt great admiration and affection.[7]

The young widow never returned to Ceylon and never remarried. She took a small house in Kent, "The Thatched Cottage," and with the help of her mother and unmarried sister raised Ananda and looked after his education until he went away at the age of twelve to Wycliffe College, a preparatory school. There is a photograph of the family from this time; Ananda is sitting in the garden at the cottage with the three "girls," as he called them, a lanky, gentle-looking boy with his arm flung around a sizable spaniel. The dog is posing with a solemnity entirely absent in the boy. The atmosphere as a whole is thoroughly English, without, for the

[7] Quoted by Singam, "Great Thoughts," p. 2.

moment, a trace of the influence of Ananda's inspired Ceylonese father.[8]
Here began his English years, which lasted with few recorded breaks until
he was fully grown—twenty-five years of age, a trained geologist and
botanist (see Figure 2).

Coomaraswamy attended Wycliffe College for some eight years, devel-
oping there a strong interest in life sciences and geology. He explored the
geological deposits of the part of Gloucestershire where the school is lo-
cated, hunted fossils, contributed papers on his findings to the school jour-
nal.[9] His academic career was outstanding, as were his contributions to
Literary Society debates and his lectures in the Science Club. In 1897, he
entered University College, London, receiving a B.Sc. in Geology and
Botany (with First Class Honors) in 1900. In 1903 he was named a Fel-
low of University College. It seems likely that by this time he had already
returned to Ceylon to spend a year studying its geology at his own ex-
pense. His findings prompted the authorities in England and Ceylon
to form a Mineralogical Survey of Ceylon, of which he became the first
director.[10] His earliest publications in professional journals, dating from
1900, concern themselves with geological data gathered in Ceylon and
India. In 1906 he earned his doctorate (D.Sc.) from London University
with a thesis composed of official reports on Ceylonese mineralogy and
other scientific papers; not breaking the family tradition for such achieve-
ments, he was the first Ceylonese to earn London University's highest
degree.[11]

The significance of this early scientific training cannot be exaggerated.
It gave him the predisposition and stamina to treat subjects systematically
and completely, as he did in his first important book, *Mediaeval Sinhalese*

[8] *Memorial Volume*, photograph facing p. 146.

[9] *Ibid.*, pp. 157–160; *Unpublished History*, pp. 18 ff.

[10] For knowledge of AKC's geological work, the sources are a memoir by Dr. K.
Kularatnam of the University of Ceylon, *Memorial Volume*, pp. 168–171; Dr. F. L.
Woodward's memoir, *ibid.*, pp. 198–201; AKC's own articles on geology, Biblio.
Nos. 1–26, 35, 41, 42, 67, in the *Working Bibliography*; and passages in AKC's
other writings of the period 1905–1908. His final Administration Report on the
Mineralogical Survey is dated 1906. James Crouch, in his recently published "Ananda
Coomaraswamy in Ceylon: A Bibliography," reports evidence that AKC "made
nearly annual visits to Ceylon, usually accompanied by his mother, the first taking
place perhaps as early as 1896," and that during his visit in 1898 he mapped the
Kandy District in part.

[11] His D.Sc. is recorded in the *London University Gazette* (7 February 1906),
p. 82.

Figure 2. Coomaraswamy in England, ca. 1900.

Art,[12] an encyclopedic study of the arts and crafts of Ceylon as they existed before English sovereignty. It gave him the ability to understand and describe craft processes in detail, akin as they are to laboratory processes in which the state of every substance and its correct manipulation at a given moment are of great importance. Coomaraswamy was not without sentimentality in his earlier years, as we shall see, but his criticism in later life of any kind of sentimentality in discussions of art, and his unemotional, factual approach to the study of Hindu and Buddhist doctrines, which have so often been presented in the West with emotional appeal, are also due to his extensive training in scientific method. Other results of his education in England, no less important than these, can best be discussed after we have followed the course of Coomaraswamy's life in Ceylon and India.

[12] AKC, *Mediaeval Sinhalese Art, Being a Monograph on Mediaeval Sinhalese Arts and Crafts, Mainly as Surviving in the Eighteenth Century, with an Account of the Structure of Society and the Status of the Craftsman* (Broad Campden, 1908; 2nd ed., incorporating the author's corrections, New York, 1956).

II. Ceylon, 1902–1905:
The Transformation of a Geologist

Coomaraswamy arrived in Ceylon with his English wife, Ethel Mary (*née* Partridge), married June 19, 1902, and settled in a bungalow just outside Kandy, the capital of the last independent Sinhalese kingdom, situated in the central highlands of the island. Ethel (see Figure 3) was a good photographer and doubtless able to rough it; she took most of the photographs illustrating his *Mediaeval Sinhalese Art* and prepared a portfolio of photographs of Ceylonese craftsmen at work, often in villages difficult of access.[1] When not accompanying her husband in the countryside, she studied traditional Ceylonese embroidery, offered classes in it, and worked on the English translation of old Ceylonese texts.[2]

Coomaraswamy spent most of his time in the field, "true to high geological tradition," as a Ceylonese scientist remarked in a memoir,[3] "conducting his traverses on foot and by bullock cart; . . . (he) thus came to know his Minerals and Rocks very intimately indeed." The results were very satisfactory. He published geological maps, discovered workable occurrences of mica, graphite, corundum, and other minerals, brought out Administration Reports for four successive years in addition to separate articles, and in 1904 discovered a new mineral, thorianite, an oxide of

[1] A copy is preserved in the library of the Boston Museum of Fine Arts.

[2] Cf. Ethel Coomaraswamy, "Old Sinhalese Embroidery," *The Ceylon National Review*, II (July 1906), 119 ff.; and the short notice of her translations in *Memorial Volume*, p. 198. The article is in the spirit of her husband's research at the time. New information concerning the background and life of Ethel is becoming available through the work of an English scholar, Alan Crawford, who has studied the papers of C. R. Ashbee and his wife, both of whom knew Ethel well. Cf. Alan Crawford, "Ananda Coomaraswamy and C. R. Ashbee," in S. Durai Raja Singam, ed., *Ananda Coomaraswamy: Remembering and Remembering Again and Again* (Kuala Lumpur, 1974), pp. 239–242.

[3] Kularatnam in *Memorial Volume*, p. 168. This memoir by a Ceylonese scientist gives a very favorable evaluation of AKC's geological work. A similar view is expressed by Frank Dawson Adams, *Canadian Journal of Research* (1929), p. 430.

Figure 3. Ethel Coomaraswamy, ca. 1905.

thorium and uranium.[4] It must indicate something of the character of this work that Coomaraswamy's co-worker, Parsons, who succeeded him as director of the Survey, was lost in the jungle in 1909. Nonetheless, the most memorable photograph of Coomaraswamy at this period is a joyful one, showing Ethel seated in a cart yoked to two oxen while Ananda, in a pith helmet, is up front checking the animals.[5] Another hint of the atmosphere of these early days in Ceylon is given by Coomaraswamy's first book plate, of which a few examples have survived (Figure 4). It

Figure 4. Coomaraswamy's Book Plate,
Ceylon, 1903.

shows a corner of Coomaraswamy's study, crowded with the tools and books of his trade; a window in the back is open on some high Ceylonese peaks. Students of art will recognize that, although the setting is Ceylon, the conventions of this little print are all of the Northern Renaissance.

Many times in the course of his writings, Coomaraswamy had occasion to tell the life story of the Buddha, hence of that literally portentous day when young Prince Siddhattha rode forth from his father's palace and saw

[4] Cf. AKC, "Report on Thorianite and Thorite" (1904).
[5] Coomaraswamy family collection.

the four signs of the human condition, which until then had been hidden from him: an old man, a sick man, a corpse, and a *bhikkhu* (a religious mendicant)—aging, sickness, death, and a man unmoved by them. Thereupon—in Coomaraswamy's last telling of the event, which captures the characteristically swift Buddhist movement from fact to principle— "Straightway he resolved to seek and find a remedy for the mortality that is inherent in all composite things, in all that has had a beginning and must therefore come to an end."[6] An event of far smaller magnitude but similar flavor took place in Coomaraswamy's life at this time, probably 1904. Like the story of Prince Siddhattha, it has the quality of myth as Coomaraswamy recounted it in one of his earliest published writings touching on art; it has, too, a certain awkwardness, as if the young writer, just beginning to recognize that he must learn to write effectively because he has found things to say, is trying to compress several years' experience into too small a vessel. He called the essay *Borrowed Plumes*. At the beginning of the piece, which is part autobiography, part indictment, he described himself as living in a headman's house in a remote village not far from Adam's Peak. He prospected during the early morning and generally returned to the village for late breakfast and a rest. A pilgrim's track from Ratnapura to Adam's Peak passed through the village. At that moment it was not pilgrimage season, but he had once made the journey himself and seen "the pilgrims that came there from far and near, folk of all ages and each sex. . . . There were even some who made the journey on hands and knees in fulfillment of a vow." On one particular morning, as he sat in front of his host's house after breakfast, all of that came back to him. The morning was pleasant. The sound of working songs reached him from nearby fields: "an old man led in a cracked and quavering voice . . . the music a sort of plainsong or chant." He congratulated himself on the peaceful life he had found. But then a seemingly inoffensive pair came down the road: a Sinhalese mother and child proudly dressed in the European fashion. Their clothes were bedraggled and filthy, painfully out of place, yet

these were not paupers of the village as might be supposed, but thought rather well of themselves, and were looked up to, as wearing European dress. They were the local converts to a foreign religion

[6] AKC and I. B. Horner, *The Living Thoughts of Gotama the Buddha* (London, 1948). In AKC's introduction (the part for which he is responsible in this collaborative work), this passage appears on p. 2.

and a foreign dress, equally unnatural and equally misunderstood. And therewith came before my mind all I had seen in the last two years of the ruin of native life and manners before advancing civilization; which last indeed I had sometimes escaped in the remoter jungle districts, but which after all, dogs one's footsteps everywhere. ... And I knew it to be a part of what is happening all the world over, the continual destruction of national character and individuality and art. . . .

From these thoughts, others shaped themselves:

How different it might be if we Ceylonese were bolder and more independent, not afraid to stand on our own legs, and not ashamed of our nationalities. Why do we not meet the wave of civilization on equal terms? ... Our eastern civilization was here 2000 years ago; shall its spirit be broken utterly before the new commercialism of the west? ... Sometimes I think the eastern spirit is not dead, but sleeping, and may yet play a great part in the world's spiritual life.[7]

Coomaraswamy knew England as his home, but he stood in relation to Ceylon as did no other Englishman, and he perceived the results of English influence on the island perhaps more clearly than any man before him. He had nothing to attain in the way of English culture, as pure-blooded Ceylonese often felt they did; his vantage point was a precise middle ground, free of a sense of inferiority, free of a sense of superiority. He was aware of his position; in 1906, he told an audience in Jaffna, "I believe it is difficult for any of us, who have not actually been brought up in England, to realise the hopeless inadequacy of our attempts at imitation; to Englishmen the absurdity is obvious, but to us it is not revealed. Coming freshly to the East and starting from the ordinary English point of view, I have been struck."[8]

Ceylon had been a crown colony of the British Empire since 1802. In the two previous centuries, it had already been declared a possession of Philip II of Spain by his Portuguese traders, who initiated mercantile relations with the Kandyan kings in 1505, and been ruled by the Dutch, who superseded the Portuguese in the mid-seventeenth century. All of

[7] AKC, *Borrowed Plumes* (1905). This passage is cited from the article as reprinted in S. Durai Raja Singam, *Coomaraswamiana* (Kuala Lumpur, 1959), pp. 3–7.

[8] Quoted in *The Ceylon National Review*, I (1906), 226.

these European arrivals left relatively untouched the hill kingdom of
Kandy at the center of the island, which ceased to exist as an independent
power only in 1815–1818, when discord between the king and his chiefs
opened the way to British invasion. Until that time, European sovereignty
was limited to the coastal areas and ports. The Portuguese, who inter-
married with the Sinhalese and Tamils, introduced the Roman Catholic
religion among lower castes and left a legacy of Portuguese names still
current in Ceylon. The Dutch ruled more ably, establishing the system
of Roman-Dutch law that prevails to this day and leaving behind, with
the coming of British rule, a colony of Burghers who rarely intermarried
with the Ceylonese but continued to staff minor administrative and mer-
cantile posts until Ceylon achieved its independence from European rule
in 1947. British hegemony, assumed during the Napoleonic Wars, was
prompted by the East India Company—which, like the other European
traders, was interested in exporting cinnamon; the island's strategic loca-
tion vis-à-vis India furnished the primary motive for assuming control
of it. In the 1820s the trade in spices lost its importance, due to competition
from the Dutch East Indies, but new plantations of coffee, cinchona (for
quinine), rubber, and finally tea in the late nineteenth century, main-
tained the island's trade. Ceylon was always of strategic importance to
maritime powers, and with the opening of the Suez Canal in 1869 it pro-
vided ports of call for shipping, particularly at Colombo on the east coast,
where Coomaraswamy was born.[9]

The British administration of Ceylon had the all-inclusive quality as-
sociated with the British Raj in India: every sector of public life was
touched by the shift to a large-scale plantation and export economy that
required new roads, a dependable labor force, and so on; private life was
equally transformed by the growth of a Ceylonese middle class engaged
in business and educated in English-language schools modeled on Eng-
lish schools of the same level. The school system in India, described
by Lord Macaulay as designed to create a class of persons Indian in race
but English in education and outlook, had its analogue in Ceylon. The
prestige of English values and the neglect of Ceylonese had reached its
climax in the years before Coomaraswamy's return as a young man: his
father represented an unusually accomplished blend between the two cul-
tures, against a background of cultural domination that his son, in 1905,
found unacceptable.

[9] For a concise history of Ceylon, cf. E.F.C. Ludowyk, *The Modern History of
Ceylon* (New York, 1966).

In this way, a geologist who set out from England certainly with enormous curiosity and warmth for the country of his ancestors, but with a professional commitment that had little to do with social and cultural affairs, found himself dreaming of reform and studying pre-colonial art and society. There is little in what can currently be documented in Coomaraswamy's early biography to account for the interest in art, architecture, and craftsmanship that from the beginning distinguishes his nongeological writings. As soon as he began to write on these subjects, it was obvious that his greatest mentor, the man from whom he learned the most and upon whose life he patterned his own throughout these years, was not an Oriental at all but the English craftsman and social thinker, William Morris. But Morris's influence (to be discussed later in detail) only becomes apparent at this time of Coomaraswamy's transformation; one is left wondering why a geologist's eye wandered so irrevocably from the ground upward, to the buildings and artifacts of a people. That Coomaraswamy felt drawn toward an active role in society was the natural consequence of his father's example and heredity; that he became a student of the history of art must be due, in part, to an intimate process of awakening to his individuality. It will be clear in what follows that the history of art was never for him either a light question —one that had to do only with pleasures—or a question of scholarship for its own sake, but rather a question of setting right what had gone amiss partly through ignorance of the past.

In 1905, the year of his first writings on art, while still director of the Mineralogical Survey, he published "An Open Letter to the Kandyan Chiefs" in *The Ceylon Observer*, an independent newspaper.

During the last two years, I have given my spare time to studying old Kandyan work in architecture and all the crafts that flourished in those times that seem now so far away. I have seen old buildings and new; and in the minor arts it has not been once or twice only that I have attempted to get made for myself some one or other of the wares that were once produced so easily and so well, and of which a little of the wreckage survives in a few museums and private collections; and it has been again and again borne in upon me as the result of bitter experience both in the remotest villages and in Kandy itself, that the character of steady competence which once distinguished the Kandyan artist craftsman has gone forever; a change such as the industrial revolution has brought about almost all over the world.

Further in the letter, describing the neglect of old buildings, he remarked that he had copied the frescoes in the *vihara* (Buddhist prayer hall) at Degaldoruwa; it is the earliest sign that he was something of a draftsman.

Not only Ceylonese art, but also its literature and music had fallen on bad days. As he pointed out in another public letter, Sinhalese religious and heroic literature, romances, and music, were going unpublished and unstudied while Wordsworth and European music assumed their place.[10] His pamphlets and letters reached like-minded readers in Ceylon. There appeared the idea of forming a society to foster a more enlightened public opinion concerning these and related issues, and in 1905 several Europeans long resident in Ceylon and already active in encouraging Buddhist studies came together with the Coomaraswamys to found the Ceylon Social Reform Society.

[10] "Unfamiliar Kandyan Literature" (1905). Reprinted in Singam, *Coomaraswamiana.*

III. The Ceylon Social Reform Society,

1905–1907

To express the views of the Ceylon Social Reform Society, a journal was established, its first number appearing in January 1906, with an unpretentious cover designed by Coomaraswamy, who also served as its editor in association with two others. The opening number included a formal manifesto and a list of the society's membership, at the top of which occurred Coomaraswamy's name as president (Figure 5 is a portrait of Coomaraswamy at this time). The manifesto is interesting to read in its entirety, not only for its content but for its elegantly British, thoroughly Victorian tone. There is no contradiction: in the first place, the society took a moderately friendly attitude towards Western culture; and second, Ceylon had been a British colony for so long that its voice, even the voice of awakening nationalism, was inevitably an English one.

The Ceylon Social Reform Society

Manifesto

The Ceylon Social Reform Society has been formed, in order to encourage and initiate reform in social customs amongst the Ceylonese, and to discourage the thoughtless imitation of unsuitable European habits and customs.

It is felt that many Eastern nations are fast losing their individuality and with it their value as independent expressions of the possibilities of human development. An imitative habit, based perhaps on admiration for the command of natural forces which Western nations have attained, has unfortunately involved the adoption of a veneer of Western habits and customs, while the real elements of superiority in Western culture have been almost entirely neglected; at the same time

22

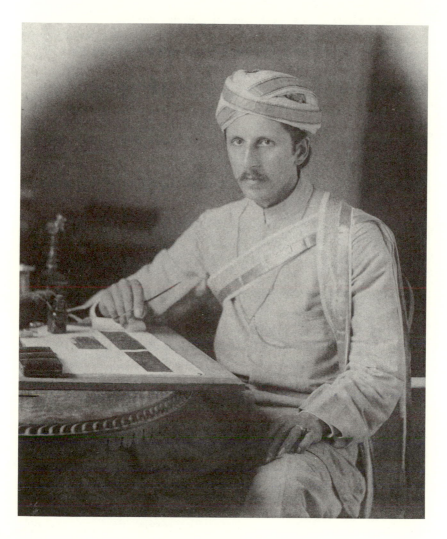

Figure 5. Coomaraswamy, ca. 1907.

this straining after the Western point of view has equally led to the neglect of the elements of superiority in the culture and civilisation of the East. These points are illustrated by the caricature of Western culture so often presented by Eastern men and women who have broken with all natural traditions of their own and who do not realise that it is not only undesirable, but impossible for them to consistently adopt the outlook on life of Western nations, suited to quite another climate and to other races of men; so that the thoughtless imitation of foreign manners involves the suppression rather than the development of "every real betterness."

An endeavour will therefore be made to educate public opinion amongst the Eastern races of Ceylon, with a view to encouraging their development on the lines of Eastern culture, and in the hope of leading them to study the best features of Western culture rather than its superficial peculiarities. Although it is considered by the Society that in such matters as language, diet and dress, we have to deal rather with the symptoms than the causes of the decadence of Eastern nations, efforts will be made to restore a natural pride in such expressions of national individuality.

The Society desires to promote sympathy and mutual respect between men of different nationalities, and in particular to emphasize the natural bonds of fellowship uniting the various Eastern races in Ceylon.

Men and women sharing these views are invited to become members, and to assist the work of the Society. Members will not be bound to adopt any definite course with regard to the particular reforms advocated by the Society from time to time, but it is essential that they should be in sympathy with the general principles laid down above.

The work at present contemplated by the Society includes the encouragement of temperance and vegetarianism, the retention or readoption of national dress (especially on formal occasions) and of national social customs connected with weddings, funerals and so forth. In connection with the latter, the Society is strongly in favour of cremation, as at once the most sensible and sanitary method of disposing of the dead, and speaking generally the traditional method of the East. Vegetarianism is advocated as being the most natural and healthy diet and also in keeping with the traditions of the East. The ethical and religious aspects of the question will be emphasized by the members to whom these points of view especially appeal.

With respect to language and education, an attempt will be made to influence public opinion; it is felt by the Society that the education of children at schools where their own language is not taught, or not taught efficiently, is much to be regretted, and it is hoped that parents will insist upon the proper teaching of their own language in any school to which they may be inclined to send their own children. The Society is also anxious to encourage the study of Pali and Sanskrit literature, and of Tamil and Sinhalese, and would desire to combine a general education on the lines of Eastern culture with the elements of Western culture (particularly science) best suited to the needs of the time.

The Society is anxious to encourage the revival of native arts and sciences, and in respect of the former especially to re-create a local demand for wares locally made, as being in every respect more fitted to local needs than any mechanical Western manufactured goods are likely to become. The Society also desires to assist in the protection of ancient buildings and works of art, and to check the destruction of works of art which goes on under the name of re-decoration and repair. The establishment of schools of native arts and sciences will be considered.

In religious matters the Society is in favour of the greatest possible freedom.[1]

Underlying this document, with its multiplicity of concerns ranging from broad questions of national identity to nitpicking views on personal hygiene, is a Victorian conviction that humanity, both the individual and the community, is susceptible to reform through good means—obvious, logical means.[2] Coomaraswamy's adult life began at this time, when one could still invest hope in an idealistic program of general reform. He moved with the rest of his century into a different frame of mind, but the call for reform, even in the wholly changed conditions of his later life, never disappeared from his writings dealing with society, education, and the social function of art; his reform spirit underwent a sea change, but never a dilution.

Coomaraswamy's life was many sided after 1905. He finished his final

[1] *The Ceylon National Review*, I (1906), ii–iii. Unsigned, but presumably owing much to the president of the society.

[2] Cf. Jerome Hamilton Buckley, *The Victorian Temper: A Study in Literary Culture* (Cambridge, Mass., 1951), p. 5.

Administration Report for the Mineralogical Survey, probably in the early part of 1907; thus he was doubtless concerned with geology throughout his years of active participation in the Reform Society (1905–1907). He was gathering, meanwhile, the material for his encyclopedic study of mediaeval Sinhalese art and publishing a few finished sections in local periodicals; he also built a personal collection of Ceylonese arts and crafts—jewelry, textiles, pottery, brasswork, and bronzes—and at the same time making purchases for the Colombo Museum.[3] He arranged and wrote the handbook for an exhibition of arts and crafts in 1906 that brought craftsmen to the exhibition hall itself to show their techniques. This handbook, with its attentive descriptions of craft processes and its basically simple attitude toward art—neither Romantic, nor intellectually technical, nor haunted by a sense that too much of traditional value had been lost (all of which characterize his writings at certain later times)—is something of a Song of Innocence, the expression of a rich and unclouded love of making and things. He had also begun during this period to widen his horizons to include the art and culture of India, and was prepared by 1908 to present a paper in Copenhagen, at the Fifteenth International Oriental Congress, on a controversial subject, "The Influence of Greek on Indian Art." And he produced articles and book reviews for *The Ceylon National Review* while working for the Reform Society in other ways: holding lectures in various cities of the island (cf. Figure 6), publicizing its program through an article in an Indian periodical, founding a new branch of the society in Jaffna, at the northernmost tip of the island.[4] Ceylon was a microcosm; it allowed him to see things as a whole, although on a small scale, and to try out many forms of activity. The experience of a whole marked him, never permitting him thereafter to think about art without also thinking about artists, or about fine art without crafts, or about museums where things are rare and protected without the marketplace where things are available. He was destined to become a specialist in Indian art, but he was also a generalist concerned with the entire civilization, the inner and outer conditions that give works of art their character.

[3] Cf. Dr. M. D. Raghavan of the National Museum, Colombo, in *Memorial Volume*, pp. 171–180.

[4] Cf. *The Ceylon National Review*, I (1906), 12 ff. The Reform Society also sponsored guest lecturers such as Annie Besant, who spoke in November 1907, on "National Reform: A Plea for a Return to the Simpler Eastern Life," according to an announcement in the *Review*. In that year, 1907, she had been elected president of the International Theosophical Society, which did important work on behalf of Indian nationalism and national education.

Figure 6. Announcement of a Lecture by Coomaraswamy, Ceylon, ca. 1906.

Coomaraswamy's love of a *public* activity is apparent from this time on. Even many years later, when his scholarly work reached a degree of intricacy and difficulty that excluded interesting the public in it directly, he rather frequently lectured at American colleges, universities, and museums on subjects and in a style accessible to everyone; in the mid-1930s he gave a series of radio broadcasts on art, a step that would appear inconsistent on the part of the austere, philosophical scholar that he by then had become, if one were not aware that he became an art historian in response to public need and never ceased to see his work in that light. It also seems appropriate to attribute his prolific writings in later years to the training of Ceylon where his life, compounded of public debate, *Review* deadlines, research in the field, and initiatives of all kinds (as in Jaffna, 1906: "The formation of a museum . . . will help us to give up our habit of regarding old relics such as I collect merely as curiosities"),[5] made him willing and able to *do* a great deal.

Coomaraswamy's thought and style in this period are most evident in *Mediaeval Sinhalese Art*, published in England not long after he left Ceylon in 1907 with the express purpose of seeing to its publication. It would be interesting to consider two short articles from this period that have many of the characteristics of *Mediaeval Sinhalese Art*. From the beginning, he was a literary artist; putting his thoughts on paper was not a burden but an occasion. "Kandyan Art: What It Meant and How It Ended" gives a brief account of traditional Ceylonese art, its characteristics and the conditions under which it was produced, and follows this by an indictment of the effects of modern civilization on the old order. Since we shall look at *Mediaeval Sinhalese Art* in some detail, the only passage from the article worth noting here is one in which he draws a line:

In looking back to Kandyan times, it must not be forgotten that the craftsmen, and all the folk indeed, were subject to a certain amount of violence and oppression directly practised by their chiefs or by the king, or resulting from wars with the Tamils, and later, with the Portuguese and Dutch. Moreover the people at large had no political rights and men were always bound and hampered by caste restrictions, though we have already seen that these did not interfere with the unity of the people as a whole and served a good end in checking the accumulation of lands by wealthy persons; and it is clear that in the

5 *The Ceylon National Review*, I (1906), 14.

main all this stood apart from the craftsman's daily work, though it must have had some hindering effect therein. But not all the highway robbery and violence of kings or conquerors made the production of real art impossible, as has the industrial revolution, which developing first in Europe has spread to every quarter of the earth, destroying in a month the traditions of a thousand years.[6]

The admiration for traditional, preindustrial civilizations, which was born in Coomaraswamy's Ceylon years and remained a determining factor throughout his life, did on occasion slip into romanticism, after the model of Pre-Raphaelite painting in the West and the archaizing poems of William Morris. But here at the point when this admiration had just been created, he cautioned enthusiasm with a word about violence in the older order of things; many times in later years he disavowed any wish literally to "turn the clock back."[7]

The second article, "Anglicisation of the East," is a heated account, giving credit to the English but pointing out the often unintentional destruction of national culture that they brought about.

> Englishmen, whose administrative capacities and general ability it would be pointless to deny, are so firmly convinced of the absolute superiority of their own language, literature, music, art, morals and religion over those of any other peoples—an attitude of mind proverbially ascribed to the Englishman abroad in Europe, and still more obvious when he becomes the ruler of an eastern land—that it is deemed heresy even to question the desirability of grafting all these elements of western culture upon the ancient tree of Indian civilization. However honourable the exceptions, it is true that the majority of Englishmen in the East . . . have known little and cared less about the literary, artistic, and religious side of Indian life.[8]

On the other hand, he was not overly impressed with his contemporary Ceylonese, who fell easily into imitation of the English, and usually derived from their English educations only enough to become, as he wrote, shop-assistants or bureaucrats. He went on to examine the question of national education in some detail, pointing out especially that because no Ceylon National University existed, the price of higher education in the

[6] *Ibid.*, p. 6.

[7] Cf. AKC, "Note on a Review by Richard Florsheim" (1938). Reprinted in *Christian and Oriental Philosophy of Art*, pp. 86–88.

[8] *Ceylon National Review*, I (1906), 181.

English system was total neglect of Ceylonese language, literature, and traditions, hence an educated class "estranged from the bulk of their fellow countrymen." He acknowledged the importance of English as a *lingua franca* among the various language groups in India and Ceylon, but insisted on the importance of studying national culture and languages: "The educational need of India . . . is the development of its peoples' intelligence through the medium of their own national culture."[9] In the section following, on art, he evoked with what now seems a heavy touch of Romanticism the state of Indian art even in the mid-nineteenth century. He wrote of the "heart-rending" destruction of popular art in India; "in many a quiet village," he continued, "dyers of yarn and cloth led an uneventful life amidst the fields of madder," until dragged into poverty by industrial competition. What he wrote was true—and much of it was rooted in Victorian ideas and attitudes, transferred to the East but easily spotted: above all, William Morris's yearning for a better yesterday and Thomas Carlyle's fiery Biblical rhetoric.

Coomaraswamy was not the first to describe in regretful terms the destruction of Indian craft industries and their idyllic village setting; nor can his intensity be attributed solely to his special sympathy as an Oriental for India's dilemma. He was preceded in both by an Englishman, Sir George Birdwood, curator of the Indian Section of South Kensington Museum (later the Victoria and Albert), whose book, *The Industrial Arts of India*, published in 1880 for the museum, attacked "the fierce and merciless competition of the English manufacturer,"[10] which had caused hereditary craftsmen to accept drudgery in "the colossal mills of Bombay." Birdwood's vision of the India threatened by Manchester and Birmingham was no less loving than Coomaraswamy's. His book was, in a number of ways, the model for *Mediaeval Sinhalese Art*, and we shall return to it in that connection.

Nonetheless, Coomaraswamy seems a little out of touch with the "uneventful life amidst the fields of madder" to which he referred, although the knowledge of craftsmanship that he displays in *Mediaeval Sinhalese Art,* as well as his descriptions of his life in Ceylon, prove beyond doubt that he knew the peasant and artisan classes better than most did.[11] These

[9] *Ibid.*, p. 186.

[10] Birdwood, *The Industrial Arts of India*, p. 140.

[11] Though the unspoilt villager is a man worth knowing well, the 'educated' classes are sadly degenerate and de-nationalised," AKC, *Mediaeval Sinhalese Art* (1908), p. 15. For a factual account by AKC of the life of the peasant and artisan classes in Ceylon, cf. "The Village Community and Modern Progress" (1908).

early essays illustrate a characteristic of his, both in this period and through his life until the mid-1920s. It is the presence of what might be called unexamined material in his thought and language: whole blocks of ideas and ways of expressing them that come from some other person (as influences, to use a familiar term) and stand out as impurities still needing to be either more deeply assimilated or rejected. This observation can be made apropos the early works of any writer, but with Coomaraswamy it is surprising because he devoted his later years to the *direct* study of source material and maintained his independence from nearly every contemporary school of thought. Here the mood of Victorian Romanticism still interposed a screen between his powers of observation and his topic.

Coomaraswamy's familiarity with the Bible, demonstrated by these early essays in which he ably quotes New Testament, raises the question of his religious beliefs at this period. Certainly at Wycliffe College he received a thorough grounding in Christianity. His mother is said to have been inclined toward the Hindu point of view, and his father, although Hindu, had published translations of Buddhist texts. During the Ceylon years, Coomaraswamy was attracted by Hinduism and Buddhism because they seemed more complete than Christianity: "Religion is not in the East, as it is in the West, a formula or a doctrine, but a way of looking at life, and includes all life, so that there is no division into sacred and profane."[12] On his return to England from Ceylon, in 1907, he traveled extensively in India; it was probably during this voyage that he became formally a Hindu in Lahore.[13] He met the leaders of the Theosophical Society in Benares and Madras—at least Annie Besant and Bhagavan Das, who concerned themselves with Indian religious thought but were also extremely active in the nationalist movement. In 1907 Bhagavan Das inscribed a book to him that is still in his library. The serious concern of Theosophists with Indian religion, as well as their nationalist activity, attracted Coomaraswamy at this time, although in later years he mistrusted Theosophy and insisted on the necessity of learning directly from the sources of religious knowledge, both the "Living Rule," as Roman Catholic monasticism describes its living exemplars, and the written texts.

Coomaraswamy's writings never betray his formal commitment to Hinduism: he derived understanding from all religious traditions in later

[12] AKC, review article, *The Ceylon National Review* (1908), p. 244.
[13] Nowhere published, this information has been passed down in the Coomaraswamy family.

years and tried to demonstrate that there is fundamentally only one Truth, expounded in various ways; but his understanding of the *structure* of a rightly lived life—his understanding of his own activities—seems to owe more to the *Bhagavad Gītā* than to any other source, and his intention to spend his old age in semiretirement in north India is an entirely Hindu conception of what is fitting for a man who has accomplished his duties in the world. Although the passage quoted on religion in the East and West seems to deprecate doctrine and formula, as time went on Coomaraswamy was preeminently interested in the intellectual aspects of Hinduism and Buddhism; he believed that if the thought is not right, not much else can be right. It seems likely that in his early days in Ceylon it would have been very difficult, perhaps impossible, to encounter a religious teacher of the kind that Ramana Maharshi exemplified in India during much of the first half of this century. The Buddhist tradition in Ceylon had become intellectual—true to the letter—according to a European who entered a Buddhist monastery in Ceylon but eventually found the tradition more vital in Tibet.[14] Coomaraswamy's writings in the Ceylon period show that he was touched by the formal religious art and architecture of the island and learned much from seeing that a religious conception of life suffused the life and artifacts of the common people of Ceylon, but he seems to have had little significant contact with the monastic community. Among his acknowledgments in the foreword of *Mediaeval Sinhalese Art*, he mentioned "the invariable courtesy of Buddhist Priests," but he was an idealist, a social reformer, and a student of art, not yet of religion.

[14] Cf. Lama Anagarika Govinda, *The Way of the White Clouds: A Buddhist Pilgrim in Tibet* (London, 1966), pp. 31, 73.

IV. *Mediaeval Sinhalese Art*

The heart of Coomaraswamy's experience in Ceylon is contained in *Mediaeval Sinhalese Art*, published in 1908 in England under unusual conditions. This book represents his first major achievement as an art historian; its lasting value is well enough demonstrated by the fact that the government of Ceylon, in cooperation with a New York publisher, arranged for a new edition of the work in 1956. It is, as we have said, the fruit of personal experience—conversations with craftsmen and observation of their work, a personal collection of arts and crafts, photographs taken for the most part by his wife—but the result is still encyclopedic in format. The kind of experience underlying it is illustrated by his account of craftsmen working on his house in Kandy, a scene to which he often referred in later writings because it represented to him a certain ideal.

> I have had craftsmen working at my house in Kandy for weeks together; just as they once worked in the royal workshop. They had no idea of "making money" or "bettering themselves"; they wanted only money sufficient to buy food for themselves and their families; they had no wish to save money. When a large piece of work was completed they would expect some special gift, such as a good cloth. They rarely worked a week without having to go home for a few days to find some strayed buffalo, or to take part in the cultivation of their fields. Yet they were always most conscientious in money matters, such as expenditure on materials; and though they would have hated fixed hours of work, often worked far into the night by lamplight, purely by their own wish, and because they so much loved the work itself. Their pride in real capacity was most naive and unaffected. Their greatest possible ambition was that I should buy them some small piece of land and reward them with it, as did the kings of old.[1]

[1] AKC, *Mediaeval Sinhalese Art*, p. 57. This experience was still with him in 1944, when he wrote the introduction to a book of essays by Eric Gill, the English sculptor and typographer. Cf. Eric Gill, *It All Goes Together* (New York, 1944), p. x.

If Coomaraswamy in his role as a patron has a slightly patronizing tone, throughout the book he generally places himself on the level of the craftsman, learning his techniques, concerns, and language.

Coomaraswamy was dealing in this book with the *later* traditional arts of Ceylon, not with the better known periods that produced the very impressive Seated Buddha at Anurādhapura (A.D. 6th–7th centuries), refined bronzes of Hindu gods and goddesses (7th–12th centuries),[2] and the austere but intensely alive sculptural groups at Polonnaruva (12th century). In the foreword to his book, he set its limits and suggested its spirit:

> This book is a record of the work and the life of the craftsman in a feudal society not unlike that of Early Mediaeval Europe. It deals, not with a period of great attainment in fine art, but with a beautiful and dignified scheme of peasant decoration, based upon the traditions of Indian art and craft. . . . Mediaeval Sinhalese Art was the art of a people for whom husbandry was the most honourable of all occupations, amongst whom the landless man was a nobody, and whose ploughmen spoke as elegantly as courtiers. It was a religious art, and so a popular art. It was also essentially a national art; the craftsmen, forming an integral part of the Civil Service, were rewarded with grants of State land, no less than soldiers or husbandmen. It was the art of a people whose kings were "one with the religion and the people,"—perhaps the most significant phrase in the whole of that magnificent chronicle, the *Mahāvaṃsa*.[3]

The art of people whose "ploughmen spoke as elegantly as courtiers"— this apparent example of Romantic nostalgia is, in fact, drawn from the late seventeenth-century chronicle, *An Historical Relation of Ceylon*, by the Englishman Robert Knox, political prisoner of the Kandyan king for eighteen years.[4] Looking back to this period prior to the British, Coomaraswamy found conditions that he thought nearly ideal for the growth and maintenance of a popular art. It was the very opposite, in his view, of conditions in the industrial West, where "the people" and craftsmen had decayed into a proletariat working under factory conditions to produce goods that had no art in them—certainly not the art of the factory

[2] Cf. AKC, "Bronzes from Ceylon, Chiefly in the Colombo Museum" (1914).

[3] *Mediaeval Sinhalese Art*, pp. v–vi.

[4] Robert Knox, *An Historical Relation of the Island of Ceylon in the East Indies* (London 1681). A modern edition, ed. James Ryan, was published in Glasgow, 1911.

worker himself. A further consequence of industrial production, in his analysis (which follows William Morris's), is that concern for art became the province of a privileged few; it became "fine art," essentially a luxury doing nothing to improve the diminished quality of manufactured goods, the squalor and pollution of the industrial landscape, and the diminished quality of men. "Cheap work, cheap men."[5] The crafts and popular art in general appeared to him to be one of the principal means by which culture was transmitted, not only among craftsmen who apprenticed in a given trade, learning the necessary skills, the traditional iconographies and ornaments, and the attentive frame of mind on which artisanship depends, but also for the whole population—the consumer, as Coomaraswamy was already saying in this book. The handmade environment had more "temperament." Thus, from the outset, *Mediaeval Sinhalese Art* is conceived as a study of working conditions and crafted products that differ from the factories and manufactures of the modern West, but have a kinship with the Western Middle Ages, which Coomaraswamy had learned to appreciate certainly, in the first place, because the English have a feeling of warmth for their mediaeval past, but also because the Middle Ages represented an untarnished ideal for William Morris, Coomaraswamy's first teacher. The Kandyan kingdom was a model of preindustrial society in some ways more accessible than the European Middle Ages; Coomaraswamy's book was read at the time of its publication precisely by those people in England who were trying to learn from their own Middle Ages how to reorganize manufacture so that it would become once again "a means of culture."[6] His book's title is an acknowledgment of this connection and this audience. It is worth noting that Coomaraswamy did not invent the idea that Indian and Ceylonese art have an intimate relation with the Middle Ages. In a later book, he cited the great nineteenth-century historian of Indian architecture, Fergusson, who had occasion in 1839 in India to watch the raising of a traditional cenotaph, and remarked that "from its architect I learned more of the secrets of art as practised in the Middle Ages than I have learned from all the books I have since read."[7]

We have already noted that the chief inspiration for *Mediaeval Sinhalese Art* was Sir George Birdwood's *The Industrial Arts of India*. A great

[5] *Mediaeval Sinhalese Art*, p. vii.

[6] *Ibid.*

[7] Quoted by AKC, *The Arts and Crafts of India and Ceylon* (Edinburgh and London, 1913), p. 132.

appreciator of Indian craft industries and a student of Hindu scripture and myth, Birdwood had written a descriptive study of every kind of Indian "art manufacture," as he and his generation liked to say, prefaced by more than one hundred pages on the iconography of Indian divinities, the content of the epics, and the organization and themes of the sacred writings. In the most interesting pages of his text,[8] he showed himself to be wholly out of sympathy with mediaeval Indian religion, whose gods with multiple arms and composite bodies were so monstrous to him that he considered "sculpture and painting . . . unknown, as fine arts, in India," being rendered unattainable through the "evil influence of the Puranas on Indian art." In spite of this attitude, Coomaraswamy found much of importance in his pages: recognition that mechanical industry had destroyed fine work both in England and in India, as well as the good taste of the general populace; admiration for guild organizations as the guarantor of standards and the means of transmitting knowledge from generation to generation; appreciation of the effects of wealthy, dependable patronage on artists' work; and acknowledgment of the beauty of the whole environment that prevails where industrialization is absent. Coomaraswamy's book differs from Birdwood's through its greater degree of intimacy with the ways of thought of Asian artists, and in its interest in craft processes, not merely in the products. Coomaraswamy also took great pains to have text illustrations that expressed to some extent the real character of Sinhalese art, as well as photographs in great number; while Birdwood tolerated steel engravings that showed well enough the forms of metalwork and the like, but gave every subject a uniform coldness. It is also true that Coomaraswamy never lost from sight his purpose of comparing preindustrial and industrial products, working conditions, and ethos; while Birdwood, who was writing a manual for the Indian Section of South Kensington Museum, restricted his comments on these subjects.

After sketching the history of Ceylon in the first chapter of *Mediaeval Sinhalese Art*, Coomaraswamy devoted the second to a reconstruction of the Kandyan social order, a highly interdependent feudal structure dominated by the king and his regional chiefs, based on exchange of services, land, agricultural produce, and articles of manufacture, with twenty-six or more castes corresponding to vocations. One feature of this society that deeply impressed him was its cultural *unanimity*; Knox's

[8] Birdwood, *The Industrial Arts of India*, pp. 125–143.

chronicle, in particular, recorded this feature in words that Coomaraswamy often quoted. Coomaraswamy wrote:

> Observe how remarkably the different parts of the social organism were fitted and dovetailed together; there was a place for every man, and no man could be spared; class distinctions were not invidious, nor emphasized by differences of culture. . . . A Sinhalese proverb runs, "Take a Ploughman from the Plough and wash off his dirt, and he is fit to rule a kingdom." "This was spoken," says Knox, "of the People of *Cande Uda* . . . because of the Civility, Understanding and Gravity of the poorest men among them."[9]

In his later years, Coomaraswamy was interested in the question of what links the culture of one social level with another; there is no doubt that he only felt at peace with civilizations in which popular culture revealed in some form the same concerns that appeared on more elite levels.

Knox's words in the above passage refer to a certain unanimity of thought that Coomaraswamy attributed to "a state religion which was also the religion of the people."[10] This provided the conditions for "popular art":

> The landholding craftsmen were practically state-endowed; and in return their work was done essentially for the people themselves, whose palaces and picture galleries were the viharas and devales where they worshipped, and with which their festivals were associated. Luxury was little, and the amount of fine art absorbed and hidden away by royalty and other wealthy persons was small compared with that belonging to the Church and so to the whole folk. Just so was it in mediaeval Europe; art was for the people, and no lack of it. Now it is otherwise, and art is for the rich only, and hard to come by.[11]

In this way, he extended the concept of unanimity from the domain of general culture to a sharing in the achievements of hieratic art—the arts proper to places of worship. He saw the circle widening still further, to include the everyday arts, tools, utensils, and furnishings of the household. Although not principally religious in intent, objects of daily use were not entirely unlike the products of hieratic art; particularly in their ornamentation, which shared the repertory of motifs found in higher arts. It was an enormously important discovery for Coomaraswamy to find

[9] *Mediaeval Sinhalese Art*, pp. 28–29.
[10] *Ibid.*, p. 15. [11] *Ibid.*, p. 49.

that utilitarian objects in the Kandyan tradition participated in the spirituality of the culture, although as yet he could only define the participation in a vague and wordy way, mainly borrowed from William Morris. The distinction between fine art and applied art no longer appeared essential to him, but rather an accident due to the impoverishment of applied art at a given time and place, and very likely a sign that fine art was also impoverished.

The artist-craftsman's place in Kandyan society is another feature that Coomaraswamy thought important to recognize. In an agricultural society, the village craftsman was assured of his livelihood by the regular and wide demands made on him for the products of his particular craft, and he typically held land of his own. The finer craftsman, working periodically or constantly for court and capital, was equally sure of his reward and his stable place in society. Working within a tradition of forms, ornaments, and established ways of proceeding in actual labor, for patrons upon whose need for their work they could depend, artist-craftsmen were in a position that did not encourage works of individual genius, but did maintain many qualities in their work: iconographic correctness, aptness for use, and always a certain beauty. Discussing the conventions of Buddhist art in the Kandyan period, Coomaraswamy wrote:

> Just how long ago the rules were formulated is uncertain . . . but no doubt one object of them was to make possible the reproduction of images in sufficient quantity by average workmen at all times. This, rightly, I think, set religious above "artistic" considerations; but, art having thus sought first the kingdom of God and His righteousness, the rest was added to it. For such convention is a far greater help than hindrance to real art. It does not prevent the man of genius from producing the most beautiful work possible, though ensuring that it shall so far conform to an accepted standard as to be immediate and universal in its appeal; at the same time it does prevent the possibility of "the holy and elevating subjects being treated absurdly or stupidly, so as to wound the feelings of serious men"; which happens every day now that the old tradition is generally broken with.[12]

Within the artistic tradition, Coomaraswamy was especially interested in the guild system prevailing for crafts associated with the Royal House. Guilds provided general and technical schooling for young craftsmen and protected the standards and interests of accomplished craftsmen. Trans-

[12] *Ibid.*, p. 48.

mission from father to son was the norm, but pupils from other families were also accepted.[13] The whole of a craft was learned; division of labor had no formal part in guild organization. As regards ornamental and figurative art, the teaching offered was not drawing from nature, anatomical study, and the like, but the transmission of a traditional vocabulary and style that could hardly be called naturalistic. This traditional vocabulary ran for the most part parallel to nature, composed as it was of an enormous variety of plant and animal forms, human and divine images, and relatively abstract designs such as the 108 auspicious symbols that may ornament the Buddha's foot,[14] but it was learned without reference to natural antecedents. "The Kandyan artist carried in his head the elements of his art, and composed them as occasion required."[15]

Upon publication, *Mediaeval Sinhalese Art* aroused at least as much interest in England as in Ceylon. Roger Fry, the outstanding English art critic of his day, wrote that Coomaraswamy

is not concerned with the history of great masterpieces; his work is almost as much sociological as aesthetic; he seeks to investigate and explain the methods of Sinhalese craftsmen, to fix the outlines of an artistic industry and education before it finally disappears. The interest of such an attempt is great. . . . Ourselves, ever more and more disgusted with the effects upon art and life of machinery under commercial competition, have, since Ruskin pointed the way, turned with eager curiosity to the study of mediaeval craftsmanship and organization of labour. In this direction Dr. Coomaraswamy's record is likely to be of great value.[16]

[13] AKC's closest investigation of teaching methods under this system is found *ibid.*, appendix to chapter III, "Teaching of Drawing."
[14] *Ibid.*, pp. 110–111, and fig. 69.
[15] *Ibid.*, p. 171.
[16] Roger Fry, "Oriental Art," *The Quarterly Review*, No. 422 (1910), pp. 237–238.

V. England, 1907–1908:
"Craftsmanship Is a Mode
of Thought"[1]

Coomaraswamy left Ceylon at the beginning of 1907 and by autumn, after traveling in India, was established in a grand manor house at Broad Campden, an English country village not far from Stratford-on-Avon. He continued to contribute articles to *The Ceylon National Review* until (according to the memoir of a friend from that time) it died a "natural death for want of support, as is the way in Ceylon."[2] He maintained his connection with Ceylon—he published there a book of articles in 1909, *Essays in National Idealism*; he spoke at the Ceylon Dinner in London the same year;[3] he included Ceylon as an integral part of his earliest general history of Indian art;[4] he wrote a monograph for the Colombo Museum[5]—but in fact his departure had something final in it. Ceylon had not been ready to respond to his ideas, not ready to create and support a "Mistral."

Frédéric Mistral, the poet and patriot who led a peaceful cultural revolution in the south of France in the late nineteenth and early twentieth centuries, which aimed to reestablish the literature and customs of the *pays de la langue d'oc*, represented for Coomaraswamy the unachieved ideal he had dreamed for Ceylon. Writing from his new home in England in 1908 to *The Ceylon National Review*, he evoked the image of Mistral in words that barely hid his personal regret: "Where then is our Mistral, and the followers of him? for no national culture can be saved by the efforts of one man only, unless he draws others to him. We need a

[1] AKC, *The Arts and Crafts of India and Ceylon*, p. xii.

[2] *Memorial Volume*, p. 199.

[3] Cf. *The Ceylon National Review* (1909), p. 69, for an account of his address to Ceylonese students on this occasion.

[4] *The Arts and Crafts of India and Ceylon* (1913).

[5] "Bronzes from Ceylon, Chiefly in the Colombo Museum" (1914).

Mistral in Ceylon, and a thousand willing helpers."[6] The English in Ceylon had generally not aided Coomaraswamy's efforts—their newspapers were filled with cutting remarks about "Ananda K." and his doings. The Ceylonese had only gathered behind him enough to form an active Society, but not enough to alter society at large. The problems that he had tried to solve in 1905–1907 lingered on. As the then director of the Colombo museums, M. D. Raghavan, wrote shortly after Ceylon attained independence, "his prophetic words were not of much avail,—and indigenous arts languished. The problem has now come to us with greater force than ever."[7] A Ceylon Arts Council was created in 1949 by the new government and the republication of *Mediaeval Sinhalese Art*, seven years later, is an achievement of its program. On the other hand, Coomaraswamy's educational objectives were not so slow in coming to realization. University College was opened in 1921, offering higher education in the country itself for the first time, and although it did not occupy itself with indigenous culture to the degree that Coomaraswamy had desired, it educated a larger number of individuals capable of taking responsibility in Ceylon, come Independence, than there would otherwise have been.

In the politics of the decades before Independence, Coomaraswamy's two cousins, Sir Ponnambalam Arunachalam and Ponnambalam Ramanathan, played important roles on behalf of the nationalist movement. Coomaraswamy did not disguise in later years his disappointment with Ceylon, but it must be said that he was disappointed by India, too, on the practical level, in the years soon to be recounted; his presence in the United States, although enormously fruitful and fulfilling, was due in part to the lack of receptiveness he encountered in both countries in the years before and during World War I. In 1927, in his *History of Indian and Indonesian Art*, he concluded his study of Ceylon with a desperate observation: "Descendants of the higher craftsmen are still able to carry out difficult tasks with conspicuous ability, and suffer more from lack of patronage than lack of skill. But the taste of "educated" Sinhalese has degenerated beyond recovery, and some modern Buddhist constructions are not surpassed for incongruity and ugliness by any buildings in the world."[8] The harshness softened only with time. Writing of India in 1937, but with a wide view that included Ceylon, he was only then some-

[6] AKC, review article, *The Ceylon National Review* (1908), p. 153.

[7] *Memorial Volume*, p. 177.

[8] AKC, *History of Indian and Indonesian Art* (Leipzig, New York, and London, 1927), p. 169.

what able to accept the destruction of traditional art as a *fait accompli*, and saw in the simple austerity of Indian homespun cloth—Gandhi's *khaddar*—the beginnings of a new, modest, but fully Indian artistic environment.[9]

In England, Coomaraswamy settled in an elegant house known as Norman Chapel; a small Norman church formed the nucleus of its predominantly Tudor structure (Figure 7). He had purchased it with funds inherited a year or two earlier, a very considerable fortune. His new home was in Broad Campden, next village over from Chipping Campden, where the English architect Charles Robert Ashbee directed a guild and school of handicraft that had moved from London several years earlier after more than twelve years in London's East End. Alan Crawford, the English scholar who has had the opportunity to study Ashbee's papers, notes that Mrs. Coomaraswamy's brother, Fred Partridge, was a silversmith working at the Guild.[10] It seems likely that Ashbee recommended the house to Coomaraswamy. Coomaraswamy asked him to take care of some restoration, and the architect responded by assigning guild craftsmen to the job. Ashbee published an illustrated article on the house in *The International Studio* for 1907,[11] noting that it was "a unique building and in its way one of the most interesting in England," and adding comments about its owner that give a glimpse of how Coomaraswamy made the transition from one country to the other:

A word should be added about the metalwork. This is for the most part beautiful Sinhalese craftsmanship, some of it richly damascened by native workmen. Dr. A. K. Coomaraswamy, for whom I have had the privilege of working, and who now lives in the house, sent this over from Ceylon. He has also added many other splendid and beautiful Oriental treasures, and his collection of Sinhalese arts and crafts, upon a history of which he is at present engaged, is curiously fitted to the character of the building in which it is placed. It is in-

[9] AKC, "The Part of Art in Indian Life" (1937), SP I, 98–100.
[10] Alan Crawford, "Ananda Coomaraswamy and C. R. Ashbee," in S. Durai Raja Singam, ed., *Ananda Coomaraswamy: Remembering and Remembering Again and Again* (Kuala Lumpur, 1974), p. 239.
[11] C. R. Ashbee, "The 'Norman Chapel' Buildings at Broad Campden, in Gloucestershire," *The International Studio* (1907), pp. 289–296. Also *idem*, "Chipping Campden and Its Craftsmanship," *Christian Art* (1908), pp. 79–87, 107–117.

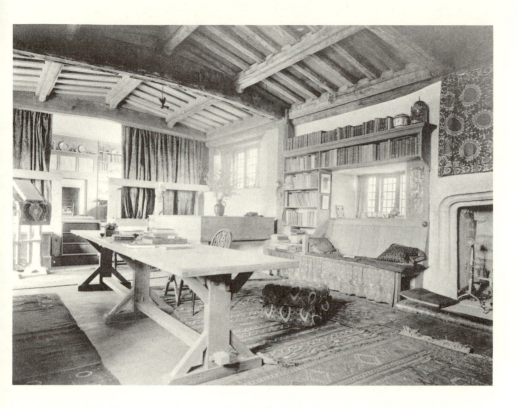

Figure 7. A Room in Norman Chapel, Coomaraswamy's English Home, ca. 1908.

deed fortunate that the building is owned by one whose taste is so sympathetically conservative.[12]

In 1898, Ashbee's guild had purchased from the executors of William Morris's estate the printing presses on which Morris produced his edition of Chaucer (as well as other luxurious volumes); this was the Kelmscott Press.[13] Not only presses, but all the equipment of Morris's shop, with the exception of type and blocks, were transferred first to Essex House, the guild's London home, and later to Chipping Campden, where it continued to be called Essex House Press. Several experienced compositors and printers from the Kelmscott shop accompanied the presses, and paper and vellum were bought from Morris's sources, while new blocks were cut as needed by Morris's former shopmen. The "little typographical adventure,"[14] as Morris had called it, conceived late in his life and still a new and attractive idea at the time of his death in 1896, received a generous prolongation of its life through Ashbee's guild. The most ambitious product of the press during its first years with the guild was the Prayer Book of King Edward VII, a royal commission. According to Ashbee's account, his material and artistic success encouraged many other private presses in England and America to try their hand, and there developed considerable activity in the field of artistically conceived, privately printed editions, due in the first place to Morris's initiative. Nikolaus Pevsner, the English historian, attributes to these presses a major role in securing "for the plain unadorned typeface its place in modern book production."[15] But Pevsner's remark does not really apply to Essex House, which used for some time the mediaeval typefaces preferred by Morris, as well as more modern ones.

In 1907, a time of financial depression, the press closed, but reopened in the fall of the same year in quite a new setting: Ananda Coomaraswamy's

[12] Ashbee, "The 'Norman Chapel'," p. 294.

[13] For the history of the Kelmscott Press, cf. H. H. Sparling, *The Kelmscott Press* (London, 1924), and William Morris, *The Art and Craft of Printing: A Note by William Morris on His Aims in Founding the Kelmscott Press* (New Rochelle, 1902). C. R. Ashbee gives the history of Essex House Press in *The Private Press: A Study in Idealism, To Which Is Added a Bibliography of the Essex House Press* (Broad Campden, 1909), and in his general study of the Guild, *An Endeavor towards the Teaching of John Ruskin and William Morris* (London, 1901).

[14] Morris, letter to his future printer and compositor William Bowden, January 3, 1891, quoted by J. W. Mackail, *The Life of William Morris* (London, 1899).

[15] Nikolaus Pevsner, *Pioneers of Modern Design* (Harmondsworth, England, 1960), p. 140.

house at Broad Campden. Hence these words concluding the Foreword to *Mediaeval Sinhalese Art*: "this book has been printed by hand, upon the press used by William Morris for printing the Kelmscott Chaucer. The printing, carried on in the Norman Chapel at Broad Campden, has occupied some fifteen months. I cannot help seeing in these very facts an illustration of the way in which the East and West may together be united in an endeavour to restore the true Art of Living which has for so long been neglected by humanity."[16] There is also a notice that the first edition comprised only 425 copies.

Before continuing with this account of Broad Campden, the reader might well wish to pause in the recognition that Coomaraswamy, in this period, could be devastatingly moralistic and, by hindsight, seems naive: grand allusions to the Art of Living, to the neglect of all humanity. The idealistic critics of industrial society who gathered with Coomaraswamy under the brocaded banner of the Morris movement strike one nowadays, if one reads them at all, as at best powerful and gifted with insight—morally moving in a way that is not easily forgotten—yet so high in their vision of things that they missed simple realities. Nonetheless, the naive idealism that will be heard from time to time in Coomaraswamy's writings throughout this period is the tendency of a good mind, and there is no sense in rushing forward to its transformation in later years. During this time in England, which was broken by long excursions in India, he contributed with characteristic intensity to the idealistic current of thought that had been initiated by Ruskin and Morris and carried on by Ashbee and others. In Ceylon, Coomaraswamy had already shown through word and action his valuation of William Morris. During the presswork for *Mediaeval Sinhalese Art*, personally attended to in the company of Morris's old shopmen on a press that had known the master's hands, we must imagine him as receiving once again the strong imprint of Morris's life and ideas. The relation between the two men is in fact so strong and intricate that it has seemed best to reserve a chapter to that subject rather than introduce it here.

At this great distance, Coomaraswamy in Broad Campden gives the impression of a man working hard but not failing to enjoy the leisure and time for reflection that his country home afforded him. He and his wife had a salon of sorts. His library still contains little signs of its life: a carefully printed invitation to hear a Saturday evening lecture by a visiting

[16] *Mediaeval Sinhalese Art*, p. ix.

speaker on Hans Christian Andersen, "in the Library at Norman Chapel"; a card from 1908 asking his friends "to meet Sister Nivedita, author of 'The Web of Indian Life,' on Sunday Afternoon. . . . Sister Nivedita will speak on 'The Life of Indian Women in Relation to Religion, Education, and Nationalism.' It is hoped that you will remain for tea." (Nivedita [Margaret E. Noble], an Irishwoman who had become a disciple of Swami Vivekānanda, and who played a central role in the Indian nationalist movement during the early years of the century, had at that time voluntarily exiled herself from India, where she was threatened with prison or deportation.[17] She sought refuge from those eventualities "in the lion's jaws," as her biographer puts it, that is, in England, where she could still be useful to the nationalist movement.) Nivedita's audience at Broad Campden must have included many from the Arts and Crafts circle, which, since Morris's eloquent plea in 1878 for the preservation of Indian arts and crafts, had been sympathetic towards Indian interests. Coomaraswamy continued, through Essex House Press, to call Englishmen's attention to the Indian point of view on questions relating to the national life of India—by now, India rather than Ceylon had become the focus of his attention. One of his pamphlets from the period 1907-1910, when he managed the Press, is a beautifully worded analysis of the struggle between Britain and India, whose candor makes one fear for its author's security in England but also admire the liberal atmosphere, at least "at home," that made it possible to make public statements of the kind. The pamphlet's title, "The Deeper Meaning of the Struggle," is borrowed verbatim from William Morris.

> The shadow of a coming conflict overhangs the Indian sky. It cannot be much longer postponed, certainly not indefinitely avoided, and the manner, and in some measure the result, will depend largely upon the wisdom and foresight of the opposing parties. Signs are not wanting that the struggle will be a very bitter one. Every day in India the gulf between Englishmen and Indians widens. . . . The future cannot be postponed for ever. "Svaraj," or self-government, is the ideal of young India, and it depends upon the wisdom and sympathy of the English rulers of India to say whether it shall be allowed to proceed peacefully towards the inevitable goal.[18]

[17] Cf. Lizelle Reymond, *Nivédita: fille de l'Inde* (Neuchâtel, c. 1943).
[18] AKC, *The Deeper Meaning of the Struggle* (1907), pp. 3-4.

Coomaraswamy's most significant associate during these years in England was C. R. Ashbee, who introduced him not only to the current phase of the Arts and Crafts movement, but to men of influence in the London art world—artists, patrons, critics. A little book that Ashbee published in 1901, *An Endeavour towards the Teaching of John Ruskin and William Morris*, describes the history of his school and guild near Coomaraswamy's home. The account is full of atmosphere. In 1886, Ashbee founded "a small Ruskin class" composed of three pupils, but soon, under the influence of Ruskin's *Fors Clavigera* and *Crown of Wild Olive*, a design class grew out of it with some thirty pupils attending. Good public reception of their work as mere "dilettanti" encouraged them to "make it work for life and bread," and they conceived the idea of a guild whose masters would teach in an associated school. This was inaugurated in 1888 as The Guild and School of Handicraft and, although the school dropped away for a while in the face of competition from state schools, the guild flourished on its commissions and continued to teach informally in its workshops. It showed under the auspices of the Arts and Crafts Exhibition Society whose occasional exhibitions, since Morris founded the society and nurtured its growth, had grouped before the public eye the best work of anti-industrial handicraft groups and individuals. In addition to this, Ashbee's guild sent its instructors throughout the British Isles to teach in technical schools, and Ashbee periodically wrote up its activities for various art journals, keeping it in view as an ambitious attempt to actualize John Ruskin's dream of a "Guild of St. George," which the famous critic had never brought to life except on paper. When the guild moved to Chipping Campden in 1902, it numbered nearly 150 men, women, and children, many of whom had left London to continue working with it. Joiners, carvers, blacksmiths, metalworkers, enamel craftsmen, jewelers, printers found themselves in a little town "fortunately sheltered from industrialism," as Ashbee wrote in 1908, "one of the few perfect survivals of the Middle Ages."[19] They evolved a certain culture there:

such culture as comes of or tends to association, the association of men and women who are engaged upon a work that is not extraordinary, but perhaps a little above the ordinary. As soon as men and women meet together in an honest conviction and endeavour to improve the condition of their existence, to think of other things than the money

[19] Ashbee, "Chipping Campden and Its Craftsmanship," p. 79.

at week's end, the fretting details of the house, or the beer at the bar, then it is that culture which all should and many do desire begins."[20]

In another book, Ashbee evoked their spirit in lighter terms. The guild was "the practical effort of a body of English craftsmen, who, aided by a little group of capitalists, have taken their labour, their skill and their traditions with them, packed up their kit and gone off into the country to labour."[21]

In spite of this not unlikeable rhetoric, if we look at objects made by guild craftsmen, they generally prove to be undistinguished—nearly styleless, or, if stylish, then reminiscent of better things;[22] and if one reads about the day-to-day life of the guildsmen, one feels as far from Utopia as ever: "The other day we acted a Ben Johnson play, of which the proceedings go to the making of a bathing lake. A workman's club is instituted by the Guild, as is also a guesthouse . . . and the Sports Club is a necessary feature in the life of the whole." Nevertheless, it was an adventure, and it engaged the interest of the London art world. W. R. Lethaby and Walter Crane were among the trustees of the Campden School of Arts and Crafts (as the school was renamed), and William Rothenstein, a leading figure in London at the time and later principal of the Royal College of Art, used to visit Ashbee at Campden, where he formed a friendship with Coomaraswamy in 1909 or thereabouts. The passage cited earlier from Roger Fry's review is another sign of sympathy in high places with the forces putting industrialization in question.

The high-water mark of the guild was made in the years just following its move; it ran into financial difficulty soon after, and in 1908 was dissolved, although the School of Arts and Crafts continued much longer. When Coomaraswamy arrived in Broad Campden, Ashbee was probably just finishing a book in which he explained the problems that beset the guild and expounded the philosophy that had led to its founding and

[20] Ashbee, "The Guild of Handicraft, Chipping Campden," *The Art Journal* (1903), p. 148.

[21] Ashbee, *Craftsmanship in Competitive Industry* (Campden and London, 1908), p. 16.

[22] See, for example, a silver spoon warmer and jewelry illustrated in "The Guild of Handicraft, Chipping Campden"; also C. R. Ashbee, *On the Need for the Establishment of Country Schools of Arts and Crafts* (Campden, 1906). In fairness, it should be said that Ashbee's own silver pieces have some flair; cf. Robert Schmutzler, *Art Nouveau* (New York, 1964), figs. 177, 178, 181.

would, he hoped, survive its dissolution.[23] To understand Coomaraswamy during these years, it is important to be acquainted with the intellectual armament and forcefully emotional language of Ashbee in this book, where he spoke as a leading member of the Arts and Crafts movement. Ashbee outlined the principal sneers at the Arts and Crafts movement and, toward the beginning of his book, expressed its passionate opposition to commercial industry:

> I seek to show . . . that this Arts and Crafts movement, which began with the earnestness of the Pre-Raphaelite painters, the prophetic enthusiasm of Ruskin and the Titanic energy of Morris, is not what the public has thought it to be, or is seeking to make it: a nursery for luxuries, a hothouse for the production of mere trivialities and useless things for the rich. . . . The Arts and Crafts movement, . . . if it means anything, means Standard, whether of work or of life, the protection of Standard, whether in the product or the producer. . . . To the men of this movement, who are seeking to compass the destruction of the commercial system, to discredit it, undermine it, overthrow it, their mission is just as serious and just as sacred as was that of their great grandfather who first helped raise it into being.[24]

The movement held that, in the near future, government would recognize so clearly the destruction caused by industrialization that it would begin to legislate against machine production. This was a dream, the kind of dream men entertained where a good-sized midlands region was called the "Black Country" because of its industrial pollution. The legislation was not to be a total prohibition:

> Now I do not wish it to be supposed that I want in any way to have an embargo put upon the invention of new machinery. The Luddites in the Eighteenth Century broke up the Spinning Jenny, and the makers of wigs in the reign of George III petitioned parliament to stop people wearing their own hair, because it interfered with their handicrafts. Both efforts were futile. But I do wish to see the province of the hand work and the province of the machine work so defined, that the former when it is demonstrably better in its direct product and its human resultant than the latter, shall not continue to be at the latter's mercy.[25]

[23] *Craftsmanship in Competitive Industry.*
[24] *Ibid.*, pp. 9–10. [25] *Ibid.*, pp. 30, 83.

Ashbee was as suspicious of socialism as he was of government; the former, it seemed to him, was "based upon and served the need of the factory system";[26] its exponents were "quasi-scientific," and he doubted very much whether a socialist municipality would hire craftsmen.[27] Reading Coomaraswamy on society and the problem of a proletariat that was once a people, one wonders occasionally why the language and ideas of Marx are not more evident. A good part of the answer lies in the little faith that the Arts and Crafts circle invested in socialism by the time Coomaraswamy became a member of it. Morris was an outstanding lecturer on socialism, willing to travel the country, willing to pass out pamphlets in the streets of London, but his socialism was always humanitarian, moral, visionary; he is said to have had a difficult time of it trying to understand *Das Kapital*. The Arts and Crafts movement sprang more from spiritual discontent than from a critique of social and economic conditions. In his introduction to a book of 1909 by Coomaraswamy, *The Indian Craftsman*,[28] which grew out of the relation between the two men, Ashbee made this clear enough: "There has come over Western civilization, in the last 25 years, a green sickness, a disbelief, an unrest; it is not despondency, for in the finer minds it takes the form of an intense spiritual hopefulness; but it takes the form also of a profound disbelief in the value of the material conditions of modern progress."[29] Coomaraswamy, like Ashbee, was interested in socialism only to the extent that it shared their profound disbelief in modern progress—which was very slight.

There is another side to Ashbee that cannot be overlooked. His friends were not all conservative. In 1900, he met Frank Lloyd Wright in Chicago, and they took warmly to one another. Nine years later, Wright asked him to contribute a preface for the first European presentation of his buildings, *Ausgeführte Bauten*, the Wasmuth publication whose importance for the development of modern architecture in Europe has been affirmed by many architectural historians. In his preface, Ashbee expressed admiration for Wright's "delight in new materials, and . . . honest use of machinery," his "determination, amounting sometimes to heroism, to master the machine and use it at all costs, in an endeavour to find the forms and treatment it may render without abuse of tradition."[30] He

[26] *Ibid.*, p. 12. [27] *Ibid.*, pp. 13–14.
[28] Biblio, No. 100 in the *Working Bibliography*.
[29] *Ibid.*, pp. xii–xiii.
[30] Ashbee's preface is published in Edgar Kaufmann, *Frank Lloyd Wright: The Early Work* (New York, 1968), where this passage appears on p. 4.

quoted with approval Wright's famous early lecture, "The Art and Craft of the Machine," which called for new industrial ideals and predicted the birth of a new architecture quite unlike that of the past. At the end of his preface, Ashbee expressed a wish for a magic wand to wave over some of Wright's buildings, "not to alter their structure in plan or form, . . . but to clothe them with a more living and tender detail."[31] In this echoes the nostalgia for mediaeval craftsmanship that underlay his guild at Campden, but his positive response to Wright's buildings and ideas and the aid offered Wright by introducing him in Germany, where Ashbee already enjoyed a reputation as an architect, prevent us from writing off Ashbee as a hopeless conservative in a world quickly moving toward a revolution in architecture and all the arts. Pevsner, in his history of the early modern period, points to a change of heart in Ashbee after 1910, at which time he began to consider some of the doctrines of the Arts and Crafts movement to be "intellectual Ludditism,"[32] in the architect's own words, and incorporated in his professional practice some of Wright's principles.

This account of C. R. Ashbee's interests shows not only to what ideas Coomaraswamy was closest at the time, but also some ideas that he missed. Wright's forceful modernism passed tangentially by him and never penetrated. In sociological writings produced periodically throughout his life, Coomaraswamy remained true to the anti-industrial spirit of the Arts and Crafts circle and to his experience and historical knowledge of pre-industrial culture in the Orient. He never really applied a sensitive, unprejudiced attention to the essential theories of modern art and architecture, and when called in question, as by Meyer Schapiro of Columbia University in 1932, he replied, "If I should lean over too far on one side, as you think, it is perhaps after all salutary for the quality of Western art to be challenged, it should lead to a searching for what is sound and fundamental in it."[33]

Mediaeval Sinhalese Art entered the current of Arts and Crafts thinking, soon followed by *The Indian Craftsman*, which gave a rapid *tour d'horizon* of Arts and Crafts themes in their Indian manifestation. It is primarily a documentation, not a polemic, drawing upon historical sources, observations by English and other Western visitors, and personal experience, but the mind assembling these materials obviously agreed very pro-

[31] *Ibid.*, p. 8.
[32] Pevsner, *Pioneers of Modern Design*, p. 26.
[33] AKC, letter to Meyer Schapiro, April 30, 1932. Princeton University Collection.

foundly with the idea that workshop, problem-solving education in a patriarchal atmosphere is superior to education in large technical schools such as the English; that the close relation between patron (peasant or royal) and craftsman (village or court) produced better results than an impersonal relation between those who need things and those who make them; and so on through the canon of ideas which we have now reasonably well encompassed.

Coomaraswamy's contributions to Arts and Crafts thinking did not always take the form of studies of India and Ceylon. The best of his writing on the craftsman *in England* is contained in a lecture of 1910, published as an Essex House pamphlet, *Domestic Handicraft and Culture*. It is an unlikely title, evoking the image of an English spinster making cheerless woolens to fend off the winter winds, but the lecture is sound, with many ideas about crafts that recur in discussions today. One passage in particular, where he attempts to define the meaning of culture, shows him moving on from pure Arts and Crafts doctrine toward a more Oriental view. As always at this time of his life, when he used concepts drawn from Hindu or Buddhist thought he sounded like someone else —a Theosophist, Swami Vivekānanda, or any other of the spokesmen for Indian religion that first brought its concepts to the West. Coomaraswamy's biography shows to what extent the whole mind undergoes an apprenticeship before it emerges in relative independence, able to draw on its own resources as well as from its surroundings. Unusable and dilute in its given form, his definition of culture contained elements that he would understand better in later years:

Plato identified [culture] with the capacity for immediate and instinctive discrimination between good and bad workmanship, of whatever sort; it is perhaps in this respect that the present age is least of all cultivated. We may expand this definition by including a certain quality of recollectedness or detachment, a capacity for stillness of mind and body (restlessness is essentially uncultured), and the power of penetrating mere externals in individual men or various races. Culture includes a view of life essentially balanced, where real and false values are not confused; also, I think, a certain knowledge or interest in things which are not directly utilitarian, that is to say, which do not merely give pleasure to the senses or confirm a prejudice. . . . Certain fine things which used to be obtainable in every market-place in the world are now only to be seen in museums.

Because they are to be seen in museums, we imagine that we are cultured. . . . We know by their work that men of old were cultivated.[34]

In this passage, Coomaraswamy looks beyond Morris for definitions, toward the Oriental culture and Platonism that henceforth served increasingly as his touchstones. Although a participant in the Arts and Crafts movement, he had not identified himself exclusively with its purposes. In the period 1908–1910, he established himself as a young but considerable authority on Indian art, and the need for pioneering work in this field was so great that it soon became his principal concern. The year 1908 is his moment of debut in the polite society of scholarship; it is not only the year of publication of *Mediaeval Sinhalese Art*, but also the year when he travelled to Copenhagen to address the fifteenth International Oriental Congress on a major topic in Indian art studies,[35] and the year when he addressed in England the Third International Congress for the History of Religions on "The Relation of Art and Religion in India."[36] His concern for both art and religion were evident even as a neophyte among professional scholars. In 1909, he published an article on Buddhist bronzes in the *Journal of the Royal Asiatic Society*, and in 1910 made his first contribution to *The Burlington Magazine*, again on the little-known subject of Indian bronzes. These are prestigious journals whose acceptance of his work connotes his acceptance, respectively, in the world of serious Orientalist scholarship and the world of connoisseurship and collecting. The two were, of course, not mutually exclusive.

The year 1910 was a turning point in the history of the British understanding of Indian art. It was then that Sir George Birdwood made a classically vituperative public pronouncement on the absence of fine art in India; that Roger Fry wrote a classic defense of Oriental art; that the London *Times* printed such a passionate "Letter to the Editor" on Indian art that its art critic was moved on the following day to publish his own comments on the topic. In that year, also, the India Society was founded by Coomaraswamy and others to promote the study of Indian art and culture, and to sponsor publications that would give the first opportunity for a just appreciation of the aesthetic qualities of Indian art.

[34] AKC, *Domestic Handicraft and Culture* (1910), pp. 8 ff., 14–15.
[35] AKC, "The Influence of Greek on Indian Art" (1908); also included in *Mediaeval Sinhalese Art*, pp. 256 ff.
[36] Biblio. No. 102 in the *Working Bibliography*.

But all of these events were preceded by a long history of British attitudes toward Indian art; only in the context of this history can Coomaraswamy's early career as an art historian be understood. The history of Great Britain's pilgrimage from intolerance and ignorance toward a positive view is almost a history of manners, on its theatrical side, and certainly an example of cultural collision.

VI. The Appreciation of
Indian Art in Britain from
Ruskin to Roger Fry

John Ruskin's writings commanded a large audience in England from 1843, when his first volume on *Modern Painters* appeared, until the fading of the Arts and Crafts movement just before World War I. He was both attracted and repelled by Indian art. His writings on it, representative of educated English opinion, have the same flavor as St. Bernard of Clairvaux's famous letter on the "beautiful deformities" and "deformed beauties" of Romanesque sculpture:[1] each was an eminently moral man faced with an artistic experience so rich that it posed a threat, and each managed to exclude and denigrate the art that troubled him at the same time that he permitted himself to describe it in detail. Bernard, for example, questioned the pleasing colors of sacred images in pavement mosaics: "Why dost thou make so fair what will soon be so foul? Why lavish bright hues upon that which must needs be trodden under foot?" Ruskin found himself in a similar dilemma when he thought about India shawls and acquitted himself, with resentful petulance, from looking too deeply into the matter. He wrote of

the somewhat singular, but very palpable truth that the Chinese, and Indians, and other semi-civilized nations, can colour better than we do, and that an Indian shawl and China vase are still, in invention of colour, inimitable by us. It is their glorious ignorance of all rules that does it. ... Hitherto, it has been an actual necessity, in order to obtain power of colouring, that a nation should be half-savage: everybody could colour in the twelfth and thirteenth centuries; but we were ruled and legalized into grey in the fifteenth; ... nobody can colour anywhere, except the Hindoos and the Chinese.[2]

[1] Cf. Elizabeth G. Holt, *A Documentary History of Art* I (Princeton, 1947).
[2] John Ruskin, *Modern Painters* IV, ch. VII, 123, in *Collected Works*, ed. E. T. Cook and A. Wedderburn (London, 1903–1912), Vol. V.

Ruskin was primarily familiar with Indian decorative arts—the textiles, jewelry, inlaid boxes, metalwork, and so on—that Birdwood warmly and conscientiously described, later on, in *The Industrial Arts of India*. He seems to have had only a general impression of Indian sacred art, and its exotic iconography horrified him. He had probably seen very few good works of Indian sculpture or even good illustrations of it. In 1910, Coomaraswamy made some remarks to the Royal Asiatic Society that applied even more to Ruskin's time than to his own: "We should know what to think of an oriental art critic who judged all European art on the basis of a collection of tradesmen's oleographs, and modern Roman Catholic plaster saints, or, still worse, from the standpoint of religious prejudice. This is, however, practically what European writers have done with Indian art."[3] It is not difficult to substantiate the idea that religious prejudice colored Ruskin's judgment. So many passages in his works have this character, clothed in masterly rhetoric, that it is tempting to make columns of them. Perhaps most charming, by hindsight, are the lines in *The Seven Lamps of Architecture* in which he imagined a suitable facade for London's India House:

> adorned . . . by historical or symbolic sculpture: massively built in the first place; then chased with bas-reliefs of our Indian battles, and fretted with carvings of Oriental foliage, or inlaid with Oriental stories; and the more important members of its decoration composed of groups of Indian Life and landscape, and prominently expressing the phantasms of Hindoo worship in their subjection to the Cross.[4]

Elsewhere he called Indian religion "irrational"[5] and, while he credited the "idolizing instinct" that led both mediaeval Christian and Indian artists to make religious sculpture, he found the latter's work "non-progressive, and in great part diseased and frightful, being wrought under the influence of foolish terror, or foolish admiration."[6] The fantastic conceptions and composite animals that were acceptable in the art of mediaeval Verona and ancient Mesopotamia were to him anathema in Indian iconography.[7]

[3] AKC, "On the Study of Indian Art," a lecture published in *Art and Swadeshi* (1911), where this passage appears on p. 65.

[4] Quoted by Allen J. Greenberger, *The British Image of India: A Study in the Literature of Imperialism 1880–1960* (London, 1969), p. 175.

[5] Ruskin, *The Stones of Venice* (1851, 1853), in *Collected Works*, IX, 346.

[6] Ruskin, *Aratra Pentelici* (1872), in *Collected Works*, XX, 227.

[7] Cf. *The Stones of Venice*, pp. 188–189.

Ruskin had definite criteria for beauty. Nature—natural form—was the source of beauty; he urged artists to study it and make it their school. Indian art failed, he thought, in this respect. In his most extensive comments on Indian art, in which he compared the Indians, "a race rejoicing in art, and eminently and universally endowed with the gift of it," to the Scotch, "a people careless of art, and apparently incapable of it, their utmost efforts hitherto reaching no farther than to the variations of the positions of the bars of colour in square chequers,"[8] he vilified Indian art because it seemed neglectful of nature, thereby demonstrating the very slight degree to which Indian art was known in England in 1859, even to its leading art critic. Our contemporary appraisal of Indian art recognizes the charming trees, flowers, and landscape settings of Rajput miniatures, and compassionate studies of various animals in temple sculpture. These things strike us as expressions of delight in nature. To Ruskin they were unknown; it is easy to understand why Coomaraswamy included a portfolio of extremely fine illustrations of animals and animal avatars in his serially published collection of photographs of Indian sculpture, the *Viśvakarma* of 1912–1914. It should also be recognized that Ruskin vehemently attacked Indian artists in his book of 1859 because Great Britain had just experienced the shocking violence of the Indian Mutiny, which appeared to Ruskin and all Britain as "cruelty stretched to its fiercest . . . and corruption festered to its loathsomest in the midst of the witnessing presence of a disciplined civilization."[9] It is significant to recall this event because feelings that were fanned by this violence in the late 1850s smoldered at other times in other forms: the art of a subject people could not be accepted on equal terms.

There is, of course, the other pole: Great Britain also loved India. Within the context of art history, this is evident in the writings of Birdwood on industrial arts, and in the dream-like neoclassical beauty of the engravings that can sometimes be seen in nineteenth-century accounts of India: Indian village life is transformed in such engravings into a classical landscape, a Roman town where smoothly gowned women with elegantly simple coiffures, bare arms, sensuality and dignity in every limb, descend to the village well with something like amphorae on their heads (Figure 8). India was also the cardinal test of Englishmen's courage, perspicacity, and sense of justice; Allen Greenberger's study of the British image of India in nineteenth century novels makes this very evident. Fur-

[8] Ruskin, *The Two Paths* (1859), in *Collected Works*, XVI, 262; cf. esp., pp. 265–266.
[9] Ruskin, *The Two Paths*, p. 262.

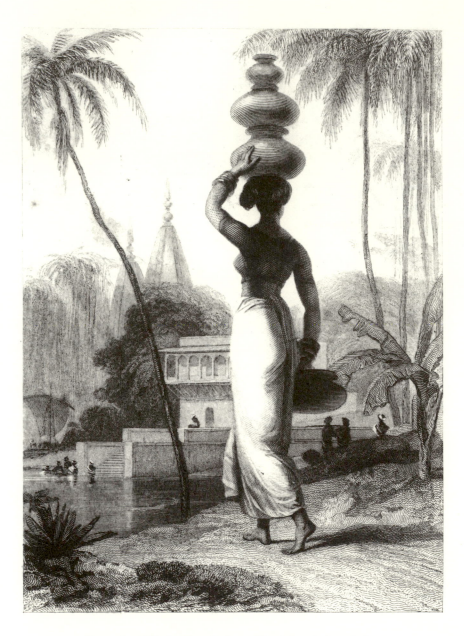

Figure 8. *A Hindoo Female*, from *The Oriental Annual 1834,*
drawing of W. Daniell, engraved by W. D. Taylor.

thermore, the English made serious efforts to translate and understand Indian literature from the time of Sir William Jones, who founded in 1784 what became the Royal Asiatic Society of Bengal and initiated a program of translation and exegesis under its auspices. This inspired a similar program in the Royal Asiatic Society of Great Britain and Ireland, founded in 1823.[10] Archaeologists treated Indian history and architecture with respect throughout the nineteenth century; Fergusson and Burgess made solid, methodical studies of the monuments of architecture. All of this, briefly outlined, is neither indifference nor disdain.

India was open to scholars of other European countries to do archaeological and iconographical study—thus Albrecht Grünwedel's *Buddhist Art in India*, first published in German in 1893, but soon after in English for the British audience,[11] and Foucher's *L'Art gréco-bouddhique du Gandhara: études sur les origines de l'influence classique dans l'art bouddhique de l'Inde et de l'Extrême-Orient* (Paris, 1905). The latter title indicates a great difficulty implicit in Ruskin: in order to be able at all to "judge" the value of Indian art, Western Classical standards were used —standards such as truth to nature—and, given this preconception, Indian art failed to qualify for serious attention *as such*. Grünwedel's work, for example, struck Coomaraswamy in 1910 as a "mass of valuable facts" that unfortunately contained "no attempt at a constructive account of the 'nature of Indian,' nor any sign of an endeavour to explain the ideals and development of art that is distinctively Buddhist."[12] In Grünwedel's book, every fact was "balanced by a corresponding misconception," and there was far too much attention given to "the insincere and un-Indian art of Gandhāra, an art that has no more interest for the artist than any other phase of decadent classic art."[13] Foucher's early work on Greco-Roman influence in Indian art represented bridge-making between the familiar set of standards and the exotic, but Coomaraswamy considered that the study of late Roman influence on only one school of Indian sculpture had been allowed to fill the horizon all too much, blotting out typically Indian schools of sculpture in other regions. His point of entry into art-historical scholarship concerning India was as an adversary of the point of view that emphasized Greek influence and even attributed the creation

[10] Cf. the early chapters of Guy Richard Welbon, *Buddhist Nirvāna and its Western Interpreters* (Chicago, 1970).

[11] London, 1901.

[12] AKC, "On the Study of Indian Art," p. 62.

[13] AKC, review article, *The Hindustan Review* (1910), p. 271.

of the Buddha image to this source, in a context of thought that had evidence to bear it out but also struck at the very heart of Indian religious tradition and pride. It is obvious that just as English and European studies of Indian art suffered from a Western bias, both aesthetic and religious, any new art history that could emerge in reaction to this would suffer from an Indian bias.

In any case, we have anticipated by taking into account the works of Grünwedel and Foucher, whom Coomaraswamy esteemed within certain limits. There was very little of a positive nature being said in England about Indian art throughout the rest of the nineteenth century. Birdwood praised the crafts but denied the existence of fine art and, like Ruskin, was horrified by "eight-armed monsters." Morris, Burne-Jones, Millais, Edwin Arnold, Walter Crane, and others close to the Arts and Crafts movement petitioned the government, in a well-known letter of 1878, for the preservation of Indian craft industries,[14] but their appeal had nothing to do with sacred art, which was still largely unfamiliar, nor with "understanding the nature of Indian," as Coomaraswamy put it. Vincent Smith, who developed into a trustworthy and comprehensive historian of Indian art, toward the beginning of his career wrote an *Early History of India* in which he expressed the view that Gandhāran sculpture, while the best India offers, still only "echoes . . . the second-rate Roman art of the third and fourth centuries," and told the reader that Indian art "has scarcely, at any time, essayed an attempt to give visible form to any divine ideal."[15] It will be interesting later to examine his change of viewpoint; he kept certain reservations throughout his career.

At the beginning of his work on Indian art, Coomaraswamy collected passages of this kind from the publications of English authors. They provided for him and other art historians who undertook the defense of Indian art a natural point of departure for their own writings. Through Coomaraswamy we know that B. G. Baden-Powell in 1872 warned his fellow-citizens that "in a country like this we must not expect to find anything that appeals to mind or to deep feeling"; that Fergusson, the architectural historian, believed that "it cannot, of course, be for one moment

[14] Cited in part by Ashbee in his introduction to AKC, *The Indian Craftsman.* AKC introduced another passage from Morris on "Commercial War" in Appendix III of that book.

[15] Vincent A. Smith, quoted by E. B. Havell, *Indian Painting and Sculpture* (London, 1908), pp. 5–6.

contended that India ever reached the intellectual supremacy of Greece or the moral greatness of Rome";[16] that Alfred Maskell expressed his view of Indian art in these weary tones: "We are spoken to of things and in a language of which we are ignorant. . . . In a word, we are not interested."[17] The last touch to be added to this general picture of indifference and worse is the recognition that many educated Indians were indifferent to their artistic heritage, just as the Ceylonese were, and for the same reason: an education received in schools based on English curricula, omitting study of Indian culture. The young Coomaraswamy's relation to India as a whole is evoked by his relation to one particular Indian family, as recorded in the *Memorial Volume*:

> I was very young when [Coomaraswamy] came, as far back as 1909, and stayed with us at Benares for long weeks. It was he who first discovered the beauty and significance of many old paintings we had in the family; and it was he who first made not only me but innumerable others in the land look at Indian art with another eye.[18]

In the past hundred years, major changes in public taste have often followed the lead of artists: Japanese prints influenced the art of Van Gogh, African carvings touched Picasso and changed his art well before the public was interested. The beginnings of Western interest in Indian painting and sculpture occurred in a similar way. Coomaraswamy and his friends were literally calling upon artists to recognize what archaeologists had missed.[19] In England it was a circle of artists and Arts and Crafts people, with Roger Fry, that first experienced a *metanoia*, a change of mind with regard to Indian art (*metanoia* is a term in the Greek New Testament that Coomaraswamy liked in later years; he thought that the usual English translation of it, "repentance," is incorrect). In India, it was Ernest Binfield Havell, artist, principal of the Calcutta School of Art, and keeper of its Government Gallery, who brought about the birth of interest in Indian art. Havell was gathering experience in India when Coomaraswamy was still a boy: in 1884–1892, he was superintendent of the Madras School of Art and charged with conducting an official investigation of indigenous arts and crafts; from 1896 until 1906, he directed the Calcutta School. In the latter post he put into effect, against

[16] Quoted by AKC, *Rajput Painting* (Oxford, 1916), p. 6, n. 3.
[17] Quoted by AKC, review article, *The Ceylon National Review* (1906), p. 108.
[18] The Hon. Śri S. Prakasa in *Memorial Volume*, p. xvii.
[19] Cf., for example, AKC, "The Influence of Greek on Indian Art," p. 1.

much opposition, a general revision of teaching methods, which until his appointment had been only another manifestation of English indifference and ignorance. He described the established curriculum as follows: "the whole paraphernalia of European art-academies—the drawing-copies, casts from "the antique," the five orders of classic architecture, Gothic mouldings, etc., etc., have been imported wholesale from Europe, to form the basis of the Indian art-student's training; and at the same time, it has been held to be totally unnecessary, if not demoralising, for them to study the principles and methods of Indian painting and sculpture."[20]

Havell revised the curriculum to teach precisely "the principles and methods of Indian painting and sculpture," and attracted to the school a young student with a brilliant future, Abanindranath Tagore, nephew of the already famous Bengali poet, Rabindranath. Havell decided to sell what he called "a miscellaneous collection of European paintings"[21] owned by the Calcutta Art Gallery in order to buy Indian painting and sculpture as examples for art students. Even Indians questioned his action: "the journal which is the chief spokesman of the so-called *Swadeshi* (or national) party in Calcutta with sublime inconsistency assailed me for nearly a week in the best Bengali journalese for my share in the transaction, and, *more suo*, attributed to the Government a sinister intention of suppressing higher education in art."[22] But the program succeeded. Havell felt that the evidence of its success was to be found in the art of Abanindranath Tagore and younger pupils. He wrote in 1908, "New India has at last found an artist, Mr. Abanindro Nath Tagore, to show us something of its real mind, and it is significant that it is revealing itself in a continuity of the old artistic thought, a new expression of former convictions."[23]

Havell's art collection was "the guiding influence" on Tagore's development, as he said in the same passage, and Tagore in turn, who later became vice principal of the Calcutta Art School, trained pupils such as Nanda Lal Bose and Surendranath Ganguly, rapidly forming what came to be known as the New School of Indian Painting. Their art never entirely convinced either Havell or Coomaraswamy: each wrote of it often enough in the prewar years and praised it as an enormous improvement over what preceded it, which was a choice between wholly Westernized art and realistic, "Victorian Indian" versions of Indian

[20] Havell, *Indian Painting and Sculpture*, p. 250.
[21] *Ibid.*, p. 254.　　[22] *Ibid.*　　[23] *Ibid.*, p. 256.

gods and heroes produced notably by Ravi Varma. But neither, particularly Coomaraswamy, could bring himself to praise it to the skies without pointing out the admixture of Western and Japanese influence in its style, a certain weakness in its conceptions, a lack of the ancient vitality. Nevertheless it was the center of something new in India. Coomaraswamy was close to Tagore and the school, probably from the time of his Indian tour of 1907. He arranged for paintings by Tagore and his pupils to be used as illustrations for his *Myths of the Hindus and Buddhists*, published in England in 1913.[24]

Havell was capable of far more significant contributions than the foundation of a school of painting which, in its probably inevitable archaism, was limited from the outset. In 1908, the year when Coomaraswamy's *Mediaeval Sinhalese Art* appeared, he published *Indian Sculpture and Painting: Illustrated by Typical Masterpieces with an Explanation of Their Motives and Ideals*, a full-length work prefaced by these words: "To Artists, Art Workers and Those Who Respect Art, This Attempt to Vindicate India's Position in the Fine Arts is Dedicated." Both title and dedication were combative, and the book is true to their spirit, but it was recognized as an important and convincing new study. Roger Fry, in his key article of 1910, "Oriental Art," praised the book and excused its righteous indignation, while Coomaraswamy deemed it "the first serious attempt to understand and appreciate Indian art."[25] He hailed its balanced treatment: the Greco-Roman art of Gandhāra no longer occupied center stage, and truly excellent works of art (which by and large still remain in the canon of Indian masterpieces) were given extensive discussion, both as to their iconographic meaning and their specific beauty. In later years, when eminent Indian art historians such as O. C. Gangoly looked back on the development of their field, they would point to this book, with all its defects, as the ground-breaking one.[26] The defects were substantial enough, both here and in books that followed, to prompt the impeccable historian of Islamic architecture, K.A.C. Creswell, in a letter of 1928 to Coomaraswamy, to describe Havell's work as "ravings";[27] and Hermann

[24] A paperback reprint was published in New York (1967), with illustrations of ancient art replacing the series by Tagore and his followers. The choice against including their work was made by Doña Luisa Coomaraswamy, who in this case was following her husband's own second thoughts.

[25] AKC, *The Hindustan Review* (1910), p. 271.

[26] O. C. Gangoly, *Orissan Sculpture and Architecture* (Calcutta, 1956), introduction.

[27] K.A.C. Creswell, letter to AKC, 1 July 1928, Princeton Collection.

Goetz, one of the excellent historians of Indian art schooled in Germany in the first half of this century, thought that Havell "had restored the self-esteem of Indian art, often in a one-sided and crudely chauvinistic manner, but too often misunderstanding the themes and objects of art for art itself."[28]

Coomaraswamy certainly learned from this book, not only from its successes but also from the mistakes, which it would be necessary to avoid in the future. Coomaraswamy was more of a scholar than Havell, even in these early days when he occasionally indulged in writing a piece that mixed English Romanticism, a fuzzy understanding of Vedānta, and art history in a blend that leaves people who revere his later writings with unparalleled indigestion.

Havell's *Indian Sculpture and Painting* has an extraordinary frontispiece: it reproduces a Mughal painting of four men, turbaned and robed, sitting quietly together in the foreground, with a broad sunset landscape behind them. Two of them are speaking with the oldest, who sits on a mat with his legs bound against his body for comfort, listening intently to the one who seems to be speaking at that moment. To the side sits a fourth man, also grey with age, enveloped in a dark cape. By the turn of his head and the direction of his glance, it seems that he is both listening to the others and occupied with his own thoughts. The oldest, sitting on his mat, is expressively posed: his compact body and sharp, aged profile suggest a serene but alert state of mind, while his arms hug his body in a way that suggests the tension of his effort to listen to the younger man addressing him. Even in the imperfect color reproduction that Havell could have made at the time, the miniature breathes the spirit of Indian wisdom. It probably represented a certain ideal of dialogue to Havell, and indicates the direction that he wished to pursue with his English audience.

His book's best points were its well-chosen illustrations, a series of Hindu and Buddhist works from India, Nepal, Tibet, Ceylon, and Indonesia, and a text that presented some fundamentals of history, style, and iconography in a sympathetic way. What troubled even a persuaded reader like Roger Fry was Havell's tendency to reverse the familiar idea that European art is superior to Indian art. Havell wrote that "the best Indian sculpture touched a deeper note of feeling and finer sentiments than the best Greek";[29] declared that the "heaven-born quality of inspiration"

[28] Hermann Goetz in *Memorial Volume*, pp. 325–331.
[29] Havell, *Indian Painting and Sculpture*, p. 142.

in the sculpture at Borobuḍur was "rarely equalled, and never excelled" by European art;[30] habitually compared Oriental art with specific European examples—for example, the Borobuḍur reliefs with Ghiberti's baptistry doors—and always managed to praise the Eastern work to the skies while burying the Western.[31] He entertained a romantic notion of the simplicity of the pious Buddhist or Hindu artist, working anonymously in conditions of great natural beauty to produce a reverent art.[32] He unremittingly attacked "the modern dilettante critic,"[33] to whose taste for anatomical accuracy and realistic art—that is, for the Academic art of the nineteenth century—he attributed the English public's disdain of Indian art.

By the time *Indian Painting and Sculpture* was published, Havell and Coomaraswamy were friends. Havell was writing a new book, traveling, and lecturing on Indian art; Coomaraswamy was preparing for a trip to India, where his first host, in January 1909, seems to have been Abanindranath Tagore, Havell's former pupil, in Calcutta.[34] Havell and Coomaraswamy were exchanging lantern slides, books, recommendations on art-historical points, quoting one another, and reviewing each other's publications—which is to say that they experienced that warm blend of shoptalk and friendship which, in the best circumstances, links professionals in a field. Coomaraswamy's letters to Havell have not yet come to light. Havell expressed himself freely to Coomaraswamy, as in a letter of December 1908, concerning a reviewer of *Indian Sculpture and Painting*:

It is so characteristically British to concede that Indian art is good enough for Indians, but cannot possibly be compared with the best works of Greece and Italy, and with British inconsequence he doesn't see how illogical it is to expect Indian art to survive unless Indians can sincerely believe that it is as good (or better than) any other art the world ever produced. It is a fine example of the condescension

[30] *Ibid.*, p. 118.

[31] *Ibid.*, p. 116. AKC was not free of the tendency to make such defensive comparisons in his early works, although by 1918 he had thought over the whole subject of comparison and sent a Christmas greeting to his friends with an unconventional text: one of three epigrams printed on the greeting reads, "To compare is immoral" (library of Professor William S. Wilson III, New York).

[32] Havell, *Indian Painting and Sculpture*, pp. 117–118.

[33] *Ibid.*, pp. 147 and elsewhere.

[34] Cf. E. B. Havell, letter to AKC, 22 September 1908, Princeton Collection, which implies this itinerary.

which must always be more exasperating to Indians than aggressive Philistinism.[35]

Havell followed up his work on sculpture and painting in 1911 with a book on the cultural and religious background of Indian art, *The Ideals of Indian Art* (London, 1911; New York, 1913), and in 1913 published his *Indian Architecture: Its Psychology, Structure, and History from the First Muhammadan Invasion to the Present Day*. Coomaraswamy reviewed the book both in England and in India; he had by then acquired his lifetime custom of publishing indiscriminately in Eastern and Western journals, which corresponded perfectly to his sense of being at home in both hemispheres.[36] Havell's fourth book in his series was *The Ancient and Mediaeval Architecture of India* (London, 1914). In Coomaraswamy's London *Times* review of this volume is evidence of the serious reservations that eventually tempered his view of Havell's work: "While the present beautifully illustrated volume is full of suggestive interpretation, it is also bewildering, because so many difficult and complex problems are solved with such facility, and yet the working out of the problem is rarely supplied; and nothing is gained by assuming that every archaeologist must be wrong merely because he is an archaeologist."[37]

Returning to 1908, we must recognize that Coomaraswamy too, at this period, was sometimes a maker of "suggestive interpretations" and a facile resolver of "difficult and complex problems." Two works, *The Aims of Indian Art* and *The Message of the East*, of 1908 and 1909 respectively, are as extreme as Havell's. The former is an effusive account of the spirit of Indian art in which Indian religious concepts are used in a youthful, unintentionally careless way. Many ideas that Coomaraswamy would later study and expound with great rigor are presented there in a bouquet:

> What, after all, is the secret of Indian greatness? Not a dogma or a book; but the great open secret that all knowledge and all truth are absolute and infinite, waiting not to be created, but to be found; the secret of the infinite superiority of intuition, the method of direct

[35] Letter to AKC, 26 December 1908, Princeton Collection.

[36] AKC's reviews appeared in *The Burlington Magazine* (March 1914), p. 351, and in *The Hindustan Review* (January 1913), pp. 67ff.

[37] *The Times* (London), 2 March 1915, clipping in Princeton Collection. An extensive new study of E. B. Havell is being prepared as a dissertation (Harvard University) by Marhukh Tarapor, to whom I am grateful for advice concerning her subject.

perception, over the intellect, regarded as a mere organ of discrimination. There is about us a storehouse of the As-Yet-Unknown, infinite and inexhaustible; but to this wisdom, the way of access is not through intellectual activity. The intuition that reaches to it, we call Imagination and Genius.[38]

The reference to Imagination is one of the earliest signs that Coomaraswamy was already reading William Blake, who became for him, alongside Walt Whitman and Nietzsche, a representative of what he for a while hoped—again with romantic enthusiasm—would be the new philosophy of the West, something that he called Idealistic Individualism.

The Message of the East also has its fair share of "moonshine and stardust," to borrow a phrase from an American physician who is sympathetic to Indian thought but allergic to its misrepresentation. The title is pretentious; the East is too large a place to have just one message, transmittable by just one young man in his early thirties. But in some ways the book is prophetic: Coomaraswamy acknowledged the Anglicization of the East and even welcomed it in certain respects, but predicted that there would be an "inward and subtle Indianization of the West," because the West was approaching a crisis in which it would need help to renew its creative powers. The prophecy has been substantially fulfilled, but at that time in his life Coomaraswamy had not yet submitted to the intellectual discipline that would make his later works on Indian art and thought among the most reliable and comprehensive sources for students of Indian culture. In any case, he concluded the book, published only in India, with an eloquent reformer's essay on "Art and Swadeshi"—the latter was the nationalist movement to boycott imports from England while encouraging Indian manufactures. At this time, he was much more himself as a social critic and exponent of national culture than as a mystic.

With the publication of Havell's and Coomaraswamy's books in England in 1908, two schools of thought on Indian art faced one another: that of the old guard, best represented at that late date by Sir George Birdwood, and the new school of critics sympathetic to Indian art. Roger Fry in January 1910, tried to efface the differences between these schools through his sensitive, gently instructive article in *The Quarterly Review*. In form, his article was a review of Coomaraswamy's book on Ceylon, Havell's on India, Gaston Migeon's *Manuel d'art musulman* (Paris, 1907), and Laurence Binyon's *Painting in the Far East* (London, 1908), but

[38] AKC, *The Aims of Indian Art*, p. 1.

in effect he summarized the sources and character of contemporary English taste in art, affirmed that Oriental art could provide the alert observer with "a vast mass of new aesthetic experience," and described his own progress in understanding and appreciating the arts that the four authors had presented. It is a thoroughly conciliatory article, expressing sympathy for critics and students who are bewildered by "the multiplicity and strangeness of the new unassimilated material," but calling on them, in unaggressive words, to accept the new challenge.

> When once we have admitted that the Graeco-Roman and high Renaissance view of art . . . are not the only right ones, we have admitted that artistic expression need not necessarily take effect through a scientifically complete representation of natural appearances, and the painting of China and Japan, the drawings of Persian potters and illuminators, the ivories, bronzes, and textiles of the early Mohammedan craftsmen, all claim a right to serious consideration. And now, finally, the claim is being brought forward on behalf of the sculptures of India, Java, and Ceylon. These claims have got to be faced; we can no longer hide behind the Elgin marbles and refuse to look; we have no longer any system of aesthetics which can rule out, *a priori*, even the most fantastic and unreal artistic forms. They must be judged in themselves and by their own standards.[39]

Fry identified the principal obstacle in front of "the average amateur" of fine art as an ingrained preference for representative art in which "likeness to natural appearances" serves as "the chief criterion of value," and pointed out that this preference also made it impossible for the average amateur to appreciate primitive Italian art or Byzantine. Coomaraswamy was so outraged by this particular prejudice during his years in England that throughout his writings, even on into the late 1930s, he occasionally protested against it, although by that time the average amateur was interested in many kinds of nonrepresentational art, both ancient and contemporary.

Fry found Chinese and Japanese painting far easier of access than Indian sculpture; Indian iconography was strange and more difficult to accept, and the best sculpture that he had seen with his own eyes, the Amarāvatī reliefs in the British Museum, seemed to have "a rococo style deprived of the lightness and elegance which alone makes that style

[39] Roger Fry, "Oriental Art," *The Quarterly Review*, No. 422 (1910), p. 226.

tolerable." On the other hand, he found that "there are reproduced in Mr. Havell's book many sculptures which must appeal deeply to any unbiased and sensitive European." Fry himself was not free of bias; it is implicit in his description of the Borobuḍur reliefs as coming near to certain Greek reliefs, "though in their over-ripe sweetness and richness of effect one would compare them with neo-Attic rather than with Pheidian examples."[40] This is hardly a demonstration of how to judge exotic works of art "in themselves and by their own standards," as he had proposed at the beginning. In sum, Fry's article provided something for everybody: a marvelously intelligent personal approach to Oriental art, as well as some intentional and unintentional remarks showing that he himself was not yet fully able to accept it. His article was immediately recognized by admirers of Indian art as a sign of change.[41]

Almost simultaneously with the appearance of Fry's opinions, the two schools of thought on Indian art confronted one another at a meeting of the Indian Section of the Royal Society of Arts, and the profound disagreement evident at that private gathering finally spilled over onto the editorial page of the London *Times*. The complete minutes of the session were published in the *Journal of the Royal Society of Arts* for February 4, 1910. Its chairman was Sir George Birdwood, its principal speaker E. B. Havell, who addressed himself to the subject of the art administration in India. Among those in the audience who afterwards commented on the address were Coomaraswamy, the well-known artist Walter Crane, and Coomaraswamy's friend, William Rothenstein. Havell's discussion of the problems of art schools and government patronage in India aroused reasonable expressions of agreement and disagreement from the chairman, who was first to comment, but Sir George devoted the bulk of his riposte to the question of the existence of fine art in India.

As to this recently raised question of the existence in India,—India of the Hindus,—of a typical, idiosyncratic and idiomatic "fine art" . . . I have up to the present, and through an experience of seventy-eight years, found no examples in India; and, judging from my experience, I should say that India had never prized art for art itself's sake. I never saw a Hindu painting, sculpture, bronze . . . etc., that was not first, throughout and last . . . either a sacrosanct article of utility . . .

[40] *Ibid.*, pp. 235–237.
[41] Cf. Vincent A. Smith, *History of Fine Art in India and Ceylon* (London, 1911), Introduction, where the author gives an account of the years leading up to 1910.

or a ritualised, and generally monstrous representation of the high gods, and epic heroes . . . ; the materials, shapes, and colours of these objects being all determined by the most arbitrary principles, and the most peremptory and stringent canons, that could have possibly been devised for the creation and perpetuation of such conventional forms. . . . My attention is drawn to the photograph, on my left, of an image of the Buddha as an example of Indian "fine art." . . . Few of us have the faith of the new school of "Symbolists" in a symbolism that outrages artistic sensibilities and proprieties by virtually regarding art as but a framework for its myths . . . and strange semeiological devices; and one might as reasonably rave over Algebraical symbols as examples of "fine art." . . . This senseless similitude, in its immemorial fixed pose, is nothing more than an uninspired brazen image, vacuously squinting down its nose to its thumbs, knees, and toes. A boiled suet pudding would serve equally well as a symbol of passionless purity and serenity of soul.[42]

Birdwood was looking at a photograph of an Indonesian stone sculpture, a *dhyāni* Buddha (Buddha seated in meditation) from Borobuḍur.[43] Its soft features and smooth, rounded limbs reminded him of a certain kind of pudding, no longer very familiar in America, made with flour, bread crumbs and seasonings, or else with fruit, and thickened to the right consistency by purified animal fat—suet.

Walter Crane was the first to frame a response to Birdwood's remarks. He pointed out how much Birdwood had contributed to the welfare of Indian industrial art and went on to state that his own experience of the sculptured temples of south India obliged him to rank them with the "splendid vital sculpture of the French thirteenth century." It was "a great mistake" to suppose that fine art did not exist in India. Coomaraswamy spoke for perhaps fifteen minutes, starting with a thorough-going criticism of the Indian holdings of the South Kensington Museum, of which Birdwood was curator. It was "an emporium of industrial art, valuable as far as it went," but not likely to create "any special feeling of respect for, or any enlarged comprehension of, the expression of Indian thought and feeling in art." He then offered some of his own observations on the inadequacies of art schools in India and the inadequacies of critics

[42] *Journal of the Royal Society of Arts* (4 February 1910), pp. 286–287.
[43] Cf. Sherman E. Lee, *A History of Far Eastern Art* (New York, 1964), p. 129, fig. 152, for a representative example.

when they turned to Indian art, and praised Havell's work as "the beginning of a new order of things." Regarding Birdwood's view of fine art in India, he could "only say that if Sir George Birdwood chose to call the Royal Academy or the Paris Salon, 'fine,' and such a figure as the Avalokiteśvara of Mr. Havell's book (Plate XI), 'decorative,' then he preferred decorative to fine art, and regarded the decorative as a profounder revelation, a more living utterance than the fine."[44] Havell closed the evening with a reminder to his audience that France and Germany (France, "who had been the teacher of several generations of British artists") were far ahead of England in the size and quality of their museum collections of Indian art, and that educated Indians were beginning to understand their own art. It would be "impolitic" of Great Britain to lag behind.

When the minutes of the meeting were published in February, a group of artists and critics, some of whom had attended the meeting, wrote a letter to the London *Times* in which they quoted the essence of Birdwood's remarks, especially the passage in which he compared the Buddha in meditation to a pudding, and declared their own view of Indian art: "We find in the best art of India a lofty and adequate expression of the religious emotion of the people and of their deepest thoughts on the subject of the divine. We recognize in the Buddha type of sacred figure one of the great artistic inspirations of the world. We hold that the existence of a distinct, a potent, and a living tradition of art is a possession of priceless value to the Indian people."[45] On the following day, an editorial appeared in the *Times* bearing the title "Art in India,"[46] which expressed general agreement with the "distinguished artists and critics" who contributed the letter, and went on to propose the interesting theory that art in the West, at its worst, was wholly realistic and inexpressive, while art in the East, at its worst, was wholly symbolic and inexpressive. Each had something to learn: to demand expressiveness, over and above the conventional subject-matter to which each was entitled and accustomed. Expressive power was suggested as a common criterion for East and West, and, through it, each could "understand the art of the other in spite of all differences of convention." The editorial was a reasonable attempt to set things in order, but superficial.

[44] *Journal of the Royal Society of Arts* (4 February 1910), pp. 289–290.
[45] *The Times* (London) (28 February 1910), clipping in the notebooks of AKC, family collection.
[46] *Ibid.*, 1 March 1910.

The most significant consequence of the Royal Society meeting was that it prompted Rothenstein, Coomaraswamy, Havell, Roger Fry, the well-known scholar W. R. Lethaby, and others, to found the India Society. By the time Rothenstein wrote his autobiography, *Men and Memories*, in the 1930s, the India Society, transformed into the Royal India Society, was well known for the publications it sponsored and for its periodical, *Indian Art and Letters*. But when Coomaraswamy described the society to an audience in London, just one year after its foundation, it still sounded fragile. He informed his listeners of "the India Society, in which English and Indian and other Continental ladies and gentlemen combined for the study of the aesthetic aspects of Indian culture. We find before us not only an enormous amount of work to be undertaken but many willing workers to undertake it. . . . *The Discovery of Asia, then, has become to Europe no longer a piratical expedition, but a spiritual adventure.*"[47] The fragility derives not only from the youthfulness of the society, nor only from Coomaraswamy's painfully elegant description of its members, but from the key word "aesthetic." Although he was willing to use this term in his early years, it was not long before he began to sense that it was a weak one, which did not describe anything that truly interested him in his experience of works of art, and would especially need to be questioned in relation to Indian art (see Chapter XVIII). In any case, the India Society very rapidly undertook a publishing program. In the year of its foundation there appeared the first of its series, a selection of *Indian Drawings* by Coomaraswamy, with his brief introduction. Havell produced its second publication shortly after, *Eleven Plates Representing Works of Indian Sculpture Chiefly in English Collections*,[48] and Coomaraswamy made another selection of drawings for *Indian Drawings, Second Series: Chiefly Rajput*, which appeared in 1912 and displayed, as its title indicates, his new discovery in Indian art: the Hindu drawings and paintings of Rajputana and the Punjab hills of North India.

One other event in the year 1910 must be given its place: Coomaraswamy's address, "On the Study of Indian Art," to the Royal Asiatic Society. Although Coomaraswamy remained experimental and avant-garde in his speculative philosophical writings throughout the next decade, he already foresaw a rigorous program of study that would be

[47] AKC, "Education in Ceylon," p. 140, included in *Art and Swadeshi* (Madras, 1911), italics in the original.
[48] London, 1911.

72

necessary to make Indian art comprehensible to the West. His Romanti-
cism, his growing delight in the fashionable, which we will see very
well in the next years of his life, fell away before the opportunity to make
fundamental contributions in this field. He had written in 1908 that
"materials are not yet available for the detailed history of Indian art or of
any off-shoot or branch of Indian art,"[49] and four years later he repeated
that "the study of Indian culture in all aesthetic aspects, save literary,
remains an almost unworked field."[50] His lecture of 1910, coming at a
time when he had shown his competence to accept this challenge but
had not yet produced a great volume of work, reflects the seriousness
with which he set out to write the history of Indian art. It recorded a
series of commitments: to express in English how Indian art and culture
appear to the Indian mind; to found art-historical and critical study on
traditional aesthetic and technical treatises; to accept that Indian art is
essentially religious, and to retain this recognition even within a *history*
of Indian art, although the nature of histories is to emphasize dates, facts,
and stylistic sequences. He never departed from these commitments; only
added to them in later years. It is rare for a scholar to find himself in front
of such a vast opportunity.

Coomaraswamy was not alone in recognizing opportunity and neces-
sity. Havell was of course there, working on his series of books, and
Vincent A. Smith published a large *History of Fine Art in India and
Ceylon* in 1911. In the first edition of his book, Smith acknowledged
Coomaraswamy's work on Ceylonese art and Indian bronzes, and credited
him, as well as Havell and John Marshall of the Archaeological Survey,
with putting the whole of Indian art back in question. He believed that
Coomaraswamy, and more so Havell, had overstated their case in many
instances. Coomaraswamy's enthusiasm for South Indian and Ceylonese
bronzes of the Dancing Shiva appeared to him excessive, primarily be-
cause he could still not abide Indian images with many arms: "To my
mind," he wrote, "it appears impossible to defend the representation of
such forms on artistic grounds. The spirited Polonnaruwa bronzes of the
dancing Śiva . . . are grievously marred as works of art by the hideous
extra arm brought across the chest."[51] Smith also cited *The Aims of Indian
Art* as typical of Coomaraswamy,[52] although that book represents a stage

[49] *Mediaeval Sinhalese Art*, p. 250.
[50] AKC, "Rajput Painting" (1912–1913), p. 139.
[51] Smith, *History*, 1st ed., 6. [52] *Ibid.*, p. 128 and elsewhere.

of work that Coomaraswamy rapidly outgrew. In any case, the transformation of this astute author, once a member of the "old guard" that refused to credit India with any fine art at all, into a systematic, sympathetic historian of Indian fine art, marked the end of an era and the beginning of a new one. By 1911, Coomaraswamy, too, had found his direction as an historian of Indian art and was already engaged in the travel, collecting, and research that led to his most important single contribution to knowledge of the content of Indian art history: his discovery of Rajput painting.

VII. India, 1909–1913:
Art and Swadeshi,
The Tagore Circle

Coomaraswamy is difficult to follow in this period when he divided his time between England and India, but evidence from a number of sources,[1] pieced together with anxiety over finding him in two places at once, indicates that he spent nearly the whole of 1909 in India and returned to Broad Campden by December of that year. He went out again to India the following summer by way of Munich, where an exhibition of Islamic art attracted the attention of English connoisseurs, and spent probably two years in various parts of India before returning to England by summer 1912. He was again in India in 1913: a letter to him dated October of that year indicates that he was then just on the point of leaving. Not only his whereabouts, but also his interests were twofold during these years. In India he joined, with the ease and naturalness of predestination, the most influential circle of nationalist thinkers in Bengal. In England, he continued to thrash out for himself the significance of some of the major intellectual currents of the day: Nietzschean thought, espoused by a circle of brilliant Englishmen in the prewar period; the revival of William Blake; anti-industrialism, which was being argued more intensely than ever; the status of women and revised understandings of love and marriage. He was now in his middle thirties, growing up but still a rare mixture of refinement and rebelliousness.

Coomaraswamy's wife Ethel remained behind to take care of Norman Chapel during his first voyage to India in 1909. Essex House Press was placed under the supervision of Philip Mairet, a young draftsman in Ashbee's circle. Ethel accompanied Coomaraswamy on the voyage to India in 1910 but returned to England when he decided to stay on at

[1] Dated articles, letters at Princeton and in the family collection, even book inscriptions in AKC's library enter into the calculations.

length,[2] and their marriage broke up in this period. It is difficult now to know the causes—and certainly Coomaraswamy, with his distaste for biography, would find it irrelevant for us to know of them. They kept their affection for one another and corresponded even late in life. Ethel later married Philip Mairet, who went on to become the editor of *The New English Weekly*, a journal of politics and the arts whose point of view was very close to Coomaraswamy's. It published frequent Letters to the Editor from his pen during the 1930s and 1940s. A gifted weaver and needlewoman, Ethel worked at her crafts and published a number of books on them. She sent copies to Coomaraswamy in America.

The India to which Coomaraswamy came early in 1909 was in the midst of the political and social crisis that marked the beginning of the popular nationalist movement.[3] Nationalism of various kinds was not unknown in nineteenth-century India; the Indian National Congress had been organized and first met in 1885 as a legally established body charged with expressing Indian projects and grievances. The stability and moderation of India was destroyed by the partition of Bengal, an action promoted particularly by Lord Curzon, chief English administrator of India from 1898 to 1905. Bengal, with a mixed Hindu and Muslim population of seventy-eight million, was divided by a proclamation of 1 September 1905, into two provinces: Bengal proper, largely Hindu in population, and a separate province of Eastern Bengal and Assam, where Muslims were in the majority. For two years before the proclamation, antipartition agitation had been rife, supported at first by Hindus and Muslims alike and by a significant number of English leaders and newspapers. Later the government gained Muslim support for its program, and opposition to partition ceased in England when Hindu terrorists began spreading violence.

The partition, officially presented as an administrative necessity for dealing with such a large province, is now considered by Indian historians

[2] As previously noted (cf. Ch. 2, n. 2), Alan Crawford's study of Ashbee's unpublished papers, as well as those of Philip Mairet, has helped me to grasp the history of this period. Although I have not had the opportunity to see those papers, I expect Mr. Crawford's further publications to provide still more insight.

[3] For the history of this period, cf. R. C. Majumdar, *History of the Freedom Movement in India*, Vol. II (Calcutta, 1963); H. H. Dodwell, ed., *The Cambridge History of India*, Vol. VI (Delhi, 1964); Haridas and Uma Mukherjee, *Sri Aurobindo and the New Thought in Indian Politics* (Calcutta, 1964); K. M. Munshi, *Struggle for Freedom (History and Culture of the Indian People*, Vol. XI) (Bombay, 1969).

to have been designed to create an eastern province with a majority of Muslims sympathetic to the government, and to diminish the refractoriness of the remaining part of the province, centered on Calcutta, by including its more educated, restive Bengali population in an administrative unit that included the more loyal regions of Bihar and Orissa to the west and south. The Bengalis in 1903–1905 believed that the unity of their race and land was being destroyed without hearing and promised, months before the proclamation was official, "a strenuous and persistent struggle in which no expense or sacrifice will be grudged. . . . We are not guilty of the smallest exaggeration when we say that we are on the threshold of an agitation, which, for its intensity and its universality, will be unrivalled in the annals of this province."[4] On 7 August 1905, at a meeting in the Town Hall of Calcutta, after months of petitions, mass meetings, and newspaper editorials had failed to dissuade the Curzon government, the leaders of Bengal decided to adopt a policy of boycott and swadeshi.

Boycott of English goods, imported on a vast scale, constituted a non-violent political action that had been put forward at other times of crisis in Anglo-Indian affairs, but had never worked successfully until this period. Swadeshi—"own country," as Coomaraswamy literally translated it[5]—was the slogan and most characteristic word of this period. It signified the movement to purchase only Indian goods and to encourage local industries, which quickly blossomed into concern for the revival of every aspect of national culture: education, religion, language, dress, art. Initiated as political weapons in a particular crisis, boycott and swadeshi became means of "non-cooperation with the British in every field; . . . the object aimed at was a political regeneration of the country, with the distant goal of absolute freedom looming large before the eyes of the more advanced section."[6] Students participated in the swadeshi movement by refusing to take the examinations of government-sponsored Calcutta University, attending large public meetings, picketing, and establishing swadeshi stores where domestic goods were sold. Peasants understood swadeshi and cooperated with it. Meanwhile Extremist political thought, as the new ideas were called in contrast to those of the

[4] Majumdar, *History of the Freedom Movement*, II, 7, quoting the leading Bengali nationalist, Surendra Nath Banerji, in an editorial of 7 July 1905.

[5] AKC, "Young India," published in *The Dance of Shiva* (New York, 1918), p. 158.

[6] Majumdar, *History of the Freedom Movement*, II, 33.

Moderates in the Indian National Congress, began to find eloquent expression in English-language and vernacular newspapers, most notable among them *Bande Mataram*, edited by Bipin Chandra Pal and Aurobindo Ghose.[7] Aurobindo had received a first in classics at Cambridge; his literary powers were acknowledged even by his enemies. *Bande Mataram*—its title, *Hail to the Mother*, taken from a popular nationalist song that had been circulating in Bengal for several decades—flourished between 1906 and 1908; the English judged that its pages "reeked with sedition,"[8] but were unable to close it down until after the passage of a Press Act in mid-1908. At the same time, Aurobindo was jailed for over a year, on charges of conspiracy in a bombing that eventually proved groundless (Coomaraswamy arrived in Calcutta while Aurobindo was in jail; there is no evidence that they met). Aurobindo's editorials preached swadeshi, passive resistance, and complete independence. He was not nonviolent; he argued that the Brahmin code of nonviolence was inappropriate to politics, although he did believe in passive resistance. Bengal in these swadeshi years (1905–1911) saw the birth of "the cult of revolution" and the "philosophy of the bomb," as the historian Mukherjee puts it,[9] as well as the first widespread practice of nonviolent resistance.[10]

Swadeshi and boycott, accompanied by strong nationalist propaganda and violence, continued in Bengal and spread to other parts of India during the administration of Lord Minto, who replaced Lord Curzon as viceroy of India in late 1905. In 1910, when Lord Hardinge became chief administrator of India, he recognized that something would have to be done to reduce tensions in Bengal, which appeared to him to be "seething with sedition," "political unrest," and "terrorism."[11] In 1912, a series of government proclamations announced a revised administrative division of Bengal, which reunited the Bengali-speaking region, gathered Bihar, Orissa, and Chotanagpur into a separate province, and restored Assam to its

[7] Cf. Mukherjee, *Sri Aurobindo.*

[8] *Ibid.*, foreword, p. viii. [9] *Ibid.*, p. xxx.

[10] Aurobindo Ghose underwent "a great change . . . during the seclusion of his jail life. He practically gave up politics and took to a life of religious meditation, in which, he conceived, lay the true path of India's salvation. . . . But he did not altogether eschew politics. . . . The Government suspected that he was still connected with the terrorist movement and decided to deport him. Having got some inkling of it, Arabinda secretly left Calcutta, and . . . proceeded to Pondicherry where he spent the rest of his life as a spiritual *guru*." Majumdar, *History of the Freedom Movement*, p. 198.

[11] Cf. Munshi, *Struggle for Freedom*, ch. VII, pp. 161 ff.

former status. In addition, the seat of the British imperial government was moved from Calcutta to Delhi, where a new Delhi quickly rose. Havell and Coomaraswamy led a verbal attack on the English planners of New Delhi, urging them to use Indian architects and masons in the construction of government buildings for reasons of economy, excellence, and suitability, and as a much-needed example of state patronage of indigenous industry.[12] In any case, the Bengalis had achieved the virtual annulment of the partition; the nationalist movement born in their province was not destined to subside. In 1919 Gandhi became its recognized leader.

The blood and tears of this period did not entirely destroy the pleasure of life in Bengal (cf. Figure 9). Coomaraswamy entered a charmed circle early in 1909, when he joined the Tagores at their family home, Jorasanko, in Calcutta. They were an old, aristocratic, and wealthy Bengali family that counted sages and good businessmen among their ancestors. William Rothenstein, the English artist with whom Coomaraswamy was friendly, visited them in 1910 during a voyage that he made partly in Coomaraswamy's company. Rothenstein described the household in his memoirs:

> Abanindranath Tagore and his brother Goganendranath came to take me to their home at Jorasanko; a delightful house, full of lovely things, of paintings, bronzes, stuffs, and musical instruments. Their collection of Indian paintings was the best I had seen, made, as it was, by artists. Goganendranath, a man of singular charm and culture, was a kind of Indian Ricketts, who seemed to have seen and read about everything. I was attracted, each time I went to Jorasanko, by their uncle, a strikingly handsome figure, dressed in a white *dhoti* and *chaddur*, who sat silently listening as we talked. I felt an immediate attraction, and asked whether I might draw him, for I discerned an inner charm as well as great physical beauty, which I tried to set down with my pencil. That this uncle was one of the remarkable men of his time no one gave me a hint.[13]

[12] AKC, "The Royal Palaces of Rajputana" (1914); AKC, letter to *The Manchester Guardian*, October 1912; cf. E. B. Havell, *Indian Architecture: Its Psychology, Structure, and History from the First Muhammadan Invasion to the Present Day* (London, 1913), for Havell's views on the question.
[13] Sir William Rothenstein, *Men and Memories*, 3 vols. (London, 1931–1939); Vol. II, ch. xxviii, "An Indian Pilgrimage," p. 249. The uncle whom Rothenstein sketched was the poet Rabindranath Tagore.

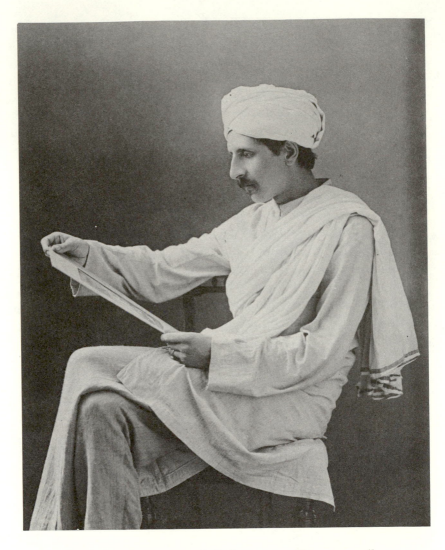

Figure 9. Coomaraswamy in India, ca. 1909: The young *rasika*.

Rothenstein's description comes to life in a fluent sketch by Nandalal
Bose, Abanindranath's most gifted pupil, of the studio at Jorasanko at
midday sometime in 1910 or 1911 (Figure 10). The three Tagore brothers,
Samarendranath, Goganendranath, and Abanindranath, are reclining with
books and hubble-bubbles in the rear of a studio crowded with paintings
and art objects, while Coomaraswamy and Nandalal Bose converse in the
foreground about a painting that Nandalal has underway. Coomara-
swamy is represented as a handsome young man of serpentine grace
and intensity with long billowing hair and an unmistakable gold ear-
ring. Photographs from this period (such as Figure 11) confirm Nanda-
lal's portrait: Coomaraswamy is sometimes full of good humor, sometimes
ferocious in them, and the earring hangs in mid-air, somewhere between
fashion and insolence. More must be said about the implications of this
portrait, but it seems wise at this point to consider the Tagores' role in
the nationalist movement.

Rabindranath (1861–1941) had authority in Bengal, not as a politician,
although he appeared at nationalist meetings and lectured on swadeshi,
but rather as patriot, poet, songwriter, and religious philosopher. His
earliest writings date into the nineteenth century. The period 1901–1914
was perhaps his most creative; the poetry of these years in English trans-
lation won him the Nobel Prize for Literature in 1913. He was the poet
of the swadeshi movement, an irreplaceable element in its spiritual life,
an incarnation of the national spirit. It was he who declared in a public
letter that the day when Partition was actually effected, October 16th,
would thenceforth be a day for celebration of "the indelible unity of the
Bengali race."[14] The symbol of that day was a yellow thread, the *Rakhi*,
which all Bengalis of every religion and caste tied on one another's arms.
Rabindranath's songs praised the beauties of Bengal and revived the image
of India's heroic, chivalric past; they exercised a very strong influence on
young Bengalis. Dilettante as it may seem to have written songs at a
time of intense political conflict, we know well enough from recent ex-
perience in the United States that music can not only support a cultural
revolution but extend it.

Rabindranath was concerned with National Education far more than
with politics; his interest in this respect was parallel to that of Coomara-
swamy, who, as we shall see, was severely critical of Indian leaders who
thought only in political and economic terms. Rabindranath founded a
school at Santiniketan in 1901, some one hundred miles from Calcutta,

[14] Majumdar, *History of the Freedom Movement*, pp. 24 ff.

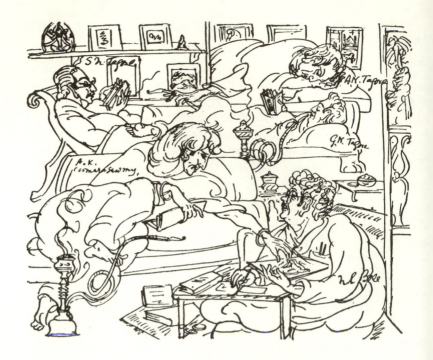

Figure 10. The Studio of Abanindranath Tagore at Jorasanko, Calcutta, ca. 1910, by Nandalal Bose.

Figure 11. Coomaraswamy, ca. 1910.

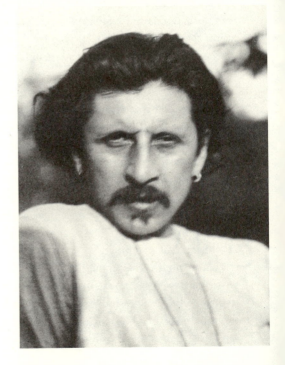

where his father, Maharshi Devendranath Tagore, had established an ashram in 1863. In 1922, he opened Viśvabhāratī International University, also at Santiniketan. The university's program differed notably from government-sponsored institutions by its concern with Eastern as well as Western history, religion, science, and so on, and by its interest in "that simplicity in externals which is necessary for true spiritual realization, in amity, good-fellowship and cooperation between the thinkers and scholars of both Eastern and Western countries, free from all antagonisms of race, nationality, creed or caste, and in the name of the One Supreme Being who is *Shantam Shivam, Advaitam*."[15]

We can wonder why Coomaraswamy did not stay with the Tagores and become a permanent participant in their effort to establish national ideals and educational institutions: the awakening of Bengal must have represented for him the realization of at least a portion of his dreams for Ceylon; Bengali unrest was the background of his activities in Ceylon. Furthermore, the Tagores had the intellect, diversity of talents, energy, and wealth to accomplish their purposes. Two answers to this question come to mind. In the first place, Coomaraswamy did try during these years to establish himself permanently in India, but wished to do so on his own terms: he sought, as we shall see, to give his extremely rich art collection to the people of India, provided a National Museum be established to house his collection and others. He would gladly have remained as the director of such a museum. He tried also to obtain a university post as a professor of Indian art and culture, but for both this and the museum the times were not ripe. Second, his interest in art history bound him to the West, not only because it was quite advanced as a study in the West and nearly nonexistent in India, but also for practical reasons, such as the impossibility of having an illustrated book on art produced properly in India. Coomaraswamy's most elegant publication, *Rajput Painting*, which appeared in England in 1916, could only have been produced by an experienced publisher with enough capital to finance a meticulous and luxurious set of volumes, and such was unavailable in India. He was destined not to sink into "the web of Indian life," to use the romantic but evocative title of a book by Sister Nivedita, written during the swadeshi years.

Coomaraswamy's relation with Rabindranath, sixteen years his senior, is best understood through the essay on "Poems of Rabindranath Tagore," included in his book of nationalist essays, *Art and Swadeshi* (Madras,

[15] *Ibid.*

1911). The essay is a collection of translations, but also contains Coomaraswamy's appreciation of Rabindranath, a brief biography of the poet, and some general comments on the revival of national literature. Rabindranath represented for him precisely the type of poet and artist that understands more and creates more of benefit to a nation than do narrow-minded politicians, however sincere their national feeling.

> It would be difficult to exaggerate the significance for Indian nationalism of such heroic figures as that of Rabindranath Tagore, the Bengali poet, dramatist and musical composer; "for nations are destroyed or flourish in proportion as their poetry, painting, and music are destroyed or flourish." . . . The pure politician is often no nationalist at all, in an idealistic sense. . . . It is the work of poets (poet, painter, sculptor, musician, "artist,"—all these are synonyms) to make their hearers free: it is they alone who establish the status of nations.[16]

Later in the essay appears the most intensely nostalgic reflection to be found anywhere in Coomaraswamy's writings, on the loss of the traditional environment. He charges poets with the task of restoration:

> The painters of our visions—the makers of our songs—the builders of our houses—the weavers of our garments, these all are a touchstone that can turn to gold for us both past and present, if we will it so. These, if we would let them, could lead us back to a world we have lost, the world to which our real greatness belongs, a world for which nothing can ever compensate. . . . We have poets as our guides to take us back to the elemental and real things in life. They can show to us the significance of little things, the wonder of what is always going on. They tell us what we are not because of the dolls in our childhood's games, because of the rivers that we worship as divinities, because of the skill of craftsmen and the loneliness of saints, because of the beauty of women, and the splendid indifference of men to danger and to death.[17]

Living close to the Tagores reinforced Coomaraswamy's nostalgia, but living there also gave him a central place from which to make accurate observations of India's problems, to see close at hand the difficulties in-

[16] AKC, "Poems of Rabindranath Tagore," pp. 111 ff. in *Art and Swadeshi*; this passage appears on pp. 111–112.
[17] *Ibid.*, pp. 114–115.

volved in cultural revivals—so unlike cultural originals—and to experience traditional Indian music, dance, and visual art in abundance.

Coomaraswamy and Rabindranath met a number of times after Coomaraswamy moved to America. The younger man wrote the foreword to an exhibition of Rabindranath's paintings held in New York in 1930; late in life, the poet had turned avocationally to painting. By this time, Coomaraswamy was disappointed in Rabindranath. He thought that the poet did not continue to grow after a certain time, that his literary works were always beautiful, but did not come from a person still in evolution.[18] Be that as it may, there is an interesting photograph of the two men together in Boston in the early 1930s (Figure 12): the poet has the full beauty that characterized his old age as he sits in a rather stiff, camera-shy manner, while the art historian bends slightly toward him with a warm and thoughtful expression in his face.

Abanindranath Tagore, Rabindranath's nephew, although only ten years younger than he, was doubtless a close friend of Coomaraswamy in spite of Coomaraswamy's critical assessment of the modern school of Indian painting. Coomaraswamy wrote in 1911 that "a great responsibility now rests upon the members of the Calcutta group, and upon the public for whom they work. What has been accomplished constitutes, considering the very adverse conditions obtaining in India a few years ago, and to almost the same extent at the present day, much; but it is not what the world has a right to expect from India."[19] At the time Coomaraswamy was in Calcutta, indeed throughout the period 1905–1915, Abanindranath was vice-principal of the government School of Art in Calcutta, teaching Indian styles of painting. He was also very active in an organization formed in 1907, the Indian Society of Oriental Art, which provided a

[18] Conversation of the author with Dr. R. P. Coomaraswamy, confirmed by a comment in AKC's 1923 review of Mazumdar, *Modern Indian Artists*, Vol. I: "The work of the Bengali painters is infinitely refined, but certainly not spiritual. Like Rabindranath Tagore, the modern Indian artists know what they ought to feel and to experience, but there is no evidence in their work that they have actually felt" (*Orient* I:4 [1923], 49). Perhaps this shockingly negative attitude reflects something of AKC's opinion, in 1923, of his own enthusiasms in the period when he was close to Rabindranath. For further study of AKC's relation to the poet, cf. Śrī Amiya Kumar Sen in the *Memorial Volume*, pp. 246–257, and a comment by M. D. Raghavan in the same volume, p. 179. A photograph of AKC with Rabindranath in 1911 faces p. 250 in that volume.

[19] AKC, "The Modern School of Indian Painting" (1911); also printed in *Art and Industry*, XV, No. 120, 67–69, wherein this passage appears on p. 69.

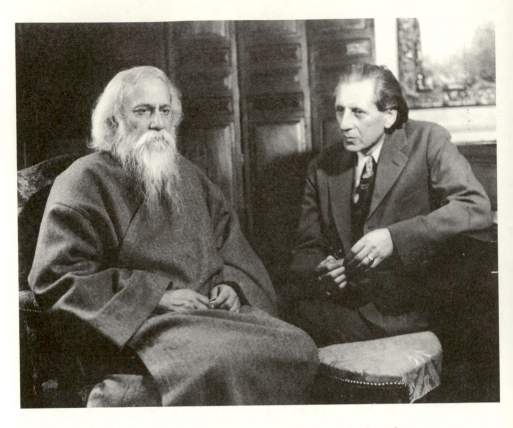

Figure 12. Coomaraswamy and Rabindranath Tagore, in the early 1930s.

milieu for Coomaraswamy and offered him significant opportunities to exercise his métier. The society's early history has been evoked in an unsystematic but rich way in the Golden Jubilee Number of its *Journal*, edited by Abanindranath and Stella Kramrisch from the time of its founding in the 1930s.[20] The society grew out of an art club begun by Havell that attracted the interest of some outstanding Englishmen in Calcutta as well as the support of the Tagores. Lord Kitchener, military commander-in-chief in India, was its first president; Sir John Woodroffe, a judge in the Calcutta High Court who is remembered now for his extensive, arduous studies of tantric religion, was extremely active in the society. Coomaraswamy gave a lecture, "On Mughal and Rajput Painting,"[21] in Woodroffe's home in 1910 under the society's auspices. There is no evidence that Woodroffe particularly influenced Coomaraswamy's thought at this time, but it must have some significance that they moved in the same milieu in Calcutta. In 1913, Coomaraswamy published a book that had nothing directly to do with art, *Myths of the Hindus and Buddhists*;[22] in 1916 appeared *Buddha and the Gospel of Buddhism*, his first lengthy exposition of religious doctrine.[23] These books happened in sight, so to speak, of his friends in India, although they were published in Great Britain and the United States.

The society's activities included annual exhibitions of modern art, lectures, and from 1919, the publication of the periodical *Rupam* (later superseded by the *Journal*). Through a school of painting and sculpture, it formed young artists at the same time that it gathered a number of major historians of Indian art: Ordhendra C. Gangoly edited *Rupam* in his younger days; Stella Kramrisch edited the *Journal*. In 1910, the society gave Coomaraswamy the responsibility of organizing an exhibition of old and new Indian art to be displayed at a large popular fair, the United Provinces Exhibition at Allahabad, during the winter of 1910–1911. In the autumn of 1910, he toured the north of India, collecting, in Gangoly's words, "an enormous quantity of the finest specimens of Indian Paintings and Drawings and other masterpieces which presented Indian Art in hitherto unknown phases and expressions."[24] Another acquaintance of Coomaraswamy's in those years indicates in a memoir that he was already

[20] *Journal of the Indian Society of Oriental Art*, Golden Jubilee Number (1961).
[21] Published in *Art and Swadeshi*, pp. 74 ff.
[22] London, 1913. AKC was coauthor with Sister Nivedita.
[23] London and New York, 1916.
[24] O. C. Gangoly in *Memorial Volume*, p. 92.

well known in India by that time through his articles in various English-language periodicals. His tour had something of the flavor of a "grass-roots" campaign:

A kind of hero worship grew up in the mind of the younger generation who came into touch with him; and those of us who had read his articles published in the *Central Hindu College Magazine*, the *Indian Review* and the *Modern Review* in the opening years of this century regarded him as an outstanding force of the time. . . . I remember how in every town and city which he visited for collecting pictures for the great exhibition at Allahabad in 1910, he made an impression on young minds and left crowds of them to ruminate on his central ideas. The great work that he did to educate public taste for Indian art exhibited at Allahabad stands out as a landmark in the evolution of modern India.[25]

The tendency to lionize that we note in some commentators on Coomaraswamy is often balanced by looking for other comments on the same topic. Coomaraswamy stayed with Bhagavan Das, the Indian philosopher then closely associated with Theosophy, at his home in Benares while he was preparing the exhibition, and later camped in Allahabad during an especially interesting period. Rothenstein met him there and traveled with him. Rothenstein's relaxed descriptions of these times with Coomaraswamy indicate that they were just keen-minded men who took pleasure in one another's company: they were neither lions nor legends. Rothenstein wrote:

Before I left Benares, Coomaraswamy, who was directing an arts and crafts exhibition, asked me to join him at Allahabad. I found him living in a tent; and, provided with a similar one, I stayed to see the famous *mela*, the annual religious fair, and the fakirs and mendicants who came there from all parts of India. . . . Idols, idol worship, priests with their distinctive dress, processions and fairs, all the outer forms of India's many religions, attracted me strongly. . . . I was eager to see the mediaeval temples at Puri and Bhuveneshwar; so was Coomaraswamy, who had come on to Calcutta from Allahabad, and thither

[25] J. M. Hafiz Syed, "Dr. Ananda K. Coomaraswamy: Some Reminiscences and an Appreciation," *India and the World*, I:6 (1947), 18 ff. For a further brief evocation of this period, cf. Bhagavan Das in *Memorial Volume*, pp. 311–312.

we went together. The Tagores put their Puri house at our disposal; and although half a dozen domestics met us at the station, yet the house was bare, so simply do Indians live.[26]

Coomaraswamy's repute in India was at this time due primarily to his nationalist writings, most of them collected into two volumes: *Essays in National Idealism*, published in Ceylon in 1909, but composed mainly of articles that had appeared in India; and *Art and Swadeshi*, published at Madras in 1911. Aurobindo had written of politics and cultural revival; Coomaraswamy wrote of cultural revival and politics. He despised "the merely material ideal of prosperity which is too exclusively striven for by our economists and politicians. . . . Such an aim defeats itself."[27]

India, politically and economically free, but subdued by Europe in her inmost soul is scarcely an ideal to be dreamt of, or to live, or die, for It is the weakness of our national movement that we do not love India; we love suburban England, we love the comfortable bourgeois prosperity that is to be some day established when we have learned enough science and forgotten enough art to successfully compete with Europe in a commercial war.[28]

In his two best essays on this topic, "Art and Swadeshi" and "Swadeshi True and False," Coomaraswamy manifested again the rhetorical powers and demanding moral vision that characterized his Ceylon years. His central point, as before, was that Indians had forgotten what it is to be Indian and, largely through snobbery, had covered themselves with the borrowed plumes of a misunderstood Western culture. Swadeshi was good in principle, but in practice its leaders had "but one thought before them"—"to save money"; it fostered the growth of factories for manufacturing "enamelled cufflinks (with pansies on them)" and other "unlovely inutilities." "I do not think," Coomaraswamy continued, "we fully realize the depth of our present intellectual poverty."[29]

There is a strong momentum in the swadeshi essays. What can become of such momentum? Is it bound for self-destructive collision with a world that will never be ideal, or can it find paths that will allow it to keep

[26] Rothenstein, *Men and Memories*, II, 248, 250. AKC put up a prize of 250 rupees at the exhibition for the best essay on trade guilds in India. A handbill announcing the competition and stating its regulations is preserved in the family collection.
[27] *Art and Swadeshi*, p. 2. [28] *Ibid.*, pp. 3–4.
[29] *Ibid.*, pp. 10–12.

moving and keep creative? For Coomaraswamy, the pattern of the paths he found is, of course, neither more nor less than his life in later years. Coomaraswamy in a rage: it is a mood that recurred time and again until the very end; a mood and a resource, although not a social grace.

In the two books of nationalist essays, direct social commentary was only one element of the message; other essays dealt with a great range of topics: Indian music, yoga, the question of Christian missions in India, the songs of itinerant singers, craft problems such as the conflict between modern aniline dyes and traditional organic dyes. They reflected his concern with Indian culture and incited his reader to follow suit. Indian commentators in the *Memorial Volume* write that his message was heard and "changed the course of life of many a man."[30] A review of *Essays in National Idealism* in *The Modern Review*, a well-known exponent of progressive Hindu thought, remarked that Coomaraswamy "is a logical and uncompromising reactionary. . . . Yet we cannot deny the beauty and truths of the pure ideal as he so nobly and persistently holds it up before us. . . . We think the book he has written to be of surpassing value."[31] If his views were expressed with the fire of an Extremist, they turn out in the end to be utterly unlike Extremist thought. By 1914, he was no longer really anxious for the immediate independence of India. Two comments from that year illustrate his position:

Before we can have India, we must become Indians. . . . I firmly believe the only service possible to render to the cause of Indian freedom, is service to Indian ideas.[32]

The time has not yet come, though perhaps its seeds have been sown, when the Indian consciousness could so far recover its equipoise as to require expression in terms of immediate self-dominion. One could wish it otherwise, but it is a fact beyond denial that India has yet to go through the European experience of Industrialism, and must cope with the problems of Industrialism before she can become free in any

[30] M. D. Raghavan in *Memorial Volume*, p. 175. A similar view was expressed by Śrī Sisir Kumar Ghose, *ibid.*, p. 167: "During the years of the Swadeshi, it was Coomaraswamy, who, along with Annie Besant, Rabindranath, Śrī Aurobindo and others, taught us the fine points of nationalism which politicians are apt to overlook."

[31] Review quoted from a Madras edition of *Essays in National Idealism*, which seems to have appeared in 1909. Copy in the Princeton Collection.

[32] AKC, review article, September 1914. Seen only in typescript in the Princeton Collection, wherein this passage appears on p. 4.

sense worth the name; her ultimate freedom has to be won in mental warfare, and not in rebellion.[33]

Coomaraswamy himself was in the service of Indian ideas. In an essay on schools of art in India, in *Art and Swadeshi*, he brought up the idea that the Indian artist would have to be once again "saturated with the traditional culture of the East" in order to know how and what to see.[34] The term "saturation" is an effective description of what happens when one comes to know something well: not only are mind and heart full, but a critical point is reached at which new internal events are possible, crystallizations of one kind or another. Coomaraswamy was saturating himself with Indian culture throughout this period in his characteristically active way. He traveled, as we have seen, to the monuments of art and architecture; he attended many sessions of music and dance that lasted in traditional Indian fashion until dawn, and these greatly stirred him;[35] he absorbed the epic literature of India not merely by reading it, but by reexpressing it in *Myths of the Hindus and Buddhists*. He was, in fact, only coauthor of this book with Sister Nivedita, whom we have already met lecturing at his home in Broad Campden. Nivedita had been an intimate of the Tagores in Calcutta for many years. Among her many activities, she had founded a school whose curriculum was based on the epics. When she died in 1911, she had completed about a third of an English retelling of the *Mahābhārata*, *Rāmāyaṇa*, *Krishna Līlā*, and other major Indian myths, and it fell to Coomaraswamy to complete the volume.

Coomaraswamy was among the few lovers of Indian music who tried, in these early days, to present its character and basic structures to the English audience. He shared this interest with Fox-Strangways, a professional musicologist and colleague in the India Society.[36] Indian music would, however, probably have remained a very secondary interest for Coomaraswamy if he had not met a young musician in London, probably in 1910, at a recital given by some of the pupils of Cecil Sharp. Cecil Sharp was the musician and writer responsible for the revival of interest in English folk song; he was well known for his published collections of

[33] AKC, "Indian Aid" (1914). This passage, with its Blakean expression "mental warfare" and its overriding concern with industrialism, gives a foretaste of the aspect of his writings discussed in Chapter IX.

[34] *Art and Swadeshi*, p. 50.

[35] AKC's writings on music, Biblio. Nos. 57, 81, 95, 124, 136, 137, 148, 151, 157, 195, 271 in the *Working Bibliography*.

[36] Cf. A. H. Fox-Strangways, *The Music of Hindustan* (Oxford, 1914).

folk songs, a dance ensemble that he directed from 1911 on, and the extraordinary efforts he made to gather up nearly lost music from the few who could remember it (in the American Appalachians, he found forgotten English songs). One of his pupils, Alice Richardson, was to be Coomaraswamy's second wife. She accompanied him to India; the first we hear of her there is in the summer of 1911, when she and Coomaraswamy were living in a house-boat at Śrinagar, far to the north in Kashmir.[37] Coomaraswamy had settled briefly in that region to have access to various small cities in the foothills of the Himalayas where painting had flourished a hundred years earlier; he was at work on his study of Rajput painting. They had brought with them from further south a teacher of music. In his introduction to a book of *Thirty Songs from the Panjab and Kashmir*, transcribed with music and words by his wife, who now used the Indian name Ratan Devī professionally, Coomaraswamy evoked this period in their life:

> A few words must be said about our Ustād, Abdul Rahīm of Kapurthala. Between him and Devī there was formal acceptance of the relation of teacher and pupil, with all due solemnity and offerings. Thereafter Abdul Rahīm came with us for about ten weeks to Kashmir, and Devī studied daily. . . . He sings with equal earnestness of Krishna or Allah, exemplifying the complete fusion of Hindu and Moslem tradition characteristic of so many parts of northern India today. He is devout and even superstitious; he would hesitate to sing dīpak rāg, unless in very cold weather.[38]

Devī must have learned with extraordinary facility and her native talents must have been exceptional, for by 1912 when Coomaraswamy and she were once again in England, she was able to give recitals of Indian music, accompanying herself with a *tambura*, which won the praise of some of the most distinguished Englishmen of the day, as well as of music critics and native Indian connoisseurs. Rabindranath Tagore heard her in London and found himself passing from uneasy anticipation to complete delight in her mastery of all the technical difficulties of Indian song, which she combined with a voice far superior in quality and training to that of most Indian singers.[39] W. B. Yeats wrote that "Mrs. Coomaraswamy's

[37] This episode is briefly described by Śrī Mukandi Lal in *Memorial Volume*, pp. 308–309.
[38] London, 1913, p. 3.
[39] *Ibid.*, foreword by Rabindranath Tagore, pp. v–vii.

singing delighted me. It was as though a moment of life had caught fire, an emotion had come to a sudden casual perfection."[40] Since Indian music needed something of an intellectual introduction before it could be heard by Western audiences, Coomaraswamy spoke briefly before Devī's performances. She performed widely in England, and indeed when they first went to America in early 1916, it was for a concert tour. Publicity photographs and concert programs from 1912–1916 show Devī's professional appearance (Figure 13): a young Englishwoman, dressed in tradi-

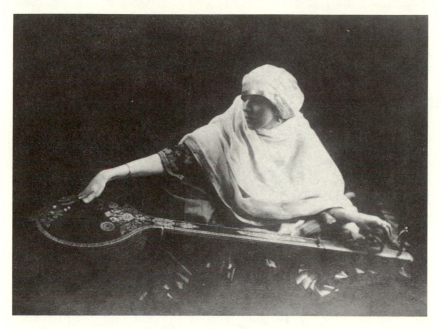

Figure 13. Ratan Devī in performance, ca. 1916.

tional Indian fashion, is seated on the ground with a shawl drawn around her head, her fingers moving across the strings of an ornate *tambura*, her face—despite strong English features—harmoniously consistent with her costume.

By August 1912, when *Thirty Songs* was ready for press, Dr. and Mrs. Coomaraswamy could dedicate the book to their first-born son, Narada.

[40] Quoted from a publicity leaflet, family collection.

VIII. *Rajput Painting*

Throughout this period in India, and also in England during periods of writing, reflection, and research in museum collections, Coomaraswamy's principal occupation was his study of Rajput painting. He was denied the pleasure of seeing his ideals for India realized to any great degree in day-to-day life, but in recompense, as if by the will of some just god, he was given the privilege of retrieving from neglect one of the most delightful phases of Indian art, the painting of northern India in the sixteenth through nineteenth centuries. The aristocratic, religious, yet sensual world of Rajput painting embodied an ideal India more than capable of satisfying his longing. It seems unbelievable now that this art, ranging in character from highly colored, expressionistic works to refined, subtly emotional ones that display attentive brushwork and a great love of the human figure, could ever have been unrecognized and unknown in the West. It has become, in the past fifty years, the phase of Indian art most accessible to private collectors, both in terms of availability and in terms of its warmly human iconography. Yet Coomaraswamy is generally acknowledged to have "discovered" this art. His writings in the period 1912–1916 and the large collection that he gathered and brought back to England opened a field of scholarly study and collecting that had previously gone unnoticed for several reasons.

In the first place, Indian art had not yet been studied carefully, and Indians themselves cared little for the old paintings they may have inherited. Second, Rajput painting had simply not been collected; its masterpieces, many of them, only became known when Coomaraswamy published examples from his collection and when he called attention to the best in British and Indian collections. Third, this art of the Hindu courts in Rajasthan and the Punjab hills had been confused with the contemporaneous art of the Mughal Empire, with which it shares some characteristics. To verify the state of knowledge of Rajput painting ca. 1910, when Coomaraswamy first began collecting, one need only look at Havell's *Indian Sculpture and Painting* of 1908, which does not even recognize the

existence of late schools of painting apart from the Mughal, and at Vincent Smith's *History of Fine Art in India and Ceylon* of 1911, where there is a chapter with the promising title "Hindu Painting, Mediaeval and Modern," as well as one on "Eighteenth-Century Painting, Chiefly Mythological," but in fact all that Smith could do at that time was acknowledge that Coomaraswamy was making some interesting discoveries and, for his own part, illustrate a few very deteriorated examples of late Hindu painting, naturalistic *genre* scenes under obvious Western influence. Coomaraswamy himself neglected Rajput painting in his 1910 publication of *Indian Drawings* for the India Society in London. Two years later he published in the same series a second volume of *Indian Drawings* to which he could then add a subtitle, *Chiefly Rajput*; he wrote in its preface that he had now had the opportunity to travel and study more and could distinguish Rajput and Mughal painting better, thanks to having handled thousands of drawings and paintings of the two schools.

Coomaraswamy's original work on Rajput painting has been corrected and amplified by a great many later scholars, but the basic view that he took has not been altered except in details and emphasis, and the importance of his collection, now for the most part in the Boston Museum of Fine Arts but also represented in other American museums,[1] has never been doubted. It is difficult to establish the sources of his collection. He traveled in the regions where this art once flourished: "the sandy plains of Rājputāna and the Panjāb, the little hills and swift rivers of the sub-Himālayan valleys, and the snowy peaks of the inner ranges."[2] In these areas, from the sixteenth century onward, were the courts of Rajput princes who first took refuge from the Mughal Empire (which grew by conquest in the second half of the sixteenth century), and later either became allies or hid more deeply in the Punjab hills. Many of these courts, where Hindu art and literature once flourished, no longer existed by the time Coomaraswamy formed his collection. He mentions making purchases from the great-grandson of a well-known early nineteenth-century painter, and in some instances bought from the collections of Indian princes such as the Maharaja of Benares. He must also have purchased many paintings from dealers and private sources, mainly families that had no use for their inherited works of art. The collection was vast by 1912–1913, kept in portfolios, systematically numbered. Denman W. Ross, the

[1] For example, The Freer Gallery, Washington, D.C., and The Metropolitan Museum of Art, New York.

[2] AKC, *Rajput Painting*, p. 73.

American art patron who arranged for the greater part of it to come to the Boston Museum of Fine Arts, recorded in his papers that it contained more than nine hundred paintings.[3] Not all were Rajput: for example, a collection of some sixty Jaina manuscript illustrations which could only have been formed during these years entered the Boston collection at the same time as the Rajput paintings.[4]

Coomaraswamy's first public comments on Rajput painting were made in 1910 at a lecture in Calcutta,[5] but his formal announcement of its existence, accompanied by illustrative examples of a quality hitherto unknown in Europe, was made in 1912 in a series of three articles published respectively in a leading British art journal, the continental *Ostasiatische Zeitschrift*, and the well-known journal, *Dawn*, in Calcutta. Four years later, in 1916, he published his comprehensive study, *Rajput Painting: Being An Account of the Hindu Paintings of Rajasthan and the Panjab Himalayas from the Sixteenth to the Nineteenth Century Described in Their Relation to Contemporary Thought.* This was by no means his last publication on Rajput painting, but its two large volumes (text and plates), if not a *summa*, were a vast prolegomenon. Its sumptuousness connotes a series of confidences that he enjoyed in England at this time: the confidence of the publishing house that engaged itself for such a luxurious production; the confidence of English connoisseurs such as Sir William Rothenstein, who were instrumental in bringing about the publication; and confidence that a public in the West had been prepared for a book of its kind.

In *Rajput Painting*, two strands can be distinguished: the purely art-historical, on the one hand, and the interpretative, on the other. Coomaraswamy could now write art history with professional sureness. There were geographical, historical, stylistic, iconographic, technical, literary, and religious patterns to be recognized and laid out for the reader, serious work in whose service he placed himself. In subject matter, *Rajput Painting* offered a marvelously complete survey of Hindu culture. The cycle of legends concerning Krishna—his *enfance*, his romances, his heroic battles—which was loved at every level of Rajput society, is one of the major themes in the paintings. Another theme, strictly aristocratic, was

[3] This information was kindly supplied by Mrs. Herbert Pratt (of the family of Denman W. Ross), who is writing his biography.

[4] Cf. AKC, *Catalogue of the Indian Collections in the Museum of Fine Arts, Boston*, Pt. 4: *Jaina Paintings and Manuscripts* (Boston, 1924).

[5] AKC, "On Mughal and Rajput Painting," in *Art and Swadeshi*, pp. 74–89.

śṛṇgāra, a picture cycle based on a typology of love that originated in Sanskrit literature and continued in Hindi writings of the period when these paintings were made. Krishna and his favorite, Rādhā, were often portrayed in the characteristic moments of this typology, and so there are, for example, beautiful scenes of them together, enjoying one another's company and the charm of a landscape (Figure 14); scenes of Rādhā preparing for a meeting (Figure 15); scenes of disappointment when Krishna was absent for no good reason. Shiva and Pārvatī, another divine couple, are portrayed in some of the most beautiful Rajput paintings of the Pahārī school, as the art of the Punjab hill kingdoms is called (Figure 16). Eight heroines, the Nāyakās, were portrayed in a series of scenes that typified woman's love; the most dramatic of these is the Abhisārikā, who goes out to seek her lover through the rain and lightning of a dark night. Coomaraswamy expressed great interest in this classification of the moments and movements of love, whose elaborateness has been only barely suggested here. Rajput painting led him to study the entire erotic culture of India. He recognized warmth and spontaneity in Indian eroticism at the same time that he was fascinated by its idea of a typology of love, which so strongly suggests that human relations are patterned. He also insisted on the remarkableness of the double meaning of the love iconography in Rajput painting: it was both sincerely sensual and sincerely religious. Like the Biblical *Song of Songs*, but even more evidently, the Krishna legends are an allegory of the soul's relation to God. The Vaishnavite devotional religion of the Rajput era saw in the patterns of human love an adequate symbol of the other love. Coomaraswamy, in his account of this theme, did not try to dissolve the freshness and charm of the Rādhā-Krishna pictures in an acid bath of religious allegory. On the contrary, he felt that his English-speaking audience needed to understand that love symbolism has first of all to do with love.

Other subjects of Rajput painting were drawn from the epics, popular ballads and romances, landscape and animal life, and to some extent the courts themselves, where portraiture flourished; but Rāgamālā paintings were more popular than all of these. Rāgamālā paintings evoke the specific atmosphere and flavor of the various musical scales, Rāgas and Rāginīs, that are the basis of Indian music.[6] Their iconography

[6] Cf. the catalogue by Pratapaditya Pal, *Rāgamālā Paintings in the Museum of Fine Arts* (Boston, 1967), which incorporates AKC's entries in his earlier *Catalogue of the Indian Collections in the Museum of Fine Arts, Boston*, Pt. 5: *Rajput Painting* (Boston, 1926).

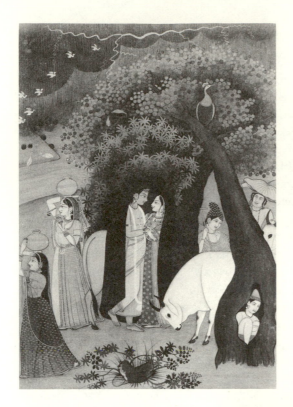

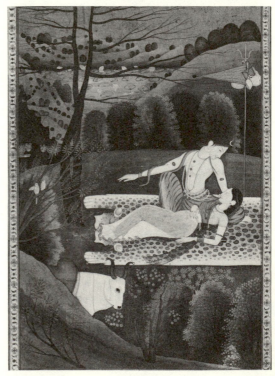

Figure 14 (above, left). *Rādhā and Krishna Sheltering from the Rain*, Kāngrā, ca. 1800.

Figure 15 (above, right). *Pūrva Rāga: Rādhā's Toilet*, Kāngrā, late 18th–early 19th century.

Figure 16 (right). *Mahādeva (Śiva) and Pārvatī*, Pahārī (Garhwāl), late 18th–early 19th century.

is diverse: musicians playing in a specific kind of landscape and weather, chivalric battles, love scenes, scenes of worship. Coomaraswamy did not attempt to include in *Rajput Painting* all of the literary sources that provided this iconography and that of the Krishna cycle, although the greater part of his book is concerned with the iconographic background. During the years he was working on *Rajput Painting* and from time to time until 1927, when his second major work on this subject appeared,[7] he published translations of the most important literature that came to pictorial expression in Rajput painting.[8] The art historian's métier, as he practiced it, extended beyond presenting visual art in a comprehensive way. Literature enjoyed equal credit with him; it was not a foreign matter to be used like a "trot" to understand otherwise incomprehensible iconography, but rather a highly honored, related artifact to be used and enjoyed concurrently with visual art.

The art-historical structure that Coomaraswamy developed in *Rajput Painting* had as one of its features a very sharp distinction between Rajput and Mughal painting. He described Mughal art as worldly, topical, occupied with the life and times of the court and with natural appearances. Its most typical works were portraits. It was essentially a secular art, and only in its greatest works did it rise to a kind of compassion that can hardly be called secular (Figure 17). Historically speaking, it was only an interlude in the development of Indian art, an admittedly brilliant departure from the norm that lasted little more than a century, from the reign of Akbar (1556–1605) through the reign of Shāh Jahān (1628–1657). Rajput painting, on the contrary, represented a continuation of the most ancient traditions of Indian painting. On stylistic and technical grounds, Coomaraswamy related this late Hindu art to the seventh- and eighth-century art of the frescoes at Ajaṇṭā. Rajput painting, essentially religious, was only responding to Mughal influence when it concerned itself on occasion with contemporary persons and events. Rajput art was also in part a folk art: its iconography and style were not strictly aristocratic but drew partially on folk traditions and, like most folk art, was for the most part anonymous. Coomaraswamy also believed that Rajput paintings circulated outside of the courts to which the most refined artists were attached. Like the icons that one finds in many Orthodox Christian homes, this art was shared by people at every social level. Un-

[7] Viz., Part 5 of the Boston catalogue, just cited.

[8] Biblio. Nos. 132, 133, 138, 143, 187, 191, 208, 216, 249, 261, 272, 284, 302, in the *Working Bibliography*.

like Mughal painting, it was little concerned with the precise imitation
of natural appearances, either of persons or of landscapes, plants, and ani-
mals; all of these elements appear in Rajput art, but transformed by the
mind's eye into a harmonious imagined world that does not compete
with nature.

This very sharp distinction between an individualistic, secular art of
natural appearances and an anonymous, religious art that revises external
appearances according to inner vision served to extricate Rajput from

Figure 17. *The Death of Ināyat Khān*, Mughal,
School of Jahangir, A.D. 1618.

the domain of Mughal art, but it has been carefully criticized by later
historians and found to be overstated. Documents of every kind have
been brought to light since Coomaraswamy's original work, which have
changed the scale of the map: what was once a generalized, distant view
of two contiguous states has been broken up and enlarged into detailed
regional maps on which the movements of individual artists and patrons
can be traced. Mughal art is now understood to have been the all-im-
portant catalyst that transformed the tradition-bound schools of Hindu
painting that existed just prior to the period of Akbar, and stylistic ele-

ments, iconographies, and artists circulated between the courts of the
Rajput princes and the Mughal centers, principally Delhi.[9] The idea that
Rajput painting is connected by an unbroken thread of tradition with
the paintings of Ajaṇtā has not survived the scrutiny of later scholarship.
Coomaraswamy's characterization of Mughal art as wholly secular and
rather empty-headed was overturned by one of his best friends in the
pages of the Coomaraswamy Festschrift. Eric Schroeder's article evoked
not only the Mughals' religious spirit, but also some specifically religious
iconographies that were common enough in Mughal art, such as the
meeting between the Emperor and an ascetic Saint.[10] The two schools
were indeed separate; the foundation for further study was laid by
Coomaraswamy through the act of separating them and forming a magnifi-
cent collection of the lesser known art, but there was more than a little of
the taste of warfare to his categorical decision in favor of the anonymous
religious, Hindu art as opposed to the art of a Muslim Empire whose
power and relative worldliness surely reminded him of quite another
empire, the British Raj. Later scholars have also been able to document
the extent to which Rajput painting was truly an aristocratic art, little if
at all known to common people. Khandalavala, in a recent book, remarked
that common people might well have understood these paintings had they
had the chance to see them because the Krishna legends were known and
beloved by all, but there is no evidence that Rajput painting was an "art
of the people."[11]

Working as a pioneer in this field, Coomaraswamy to some degree
shaped his description of Rajput painting according to his own ideals, but
his accomplishment in establishing a field of study, laying out its main
lines, and gathering many of its masterpieces, far outweighs his errors.
In later years, it is worth mentioning, Coomaraswamy had occasion to
do very extensive work on Mughal painting considered quite separately
from Rajput: he produced, aside from a number of short articles, a formal
catalogue of the Mughal collection in the Boston Museum, with an intro-
ductory text, as well as a very luxuriously printed catalogue of the Go-

[9] Cf. William G. Archer, *Indian Painting in Bundi and Kotah, Victoria and
Albert Museum Monograph No. 13* (London, 1959), as an example of recent Rajput
studies on a regional scale.

[10] Eric Schroeder, "The Troubled Image: An Essay upon Mughal Painting," in
Art and Thought, pp. 73–86.

[11] Karl Khandalavala, *Pahāri Miniature Painting* (Bombay, 1958), pp. 18–20:
"Coomaraswamy's Dicta Analyzed."

loubew collection of Muslim painting, also in the Boston Museum, which
contained numerous Mughal works.[12]

Lodged within the scholarly structure of *Rajput Painting*, there are
elements of a more personal nature, which reflect the significance that
Rajput painting had for Coomaraswamy himself. These have to do with
two general themes, India and eroticism. With respect to the first, we
have already noted that a certain ideal of India is represented in Rajput
painting. For example, after describing one of the best Rājasthānī works
(Figure 18), which passed from his collection into the Metropolitan Mu-
seum in New York, he remarked:

These drawings answer for us a whole series of questions as to what
manner of men so spoke and what manner of life they sought to

Figure 18. *Rāsa Līlā: Head of Śrī Krishna*,
Rājasthānī (Jaipur), 18th century.

[12] AKC, *Catalogue of the Indian Collections in the Museum of Fine Arts, Boston*,
Pt. 6: *Mughal Painting* (Boston, 1930); *idem, Les Miniatures orientales de la col-
lection Goloubew au Museum of Fine Arts de Boston, Ars Asiatica*, No. 13 (Paris,
1929).

praise. From these heads, so serene, so confidently poised, from these sensitive expressive hands, these white and gold coloured muslins we can reconstruct, as it were from the buried fragments of an ancient textile, the whole pattern of the Rājput civilization—simple, aristocratic, generous, and self-sufficient. No other evidence than this is needed to establish the magnificence of that old Hindū world that is vanishing before our eyes at the present day in a tornado of education and reform.[13]

Again in the pages of his own Festschrift, an old and close friend of Coomaraswamy's, the art historian Hermann Goetz, pointed out that it is a mistake to treat the historical background of Rajput painting "as an idyllic timeless world immune from the influences of an age full of wars, revolutions and cultural cross-currents."[14] Coomaraswamy in 1916 would doubtless have agreed intellectually, but in his heart he would have continued to draw only the finest line between the world of Rajput painting and the world from which it came.

With regard to the eroticism of Rajput painting, Coomaraswamy's views seem to have remained unassailed by later scholarship. He was among the early writers who did not shy away from the subject of eroticism in art, and his collection included a good number of explicitly erotic subjects which, in obedience to the taste of his times, he never published: he merely hung them in the more intimate rooms of his home. Recent publications have shown that the very best Rajput artists produced works of this kind. Something in the Anglo-Saxon temperament may still shudder to see openly sexual encounters painted with exquisite artistry, but Coomaraswamy, who described himself as "not a Victorian" in a passage quoted at the beginning of this book, found himself deeply impressed. At the beginning of his chapter on *śṛṇgāra*, he wrote:

> To love is to desire. . . . Rarely has any other art combined so little fear with so much tenderness, so much delight with such complete renunciation. If the Chinese have taught us best how to understand the life of Nature manifest in water and in mountains, Indian art at least can teach us how not to misunderstand desire, for we are constantly reminded here, that the soul of sweet delight can never be defiled. . . . The more one follows this impassioned art, the more is

[13] AKC, *Rajput Painting*, p. 15.
[14] Hermann Goetz, "Rajput Art: Its Problems," in *Art and Thought*, pp. 87 ff.; this citation, p. 88.

it clear that its complete avoidance of sentimentality, the certainty of its universal appeal, are founded in its constant reference to the physical fact. The abstract and the spiritual are constantly proved by reference to the concrete and material, as is only possible where it is believed that all is intertwined, and, . . . in the words of Kabīr, that "All the men and women of the world are His living forms."[15]

"The soul of sweet delight can never be defiled"—it is a line from William Blake, whose work struck Coomaraswamy as the English counterpart of Rajput painting. Not only Rajput painting, but also Blake's rebelliously unpuritanical attitudes toward sexual love seem to have given Coomaraswamy a kind of benediction as he sought an unconstrained but intelligent attitude towards love. The gold earring that he sported during the years that we have just been describing must be a sign that he had declared his independence from a conservative style of life that, as often as not, "misunderstood desire."

Rajput Painting was well received, although the war kept it from being read and reviewed on the continent until a few years after 1916. Laurence Binyon, in the year of publication, wrote that lovers of art "owe a real debt to Dr. Coomaraswamy. Through his studies and researches our knowledge of Indian art, and especially of Indian painting, has been greatly enlarged." The publication of this book marked a turning point in Coomaraswamy's life. The prestige of his collection and of his book attracted the interest of one of the Boston Museum's leading patrons and, through his good offices, Coomaraswamy found himself able to leave behind a life in England and India that by 1916 promised more disappointments than opportunities.

[15] AKC, *Rajput Painting*, p. 42.

104

IX. England, 1912–1916:

Blakean Protest

If the advocates of compulsory education were sincere, and
by education meant education, they would be well aware that
the first result of any real universal education would be to
rear a race who would refuse point-blank the greater part
of the activities offered by present day civilised existence. I
lay it at the door of science—not indeed as the prime cause,
but as the immediate instrument—that life under Modern
Western culture is not worth living, except for those who
are strong enough and well enough equipped to maintain a
perpetual guerilla warfare against all the purposes and idols
of that civilisation with a view to its utter transformation.[1]

Coomaraswamy, 1915

Coomaraswamy had returned to England by summer 1912, and it seems
unlikely that he was again in India until 1915—for a visit that has left
little impression on the historical record. In England he continued his
art-historical writing energetically, but that aspect of his activity calls
less for commentary than does his participation in the intensely alive,
transitional culture of the day, in which new attitudes toward art and
new kinds of art were only a part of a greater whole. In 1913, his *Arts and
Crafts of India and Ceylon* appeared, a short manual similar in scope
to Vincent Smith's much longer book of 1911, but not of a nature to
compete with it (his "competitive" book would not appear until 1927,
the very complete *History of Indian and Indonesian Art*). *Myths of the
Hindus and Buddhists* came out in the same year; *Viśvakarma*, the seri-
ally published selection of photographs of Indian art, was appearing at
intervals in 1912–1914.[2] Five articles appeared in *The Burlington Maga-
zine* in the years between 1913 and 1916, dealing with the fundamental

[1] AKC, "Love and Art" (1915), p. 577.
[2] AKC, *Viśvakarma: Examples of Indian Architecture, Sculpture, Painting, Handi-
craft, First Series: One Hundred Examples of Indian Sculpture* (London, 1912–
1914).

105

repertoire of Hindu and Buddhist art (e.g., "The Gods of Mahāyāna Buddhism") and with aesthetics.[3] In 1914, he published a monograph on Ceylonese bronzes under the auspices of the Colombo Museum and an article on Jaina art, which is among the earliest studies in a field that has grown in importance.[4] 1916 brought two major works: *Rajput Painting*, and *Buddha and the Gospel of Buddhism*, a work with only a brief chapter on art.[5] Buddhist studies in the West were then in an early stage; one of the most influential English exponents of Buddhism in the first half of this century, Christmas Humphreys, has written that Coomaraswamy's book gave him his first acquaintance with Buddhism.[6]

These were the major writings of the period. Lodged in their interstices were a number of shorter pieces that directly expressed Coomaraswamy's unrest, his search in common with a whole milieu in prewar and wartime London to find a new philosophy of life, a new politics, new directions in art and literature. In fact, Coomaraswamy's search was already structured in a certain sense by what he knew of Hinduism and Buddhism. *Buddha and the Gospel of Buddhism* represents a painstaking assimilation of Buddhist thought, and while he felt the need to improvise intellectually, as we shall see almost immediately, at another level he had already accepted the kinds of truth proper to Buddhism as his own truth. He was radical at this time in both senses of the word: immensely aggressive toward the social and political *status quo*, but also interested in root philosophies that begin with an analysis of the human condition in every respect. He did not propose any orthodoxy—Buddhist, Hindu, or other—as a solution; on the contrary, he tried to synthesize from a variety of European sources an original solution. William Blake, Nietzsche, and the contemporary theory of Guild Socialism were the major European elements that moved in his thought against a background of traditional Buddhism and Vedānta. His writings in this brief period in England can be divided into two groups: those that were calm, and those that were restless. The historical writings—*The Arts and Crafts of India and Ceylon, Rajput Painting, Buddha and the Gospel of Buddhism*, and so on— based on research and an exchange with the past—are calm and lucid, while the writings directed toward contemporary problems are restless, unrealistically demanding, impulsive. The division can be made in an-

[3] Biblio. Nos. 152, 165, 175, 183, 190 in the *Working Bibliography*.
[4] AKC, "Notes on Jaina Art" (1914).
[5] London and New York, 1916.
[6] Christmas Humphreys in *Memorial Volume*, p. 81.

other way: there is an Eastern Coomaraswamy, occupied with traditional art, philosophy, and social order, and a Western Coomaraswamy, deeply sympathetic to the most rebellious Western thinkers and seeking to impose his own orientalized version of their thought.

Coomaraswamy saw William Blake as a great spiritual teacher and artist, and he was permanently marked by him. His Nietzscheanism disappeared, as it did in many early enthusiasts, for internal reasons or out of reaction to the Great War, but Blake took an unshakable place among the Western thinkers that Coomaraswamy trusted, and as late as 1944 he cited Blake with loving admiration in the context of a discussion of religious art.[7] Blake's reputation was established by 1890. Coomaraswamy would have known Blake through the 1905 edition of his *Poetical Works*, the first good modern edition, and through the interpretative study by William Butler Yeats and Edwin John Ellis, *The Works of William Blake, Poetic, Symbolic, and Critical*, published in 1893, influential for years afterward. Coomaraswamy was personally acquainted with Yeats, and although a leading Blake scholar of our time has described the Yeats-Ellis volume as composed of "some gorgeous nonsense and much more plain nonsense,"[8] Coomaraswamy and most of his generation did not seem to mind. Coomaraswamy himself made nonsense out of Blake in some respects, but when the mental warfare of these years in Coomaraswamy's life had subsided, Blake was still with him. He was quoting Blake by 1910 because Blake's "theories of imagination and art so closely approach Oriental aesthetic," as he wrote in *Indian Drawings, Part I*. Indian art was visionary; so too Blake's art of illustrated books. Coomaraswamy in 1910 described a bronze of Dharmapāla, a dread Buddhist god, as "informed with . . . imagination raised, as Blake would have had it, to the power of vision."[9] Blake was a natural ally in the effort to make the Indian imagination acceptable. The iconography of his poems and paintings was similar in spirit to that of India, and his aesthetic criteria, present not only visibly in his works but also in his art criticism, applied without alteration to Indian art. Blake's energy, as much as his ideas, impressed Coomaraswamy; this argumentative, roughneck genius stands behind Coomaraswamy as a consciously followed model, but also, without calculation, as a man of similar temperament and destiny. Blake wrote, for example, that

[7] AKC, "Chinese Painting at Boston" (1944).
[8] Harold Bloom, *Yeats* (Oxford, 1970), p. 69.
[9] AKC, "Indian Bronzes" (1910), p. 87–88.

The great and golden rule of art, as well as of life, is this: That the more distinct, sharp, and wiry the bounding line, the more perfect the work of art, and the less keen and sharp, the greater is the evidence of weak imitation, plagiarism, and bungling. Great inventors, in all ages, knew this. . . . The want of this determinate and bounding form evidences the want of idea in the artist's mind. . . . Leave out this line, and you leave out life itself; all is chaos again, and the line of the almighty must be drawn out upon it before man or beast can exist.[10]

The idea nourished Coomaraswamy, but no more than the brilliant, intolerant, winning tone, which is close to the tone of Coomaraswamy's essays in the 1930s.

Blake, "most Indian of modern Western minds," as we have heard in *Rajput Painting*, earned Coomaraswamy's admiration for his insistence on the primacy of Imagination, his attack on materialism, his call to fellow men to be free and creative. It is the Blake of *The Marriage of Heaven and Hell* that Coomaraswamy loved best. Some present-day Blake scholars would be likely to quarrel with Coomaraswamy, but he saw in Blake's work "the essentials of religion, already written in hieroglyphics and Vedas, already taught by Christ and Orpheus and Krishna, Lao-tse and Eckhart and Rumi."[11] These lines from Coomaraswamy's most Blakean article follow a list of pronouncements transcribed from *The Marriage of Heaven and Hell* which Coomaraswamy called the "chief dogmas" of a new religion. Blake seemed to him the prophet of a new Western religion, hardly recognized as yet in 1914, but already witnessed by Blake, Nietzsche, and the poet Walt Whitman. Attempting to give a name to the new religion, he could only come up with a description, "idealistic individualism," but what he meant is clear: a philosophy that would free the individual from the old fetters of Christian morality, yet call upon him to know himself and the world in such depth that a new sense of the links between men, hence a morality, would emerge—but only as part of a quite new culture. Coomaraswamy's Blake at this time is Dionysian, a breaking free of the forces of the Prolific, a combat with the Devourers through which more and more people come to realize the presence of the Poetic Genius in themselves and others. Some of Blake's words that Coomaraswamy proposed as new scripture were:

[10] William Blake, "A Descriptive Catalogue," No. XV, consulted in Alfred Kazin, ed., *The Portable Blake* (New York, 1946), where this passage appears on p. 530.
[11] AKC, "The Religious Foundation of Life and Art" (1914), p. 33.

The worship of God is honouring his gifts in other men each according to his genius, and loving the greatest men best. Those who envy or calumniate great men hate God, for there is no other God.

Man has no Body distinct from his Soul, for that called Body is a portion of Soul discerned by the five Senses, the chief inlets of Soul in this age.

Everything that lives is holy.

If the doors of perception were cleansed, everything would appear to man as it is, infinite.[12]

The meaning of these words and others from *The Marriage* was summarized by Coomaraswamy as follows: "The religion of the future will announce as the objects, duties and meaning of life, liberty both of body and mind to exercise the divine arts of imagination—the practice of crafts and sciences, the satisfaction of desires, behaviour as a good citizen, and progress in infinite perception—each equally honourable and holy, where each is not made a sole end in itself."[13] The Guardians of this new way of life would be difficult to find. They would form a "Nietzschean aristocracy," as Coomaraswamy said, but they would have to emerge naturally, not by force. He suggested that artists—"poets, painters, sculptors, architects, musicians, and dancers," had already sensed the future direction: they alone could lead the way.

Artists are the priests of every new church; for it is essentially their consciousness that perceives intuitively the unity of all life, which forms the sole test and sanction of all new moralities, the one and only path from selfishness to brotherhood. . . . Man must also obey the deep and often scarcely expressed will, the furthest will, of his group. That is his obedience to Superman, to a soul-over-individual-man (for how can superman be *a* man?); and the aristocrats, the best, the artists are those who are most sensitive to this furthest will.[14]

The movement from a deep appreciation of Nietzsche and Blake to a Nietzschean-Blakean world-order imagined for a time not far hence was certainly desperate and wish-fulfilling. If one believes at all in synchronicity, one can hardly blame Coomaraswamy for Utopian dreaming

[12] Blake, *The Marriage of Heaven and Hell,* in *The Portable Blake,* pp. 249 ff. These sayings from Blake are drawn from several different sections of this work.
[13] AKC, "The Religious Foundation," p. 35.
[14] *Ibid.,* p. 41.

in an article written in the months just preceding August 1914, and pub-lished in the second month of war; but a better explanation is possible. His search for a new scripture was not his alone. The English Nietzsche-ans, for example, taking their cue from the scriptural style of *Thus Spake Zarathustra*, had done the same for Nietzsche as Coomaraswamy for Blake. A. R. Orage published two books in 1907-1908 on Nietzsche, one of which included a section of Nietzsche's aphorisms under the heading "New Commandments."[15]

Coomaraswamy's milieu in England at this time extended beyond the Arts and Crafts circle to include a wide London circle of people interested in politics, literature, and the arts. The focus of this mixed group was provided by a weekly periodical, *The New Age*, edited between 1907 and 1922 by Alfred R. Orage, an attractive man of faultless literary taste, the friend of Bernard Shaw and nearly everyone else of importance in London, the friend and teacher, as required, of a whole generation of young writers from Katherine Mansfield and Ezra Pound to Herbert Read.[16] Orage had arrived in London from Leeds in 1906 with Holbrook Jackson and Arthur J. Penty. On a stake borrowed in part from Shaw, they bought a failing periodical, *The New Age*, and by 1911 it had become a leading socialist commentator, appreciated for its literary and journalistic quality outside socialist circles. Although there is no evidence that Coomaraswamy was especially close to Orage in 1912-1916, he contributed four articles to *The New Age* and a number of letters to the editor.[17] On his side, Orage took an interest in Coomaraswamy's 1915 piece on "The Hindu View of Art," which he described in the weekly as follows: "In such treatises it is usual to find more sound than sense, more learning than wisdom, more chaff than wheat; but in Dr. Coomaraswamy's hands the subject becomes substantial and intelligible."[18] Orage paid a visit to Coomaraswamy in Boston in 1924, and that was probably the last they saw of each other: a letter of Orage's describing the visit records that he found Coomaraswamy cut off from new currents of thought by his single-

[15] A. R. Orage, *Nietzsche in Outline and Aphorism* (London, 1907).

[16] Cf. Wallace Martin, *The New Age under Orage: Chapters in English Cultural History* (Manchester and New York, 1967); Philip Mairet, *A. R. Orage: A Memoir* (London, 1936), but better the second edition, with a new introduction and final chapter by the author (New York, 1966; and Paul Selver, *Orage and the New Age Circle*, London, 1959).

[17] The articles are Biblio. Nos. 160, 161, 179, in the *Working Bibliography*.

[18] A. R. Orage, *The Art of Reading* (New York, 1930), p. 102 (collected writings from *The New Age*).

minded attention to the history of art: "Coomaraswamy . . . was fast asleep in his work; and had no attention for other worlds than the long dead."[19] Yet Coomaraswamy was linked to Orage and *The New Age* circle, above all through his friendship with A. J. Penty, who was closer than Orage to Coomaraswamy in his concern for the survival of craftsmanship and his hatred of industrialism.

Penty, a practicing architect and social philosopher, had begun to formulate by 1906 a scheme that acquired the name Guild Socialism by 1912, when he and Orage began expounding it in *The New Age*. His earliest book, *The Restoration of the Guild System* (London, 1906), was followed by a number of others: *Old Worlds for New: A Study of the Post-Industrialist State* (London, 1917); *Post-Industrialism* (London, 1922); and a collection of essays by various authors that he coedited with Coomaraswamy in 1914, which bore the distinctly Blakean title, *Essays in Post-Industrialism: A Symposium of Prophecy Concerning the Future of Society* (London, 1914). Penty and Coomaraswamy exercised a mutual influence on each other; the very term Post-Industrialism was coined by Coomaraswamy. A passage in Penty's book of 1922 where he mentioned this serves as an adequate introduction to his thought:

> From one point of view, Post-Industrialism connotes Medievalism, from another it could be defined as "inverted Marxism." But in any case it means the state of society that will follow the break-up of Industrialism, and might therefore be used to cover the speculations of all who recognize Industrialism is doomed. The need of some such term sufficiently inclusive to cover the ideas of those who, while sympathizing with the ideals of Socialists, yet differed with them in their attitude towards Industrialism, has long been felt, and the term Post-Industrialism, which I owe to Dr. A. K. Coomaraswamy, seems to me well-suited to supply this want.[20]

Penty also owed to Coomaraswamy a knowledge of Indian forms of the guild system, which Coomaraswamy had outlined in *The Indian Craftsman*, the 1908 publication. Penty's program, Guild Socialism, has been well described by Wallace Martin in a study of *The New Age Under Orage*;[21] Martin correctly points out that the political theory of Guild Socialism, involving a conversion of trade unions into self-regulating guilds

[19] Library of Professor William S. Wilson III, New York.
[20] A. J. Penty, *Post-Industrialism* (New York and London, 1922), p. 14.
[21] Particularly ch. xi, "Guild Socialism," pp. 193 ff.

111

operating under state charter, is "less important . . . than the ethic that it embodied and the philosophy of man that could be derived from it. . . . It can be seen as an attempt to redeem labour from the emptiness that capitalism had inflicted upon it. Workers were to be given more responsibilities in the management of industry; at the same time, they would be given more freedom in determining the conditions of their labour. . . . It was implicitly religious."[22] It differed from Marxism and Fabian Socialism most sharply in its attitude toward the machine. Penty outlined this cardinal point of difference as follows, writing a few years after the end of war, but in a vein that had not changed since the prewar years; the war had confirmed his ideas:

> Though Marx did not foresee the year, he did see that a fundamental antagonism existed between mechanical production and established traditions of social order and culture. He saw that the . . . unrestricted use of machinery would end in their destruction, but he prophesied that as a result of the changed social conditions new social and cultural standards would arise as a consequence of the reflex action of machine production. This prediction I submit has been entirely falsified by experience. There is no evidence whatsoever that machinery by any reflex action is in the way of creating any new traditions to replace the ones it has destroyed. On the contrary, all that follows in the wake of the machine is chaos and confusion.[23]

In the industrial conditions that Penty and Coomaraswamy longed for, the workers themselves would decide the extent to which machinery was useful and necessary for a given task. Quality production would replace quantity production, and the working man, whom Marx called "as much the invention of modern times as machinery itself,"[24] would recover his birthright of an intelligent occupation.

It is in this context of protest against mechanical industry that Coomaraswamy's Utopian dream makes sense. The Devourers, in his vision of things, were the Industrialists whose "Satanic mills," as he liked to quote from Blake, created a proletariat that took no pleasure in its work and learned nothing from it. Not only were they deadened by their work, the products themselves had no quality: hence individuals and the en-

[22] *Ibid.*, pp. 209-211. [23] Penty, *Post-Industrialism*, p. 39.
[24] Cited by Francis D. Klingender, *Art and the Industrial Revolution* (London, 1947); revised by Arthur Elton for the second edition (London, 1968), where this quotation appears on p. 167.

vironment degenerated, while Industrialists made enough money to be able to live apart from the poor environment and take vacations at an even greater distance from it.

The fanatical, all-encompassing opposition of Penty and Coomaraswamy to industrialism seems willfully blind to an inalterable fact: the irreversibility of the industrial revolution. Anti-industrialism was a typically nineteenth-century attitude, the position of artists and humanitarians from Robert Owen and Ruskin to Morris and the Arts and Crafts circle, who were all responding to the still recent industrialization that "seemed as transient, as capable of defeat, as it was morally and socially monstrous."[25] But in 1914 the attitude was absurdly anachronistic and led Penty, for example, to write as his contribution to the Coomaraswamy-Penty volume an essay on the impossibility of a significant architecture emerging through the use of new industrial materials. We have only to think of Frank Lloyd Wright's Chicago lecture of 1901 on "The Art and Craft of the Machine" to realize that Penty had missed the signs, incomparably more abundant in 1914, that a new architecture was on the horizon. Reyner Banham, the historian of the "First Machine Age" in which Coomaraswamy and Penty were living, has written that by this time

that barrier of incomprehension that had stood between thinking men and their mechanised environment all through the nineteenth century, in the mind of Marx as much as in the mind of Morris, began to crumble. Men whose means of moving ideas from place to place had been revolutionised at their writing desks by the typewriter and the telephone, could no longer treat the world of technology with hostility or indifference, and if there is a test that divides the men from the boys in say, 1912, it is their attitude to Ruskin. Men whose view of the aims of art and the function of design were as diverse as could be, nevertheless united in their hatred of *ce déplorable Ruskin*.[26]

And *ce déplorable Coomaraswamy?* His "Post-Industrial" attitudes in 1914 and their recurrence in even his latest work could be mercilessly

[25] Anonymous review of J.F.C. Harrison, *Robert Owen and the Owenites in Britain and America* (London, 1969), appearing in the *Times Literary Supplement* (2 April 1970), p. 361.

[26] Reyner Banham, *Theory and Design in the First Machine Age* (London, 1960), pp. 11–12.

belittled if there were not two sets of circumstances, one Eastern, the other Western, to modify the evaluation that must be made. In the first place, anti-industrialism was nothing more or less than the express policy of Gandhi throughout his years of leadership in India;[27] Coomaraswamy's views with respect to India, at least, were part of current controversy and not at all anachronistic. Even in 1937, Coomaraswamy would still write: "It makes but little difference whether one dies in the trenches suddenly or in a factory day by day."[28]

In the West, there were also circumstances that should soften our view of Coomaraswamy's Post-Industrialism. His early admiration for Morris and his experience of the craft traditions of Ceylon gave Coomaraswamy an awareness of the craftsman and of his counterpart in industrial societies, the blue-collar worker, which has been largely missing in the Western upper classes—the classes that produce many writers, art historians, and so on. Very recently this lack has become more apparent. Murray Kempton, a representative American political commentator, has written, with some remorse, that he had been able for years to specialize in Labor "and yet enter a factory on only three occasions, two of them as a tourist with Nikita Krushchev." Coomaraswamy never lost his early outrage at the human conditions of factory work. His conviction that "industry without art is brutality," a phrase borrowed in his youth from Ruskin and never forgotten, is indeed repeated many times in his later writings, but it is the repetition of an unheard prophet, not of a man with nothing new to say.

Coomaraswamy's critique of industrialism was unfashionable during his lifetime, but something similar has now appeared with such intensity and urgency that to call it a fashion would be too superficial. The ecology movement of our decade has made a more damaging case against industrialism than Coomaraswamy ever made, and its language is often identical with Coomaraswamy's and Penty's in the years before and after World War I. Even the solution that Coomaraswamy, like Gandhi, envisaged—a return to "villagism" (at least in India)—has been adopted by many young Americans through communes, while the rest of America

[27] Cf. Lloyd I. Rudolph and Susanne Hoeber Rudolph, *The Modernity of Tradition* (Chicago 1967), p. 217; also S. Durai Raja Singam, "Gandhiji and Ananda Coomaraswamy," in *Ananda Coomaraswamy: Remembering and Remembering Again and Again*, ed. S. Durai Raja Singam (Kuala Lumpur, 1974), pp. 307–319.

[28] AKC, "What is the Use of Art, Anyway?" (1937), read in the more accessible *Christian and Oriental Philosophy of Art*, p. 101.

watches their experiment in Post-Industrial living with something more than casual interest. Writers such as Lewis Mumford and Buckminster Fuller, who have been pursuing for years the question of the cultural significance of technology, are receiving attention. Coomaraswamy's early anti-industrial writings are not relevant to the current ecological debate because they rely too heavily on a romantic solution: the dissolution of industrial society, the appearance of something wholly different, a dream half-Blake, half-Morris. But his later writings on the industrial problem, those of the 1930s and 1940s, stay close to the conviction that the West is in a grave crisis, without making up any easy answers: they have the value of well-put questions, which is not small. Coomaraswamy's anti-industrialism was a liability to him as an art historian, in the sense that it put him out on a limb, made him vulnerable to attack, but it was a sign of compassion in him as a man. Even during his late years, when his principal interest was metaphysics, he collected books and articles on industrial problems and salted his writings with what he learned from them.

As a footnote to this discussion, it is interesting to recognize that it was not only the opponents of industrialism in this period who were looking back to the mediaeval period, with its guilds and traditional handcrafts, for inspiration. In the Bauhaus, the very nucleus from which the modern style in architecture and design would be generated, there was at the outset a strong mediaevalist tendency. Walter Gropius, founder and first director of the Bauhaus, sought a new, creative relation between art and industry. His words to the Weimar ministry in 1916, when he was preparing the ground for the opening of the Bauhaus in that city, might have been written by Coomaraswamy—up to the point where Gropius expressed his conviction that the machine could be pressed into the artist's service:

Whereas in the old days the entire body of man's products was manufactured exclusively by hand, today only a rapidly disappearing small portion of the world's goods is produced without the aid of machines. The natural desire to increase the efficiency of labor by introducing mechanical devices is growing continuously. The threatening danger of superficiality, which is growing as a consequence of this, can be opposed by the artist, who holds the responsibility for the formation and further development of form in the world only by sensibly coming to terms with the most powerful means of modern formal design, the machine of all types, from the simplest to the most

complicated, and by pressing it into his service, instead of avoiding it as a result of his failure to recognize the natural course of events.

Gropius's last remark seems to be his evaluation of the anti-industrialist movement. It is remarkable to see him arranging some of the same facts as Coomaraswamy and Penty, but recognizing a very different direction for the future. He went on to say that the collaboration between artist and industry in the future would not be a luxury but a necessity. The relation could be established only through much good will on both sides. A school of art teaching organic design

> could bring real support to the trades and industry and would be able ... to stimulate the industrial arts.... Among its participants a similarly happy partnership might re-emerge as that practiced in the mediaeval "lodges," where numerous related artist-craftsmen—architects, sculptors, and craftsmen of all grades—came together in a homogeneous spirit and humbly contributed their independent work to the common task resting upon them.[29]

In the early years of instruction at the Bauhaus, a guild atmosphere was encouraged by dropping the titles "professor" and "student": artists on the staff were known as Masters of Form, directors of the various shops were Masters of Craft, while students were graded as apprentices or journeymen. By 1923, the mediaevalism of the Bauhaus had fallen away; but the school was born in those wrappings. Reading the early words of Gropius with Coomaraswamy in mind, one cannot help but feel that Gropius found a way through the maze, while Coomaraswamy stayed behind. The quasi-religious inspiration of the early Bauhaus, even its Orientalism through the influence of Johannes Itten, would surely have attracted Coomaraswamy had he been aware of it; but the Bauhaus was little known until 1923, and by that time Coomaraswamy was in America engaged in art-historical work, distant from the Arts and Crafts movement and its brilliant successor at Weimar. At his distance, Coomaraswamy could know that he liked very much "anything made in the vitally contemporary style," but he probably did not realize that the genesis of that style had a *rasa*—an essential taste or flavor—nearly identical to his own.

[29] Quoted by Hans M. Wingler, *The Bauhaus* (Cambridge, Mass., 1969), p. 23.

X. England and India, 1915–1917

There are a few loose ends to gather up and fit into the fabric of the years in England. Perhaps the most important is Coomaraswamy's friendship with the artist, Eric Gill, whom he met in the circle of William Rothenstein in around 1910. Gill (1882–1940) has attracted attention in recent years, not because he was a good sculptor—he was only fair; not because he was a good writer—his argumentative books are already period pieces; not even because he was a genuinely great designer of typefaces and carved inscriptions; but because he was beautifully, quintessentially English. In the two biographies of him that appeared in the 1960s,[1] England can take stock of an entire side of her character, an independent, eccentric, opinionated side that masks a great deal of sensitivity. Gill was the English workingman, a Shakespearean mechanical come to life and eloquence in order to damn capitalism, industrialism, war, and everything else that makes it impossible to practice a craft peacefully. He was anti-industrial from first to last, but even Sir Herbert Read, the defender of industrial design, felt obliged to call him "an enlightened critic of the industrial system," in the same breath as he called Penty an "extreme reactionary."[2] The difference was not that great, but Gill was likable.

In an introduction written by Coomaraswamy in 1944 for a collection of Gill's essays, we find not only a capsule summary of their relation, but Coomaraswamy's view in old age of that whole period of his life in England. "I knew Eric Gill in England as a lovable person and as an artist, and after 1917 never saw him again. We were both of us beginning to grow up then; and since then we have corresponded regularly and were in very close agreement about fundamentals; and so it would not be untrue to say that we went to school together and grew up together,

[1] Robert Speaight, *The Life of Eric Gill* (London, 1966); Donald Attwater, *A Cell of Good Living: The Life, Works and Opinions of Eric Gill* (London, 1969).
[2] Herbert Read, *Art and Industry* (London, 1934; 3rd ed., revised, 1953). Consulted in the paperback edition (New York, 1961), where these comments appear on p. 35.

although apart."[3] Aside from an appreciation of Gill so simple and direct that he managed to communicate it concretely in just a few words, we can hear in this passage an idea that was self-evident for Coomaraswamy: something approaching real maturity comes late, and that is the normal sequence. Coomaraswamy was forty years of age in 1917.

Gill, in his autobiography,[4] gave an account of his meeting with Coomaraswamy that has its place here. His praise of Coomaraswamy is often quoted nowadays, by those who love Coomaraswamy's work, as a most fitting inscription (Gill was a stone carver, and his literary style was sometimes inscriptional). Nonetheless, Coomaraswamy's friends ought to know better than to cite any portrait too frequently. Coomaraswamy said many times in his later works that in his opinion "name" and "form" (*nāma-rūpa*) imprison an indefinable life that can only be known when one is willing to "shatter the image."

I was generally at variance with my high-art friends. . . . They were essentially aesthetes; that was the awful truth. They played about with religion and philosophy and labour politics, but that was all very superficial; what they really believed in and worked for was aesthetic emotion as understood by the art critics. . . . But there was one person, to whom I think William Rothenstein introduced me, whom I might not have met otherwise and to whose influence I am deeply grateful; I mean the philosopher and theologian, Ananda Coomaraswamy. Others have written the truth about life and religion and man's work. Others have written good clear English. Others have had the gift of witty exposition. Others have understood the metaphysics of Hinduism and Buddhism. Others have understood the true significance of erotic drawings and sculptures. Others have seen the relationships of the true and the good and the beautiful. Others have had apparently unlimited learning. Others have loved; others have been kind and generous. But I know of no one else in whom all these gifts and all these powers have been combined. I dare not confess myself his disciple; that would only embarrass him. I can only say that I believe that no other living writer has written the truth in matters of art and life and religion and piety with such wisdom and understanding. It is absurd to say he has influenced me; that would imply that his influence has borne fruit. May it be so—but I do not claim it.[5]

[3] AKC, introduction to Eric Gill, *It All Goes Together*, p. v.
[4] Eric Gill, *Autobiography* (London, 1940).
[5] *Ibid.*, pp. 172–174.

Nearly all of Gill is in this passage, by implication, and more of Coomaraswamy than has appeared yet in these pages. Gill was writing in the late 1930s, and the Coomaraswamy whom he evoked was the man of those later times, but already in the early years of their relation the subject between them was religion, sacred art, Eastern civilization. Coomaraswamy also helped him to understand his tendency towards the erotic in art by passing on to him the Indian conception of erotic symbolism and supplying him with illustrations of its various forms.[6] The book-plate

Figure 19. Coomaraswamy's Second
Book Plate. Engraving by
Eric Gill, 1920.

(Figure 19) that Gill designed for his friend in 1920 exemplifies reasonably well his mastery of letter forms and the trend of his art. The iconography of this design must derive from the *Song of Songs*. In II:8–9, the Bride cries,

> Hark! my beloved! behold, he cometh,
> Leaping upon the mountains, skipping upon the hills.
> My beloved is like a gazelle or a young hart.

But later, fully according to the logic of this kind of symbolism, her beloved is absent from her bed, and she is obliged to seek him out, just as the Rajput heroine, the *Abhisārikā*, must seek out her beloved. The

[6] Speaight, *Life of Eric Gill*, p. 271.

Bride questions the watchmen (for her, as for the *Abhisārikā*, it is night), but they have seen no one.

> Scarce had I passed from them,
> When I found him whom my soul loveth:
> I held him, and would not let him go.

Bare branches on one side, leafy trees on the other in Gill's image of the moment of reunion. Coomaraswamy seems to have made no comment on the meaning of this little Ex Libris anywhere in his writings or private papers, but it must have satisfied him, because he reordered a batch of them from Gill some twenty years after he first began to use it. Gill, in his reply to Coomaraswamy's request, courageously mentioned that he thought the girl looked rather foolish and wished he had done a better job[7] It is impossible to pin down just what Coomaraswamy and Gill had in mind when they chose this image: certainly it has the eroticism to which both were attracted, and it evokes the religious search that linked the author of *Buddha and the Gospel of Buddhism* and the deeply committed Catholic artist. Coomaraswamy must also have felt at home with it because he had in his collection of Rajput paintings several examples of a similar subject: a young woman posed gracefully beside a pet deer. Verses inscribed on such scenes suggest that the deer is an image of the soul lost in the tangle of illusion, *māyā*.[8]

There was great variety in the kinds of exchange between Coomaraswamy and Gill. Gill, for example, taught him the fine style of draughtsmanship that he himself used in portraits. Coomaraswamy's abilities as a draughtsman come to the surface infrequently, but what is perhaps his most elegant work, a portrait executed in the 1920s (Figure 20), is an application of Gill's lessons. Coomaraswamy considered Gill to be the very image of the true artist-craftsman. Gill, on his side, owed a great deal of his thought to Coomaraswamy. All of his writings reflect Coomaraswamy's influence. They were going the same way, one a scholar of philosophical temperament, the other a craftsman of philosophical temperament. Their genuine friendship is reflected abundantly in Gill's published letters[9] and throughout the writings of each.

The beginning of the Great War did not at first affect Coomaraswamy directly. He was struck, as were many others in the British Empire, by

[7] Letter to AKC, ca. 1936, family collection.
[8] Cf. AKC, *Rajput Painting*, pp. 69, 70, and Plates XLVII, LXXI A.
[9] Walter Shewring, ed., *Letters of Eric Gill* (London, 1947).

Figure 20. *Portrait of Stella Bloch*, drawing by Coomaraswamy, ca. 1922.

the patriotic words and significant military aid that India willingly of-
fered. Indian nationalists recognized that India had everything to gain
from aiding Great Britain in a European war, and they calculated rightly
that their bargaining position would be improved at the close of war.
Coomaraswamy published an essay on the Indian attitude towards the
war in *The New Age* of December 24, 1914. He admitted in the article
that a definite relation between India and wartime England was already
established—India was indeed helping to fight the war, partly through
blind patriotism, partly through calculated, self-serving patriotism—but
he believed that the most appropriate attitude of Indians was detachment.

> I do not ask anyone to be disloyal or to be loyal. . . . But I do say that
> the repartition of Europe is not a problem with which we are directly
> concerned. . . . We have not even the Germans' or the Allies' pretexts
> to forsake the ideals of humanity or to yield to the enthusiasm of
> destruction. We have no imperative call to offer military service to
> either combatant, or to rejoice intemperately at the success of this or
> that industrial empire. . . . If we do not believe that neutrality of
> thought may be efficacious for the tempering of strife, that must be
> because we forget that all things are intertwined and indivisible.
> To say that we ought not to engage our passions, is not to say that
> we need abstain from all intellectual judgment. . . . We are free to
> think, as I do think, it most desirable that the Allies should "win."[10]

Coomaraswamy's "neutrality of thought," expressed in this way at the
beginning of the war, was put to the test in 1916. England traditionally
maintained a voluntary army, but in January 1916, it was obliged to in-
stitute a series of Military Service Acts to provide for conscription. Family
memory records that Coomaraswamy declared himself a conscientious
objector rather than serve in the British armed forces. He seems to have
preferred to erase the incident from his life in later years: the most fragile
evidence remains that he took this stand, but there is no longer any reason
to keep his secret. The incident fits in with what we know of Coomara-
swamy in his late thirties. His stand must have been based on his view,
as an Indian, that "we have no imperative call to offer military service."
Doubtless the service required of him at his age and with his background
was noncombatant in the first place, and there existed noncombatant
corps for conscientious objectors, but he must also have refused to engage

[10] AKC, "A World Policy for India" (1914).

himself there,[11] because his family recalls that he was practically a political refugee when he came to the United States. In England he was apparently threatened with legal proceedings before a local tribunal of the kind that had been created by the Military Service Acts to deal with war resisters. A history of conscientious objection in England, 1916–1919, has been written;[12] it indicates that deportation to outlying parts of the British Commonwealth (New Zealand or Canada) was a punishment devised for some categories of conscientious objectors, and that those who accepted duty in noncombatant corps were frequently harassed by the conventional military. Coomaraswamy was able to get out from under the dangers of his position with the help of highly placed friends, according to his family's account. Some of his property was confiscated, but he was able to take his art collection and a large sum of money out of the country with him. When he wrote that he never saw Eric Gill again after 1917, he was saying covertly that he had never returned to England. A letter written by him late in life to a friend who had asked whether he would be coming to England confirms that he left England for good in 1917 and had no intention of returning. Neither the intention nor the legal possibility: when he tried in the 1940s to arrange for a fishing trip in Canada, he was refused permission to enter the country.[13] On the other hand, he was able to travel in India and Ceylon, and did so several times after 1917.

The series of incidents must have occurred in late 1916 or early 1917. In the first part of 1916, he and his wife came to the United States, ostensibly for a concert tour that Ratan Devī had arranged. Given the state of war, Coomaraswamy was obliged to have an influential friend write a letter to the appropriate government office testifying to his good intentions in leaving the country. Laurence Binyon, a well-known art historian associated with the British Museum, composed a letter that is preserved:

Dr. Coomaraswamy has rendered services of the greatest value to the world by his pioneer work which has done much to promote a truer understanding between India and the West. It is work which serves the best interests of the British Empire, and work which is highly appreciated by scholars all over Europe.

[11] In Raja Singam's article on AKC and Gandhi (in *Ananda Coomaraswamy: Remembering and Remembering Again and Again*), it is suggested on good evidence that AKC had thought of joining the Indian Ambulance Corps, which served Eastern troops stationed in Flanders and France.
[12] John W. Graham, *Conscription and Conscience: A History 1916–1919* (London, 1921).
[13] This information was given by a member of AKC's family.

> Dr. Coomaraswamy assures me that his only intention during his proposed visit to America was to lecture on Indian art and literature, and this only if time was left over from his wife's musical recitals in which he assists.[14]

The language of this letter, dated February 1916, implies that Coomaraswamy encountered some difficulty in obtaining the necessary permission, but by the month of May, he and his wife were in Chicago, certainly not the first stop on her concert tour;[15] in August he was receiving his mail care of Cook's, the travel bureau, in New York City. It seems probable that when Dr. and Mrs. Coomaraswamy returned to England following the tour, they found themselves in the dilemma that resulted in his exodus from Great Britain and his treatment thereafter as *persona non grata* in some parts of the British Empire. In late 1916 or early 1917 he may have been briefly in India. He was trying to arrange a peaceful departure from England in either one of two directions: India or America. He would have preferred India but, as we shall now see, India had nothing acceptable to offer, while America was ready to receive him.

Coomaraswamy coded into *Rajput Painting* a prophetic little passage on the question of an Indian National Museum—that book was published, as the reader may recall, in 1916, but these lines must have been written a year or so earlier:

> The founding of at least one national Museum of Indian Art is one of the greatest needs of the present moment, for modern India has already forgotten the past, and opportunities are passing quickly, of which European and American collectors are not slow to avail themselves. The greater part of a magnificent collection of Jaipur enamels which the Nizam of Haidarabad (a multi-millionaire) disposed of lately at half their real value, to be exchanged for the latest manufactures of Birmingham and Bond Street, was secured by the agents of American Museums. M. Goloubew's collection of Indian paintings has gone to the same country. The existing Indian Museums have been made by men better acquainted with the culture of the hill tribes than with the culture of an old Rajput court. When we consider that much the same is true of Indian collections in England, and that the history of art has not a single chair in any Indian University, it is not

[14] Laurence Binyon, letter of 7 February 1916, family collection.
[15] At least this fragment of their itinerary can be established through correspondence in the family collection.

surprising that modern Indians refuse to believe that such a thing as Indian art has ever existed.[16]

As we have already mentioned, Coomaraswamy tried to establish a museum of art by offering his collection to India on condition that a museum be created (he thought that it ought to be at Benares, the ancient holy city). The Indian Society of Oriental Art distributed a circular outlining his proposal, but, in the words of O. C. Gangoly, a witness to those times, "our nationalists, impervious to the claims of Indian Art, failed to respond to his appeal."[17] It was not just the nationalists who failed to respond. Another Indian writer recorded that "no prince or magnate who could afford to accept the offer was inclined to have any truck with a protagonist of the 'Swadeshi' movement disliked by the Government."[18] A letter from the secretary of the Nizam of Hyderabad and Deccan, the multimillionaire prince mentioned by Coomaraswamy, indicates that as late as August 1916, Coomaraswamy was trying to find a haven for himself and his collection in India: "We have had to postpone the whole scheme about the Museum owing to the War. . . . I am very sorry that we shall not have the pleasure of having you here in an appointment for which I wanted you very much, but it was impossible to get the necessary sanction. I hope, however, you will find it convenient and interesting to pay us a visit some day."[19] A visit really would not do. Coomaraswamy also tried to get a post at Benares Hindu University as a professor of Indian art and culture, but even with the help of Bhagavan Das, who held a high position in the university, nothing came of it. India wanted neither a curator of a national museum nor a professor who would concern himself with the nature of the objects in such a museum. This is not to imply that there were no public art collections in India; they existed. But Coomaraswamy had a unique collection to offer, as well as unique qualities of connoisseurship and concern. One has only to look at the over-sized serial numbers painted on ancient stone sculptures of the Buddha, a visible legacy of early curatorial practice in Indian museums, to realize that Coomaraswamy had something new in mind when he distributed his circular on behalf of a national museum.

Coomaraswamy was, in fact, weaving his fate when he came to America

[16] AKC, *Rajput Painting*, p. 82.

[17] O. C. Gangoly in *Memorial Volume*, p. 92.

[18] Trivikrama Narayanan, "Indian Art Savants, 6," *The Sunday Standard* (Madras), 5 November 1967 (clipping in the family collection).

[19] A. N. Hylari, letter to AKC, 6 August 1916, family collection.

in 1916. The diary of Dr. Denman W. Ross, the great patron of the Boston Museum of Fine Arts, indicates that Coomaraswamy had let it be known that he was willing to sell his collection.[20] Ross met Coomaraswamy, very probably during the concert tour, and was immensely interested by his collection of paintings, of which Coomaraswamy may have had examples or the book *Rajput Painting* with illustrations drawn largely from the collection. Ross decided to purchase the collection for the museum and convinced its trustees to invite Coomaraswamy to become the curator of a newly created Indian section, the first of its kind in America. Thus in the United States, the most heavily industrialized, least traditional parcel of land that the Lord tolerates on earth, a set of conditions came together that suited Coomaraswamy—far better than he knew when he accepted the museum's proposal.

[20] Communication from Mrs. Herbert Pratt, Ross's biographer.

XI. AKC in America:
The First Ten Years

I lay down the book and go to my well for water, and lo!
there I meet the servant of the Bramin . . . come to draw
water for his master, and our buckets as it were grate together
in the same well. The pure Walden water is mingled with
the sacred water of the Ganges.
Henry David Thoreau, *Walden*

I am going to impose on your good nature enough to ask you
two questions. I contemplate using either the image of Bramah
or Vishnu as a mascot or guiding spirit on my motor car
and will mount same on my radiator cap. This is not to be
done in either a spirit of ridicule or religious veneration but
rather an expression of liking for the ancient mythology.
Now, would there be anything in this use to offend the re-
ligious feeling of one of Bramahn faith and if so, just how
much of a faux pas would it be?
Letter to Coomaraswamy at the Museum, 1927

Coomaraswamy came to America apparently without the immigrant's
natural hesitation before a new life. It was really a piece of *bravura* to pub-
lish two articles on Indian art in the ultrafashionable magazine *Vanity
Fair* in 1916, during his concert tour with Ratan Devī, and the articles
themselves reflect his taste for fashionable milieus and fashionable words.
Introducing the readers of that magazine to the art of Ajaṇṭā, he con-
jured up the following vision:

If this art is "religious," it is not so because of any dogmatic quality,
but because the spiritual life is revealed clearly in the very texture of
a sensuous environment and in the milieu of aristocratic manners.
It is as if we should represent a spiritual savior of men as moving with
elegance and grace, not exciting any comment, only awakening love,
as an acknowledged leader of society in the butterfly purlieus of Palm
Beach and Fifth Avenue; and this, not as a tour de force, but as the

127

most natural thing on earth. For where else should such a one attempt to walk, unless amongst us?[1]

Certainly one of the temptations of his new life in America was to become a fashionable Hindu. He never confused himself with a swami—such was not the temptation—but what could be more remarkable than a tall, olive-skinned man in his early forties with a mane of dark hair, sensitive features, and from time to time a gold earring, a man obviously English in voice and manner and yet intriguingly something else: the quietness with which he moved, his stillness when sitting, the kinds of things that he spoke about were all Eastern and unfamiliar (cf. Figure 21). It is only his sincerity that saved him, and it did not save him so efficiently that he missed tasting the pleasures of Vanity Fair. His sincerity was perhaps in the first place his love of knowledge, a trait of character that functions like conscience. With something to be known, an historical or intellectual structure to be deciphered, he was deeply happy. Many times in his writings he expressed his joy in his scholarly vocation, and lamented that so few are able to do professionally what naturally suits them.

In America, he established himself in two worlds, that of painstaking curatorial and scholarly work, and that of modern art and modern people. In his first ten American years, he was at the height of a parabolic trajectory, the buoyant moment when the ascent is terminated but descent still imperceptible. Jack Donne; John Donne—this kind of man is part of the Anglo-Saxon heritage: fiery, witty, amorous, and studiously profane in his youth; a man of God in later years. Coomaraswamy was both Jack Donne and John Donne in the 1920s. In a book published seventy-five years earlier by the great New England thinker, Ralph Waldo Emerson, this kind of transition was described in terms that fit Coomaraswamy:

> There are degrees in idealism. We learn first to play with it academically, as the magnet was once a toy. Then we see in the heyday of youth and poetry that it may be true, that it is true in gleams and fragments. Then its countenance waxes stern and grand, and we see that it must be true. It now shows itself ethical and practical. We learn that God IS; that he is in me; and that all things are shadows of him.[2]

[1] AKC, "The Cave Paintings of Ajanta (An Almost Unique Type of Classic Indian Art which Appeals Strongly to Modernists)," p. 67.

[2] Ralph Waldo Emerson, in the essay "Circles"; cf. Brooks Atkinson, ed., *The Selected Writings of Ralph Waldo Emerson* (New York, 1940), pp. 283–284 (Modern Library Edition).

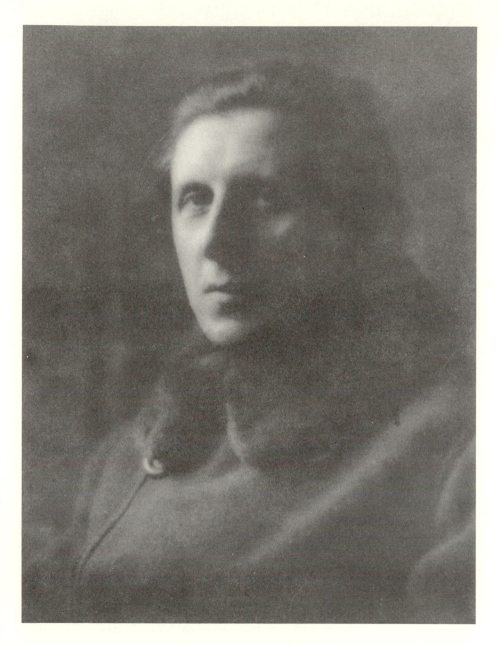

Figure 21. Coomaraswamy, 1919.

The history of the Boston Museum of Fine Arts, recently written with care and affection by Walter Muir Whitehill,[3] shows that its Oriental collections were assembled by a most unusual group of men during the thirty or so years preceding Coomaraswamy's appointment. The chain of Boston collectors and connoisseurs began with Edward Sylvester Morse, who went to Japan in 1877 to study certain forms of marine life—he was a Darwinian naturalist—and found himself fascinated by Japanese ceramics. He learned their lore and built a large collection that entered the museum in 1892. Morse, who was connected with the University of Tokyo in the 1870s, when Japan was avid for everything Western from knowledge to nonsense, had a young Harvard graduate, Ernest Francisco Fenollosa, brought over as a professor of philosophy and political economy at the university. Fenollosa also became a passionate collector, building an extraordinary collection of paintings in this time when private and monastic collections were coming on the market cheaply. The Japanese were in a frame of mind with regard to their artistic patrimony similar to that of the Indians and Ceylonese. Fenollosa took the additional step of adopting the Buddhist religion.

When Morse returned to Boston in 1880, he was a "local apostle of Japanese culture," as Mr. Whitehill puts it; his lectures inspired a young physician, William Sturgis Bigelow, to accompany him to Japan in 1882, where they joined Fenollosa and a Japanese friend, Okakura-Kakuzo, for a countrywide tour of arts and antiquities. Bigelow's wealth, earned originally by his ancestors in the China trade for which Boston was famous, permitted him to buy choice works of art. And again, following a pattern that cannot help but surprise, Bigelow was moved by Buddhism and studied it seriously. He ultimately held the highest rank available to laymen in a Buddhist monastery of the Tendai sect. He returned to Boston and became a member of the museum's Board of Trustees in 1891, but he neither abandoned Buddhism nor flaunted it. When he died in 1926, he was buried at Trinity Church. As he had stipulated, his body was clothed in a Buddhist ritual garment—by John Ellerton Lodge, as it happened, curator of Asian art at the museum and a close friend of Coomaraswamy.

Okakura-Kakuzo was no less interesting than his American friends. Son of a wealthy Japanese merchant and graduate of the Imperial Uni-

[3] Walter Muir Whitehill, *Museum of Fine Arts, Boston: A Centennial History* (Cambridge, Mass., 1970). Mr. Whitehill's account of AKC as a museum man appears mainly in pp. 362–371.

versity of Tokyo, where he had come under the influence of Fenollosa, he was so struck by the obvious truth that Japan's treasures were in danger of leaving the country forever if no controls were applied to foreign collectors that he began to agitate for a National Treasures law, which was passed in 1884. Okakura did not lose the Bostonians' friendship; on the contrary, after a period of important work in Japan devoted to discovering, evaluating, and cataloguing all works of art that could be classified as national treasures, he was invited to catalogue Far Eastern works of art in the Boston Museum. From 1904 until his death in 1913, he was associated with the museum, although not continuously resident in Boston. Okakura was a figure of international stature. He had traveled in China and India, launching the idea that "Asia is One" through various writings, particularly through a work published in 1903, *The Ideals of the East*. Havell, Coomaraswamy, and the Tagores all responded to Okakura's ideas; what Okakura envisaged in his book of 1906, *The Awakening of Japan*, was precisely what they envisaged for India. Nivedita, Coomaraswamy's friend and coauthor, considered Okakura to be "the William Morris of the East"—the very role that Coomaraswamy had tried to play within the confines of Ceylon and, to some extent, India.

Coomaraswamy and Okakura never met, only because their comings and goings failed to coincide. Coomaraswamy received a letter from him in England, January 1911, saying "I have read your books and am very desirous of meeting you," and closing with the patriotic Bengali slogan "Bande Mataram,"[4] but they were unable to be at the same place at the same time—until 1917, in a sense, when Coomaraswamy joined the Asiatic department of the Boston Museum. Okakura had been dead four years, but the fruit of his scholarship, his proud vision of the East, and his harmonious way both in thought and in life of moving between East and West, must have been in Coomaraswamy's mind at that time. Okakura is remembered now for his classic book on the tea ceremony, published in 1906.

The museum's collection of Far Eastern art was almost incredibly large by 1917. Not only the collectors whose lives we have just sketched, but also many other Bostonians donated or sold works of Far Eastern art, most of which had been acquired before the National Treasures law was enacted in Japan. Five thousand paintings, sixty thousand prints, more

[4] Family collection. An account of Okakura-Kakuzo's life, written by his Boston friends William Sturgis Bigelow and John Ellerton Lodge, appeared in *Ostasiatische Zeitschrift*, II (1914), 468–470.

than seven thousand ceramics, eight hundred Nō costumes—these quantities represent only a portion of the vast collection. Indian art was incomparably more meager, but with the acquisition of the Goloubew collection of miniatures and the Coomaraswamy collection of Rajput painting, Jaina painting, and small Indian bronzes, there was a nucleus that justified the creation of an Indian section. In his first annual report (for 1917), Coomaraswamy recorded that he had some four hundred forty objects on display, with another eleven hundred "reserved for study"— a characteristic phrase. Dr. Denman W. Ross, whom we have already briefly encountered, a teacher of painting and design at Harvard University, a man of extraordinary means, was the patron principally interested in the Indian collection. Since 1883 he had been contributing works of art in great variety to the museum, and by the time of his death in 1935 he had placed more than six thousand objects at the disposal of the Asiatic department. There was a tradition of beneficence among wealthy Bostonians whose proportions one would never have guessed before the museum's history was made public. Ross's attitudes toward art and even the details of his relationship with Coomaraswamy will not be well known until his biography is published, but it is clear that the bond of friendship between the two men was firm and survived some difficulties.

Such were the conditions that Coomaraswamy encountered at the Boston Museum. Something now needs to be said about New England, where he found himself at home. An aspect of his character that has been invisible since we last saw him living in a tent near Benares was able to reappear—and recognize that it would never be badly served again. As a geologist in Ceylon he had lived in back country. Now in America he discovered the state of Maine, and only a year or two after settling in Boston he began to spend part of the summer months in the Maine woods, either camping or in a rough cabin. He became a fisherman, a connoisseur of fly-tackle, and his friends from those years have strong memories of the fishing trips. Good fishing grounds in the state of Wyoming also attracted him. He loved that kind of living and looked forward to it inordinately during the winter. For several summers he camped beside Wyoming's lakes (Figure 22). He entered fishing contests like any other down-easter. He eventually bought a cabin in Maine, and only sold it late in life.[5]

[5] Clippings and letters in the family collection bring anecdotes to light. In the *Boston Herald* for a summer day in 1926 (clipping, no further identification available), there appeared the following: "Museum Keeper Gets Big Salmon—Dr. Coomaraswamy Latest Entrant in Herald Contest. It gives the fish and game editor

He loved the woods, but no more than did Emerson and Thoreau, whose lives and writings have essentials in common with his own. They were the American annex of the school of thought that began with Carlyle in England, the one on which Coomaraswamy was nurtured, but they were more aware of Oriental thought than anyone in the Carlyle–Ruskin– Morris line, and they had specifically American virtues that also distin-

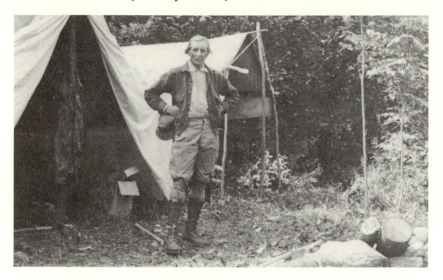

Figure 22. Coomaraswamy on vacation in Wyoming, mid-1920s.

guished them. How is it that Emerson could write in 1840, "In the woods or in a boat upon the pond, nature makes a Brahmin of me presently: eternal necessity, eternal compensation, unfathomable power, unbroken silence,—this is her creed."[6] How is it that Thoreau's bucket grated in the same well with the Brahmin's servant's, and that he could say, "Depend upon it that, rude and careless as I am, I would fain practice the yoga carefully. . . . To some extent, and at rare intervals, even I am a yogi."[7] Coomaraswamy was in the right part of the country: the Yankee

pleasure when a man like Dr. A. K. Coomaraswamy, keeper of Indian and Muhammadan art in the Boston Museum of Fine Arts, sees fit to make an entry in The Herald's 1926 fishing contest. This only goes to show that the fisherman is a real sportsman, no matter what his position may be. Dr. Coomaraswamy caught a nice 11-pound salmon at Pierce Pond, Maine. . . ."

[6] Quoted by Arthur Christy, *The Orient in American Transcendentalism: A Study of Emerson, Thoreau, and Alcott* (New York, 1932), p. 61. The image of Concord as a "land-locked port" used later in this paragraph was first used by Christy.

[7] *Ibid.*, p. 185.

clipper ships had brought Oriental goods to America through the port of Boston, but through the land-locked port of Concord, Massachusetts, in the late 1830s, Emerson and his friends Thoreau and Amos Bronson Alcott had brought another order of Oriental goods: the philosophy of the "Hindoos," the *Bhagvat-Geeta*, Sufi poetry, Lao-Tse, Chuang-Tzu, Confucius, and the formulations of Hermes Trismegistos. As Arthur Christy has pointed out in *The Orient in American Transcendentalism*, Oriental thought provided Emerson and his comrades with the elements they needed to refute eighteenth-century Rationalism, the Sensationalist psychology of Locke and Hume. The translations that reached them in Concord of the *Bhagavad Gītā*, Puranas, Brahmanas, Vedas, and Laws of Manu were the work of the Asiatic Society of Bengal, whose activities have already been briefly mentioned. But as any reader of Emerson and Thoreau knows, these texts did not fall on previously untilled soil. Concord never became an ashram, but the Transcendentalists were able to include elements of Hindu thought into a larger whole that was American. In the magazine known as *The Dial* that they published in Concord in 1840–1844, there was a section of "Ethnical Scriptures" in which texts from all the Oriental traditions that interested them were quoted. The idea of "the world's scriptures" was shared by Coomaraswamy, and developed by him in his late writings. He did not owe it to the Transcendentalists; he simply came to it by the same route as they.

It seems fair to say that Thoreau was an Indian author in the same sense that Shakespeare was a German author. Everyone interested in the awakening of India knew Thoreau, at very least his essay on *Civil Disobedience*. When Gandhi was jailed in 1922–1924, his reading list included Ruskin, Emerson, Thoreau, Carlyle.[8] Coomaraswamy had read Thoreau by 1910,[9] and never forgot him; in a late lecture in which he had occasion to discuss the four *ashramas*, or stages of life according to Hinduism, he described the third as "the forest life of retreat—the sort of life that Thoreau lived at Walden."[10] Perhaps enough has been said of this surprising

[8] Cf. Jean Herbert, *Ce que Gandhi a vraiment dit* (Paris, 1969), p. 30.
[9] Cf. AKC, preface to *Essays in National Idealism*.
[10] AKC, "A Lecture on Teaching Comparative Religion and Philosophy" (1944), unpublished in this form. Large selections of this lecture were published as "Paths that Lead to the Same Summit" (1947). A copy of the earlier version is in the Princeton Collection. Another late comment on Thoreau and his friends appears in AKC, "Understanding and Reunion: An Oriental Perspective" (1945), p. 230: "The very possibility of an 'influence,' indeed, presupposes an already existing kinship; none could be exerted where no foothold could be found. . . . Without some hidden

relation between Coomaraswamy and the New England philosophers, yet one is tempted to add more. Coomaraswamy, like Thoreau, recognized the American Indians, and felt something on the order of loneliness for them. Thoreau used to go up to Maine to visit them and explore old settlements; Coomaraswamy in his late years visited them through their myths and art, as well as through friendship with specialized anthropologists such as Leyland C. Wyman, and he came to the conclusion that "what, in fact, we cannot learn from the American Indians, we cannot any more easily learn from the East."[11] In general, Coomaraswamy sought his analogues in America—in the America round about him and in its past. He found Walt Whitman and the Transcendentalists even before he came to America; while here he found the American Indian and the Shaker communities. Among the living, he made many friends.

Coomaraswamy's work at the Boston Museum can be traced with considerable accuracy through the museum *Bulletin* and Annual Reports as well as through publications that he brought out specifically under museum auspices. There is an enormous difference between the author of *Rajput Painting* and the author of a *History of Indian and Indonesian Art* (1927). Coomaraswamy's first ten years at the museum were a time of acquisition of that level of knowledge rightly called erudition. In the course of cataloguing the Indian collections and writing about specific objects for the *Bulletin* and other journals, he acquired a literally encyclopedic knowledge relating to the history of Indian art. It was what might be called a cold knowledge; he rarely used it tendentiously to argue a point, as he did so often in younger days. It was a professorial knowledge. Although he was only briefly on a university faculty (New York University, 1928–1929), he was often addressed as professor in letters from scholars who assumed on the basis of his writings that he was formally attached to some teaching body. It is true that he lectured widely under the auspices of universities and museums throughout the country, but his only long-term commitment was to the Boston Museum, where as the years went on he became a tenured professor in all but name.

The period 1917–1923 at the museum compose the years when Coomaraswamy organized and catalogued a good part of the collection, at the same time that he enlarged it significantly. Museum catalogues are of two

affinity, could the English De Morgan and George Boole or the New England Transcendentalists have assimilated so much of the Vedānta?"

[11] AKC, "Understanding and Reunion," p. 221.

kinds: the internal catalogue, essentially a card index in which everything known about works of art is briefly recorded, including the conjectures of visiting scholars; and the formally published catalogue, which makes a collection known to the world. The most sophisticated of the second kind are called *catalogues raisonnés*, a resonant term, indicating that complete information has been supplied about each item catalogued.

By the end of 1918, Coomaraswamy could record that he had made a departmental catalogue of eighty percent of the collection, and prepared a catalogue of sculpture for publication, as well as gathered a five hundred-item bibliography of works on Indian art.[12] He had also published five articles in the museum *Bulletin* covering various aspects of the collection (Jaina manuscripts, Mughal and Rajput painting, bronzes, and Burmese tiles).[13] Until 1930 he was regularly contributing as many as four or five articles each year to the *Bulletin*. After 1930, his contributions were far less frequent, but some of them have special significance in his late oeuvre. All of these articles represent Coomaraswamy in the strict, scholarly mode to which we just referred. In a piece such as "Śaiva Sculptures: Umā-Maheśvara Groups and South Indian Bronzes," of 1922, in which he discussed a number of large stone sculptures and bronzes that he had purchased for the museum during a buying trip in India in 1920–1921, his investigation of works of art and their cultural setting no longer detoured along routes that it took in younger days. The Romanticism is absent, as is the protest against industrialism and Anglo-Saxon ignorance. This is not to say that he ceased to speak his mind; as time went on he became an ever more adamant critic of Western society, but he had learned to exclude those interests from art-historical writings. His art history became of the kind that is now *de rigueur* in every field of that discipline: erudite, detailed, impartial. The scholar's personal opinions and tastes are kept in the background or labeled as such, often with an apology for their intrusion. This is properly called *Kunstwissenschaft*: it is an historical science with a fully rationalist mode of function, the necessary complement of archaeology. A work like *Rajput Painting* combined Coomaraswamy's qualities as an art historian with his qualities as an author and inquirer into the meaning of existence, but upon his arrival in America and his acceptance of the museum's needs as his own, these two sets of qualities—quite different in nature—separated from one another. The historian went his way, directing his attention to the facts of style,

[12] AKC, *Bibliographies of Indian Art* (1925).
[13] Biblio. Nos. 194, 205, 207, 208, 209, 216 in the *Working Bibliography*.

iconography, and temporal change, and communicating his findings in professionally impartial, although not flavorless reports. The inquirer went another way, expressed himself on other occasions, matured.

The 1920–1921 buying trip, for which Coomaraswamy had already wished leave of absence in 1919 because prices were still reasonable in the Indian art market, left only a few traces of its personal significance, but in terms of museum acquisitions it was most important.[14] He was fortunate enough to be able to purchase for the museum two excellent bronzes of *Shiva Naṭarāja*, the Dancing Shiva,[15] acquisitions of significance not only for their intrinsic quality but because the Dancing Shiva had such wide appeal. In his book of essays published as *The Dance of Shiva* (New York, 1918), Coomaraswamy had popularized the image of the many-armed Indian god engaged in the cosmic dance of creation, preservation, destruction, liberation. It seems likely that through his essay this image became the archetype of Indian sacred art, as it still is today, for the majority of Western art lovers. Aside from these prizes, he brought back a number of fine bronzes and works in other media, some as gifts from the Government Museum of Madras.

Early in his career at the museum, Coomaraswamy made it his custom to donate works of art from his own collection; he did so nearly every year from 1919 to 1947. The list of his donations is easily established through the museum *Bulletin*, each of whose numbers recorded recent accessions and their sources. His donations varied in character and value. Perhaps the most beautiful is a stone sculpture, a head of an Apsaras (Figure 23), which he offered the museum in his first year there.

Parts One and Two of Coomaraswamy's *Catalogue of the Indian Collections* appeared in 1923, as well as a *Portfolio of Indian Art in the Boston Museum* comprising 108 plates illustrating the major pieces in the collection. These publications attracted scholarly interest, but they also put Indian art "in the news" for a time. While Coomaraswamy was writing in an American art periodical that "the Museum is now easily first in America in respect of the quality and range of its Indian exhibits, and is not surpassed in this respect by any museum outside India,"[16] a reviewer in a German periodical was saying much the same thing:

[14] Cf. *Boston Museum of Fine Arts Bulletin*, XIX (1921), 64, for an acquisitions list; also AKC's general account of the collection, "Indian Art in Boston" (1923). The *Bulletin* will be referred to henceforth in notes as *MFA Bulletin*.

[15] Cf. AKC, "Śaiva Sculptures."

[16] AKC, "Indian Art in Boston," p. 36.

The Boston collection represents the finest collection of Indian art in all its branches under one roof. The cream of the collection is undoubtedly the magnificent collection of Rajput, Pahari, or Kangra paintings, which has no parallel in any other part of the world. . . . The reviewer regrets that this collection, offered in its beginnings as a gift to India by Dr. Coomaraswamy, has found a permanent home in a far-away land.[17]

Figure 23. *Head of an Apsaras*, Indian, 14th century, stone.

The first two parts of the *Catalogue* were an introduction to the art and culture of India and a *catalogue raisonné* of sculpture. The former, later translated by Jean Buhot, an Orientalist with whom Coomaraswamy corresponded, and published as *Pour comprendre l'art hindou*,[18] is a graceful instruction for laymen, largely devoted to the religious background of Indian art. The catalogue of sculpture, like those that followed in the same series (*Jaina Painting and Manuscripts*, 1924; *Rajput Painting*,

[17] Reviewer in *Der Cicerone* (1924), quoted in *MFA Bulletin*, XXII (1924), 13.
[18] Paris, 1926.

1927; *Mughal Painting*, 1930)[19] is remarkable for its standard quality of art-historical scholarship. They are no more and no less than professional works of scholarship, still useful to other professionals decades after publication. They reflect Coomaraswamy's personality only slightly. In the introductory portion of the work on Jaina art, he tells the life of the *Tīrthaṇkara*, the "Finder of the Ford" by whom Jainism was first preached in this historical era, with the warmth and sensitivity to details that he characteristically demonstrated when discussing religious legends. In the catalogue of Mughal painting, he continued to aver that it was essentially a secular art, as he had been saying since 1910, but even this view, with all that it entailed for him as a value judgment, has little place in what is otherwise an impartial *catalogue raisonné*.

If the symbol of this period in Coomaraswamy's writings is his *Bibliographies of Indian Art*, a 54-page list of many hundred books with no personal comments whatsoever, the masterpiece of the period was his *History of Indian and Indonesian Art*. Published simultaneously in English and German, announced in advance by a sumptuous leaflet, it was not a publication of the Boston Museum, but it reflected the professional skill that he had acquired during his first ten years in the museum. A book of the class that Vincent Smith had established in 1911 with his *History of Fine Art in India and Ceylon*, it is a general text of encyclopedic dimensions, illustrated by four hundred photographs, more useful as a reference work to place specific periods and monuments than as an introduction to Indian art. It displays an extraordinary mastery of facts of every kind—place, style, technique, historical setting, Sanskrit and vernacular vocabulary—and an excellent selection of illustrations. Although historiography is eminently subject to the laws of history, contemporary historians of Indian art still value this book, not least as a model of how this kind of work should be done.[20]

One characteristic of the *History* that raises a question was noticed in a review by one of Coomaraswamy's closest American colleagues, W. Norman Brown, editor of the *Journal of the American Oriental Society* and a member of the faculty of the University of Pennsylvania: "The chief

[19] Volume III in this series was never completed. It was projected as a collaborative effort on the part of AKC and his fellow curator John Ellerton Lodge, but when Lodge left for the Freer Gallery in Washington, D.C., it was abandoned. This information is recorded in a letter by Doña Luisa Coomaraswamy, 24 October 1967, Princeton Collection.

[20] Cf. Benjamin Rowland, Jr., *The Art and Architecture of India: Buddhist, Hindu, Jain* (Baltimore, Md., 1953), p. xvii.

fault of the book is its distressing brevity. Almost everything is mentioned, but little gets more than the briefest treatment. What I miss most, and what I think is needed for Western readers, is interpretation—which Dr. Coomaraswamy is so well qualified to give. Footnote citations to others books are not satisfying; those books are not at hand."[21] Coomaraswamy had organized history, but had excluded the kind of interpretation to which his readers had grown accustomed in earlier works. In the context of art-historical scholarship, the *History* was an important contribution requiring little further comment, but in the context of its author's biography, one is struck by how completely Coomaraswamy was now willing to conform to the mode and standards of positivistic scholarship. A great many of his writings in the 1920s and 1930s are identical in character to the *History*; they are an engagement with the content of history, free of even passing allusion to one or another aspect of metaphysics and religion. He was once an Idealist, ready to say with Thoreau, "How much more admirable the Bhagvat-Geeta than all the ruins of the East!"[22] But now, in his professional work, he was an indefatigable student of those ruins. He had recognized perhaps more clearly than ever before that gathering the materials of history is no less important than drawing lessons from it.

This habit of erudition, his high valuation of factual knowledge, passed on into the last phase of his work, when he concerned himself primarily with metaphysics and theology. His approach to God was archaeological in spirit: he studied the strata of ideas, symbols, and mythic formulations that overlay the original revelation in each tradition; he kept a careful record of all the intellectual artifacts encountered; he kept everything, threw nothing out, even at the price of tediousness; when he had understood something at one site, he shifted to another, worked down to the same level, compared with previous findings. Just occasionally, for the sake of the artist in him, he would write a more general report, evocative rather than documentary.[23]

Coomaraswamy's integration into the American academic community took place very rapidly after he settled in Boston. Early in 1918, he lectured at Yale University on Indian music; in 1919 he gave a course of

<hr/>

[21] Family collection, source unidentified.

[22] Henry David Thoreau, *Walden*, ed. Brooks Atkinson (New York, 1937), p. 51 (Modern Library Edition).

[23] The two outstanding examples are his short book *Hinduism and Buddhism* (New York, 1943), and "The Vedānta and Western Tradition" (1939), SP II.

ten lectures on Indian art and culture at the Fogg Museum in Cambridge under the auspices of Harvard University; in the same year he also lectured at Smith College and the University of Chicago. In 1923, to continue this brief selection of lecture engagements, he spoke on Buddhism at the Community Church in New York, and was also in Hartford at the Wadsworth Athenaeum and at University Museum, Philadelphia.[24] In 1928–1929 he joined the faculty of the New York University Graduate Division of Fine Arts as a visiting professor, giving a series of fifteen lectures on Indian art and culture. Perhaps his furthest professional sortie from Boston was to the Denver Art Museum in 1929, where he delivered six lectures on South Asian art. Coomaraswamy was acquainted with the sculptor Arnold Ronnebeck, who became director of the Denver Art Museum in that year; Ronnebeck had been in the circle of the photographer Alfred Stieglitz in New York, and Stieglitz was a friend of Coomaraswamy. Ronnebeck took the occasion of Coomaraswamy's presence in Denver to do a bronze portrait of him (Figure 24)—a portrait that reflects Coomaraswamy's state of mind in the time around 1929 with unsentimental accuracy.[25] However, looking at that portrait is a look beyond the salad days to which we must turn back, the years 1917–1925, when Coomaraswamy was involved in some interesting matters that we have not yet touched on, and was also just a little Roaring, like the Twenties.

In a letter of around the year 1920 to Mary Mowbray-Clarke, the co-owner of a small bookshop in New York City, Coomaraswamy wrote, "New York has come to seem like home to me!"[26] and in another note to Mary he commented, "I'm sorry I'm missing you all this time, as well as the various intellectual excitements in the way of Little Theaters, etc.... On the other hand I like working regularly in the Museum."[27] These letters express perfectly well the roles that New York and Boston played in his life during the first ten American years. Mary Mowbray-Clarke and her husband, the sculptor John Mowbray-Clarke, were among the first friends that Dr. and Mrs. Coomaraswamy made when they came to America. During the New York theater season of 1917, when Ratan Devī

[24] AKC's lecture engagements and similar activities are recorded in the Annual Reports of the Museum of Fine Arts, beginning with the issue for 1918.

[25] Mr. L. Anthony Wright, Jr., registrar of The Denver Art Museum, generously supplied not only a photograph of this work, but also a brief biography of the sculptor, who was a student of Maillol and Bourdelle before World War I.

[26] AKC, letter to Mary Mowbray-Clarke, October 29 (1920?), library of Professor William S. Wilson III.

[27] Undated.

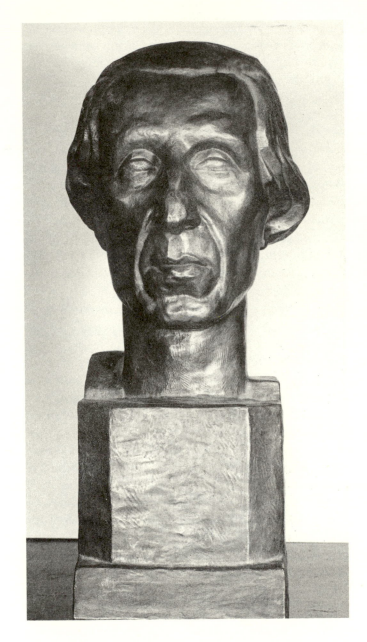

Figure 24. *Portrait of Ananda K. Coomaraswamy,*
by Arnold Ronnebeck, 1929.

was giving an evening of Indian music and dance in association with a Eurasian dancer, Roshanara, the Coomaraswamys had the opportunity to find many friends.[28] Bearers of something very old, traditional Indian culture, they nevertheless fitted without a twinge of discomfort into the artistic avant-garde of the day because they brought something genuinely beautiful and wholly unfamiliar. They were also rather daring. When they went down the street, he in a vast astrakhan coat and hat, she in a long, loose, unconventional outfit of the kind worn by their friend Isadora Duncan, they never failed to turn heads.[29] Coomaraswamy, through these years, was a winning mixture of extravagance and reserve: in company, it often seemed that he was not quite as involved as everyone else—he seemed to occupy his own atmosphere as much as the common one, to be a little withdrawn—but it was not snobbishness that made him so, and he was kind and gentle with others. Different people who knew him during these years have tried in different ways to describe this particular trait—what has just been said is partly in their words.[30] On the other hand, he had his own ideas about how to live, as will emerge when we see something of his New York life.

Coomaraswamy's marriage with Ratan Devī had started under a good sign, with strong common interests and early on a son, joined in 1914 by a little sister, Rohini. But by 1917 their marriage was in difficulty, and in a year or two they were living separately and subsequently divorced. Some of the essays that Coomaraswamy included in *The Dance of Shiva*, his popular book that brought him a measure of renown when it came out in 1918, were written during the late days of this marriage; they show him rethinking the whole question of marriage, comparing the traditional Indian view of it with what seemed to him realistically possible in the West.

Current Western theory seeks to establish marriage on a basis of romantic love and free choice; marriage thus depends on the accident of "falling in love." . . . This individualistic position, however, is only logically defensible if at the same time it is recognized that

[28] Cf. AKC, "Oriental Dances in America" (1917), and the autobiography of the dancer Ruth St. Denis (1939), pp. 246–247.

[29] This word portrait was given to the author by Rohini Coomara, the daughter of AKC and Ratan Devī, to whom thanks are due for several remarkable conversations.

[30] Dorothy Norman, in particular, evoked this quality of AKC both in conversation with the author and in a published account to be cited later in connection with Alfred Stieglitz.

to fall out of love must end the marriage. It is a high and religious ideal which justifies sexual relations only as the outward expression demanded by passionate love and regards an intimacy continued or begun for mere pleasure, or for reasons of prudence, or even as a duty, as essentially immoral; it is an ideal which isolated individuals and groups have constantly upheld; and it may be that the ultimate development of idealistic individualism will tend to a nearer realisation of it. But do not let us deceive ourselves that because the Western marriage is nominally founded upon free choice, it therefore secures a permanent unity of spiritual and physical passion.[31]

Impelled by the failure of two marriages, both of which had been conceived as permanent, Coomaraswamy found himself agreeing with that ideal of "isolated individuals and groups" who no longer really expected their love relationships to be permanent. He had also had to admit to himself that he was delighted by the company of women to a degree irreconcilable with a typical marriage. The freedom that he wished was recognized and accepted in the avant-garde New York milieu. At this point, Coomaraswamy's biographer finds himself treading the edge of a fall. The whole theme of love in the end means very little in Coomaraswamy's life. This may be just the reason why he had difficulty giving it a settled place and settling with just one woman. In his middle years he gives the impression of a man trapped by love, capable of making marvelous justifications of its power over men, of citing mediaeval Indian poems and praising the fullness of understanding that permitted so much eroticism in Indian sacred art, but all of this only concealed to some extent that he felt caught in "the storm of the world-flow," in frightful bondage to *saṃsāra*.[32] In his last twenty years or so, all of that was calmer and he was able to approach and truly live the more ascetic way of life to which he had been attracted early in life. No one who has written a book on *Buddha and the Gospel of Buddhism* and often expressed his admiration for the Hindu *sannyāsi* (the homeless wanderer, the religious hermit), can be thought to have been entirely at ease, in the depths of himself, "in the butterfly purlieus of Palm Beach and Fifth Avenue." On the other hand, he took joy in his freedom and was clear enough with himself not to be like the wolf that went one day to a priest and announced his intention to stop eating

[31] AKC, "Status of Indian Women," in *The Dance of Shiva*, pp. 103–104.

[32] "The storm of the world-flow," a phrase from Eckhart that AKC used occasionally to translate *saṃsāra*.

sheep: the priest performed a long expiatory service on the wolf's behalf; meanwhile a flock of sheep went by outside the church and the wolf could no longer contain himself. "Hurry up, Priest!" he said, "or I'll miss my dinner!"[33]

The theme of love means little in his life in the sense that he was finished with it before his great work began, and his more ascetic, externally calm life of the 1930s and 1940s bears no resemblance to "the calm after the storm": it was the storm itself, blowing inwardly. But in 1918–1920, that different mode of life was still far away, and he didn't wish it. The biographer's attention, as well as the reader's, is attracted by all the burning that he did in those years. It is obvious in his writings and other sources, and obvious also in what surrounds those years, a gossamer, gossipy material of *sous-entendus*, little reflections of younger colleagues who knew him when . . . and so on. But he loved knowledge more than women, and women probably loved him precisely for that reason.

Having given up on fidelity, he still loved one woman more than others during these years. Coomaraswamy met Stella Bloch, a girl of seventeen, at that time an untrained but gifted dancer, at a rehearsal for the Ratan Devī-Roshanara evening of Indian music and dance.[34] He was taken with her, she was frightened by him. As her cousins, the well-known art historian Richard Offner and his brother, the photographer Mortimer Offner, were at pains to point out to her, he was old enough to be her father. But she was a rebel, a candidate for the avant-garde, and ready to follow her heart toward this unique man, a notable scholar who somehow had the time, took the time, to pass through the labyrinth of love quite regularly. Coomaraswamy fell thoroughly in love with her but *à sa manière*, a manner hinted at in his essay in *The Dance of Shiva* on love in India, "Sahaja." He was admittedly in the labyrinth, but felt compelled to be as conscious as possible of his journey; love interested him, at the same time that he obeyed its laws.

> He . . . who merely *represses* desire, fails. It is easy not to walk, but we have to walk without touching the ground. To refuse the beauty of the earth—which is our birthright—from fear that we may sink

[33] This story is recorded in P. D. Ouspensky's account of the teachings of George I. Gurdjieff, *In Search of the Miraculous: Fragments of an Unknown Teaching* (New York, 1949, with later editions).

[34] Reconstruction of the beginnings of this romance and of the years following would not have been possible without the help of Ms. Bloch, who was kind enough to meet the author for several conversations.

to the level of pleasure seekers—*that* inaction would be action, and bind us to the very flesh we seek to evade. The virtue of the action of those who are free beings lies in the complete coordination of their being—body, soul and spirit, the inner and outer man, at one.

The mere action, then, reveals nothing. As do the slaves of passion impelled by purpose and poverty, so do the spiritually free. . . . When we say that Indian culture is spiritual, we do not mean that it is not sensuous. It is perhaps more sensuous than has ever been realized—because a sensuousness such as this, which can classify three hundred and sixty kinds of the fine emotions of a lover's heart, and pause to count the patterns gentle teeth may leave on the tender skin of the beloved, or to decorate her breasts with painted flowers of sandal paste—and carries perfect sweetness through the most erotic art—is inconceivable to those who are merely self-controlled. The Indian temperament makes it possible to speak of abstract things *même entre les baisers.*

For this to be possible demands a profound culture of the sexual relationship.[35]

Coomaraswamy and Stella Bloch became companions, but he could not convince her to join him in Boston. She felt at home in New York, where she could study dance, drawing, and painting; in later years she became a devoted painter. At about this time, Coomaraswamy became more interested than ever in photography. Photography considered as an artistic medium was still in a pioneer stage. He took hundreds of photographs of Stella and of landscapes, developing and printing them himself, entering some in exhibitions and photography annuals.[36]

Stella accompanied him to India and further East in 1920–1921, when she was only twenty. She recalls her passage from the rebellious, intentional ignorance of her youth to a wide appreciation of culture under Coomaraswamy's guidance. Two of her recollections from that voyage

[35] AKC, "Sahaja," in *The Dance of Shiva,* p. 130.
[36] Cf. for example, *Pictorial Photographers of America Annual* (1926–1927), Plate 9, photograph of Stella Bloch by AKC. It has not been possible to trace very many occasions when he participated in exhibitions of photography; his papers do include a print identified as an entry in a New York show in 1919, and also a checklist of photographs displayed under the auspices of The Boston Camera Club in 1931. These dates span the years of his greatest activity as a photographer and patron of photography. Thanks are due to Prof. Peter C. Bunnell, director of the Princeton Art Museum, for advice in this connection.

tie up loose threads in this narrative. When they were in Calcutta, some serious nationalist disturbances were taking place, rather violent ones. Several young nationalists approached Coomaraswamy, begging him to express his support of their activities publicly, but Coomaraswamy felt obliged to say no. Much as he thought them in the right, he disliked violence, and he may have feared for his own political security. His refusal kept him up nights. Again at Batavia, in Java, he was confronted with his past—or so he feared. When he and Stella arrived at the hotel, they were informed that the local police wanted to see them. Coomaraswamy was absolutely terrified; he had occasionally mentioned to his companion that he never wanted to meet up with Scotland Yard. They went down to the police station and were interrogated; it turned out that the police were looking for two communists and had made a mistake. Coomaraswamy's terror during these events is an oblique indication that he had never settled his accounts with the English courts of law that concerned themselves with war resisters.

Coomaraswamy and Stella were married in 1922, but agreed that she would continue to live in New York and he in Boston. They saw each other at intervals and spent summers together in Maine or Wyoming, traveled together in the East when the occasion presented itself. In 1924–1925, before or after a buying trip for the museum in India and the Far East, Coomaraswamy undertook to lead a tour of Americans around the Orient. Stella accompanied him as far as Shanghai, but returned from there. It was apparently a dismal trip. Coomaraswamy was ill adapted to the role and took less pleasure than he expected in explaining ruins. There is a photograph of him sitting disconsolately in the midst of his touring party on the steps of a temple.[37]

Coomaraswamy's New York life in these years—a kind of free fall, as unstructured and semi-bohemian as his life in Boston was orderly and earthbound—seems to have centered around The Sunwise Turn bookshop and the milieu that extended from it in various directions. The history of the bookshop has been charmingly written by one of its cofounders, Madge Jenison, in *Sunwise Turn: A Human Comedy of Bookselling* (New York, 1923). Madge Jenison and Mary Mowbray-Clarke dreamed of creating "a real bookshop . . . which would pick up all that is related to modern life in the currents that would flow in and out of the doors of such a shop, and make them available. . . . A bookshop of a different

[37] Princeton Collection.

kind . . . with a philosophy, a hundred of our favorite theories arrayed behind it."[38] In this spirit The Sunwise Turn Inc.—A Modern Book Shop was founded at 51 East 44th Street, in the Yale Club building. Mary Mowbray-Clarke, with her husband John, had been among the sponsors of the Armory Show in the winter of 1913, the famous "International Exhibition of Modern Art" that had given America its first highly publicized introduction to contemporary European art, particularly Post-Impressionism, the Fauves and Cubism.[39] John Mowbray-Clarke, a sculptor, had been involved from its inception in the Association of American Painters and Sculptors, which conceived and organized the exhibition. In 1911 he was on the committee that drew up the association's constitution, and a year later he was elected vice president, serving under its better-known president, Arthur B. Davies, the painter and graphic artist. Mowbray-Clarke and Davies each had works in the Armory Show, as did many other American artists. The Sunwise Turn Book Shop was founded in the aftermath of that show, which utterly changed the aspirations of American artists and for the first time created a public for contemporary art. Madge and Mary had been interested in color theory since a show of Post-Impressionists in 1915; they called on Arthur Davies to supply them with a decor for the shop based on the theory of chords of color. It turned out to be one of the most surprising interiors in New York; orange and related colors covered all available surfaces: walls, woodwork, and floor. And here, as the literary critic who recently rescued the archives of the bookshop puts it, "they did everything: James Joyce, Peruvian fabrics, color influence studies, Gurdjieff, handwriting analysis."[40] Their clientele included Eugene O'Neill, Ernest Hemingway, Havelock Ellis, Padraic Colum; the character Robert Cohn in Hemingway's *The Sun Also Rises* is modeled to some extent on the husband of a third partner in the shop. The Mowbray-Clarkes had a large house in Rockland County, north of New York, where they invited a great many people in the world of art and letters to spend long weekends. They had tents out on the grounds for guests that could not be accommodated indoors. The life of this rural salon does not seem to have been much described in the literature of the period, but it was surely intensely alive, intellectual, and in-

[38] Madge Jenison, *Sunwise Turn*, p. 3.
[39] Cf. Milton W. Brown, *The Story of the Armory Show* (New York, 1963); also "The Armory Show," *Art in America*, No. 1 (1963), special section for 50th anniversary of the event.
[40] Professor William S. Wilson III, in conversation with the author.

formal. Coomaraswamy loved it there—the house was called The Brocken —and often remarked in his letters to Mary how much he missed it and wished he had time to come down from New England. Mary and Coomaraswamy had a true friendship in these years, one that seems to have been off to one side of life: they watched themselves and others go through all kinds of ups and downs without creating any for one another. Coomaraswamy spent a rather lonely summer on his own in Maine, perhaps in 1919, trying from time to time to write a novel, writing to Mary in New York rather frequently; it is from these letters, preserved in Professor Wilson's little archive, that one gets an impression of their friendship.

John Mowbray-Clarke and Coomaraswamy were on good terms also. In 1917, the sculptor had done a profile portrait of Coomaraswamy, a relief medallion of a kind that he often made; this particular example was not very distinguished. In 1919, for a show in New York of Mowbray-Clarke's work that happened to include the medallion, Coomaraswamy wrote the exhibition notes. Coomaraswamy did not feel inclined to judge Mowbray-Clarke's work, but instead used the occasion to express some general thoughts.

> The two things that matter least about a work of art are its charm and its technique. What does matter is its necessity, and the quality springing from necessity which we appreciate in works of art that are truly original—that of immediacy. The only title to ideas is our ability to entertain them. Works that are original possess a life of their own aside from any question of "difference": and many a work that is traditional, influenced or plagiarised is more original than another that is conspicuously novel. It is romantic to believe the first kiss to be better than the last, or to discover spiritual value in a merely technical virginity. It is only love, and not the sequence of gestures that constitutes the truth of experience.[41]

The first part of this passage, concerned with originality, is indistinguishable from similar passages written during the 1930s and '40s. It represents that particular thought already come to maturity in his mind, although he would find more immediate and striking ways of expressing the thought. But the allusions to kisses, virginity, and so on, are typical of

[41] Kevorkian Galleries, *A Catalogue of Sculptures by John Mowbray-Clarke* (New York, 1919).

Coomaraswamy in his Roaring Twenties mood, going out of his way to find something that will *épater le bourgeois*, if ever so little.

These exhibition notes, like some other writings, indicate that he was coming to terms in these years with modern art. "The modern artist has to be his own priest, and has both to recognize the vital problems and to find his own solutions. But this apparent freedom demands at least as much obedience and self-forgetfulness as the most rigid hieratic art of the past." He also made some of his earliest remarks on abstract art, which he saw as an ascetic, idealistic reaction to the "art of luxury," whose purity was "not true to the earth." To make his point he quoted the Persian poet Rūmī:

> "Depart, learn Love, and then return before me,
> For shouldst thou fear to drink wine from Form's
> flagon, Thou canst not drain the draughts of the
> Ideal."

He then concluded: "Warning to all idealists: it is no less important to plant one's feet on the earth than to hold one's head in the air."

The Sunwise Turn Book Shop helped Coomaraswamy materially in a number of ways. Most important is that its press published *The Dance of Shiva* in 1918, the collection of fourteen "Indian essays." He had already published a book with Harvard University Press in 1917, *The Mirror of Gesture*, a translation of a Sanskrit treatise on Indian dance, and he surely could have given *The Dance of Shiva* to Harvard or to another large press, but his friendship with the Mowbray-Clarkes and his love of small presses made him prefer to work with the Sunwise Turn. The essays in this book, partly written specifically for it, partly revised from journal publications of the previous few years, represent the culmination of his career to that date as an art historian and critic of culture. They are civilized, graceful pieces, neither angry in tone nor excessively careful. He had learned to sound neither like a preacher nor like an English essayist of the old school. Here his ideas are given a first summation, not at all as dense nor as learned as the second summation of his later years, but extremely attractive and in no way contradictory to what he would later think. This book, still in print and easily found, has managed to survive in America as an introduction to Indian culture. The analysis of the iconography of Shiva dancing that he offered in the title essay was a

pioneer piece of work, improved upon since 1918, but not without acknowledgment of Coomaraswamy's original formulation.[42]

The Sunwise Turn Press also published in 1920 a collection of *Twenty-Eight Drawings* by Coomaraswamy, certainly the most *insolite, insouciant* and *invraisemblable* thing to which he ever set his name. These French explicatives are not beside the point, because the mood and subject of his drawings is quite French, and at this very time he was also trying his hand at writing love poetry in French; we shall discuss that shortly. For some time Coomaraswamy had rather lightheartedly, but still with enthusiasm, been doing brush drawings of various subjects. Like photography, it was a pastime, but he found that he was reasonably good at it it, and went into it thoroughly. The twenty-eight drawings are all devoted to the female nude or half-dressed, rendered in long, sinuous brush strokes that required definite virtuosity. The mood of the drawings ranges from cheerful sensuality, through Modigliani-like charm, to Maillol-like weight and dignity (Figure 26). Printed on rice paper with a string binding in the Japanese manner, the portfolio was a luxury item, a caprice apparently intended for the small circle of the Sunwise Turn's friends. Coomaraswamy doubtless knew Maillol's work, but it seems unlikely that he in fact knew of Modigliani, although an acquaintance of his from the *New Age* circle in England, Beatrice Hastings, became Modigliani's mistress during the war years and may have familiarized some of her English friends with his work. Coomaraswamy had his own French associations; he had contributed an iconographic note to a French publication on Indian sculpture whose principal text was by Auguste Rodin. This book had been prepared before the war, but was published only in 1921.[43] The collaboration between Coomaraswamy and Rodin, indirect as it was, suffices to account for Rodin-like drawings among the *Twenty-Eight*. But in spite of all these French associations, he was working primarily out of the Rajput tradition, whose brushwork he had described in 1918 in terms that apply, technically speaking, to his own: "Free strokes of the brush with astonishing mastery carry down in a single movement the lines of drapery flowing from head to foot, outline the features, or follow the whole contour of the body."[44] Within north Indian painting, there is even a specific tradition to which Coomaraswamy's work seems closely related, the school of

[42] Cf. Jose Pereira, *Journal of the Asiatic Society of Bombay*, XXX (1955), 71–86.
[43] AKC, "Notice sur l'entité et les noms de Çiva," in *Sculptures çivaïtes* (1921).
[44] AKC, "Rajput Painting" (1918), p. 50.

Figure 25. *Portrait of a Girl,*
by Ananda K. Coomaraswamy.

Figure 26. *Looking Down,*
by Ananda K. Coomaraswamy.

Kalighat painting, associated with artists along the route toward and at a temple of Kali near Calcutta.[45] Coomaraswamy in his years at Calcutta could hardly have avoided seeing Kalighat works, and his friend Ajit Ghosh, an art dealer, was probably already building his private collection of Kalighat art. One of the major themes of these painters was Woman, celebrated in all her attractiveness and sensuality, in keeping with the bright aspect of the goddess Kali. Their uncolored brush drawings, like the illustration here from the Ghosh collection (Figure 27) have

Figure 27. *Kalighat Drawing*, Indian, 19th century.

a marvelously gifted, improvised quality. In technique and spirit they are strikingly close to Coomaraswamy's drawings, and are certainly superior to them.

The literary equivalent of *Twenty-eight Drawings* is found in Coomaraswamy's *Three Poems*, originally published as *Poems and Epigrams* by the Sunwise Turn Press in 1918, as no more than a Christmas gift for

[45] Cf. Ajit Ghosh, "Old Bengal Paintings," *Rupam* No. 27/28 (1926), pp. 98 ff.; and W. G. Archer, *Kalighat Drawings from the Basant Kumar Birla Collection* (Bombay, 1962) (formerly Ajit Ghosh Collection).

his friends and acquaintances. But *Spirit and Flesh*, published in England in the same year with a woodcut by Eric Gill, was a more formal publication, although still minuscule.[46] Coomaraswamy had translated a good deal of poetry, typically working with a person who knew Persian, Sanskrit, Hindi, or Icelandic well and transforming their literal versions into poetic English.[47] This was his preparation for writing original verse. The eloquence of his prose has already been amply illustrated and will be apparent again. His poetry is negligible, and one does not wish to find oneself either paying overmuch attention to a Christmas gift or deploying the Horses of Instruction to trample it. Of the three poems, "La Beauté de ma Belle" is less quotable than "Body and Soul," a few lines of which go as follows:

> Beloved Undrest,
> What uttermost rest
> On thy woman's breast.
>
> Breast to my breast
> So nearly prest
> To share Love's rest.
>
> Say not in jest
> In East or West
> Aught else were best.

This versifying by the pioneer author of *Rajput Painting, Buddha and the Gospel of Buddhism,* and *The Dance of Shiva?* History keeps record of such things just as impartially as it records significant events. The epigrams that accompany the poems are more recognizably Coomaraswamy: *The world is the unknowable as we know it; Every meeting is a meeting for the first time and every parting is forever; To compare is immoral.* There is some weight in these, and an aphoristic style which was one of his legitimate weapons in the writings of his later years.

In 1920, when Coomaraswamy was preparing for the trip to the East that yielded many new acquisitions for the Boston Museum, he conceived a business venture in partnership with a bookseller, George M. L. Brown. Certainly inspired by the Sunwise Turn Book Shop, they opened a bookshop in New York City known as Orientalia, where books on the East

[46] Biblio. No. 203 in the *Working Bibliography.*
[47] Biblio. Nos. 30/103, 131, 157, 178, 182, 219, 228, 263, 264, 283 in the *Working Bibliography.*

were sold, but also works of art and craft that were either on hand or sent by Coomaraswamy as he traveled. The original subtitle of the shop, "A Clearing House for Asian Literature and Art," was changed a year later to the words still associated with Orientalia, "The only shop in America dealing exclusively in books on the East." Coomaraswamy supplied it for the first few years with books and art; for example, a letter written in the spring of 1921 refers to some Javanese batiks that he had shipped home.[48] When he left for the East in 1920, he apparently had not yet seen the shop. He wrote back to Mary Mowbray-Clarke from Japan in October: "I hear you visited Orientalia—is it interesting and does it seem promising, do you think? There is such a big field to cover, and no bookseller in America with the special knowledge, that I think there *must* be room for such a place."[49] He was justified in his hopes. Orientalia has now existed for more than fifty years and remains one of the few bookshops in New York City with an atmosphere.

Coomaraswamy himself had an impractical side; he was certainly better at thinking of good business ideas than at carrying them out. By 1923, he had withdrawn from the partnership with Mr. Brown, who seems to have been much relieved. Brown wrote to Mary in late 1923: "Orientalia, after a stormy career, largely the result of Dr. Coomaraswamy's erratic attitude toward it, is at last settling down to a steady and I hope lucrative future. . . . You probably know that Dr. Coomaraswamy has sold his interests. We remain, however, excellent friends—better probably than when we were partners."[50]

Many of the events that we have just been following are of a mixed nature: they are full of life but a little unbecoming. In one sequence of events, Coomaraswamy fulfilled something more like his essential role. Probably through the Mowbray-Clarkes, Coomaraswamy met the photographer Alfred Stieglitz, who had worked with them in preparing the Armory Show and who was in his own right perhaps the most far-sighted gallery owner in New York.[51] Stieglitz was born in New Jersey, but began

[48] AKC, letter of 13 May 1921, library of Professor William S. Wilson III.

[49] AKC, letter of 1 October 1920, *ibid.*

[50] G.M.L. Brown, letter to Mary Mowbray-Clarke, 26 December 1923, *ibid.*

[51] The relationship between AKC and Alfred Stieglitz has already been well studied by Carl Siembab, "Alfred Stieglitz," *Photography Annual 1969* (New York, 1968), pp. 10–11. The present account nonetheless adds hitherto unpublished material. For a good bibliography both of Stieglitz's writings and of works about him through 1965, cf. Doris Bry, *Alfred Stieglitz: Photographer* (Boston: Museum

his photography in Germany in 1883 during a period of study at the Berlin Polytechnic. The controversy as to whether photography is an art or merely a means of mechanical reproduction was stirring in this period, and it became Stieglitz's life work to demonstrate through his photographs that the former is true. By 1902 he was engaged in the archetypal struggle of the creative innovator who meets indifference and antagonism in the world around him. He carried on the struggle with flair and a kind of innate wisdom. He opened a gallery in New York in 1905 for the exhibition of works by his group, the Photo-Secession, but in 1908 he also began to exhibit contemporary works of painting and sculpture. A letter written by Stieglitz to Coomaraswamy in 1924 continues this account of Stieglitz and his gallery, "291":

> In trying to establish photography as an idea I ran into the world —and good and hard *up against it*—I had to analyze every encounter— to understand its significance. So I invited encounter. I ever moved ahead as a scientist. To establish and then to destroy what I had established if it could be destroyed. If it couldn't, something of value . . . had been established. It has been slow work. "291" was a laboratory for me. There for fourteen years I "examined" the world of "art" as well as the world itself. There I could try out photography and teach myself to go ahead and photograph my photographs—It was there that Cezanne and Picasso, Matisse, . . . Brancusi, Henri Rousseau and other "moderns" of France were first introduced to the American public—and *that* before they were introduced to London. "Examining" them was part of the process of examining photography.[52]

Coomaraswamy first met Stieglitz at length in early March 1923, although they were acquainted with each other earlier. He and Stella spent the evening at Stieglitz's house, and he found himself enormously impressed by the photographs there. He wrote to him shortly after that evening, "I have never before had a good opportunity to see your photo-

of Fine Arts, 1965), pp. 25–26. The present study of AKC's friendship with Stieglitz was enriched by conversations with Professor Peter Bunnell and Dorothy Norman, author of *Alfred Stieglitz: An American Seer* (New York, 1974), as well as of other works about the photographer and his circle.

[52] Alfred Stieglitz, letter to AKC, 14 February 1924, Stieglitz Archive, Bienecke Library, Yale University; ellipses are Stieglitz's. The correspondence between AKC and Alfred Stieglitz is quoted by permission.

graphs: they were quite a revelation and are totally different from all others!"[53] In the weeks following that evening with Stieglitz, Coomaraswamy inquired in the museum as to whether its trustees and curators would favor beginning a photograph collection in the print department. His strongest ally was John Ellerton Lodge, like himself a member of the Asiatic department. Coomaraswamy asked Stieglitz if he would be willing to offer twelve prints as a gift to the museum. Stieglitz not only agreed but later decided to offer a series of twenty-seven prints, while the museum, on its side, "in spite of the fact that photography as art is rather unfamiliar to most of our Trustees,"[54] as Coomaraswamy wrote Stieglitz, decided in favor of the gift.

On February 6, 1924, the day when the prints were shipped from New York to Boston, Stieglitz put a note in the mail to Coomaraswamy: "I hope the prints will give pleasure and above all that you will be satisfied with the group. It represents much thought and a great deal of work. I'm curious to hear whether your friends will feel that you have overstated the 'case.' "[55] On the following day, Coomaraswamy replied: "All the pictures forming your magnificent gift arrived safely. We are very glad that you framed them. Everyone who has seen them has been *properly* impressed. They will be shown at the Trustees' meeting this afternoon and be exhibited before long."[56] Coomaraswamy's transformation of the cliché "properly impressed" into a term reflecting the idea that there is a norm, a single appropriate response to a good work of art, is characteristic of the best of his thought. "*Properly* impressed" implies an inner pattern, a series of more or less specific psychological experiences that effective works of art are meant to evoke. One gathers that he was satisfied by the responses of his colleagues in Boston.

To accompany the exhibition of Stieglitz's work, planned for the spring of that year, Coomaraswamy had the idea that it would be good for Stieglitz to come to Boston to lecture on photography, but he found himself obliged to beat a hasty retreat from that initiative. He sent a note about it to Stieglitz: "I am advised it is better to let things stand as now without inviting you to lecture—the Trustees opposed to Photographs might feel themselves being too much pushed and the final result be adverse."[57]

[53] AKC, letter to Alfred Stieglitz, 4 March 1923, *ibid.*
[54] AKC, letter to Alfred Stieglitz, 25 April 1923, *ibid.*
[55] Alfred Stieglitz, letter to AKC, 6 February 1924, *ibid.*
[56] AKC, letter to Alfred Stieglitz, 7 February 1924, *ibid.*
[57] AKC, letter to Alfred Stieglitz, 7 March 1924, *ibid.*

A few months before the exhibition, Coomaraswamy put a brief article in the museum *Bulletin* that reflects not only a technical knowledge of photography but also a great deal of thought concerning its intrinsic nature and significance. He had thought through to a way of linking photography with the philosophical basis of all the arts that he called traditional.

> Mr. Stieglitz' work well illustrates the fundamental problems of the photographer. . . . The peculiar virtue of photography, and at the same time, in the hands of a purely mechanical operator, its severest limitation, is its power of revealing all textures and revealing all details. The art of photography is to be sought precisely at this point: it lies in using this technical perfection in such a way that every element shall hold its place and every detail contribute to the expression of the theme. Just as in other arts there is no room here for the nonessential. Inasmuch as the lens does not in the same way as the pencil lend itself to the elimination of elements, the problem is so to render every element that it becomes essential; and, inasmuch as in the last analysis there are no distinctions in Nature of significant and insignificant, the pursuit of this ideal is theoretically justified. A search for and approach to this end distinguishes the work of Alfred Stieglitz.[58]

The kind of thought displayed in this article—"inasmuch as in the last analysis there are no distinctions in Nature of significant and insignificant," and so on—is a foretaste of his thought in the 1930s and 1940s. It is only a convenient fiction that he became quite another man in those later years: the constituents of that other man are already present in the 1920s, although they needed refining. He matured alchemically; the *materia prima* was anything but lead, but it was not gold either.

Stieglitz resented to some extent that he had been obliged to make a gift of his work to the museum,[59] but the acceptance of his work there represented, in the words of a scholar who knows the Stieglitz "question" well, "a major battle . . . won in Stieglitz's lifelong war for the recognition of photography as an art."[60] Boston was the second major museum to accept photography—preceded by Buffalo, followed a few years later by

[58] AKC, "A Gift from Mr. Alfred Stieglitz" (1924). Cf. also AKC, "Photographs in the Print Department" (1923).

[59] Cf. *The Metropolitan Museum of Art Bulletin*, XXVII:7 (1969), issue devoted entirely to "Photographs in the Metropolitan," esp. pp. 334–337.

[60] Doris Bry, *Alfred Stieglitz*, p. 9.

the Metropolitan Museum of Art in New York City. Stieglitz and Coomaraswamy remained in touch with each other throughout their lives, although they were closest during the 1920s. They were both born fighters, and yet profoundly philosophical. Stieglitz had the same degree of intellectual energy as Coomaraswamy; they differed in that Stieglitz was essentially an artist who found the elements of his philosophy in his own experience. His wisdom was based on a knowledge of the experience of seeing and of all that is required for seeing to be possible again and again. Coomaraswamy, on the other hand, was essentially a scholar and a man of letters. His truth came in part from a powerful conscience whose seeds were sown by William Morris, but even more, in his later years, from poring over the religious writings of the world and recognizing, step by step, that his own nature and hence all men's natures were constituted along the lines that the texts affirmed.

To close this account of the relations between Coomaraswamy and Stieglitz, we should look at the minutes of a conversation that took place in 1928. Dorothy Norman, who was close to Stieglitz by that time and has since written several books about him, found herself facing Coomaraswamy.

I asked Coomaraswamy which modern artists in America he admired. He replied, "Not any. And no Europeans either. The very term *modern art* is an absurdity. The notion that one should attempt to be original in art is sheer nonsense."

"What," I inquired, "do you feel about Stieglitz's photography?"

Coomaraswamy replied at once, and with great enthusiasm, "His work counts. He is the one artist in America whose work truly matters."

Mystified, I asked why this should be so, since Stieglitz was no more of a "traditionalist" in the strict, Hindu sense of the word, than were any of the modern artists whose work he championed, and whom Coomaraswamy deplored. "Stieglitz's photographs," said Coomaraswamy, "are in the great tradition. In his work, precisely the right values are stressed. Symbols are used correctly. His photographs are 'absolute' art, in the same sense that Bach's music is 'absolute' music."[61]

There is no further record of Coomaraswamy's views on Stieglitz. The term "absolute" art is not one that he retained in later years, although

[61] *Ibid.*, p. 48.

some of his essays, such as "*Saṃvega*: Aesthetic Shock,"[62] are about nothing other than "absolute" art. But the term is awkward; he found a more subtle way of dealing with the question of kinds of art, particularly with the kind that is "charged with . . . significance."[63]

In the years 1917–1927, there remain now just a few tales to be told. Coomaraswamy did on occasion during these years express his views on America, but it seems best to reserve a brief study of them for later. He also wrote some articles in collaboration with his wife, for the most part about Oriental dance and theater, although one mutual foray into art theory published in the *Art Bulletin*, in 1923, should be mentioned.[64] It is a mixed piece, in part as subjective and arbitrary as the writings of the run-of-the-mill art critics whom Coomaraswamy abhorred. Legitimate experiences and observations are caught up in a polemic that tends merely to produce its opposite in the reader: to the authors' Yes, we say No. This was always a danger in Coomaraswamy's writings.

In spite of all the conflicting movements and activities in this period, Coomaraswamy concluded it in a state of intellectual stability. 1927 saw the publication of his *History*, and also his long article on "The Origin of the Buddha Image," in the *Art Bulletin*, the chief art journal in the United States. Just as the *History* was a late offering, in view of the fact that Coomaraswamy was engaged in the field nearly from its inception and had seen several general histories published, so too his study of the Buddha image, in which he presented evidence for its Indian origin, came many years after the beginning of the controversy. Nowadays the question of priority between the Greco-Roman Gandhāra images of the Buddha and the works of the Mathurā school, which developed from Indian sources, is no longer burning. The late Professor Benjamin Rowland, Jr., a close friend of Coomaraswamy's in the 1930s and 1940s, who more recently reassessed the history of the Buddha image,[65] expressed the view that it matters very little which school had temporal priority, and he saw no reason for the Buddha image not to have been created simultaneously in the north and further south, in response to the same demands and following the same iconographic formulae.[66] But in order to reach calm, historians passed through decades of controversy.

[62] 1943; cf. SP I. [63] AKC, *Asiatic Art* (1938), p. 8.

[64] AKC's collaborative works with Stella Bloch comprise Biblio. Nos. 250, 259, 278 in the *Working Bibliography*. The study of art theory is "The Appreciation of Art" (1923).

[65] Benjamin Rowland, Jr., *The Evolution of the Buddha Image* (New York, 1963).

[66] Conversation of the author with Professor Rowland.

XII. 1928–1932: *Tapas*

Tapas "is precisely Hebrew *zimzum*. *Tapas* is not a penance, because not expiatory, but rather an anguish and a passion: a dark heat of the consciousness, a kindling not yet a flame, or to take an analogy from Physics, a raising of potential to the sparking point. Notions of a smouldering continence and intellectual fermentation, as well as of a vegetative incubation, are implied."[1]

It is easy enough to see what Coomaraswamy became in his late years (1932–1947): that man can be described, his interests and passions, his friends and way of life form a pattern. It has already been possible to characterize Coomaraswamy in his younger days, that is, until 1927 or thereabouts. What is difficult to follow is his transition from the first state to the second. New subjects interest him, and there is a change in the quality of his thought; it has a new intensity, a new sense of purpose accompanying new purposes. But by such reflections we already cheat, because they describe the results of transition, not the transition itself. Coomaraswamy himself does not supply the needed insight except in a very general way. His evocation of *tapas*, for example, written just after he had entered into the new phase of his work, seems in its fullness to be more than a scholar's definition: it is both a commentary on his own life and an appeal to himself to enter ever more deeply into the creative state of *tapas*. It is an ambiguous state in which contraries are close to each other: a kindling not yet a flame; an unruly fermentation but also a passive incubation.

Coomaraswamy's external life changed again at about this time. His marriage with Stella, conceived free-style and obviously a source of happiness in its prime, declined into old age far more quickly than either of its participants, and terminated in divorce in November 1930. Stella remarried not long after, and moved to the West Coast. The young rebel

[1] AKC, *A New Approach to the Vedas: An Essay in Translation and Exegesis* (London, 1933), p. 10.

found a good marriage, had several children, and settled into her work as a painter. Coomaraswamy, on his side, remarried in the same month that the divorce became final. *The Boston Morning Globe* for November 18, 1930, reported to its readers that "A romance that had its beginning among the relics from India at the Boston Museum of Fine Arts was climaxed today by marriage." In fact, Coomaraswamy seems to have met Doña Luisa Runstein, his bride of twenty-five years of age, at a Communist rally in Cambridge where Harry Longfellow was the principal speaker.[2] A woman of Jewish origins whose family had settled in Argentina, she came to the United States at sixteen, and by the time she met Coomaraswamy was engaged in a career as a Boston society photographer under the professional name Xlata Llamas. Their marriage proved to be a fruitful and lasting one, and seems to have lifted him out of a period of ill-health and discontent that one can only see obliquely, through the Ronnebeck portrait (Figure 24), in photographs (such as Figure 28), and in family recollections. Doña Luisa bore him a son in 1932, whom they named Rama, and at about this time they acquired the home in Needham, Massachusetts, outside of Boston, where they lived for many years (cf. Figure 29).

Coomaraswamy had gone as far as he wished in the writing of history with his *History of Indian and Indonesian Art*, and while he continued to do some historical studies out of interest and in response to the requirements of the Boston Museum collection, he turned his attention increasingly to iconography. As a tool that could both serve the purpose of iconographic study and perform independent work, he developed his knowledge of Sanskrit and Pāli philology, and in the course of the early 1930s also strengthened his Latin and Greek, and took them too in the direction of philology, the study of the root forms, evolution, and meaning of words. In 1933, as part of a general shift in the Asiatic department at the museum, he was given a new title, Fellow for Research in Indian, Persian, and Mohammedan Art. In effect, this meant that he had fewer curatorial responsibilities and all the freedom he wished to pursue his research.

The year 1928 marks the beginning of his intensive work on Indian iconography and philology (and terminology—one of his publications in this year is an annotated list of Indian architectural terms).[3] This period corresponds to his *tapas*, the inner transformation that escapes our direct

[2] Conversation of the author with a member of AKC's family.
[3] AKC, "Indian Architectural Terms" (1928).

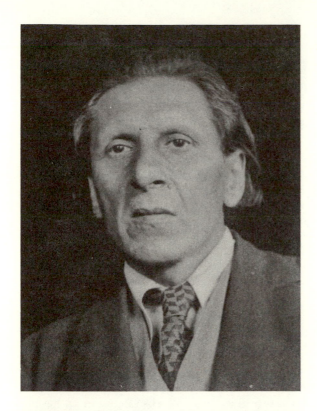

Figure 28.
Coomaraswamy, ca. 1929.

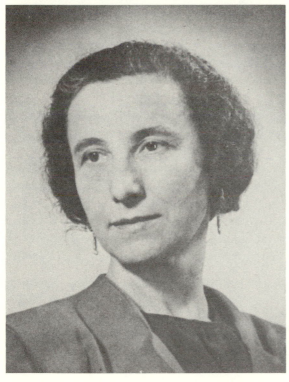

Figure 29.
Doña Luisa Coomaraswamy,
ca. 1940.

vision but whose results are evident in the writings of 1932 and thereafter. He also undertook an intensive study of the Vedas, the earliest Hindu scripture and the first literary appearance of the Brahmanical gods. The conclusion of this period of transition in his intellectual life is most clearly marked by the publication of a work devoted solely to interpretation of the Vedas: *A New Approach to the Vedas: An Essay in Translation and Exegesis* (1933). With this publication, his interest in metaphysics and religion, independent of art history, reasserted itself and took a central place in his inner life and the life of his writings until the end. His movement from the history of art, to the iconographies transmitted by history, to the meanings transmitted by iconography and scripture, was a gradual process of interiorization. Or, to put it in another way, according to a traditional analogy that Coomaraswamy often mentioned, he moved upstream to the source: from material history awash with the monuments of religious architecture, some in good repair, some in ruins; to the myths, images, and symbols that these monuments were intended to display; and then to the doctrines themselves that are the source of iconographies.[4] On the other hand, he did not abandon former interests as this process continued; for example, the clearest statement of his view of the function of museums was a lecture given in 1941.[5] His interest in art never disappeared; visual symbolism appeared to him in his late years to be "the language *par excellence* of metaphysics," providing an "alternative-formulation" (to use a Buddhist term that he valued)[6] that could not be neglected and has specific expressive powers of its own. "Moving upstream" can be a vainglorious occupation when the traveler forgets that the source is there for the stream, in a certain sense; but conversations about pure headwaters and the pollution of things and people downstream, which seem to be an occupational hazard in metaphysics, never strongly tempted this son of the craftsman William Morris.

And so everything continued—articles on works of art for the museum *Bulletin*, studies of the Oriental theater, special projects such as articles for the *Encyclopedia Britannica* and exhibition notes for an American showing of Rabindranath Tagore's paintings; but added to this was a new, highly detailed mode of iconographic study dealing largely with early iconographies. The most important of these studies was *Yakṣas*,

[4] For references to this analogy, cf. AKC, "Some Pāli Words" (1939), SP II, 324–325.

[5] AKC, "Why Exhibit Works of Art?"

[6] Cf. AKC, "Some Pāli Words," SP II, 314n; 315–316.

published in two parts by the Smithsonian Institution in 1928 and 1931; but there were also series on "Early Indian Iconography" and "Early Indian Architecture."[7] The originality of the series on early architecture was to study and illustrate representations of architecture as they figure in the relief sculpture of existing monuments; the method was iconographic, but the result was architectural history.

Yakṣas is the most obviously *transitional* work from this period. It is divided into two parts: the first, published in 1928, seems to have been intended to be complete as it stood; it was not a "Part I" with more to follow. But in the interval between 1928 and the appearance of Part II in 1931, Coomaraswamy rethought his topic and found a reservoir of iconographic and literary material that permitted him to reconstitute a pre-Vedic water cosmology with which the Yakṣas, a whole series of pre- and non-Vedic popular divinities, were intimately associated. The scope of his work enlarged greatly: not only did he attempt to present the cosmology to which such passages as *Bṛhadāraṇyaka Upaniṣad* v.5 refer ("In the beginning this world was just water"), but he intended also to present the iconography of that elaborate cosmology in orderly fashion.

It has never been a purpose of this study of Coomaraswamy's life and writings to recapitulate his knowledge: in relation to a technical Indological study such as *Yakṣas II*, it would be in any case impossible without a major digression. Its place in the development of Coomaraswamy's work should be evoked, however, perhaps best by an iconography—an image: it can be imagined as an opaque container filled with his new concern for metaphysics and religious doctrine, but not directly revealing it. Scholars often have a way of concealing their deepest motives for doing a particular piece of objective research; their research may at times even shine with the power of deeper motives. The vivacity of the mind that moves among data lightly, cleverly, with purpose, is often due to a motive that is only reflected but not revealed by the nature of the subject under discussion. For example, a brilliant historian of Christian architecture thinks of himself as an atheist with only a professional interest in the forms of Christian building, but in his heart of hearts he is undoubtedly a religious man who merely never mentioned to his pupils, nor perhaps to himself, that it is so. Coomaraswamy did not settle into this inner configuration, which may be more characteristic than one would think of Western scholars who study the religious cultures of the

[7] Biblio. Nos. 313, 325, 340, 359, 378, 379, 381, 399, 400 (cf. 401) in the *Working Bibliography*.

past, because his Eastern background really provided no justification for
remaining in it. The Hindu scheme of life provides for and urges a man
who has fulfilled his worldly obligations—raised a family, and so forth—
to turn his attention to religion with more intensity than in his younger
days, and the validity of religion is not impugned at any age. At the age
of fifty-six, in 1932, Coomaraswamy was no longer a young Householder,
as the Hindus call a family man, although he was surrounded by a young
family.

The description of Coomaraswamy's iconographic studies as mere con-
tainers for motives that would come to more direct expression should not
imply that Coomaraswamy considered scholarly studies of other cultural
forms to be inferior to theology or metaphysics. He remained an extremely
close and meticulous student of art, iconography, philology, and myth
to the end of his days. His late mysticism was not of a kind that simplifies
the inner and outer world. On the contrary, he had a great appreciation
of the complexity of the created world and of man as a part of it—a created
world not limited only to material facts, but including also spiritual facts:
myths, symbols, images, and structures of the inner life, through which
the Voyager must pass.

Coomaraswamy's transformation in the period 1928–1932 remains diffi-
cult to describe. Certainly an element in it, whether result or cause hardly
matters, was a new awareness of death. His life through most of the
1920s we have described as the apogee of a parabolic flight, a free moment
neither climbing nor decending; but by the beginning of the 1930s this
was no longer his place on the curve. One of the earliest writings that
bears the stamp of his late work is a study of the Indian conception
analogous to the Christian Last Judgment. "Mahā-Pralaya and Last
Judgment" appeared in 1932, an intense and lucid account of "the voyage
of the individual after death," in which for the first time Coomaraswamy
used a characteristic mode of presentation: he condensed, paraphrased,
and collated a series of Indian texts, referring frequently to the key
Sanskrit terms at the same time that he gave his own understanding of
the texts through a running account that is technically philosophical yet,
for instants at a time, poetic and felt. A key passage in the essay will be
quoted at greater length than usual for reasons that will become apparent:

Vedic tradition envisages the voyage (*yāna*) of the individual after
death as a passing *on* from one plane of being (*loka*) to another; and
though there is the possibility of perpetuity (*sthāyitā*) on any given

plane until the End of Time (*kalpānta, mahā-pralaya*), there is no conception of the possibility of a return to any past state. . . . More exactly, there are two different courses that may be followed: the Angelic (*devayāna*) in the case of the individual whose ship is Knowledge, and the Patriarchal (*pitṛyāna*) in his case whose ship is Works (*karma*) done with a view to reward. In the former case the individual passes by way of the "Sun" and therebeyond to the Supreme Self and the Unground: in the latter, he reaches only the "Moon," and in due course thence returns to a new corporeal state in a subsequent sub-Time (*manvantara*), when the choice of routes again presents itself. What follows here, however, does not take account of this distinction of routes, but rather of the distinction between those who on the one hand are borne on either by Understanding or by Works, being equally Wayfarers, and those on the other hand who, having neither understood nor yet wrought, the Last Judgment finds not merely unannihilate but also without merit. . . . Though the possibility of Gradual Enfranchisement (*krama-mukti*) is open to the Voyager, there is also the possibility for him whose ship is rudderless, or wrongly steered, to wander on uncharted courses toward an unknown landfall, farther and ever farther from the Quay (*ghāṭ*), so far and so long that he may not be in sight of Yonder Shore when every hither shore and every vessel is dissolved at the End of Time. So at the End of Time there is a departing of the Freed (*mukta*) and Egobound (*māna-baddhaka*). In Christian tradition this is called the Last Judgment.[8]

For readers well acquainted with Coomaraswamy's writings, this passage will provide a shock of recognition. Emancipated from his many personae—the stresses, experiments, confusions, and even brilliant achievements of the past—there has appeared the Coomaraswamy of the next fifteen years. The new synthesis is complex, but most of its features are already evident. For example, Coomaraswamy had begun to think in the 1920s, and was convinced in his later years, that man can only *entertain* ideas. "There is no private property in ideas," he would say, in part as a stratagem of his life-long attack on the deliberate subjectivity of modern artists who try to be "original," in part as a nonviolent acknowledgment that no man invents a truth, he can only discover it—admittedly he will express it in his own way, but with as little distortion as possible

[8] AKC, "Mahā-Pralaya and Last Judgment" (1932), pp. 14–15.

if he is true to his truth. This conviction of Coomaraswamy's, no mere thought but a matter of conscience, influenced the way he expressed the traditional Indian or Christian view of man: he tended to *entertain* the concepts and images he needed for a particular exposition without possessing them unduly, without elaborating for effect. He presents an image, such as "the individual whose ship is Knowledge," without exploiting its emotive potential; he has more to say and he goes on, allowing the image to do its own work on the reader, just as it previously had an effect on himself when he found it in a text. His writings at such moments are emotional but unsentimental. For Coomaraswamy as an author, and surely as a person, this indicates that he had reached a new solidity, a more sensible distribution of his inner events than he had in younger days. The lyric poet in him had abandoned its claim to leadership, but in its place there appeared something akin to a chess master, pursuing his study of the game without losing his detachment even when one or another move is exciting, beautiful, or playful: being excessively touched at any point would cause a dangerous loss of perspective and perhaps set the whole game awry. The only defect in this analogy for Coomaraswamy's new attitude lies in the idea itself of a game. He never *played* with ideas, in the ordinary sense of the word.

On the other hand, because he was a man he sinned regularly against the new order that he had realized as a thinker. If he could sustain in much of his writing a remarkable objectivity, by the time he arrived at the Boston Museum he was humanly content to have done this much. In the brilliant portrait of Coomaraswamy in his later years written by the art historian Eric Schroeder,[9] who knew him very well, we hear that Coomaraswamy was innocently cheerful as each new article came off press and made sure, in a delightfully obvious way, that his friends and acquaintances knew where to find them. This is an anecdote worth remembering when we discuss Coomaraswamy's interpretation of "traditional psychology." People who do not have a psychology are the only ones who do not bother with trying to understand psychology, and Coomaraswamy always had one to worry about. He was able to rise above it on occasion, *for occasions*, as he would say. He thought that all valid art is occasional, a response to a more or less explicit need at a definite time and place. His writing, needless to say, was his art; thinking, too, but his practice of that art is recorded only in his writing.

[9] See the Appendix to this volume, where the Schroeder memoir is reprinted in its entirety.

"A raising of potential to the sparking point"—so far, we have spoken of Coomaraswamy's transformation during these years as an exclusively internal development, a realignment of the Eastern and Western parts of his nature, a scholar's more and more definite response to the call to know God; we have also spoken of it as an event in the process of aging, a falling away of a certain amount of nonsense that permitted Coomaraswamy a clearer view of himself. We have yet to speak of an external influence that was strong: the example of René Guénon. René Guénon (1886–1951) is not well known in the United States, although some of his important writings have been translated into English.[10] In France, since the appearance of his first book in 1921 he has always had a small audience, which has grown considerably in the past ten years with the posthumous republication of a great many works. Coomaraswamy's first written statement on Guénon accompanied a translation, published in 1935, of a chapter from Guénon's book, *La Crise du monde moderne* (Paris, 1927). In general one can know which foreign authors intensely interested Coomaraswamy by seeing whom he translated; this was true in Coomaraswamy's youth, when he translated Tagore and earlier Indian poets, and true in his maturity, when he translated particularly Guénon and Walter Andrae, a German archaeologist of profoundly philosophical temperament.[11] Coomaraswamy's approach to the Vedas and other Indian scripture was also to translate; the result that he sought in such work was a correct translation and appropriate commentary. Through his translation of Guénon in 1935, published in an Indian quarterly connected with Tagore's International University at Santiniketan, he was trying to introduce to the Indian public a man whose thought was in essence Indian. He prefaced his translation as follows:

The translator holds that no living writer in modern Europe is more significant that René Guénon, whose task it has been to expound the universal metaphysical tradition that has been the essential foundation of every past culture, and which represents the indispensable basis

[10] Guénon's works in English translation include *East and West* (London, 1941); *Crisis of the Modern World* (London, 1943); *Man and His Becoming According to the Vedānta* (London, 1945); *Introduction to the Study of the Hindu Doctrines* (London, 1945); and *The Reign of Quantity and The Signs of the Times* (London, 1953). A good study of Guénon's life and work is by Paul Sérant, *René Guénon* (Paris, 1953). Some of the major essays are now easily available in paperback editions.

[11] Cf. AKC, "Walter Andrae's *Die ionische Säule: Bauform oder Symbol?: A Review*," SP I.

for any civilisation deserving to be so called. In Guénon's view (shared by the translator) Europe has diverged from this path ever farther since the thirteenth century: only since that time have Europe and Asia been truly divided in spirit. . . . Europe and Asia can meet, and can only meet in complete accord, upon the common ground of the metaphysical and purely intellectual tradition.[12]

By 1935, many of Guénon's most important works were already published. In 1921 appeared his *Introduction générale à l'étude des doctrines hindoues; Orient et Occident* in 1924; *L'Homme et son devenir selon le Vedānta* in 1925; *La Crise du monde moderne* in 1927. These constitute the canon of Guénon's most general writings, to which could be added a late work, also the best introduction to his thought, *Le Règne de la quantité et les signes des temps*, 1945. In all of these works, which Coomaraswamy must have started reading in about 1930 (with the exception of the last), can be found the deep understanding of Eastern metaphysics, the elaborate conception of traditional culture, the merciless attack on modern Western culture that had been present in Coomaraswamy's work before 1932, but never in such a mature and definite form. Guénon's writings almost undoubtedly pointed the way for Coomaraswamy; they were a *quod erat demonstrandum* for him, a proof of the value of traditional culture and an encouragement to rethink his entire conception of traditional art, aesthetic, religion, and metaphysic. Paul Sérant, in his excellent study of René Guénon, wrote that Guénon's work "confirmed" Coomaraswamy "in his own metaphysical convictions,"[13] and also pointed out that Guénon had learned from Coomaraswamy: in Guénon's second edition of the *Introduction générale*, for example, he revised his chapter on Buddhism to accord with Coomaraswamy's understanding of it. From about the middle 1930s, Coomaraswamy and Guénon paced each other, in a certain sense. Coomaraswamy contributed articles to the monthly journal, *Études traditionelles*, whose tone and contents were very largely determined by Guénon, its most frequent contributor. He corresponded with Guénon, who lived in Cairo in later life, and frequently sent offprints of publications, which Guénon faithfully summarized for the French audience in the pages of *Études traditionelles*. Guénon occasionally wrote articles on themes suggested to him by something Coomaraswamy had written, and

[12] AKC, introductory note to his translation of René Guénon, "Sacred and Profane Science" (1935).
[13] Sérant, *René Guénon*, p. 18.

the reverse was also true. The relation between them in this respect is represented by a dry but interesting note that Coomaraswamy added to the beginning of his 1935 article on Jaina iconography, in which he recounted the fundamental myth of Jainism. "For what is to be understood by a 'myth,'" he wrote, "see Guénon, 'Mythes, Mystères, et Symboles,' *Le Voile d'Isis*, No. 190, 1935."[14] This was the only reference he thought necessary. Or again, in 1939 he wrote that he would in the context of the particular article in question take for granted "the reader's knowledge of the significance of initiation in India and elsewhere," and referred the reader to "the comprehensive series of articles on 'Initiation' published by M. René Guénon in recent volumes of *Études traditionelles*. We hope to publish on some future occasion some of the principal Indian texts in which the subject is treated."[15] Guénon generally treated in a more abstract and theoretical mode subjects that Coomaraswamy treated in the specific terms of the Indian, Platonic, or Christian traditions.

These two like-minded men never met; nonetheless, they were close. Guénon in his typically formal manner referred to Coomaraswamy as "notre éminent collaborateur,"[16] while Coomaraswamy devoted an entire essay to Guénon's work in the effort to make it better known in America. His essay "Eastern Wisdom and Western Knowledge" appeared in 1943 in *Isis*, the journal of the history of science edited by George Sarton, one of Coomaraswamy's dearest friends at Harvard University. Sarton felt obliged to warn the readers of *Isis* with a prefatory note: "The author of this essay, deeply versed in Western as well as in Eastern lore, is the leading mystical philosopher in this country and the most able to study Guénon's views from the inside. The Editor of *Isis* and the majority of its readers do not share those views but welcome an authoritative and sympathetic explanation of them."[17]

There is no need at this point to go much further into the relation between Coomaraswamy and Guénon; what is common in their thought will emerge naturally in the discussions of Chapter XVIII. Coomaraswamy was not a lesser Guénon, nor vice versa; their thought was com-

[14] AKC, "The 'Conqueror's Life' in Jaina Painting" (1935), p. 128, n. 1.

[15] AKC, "Some Pāli Words," SP II, 289n. Guénon's essays on this theme have been collected in his *Aperçus sur l'initiation* (2nd ed., Paris, 1953).

[16] For example, in Guénon's review of AKC, "The Christian and Oriental, or True, Philosophy of Art," which appeared in *Études traditionelles*, XLV (1940), 31 ff.

[17] P. 359, note 1. This article was reprinted in AKC, *Am I My Brother's Keeper?* (New York, 1947), pp. 54 ff.

plementary. Coomaraswamy's most individual achievements, his profound reunderstanding of art and aesthetics, his Vedic studies, and his studies of the whole network of traditional thought, are quite different in character from Guénon's work. Guénon wrote occasionally on art, and a great deal on symbolism, but his was not the kind of mind that learned very much from art. He was an extraordinary thinker and engaged from his youth in philosophical studies; his thought was strictly orthodox and traditional, but tended to be more distant from the texts, from "chapter and verse," than was Coomaraswamy's. He proceeded by an intuitive, intellectual process, while Coomaraswamy engaged in a more scholastic struggle to understand the details. Guénon would voice a principle; Coomaraswamy in his metaphysical studies would collate a series of Indian, Platonic, and Christian texts where a principle was voiced, and *accompany* this scholarly labor with a commentary that from time to time shone with intuitive discoveries. Coomaraswamy's vocation was essentially scholarly. He studied and wrote about metaphysics and theology in his later years because he could thereby understand himself and help others to understand themselves, but he never claimed to be a *guru*. He considered his writings to be the map of a Way that he had not entirely covered on foot, in his own person—this is the very image that he used in a letter written shortly before he died.[18] Guénon's vocation was something else. Guénon was discreet about his personal life, but it is well known now that he was a member of a Sufi order in Egypt. To his philosophical expositions of the multiple states of being, which is all that he chose—perhaps wrongly—to put into his books, there corresponded a long and devoted practical study of Sufism. Scholarship, while certainly one of his means, was subordinated to the message whose twin sources were traditional teachings and hard thinking.

Guénon and his followers (to whose works there will be references in Chapter XVIII) were European rebels against the materialism and spiritual ignorance of Europe; they not only looked to the East, as scholars, but went East in search of knowledge. When they wrote about either modern Europe, which they describe as antitraditional, or traditional Christendom, they do so from a point of view and with insights—as well as prejudices—acquired in the East. Coomaraswamy was similar to them, but he was touched by a revival within the Western tradition itself to which Guénon was not at all so close: Neo-Scholasticism.

[18] AKC, letter to John Layard, August 1947, family collection.

The revival of studies of St. Thomas Aquinas and the other School-
men was initiated by an encyclical of Pope Leo XIII in 1879, *Aeterni
Patris*, which urged a reexamination of Roman Catholic philosophy, par-
ticularly of Thomism. The *Oxford Dictionary of the Christian Church*
happens to suggest exactly what significance Thomism was to have for
Coomaraswamy: "In the 19th and 20th centuries it has become increas-
ingly important as a reaction against a destructive subjectivism." The two
best-known exponents of Scholasticism in our time have been Etienne
Gilson and Jacques Maritain, respectively seven and nine years younger
than Coomaraswamy. Maritain's important book on the Scholastic theory
of art, *Art et scolastique* (Paris, 1920, with later editions), became the
inevitable point of departure for any serious interest in the subject, and,
although it seems probable that Coomaraswamy knew this book not long
after publication, he only gave it a serious reading in the years of his
transformation, 1928–1932. Eric Gill read *Art et scolastique* in 1922, and
it struck him as a revelation. He arranged for an English translation, and
his own philosophy of art in later years is an extension of Maritain's
thought almost as much as it is an extension of Coomaraswamy's thought.
It is not possible that Coomaraswamy could remain unaware of so great
an enthusiasm in his friend Eric Gill at the beginning of the 1920s, but
his own writing only shows a serious engagement with Catholic thought
in 1934, the year of publication of his collection of essays, *The Transforma-
tion of Nature in Art*. This date, 1934, leads us once again to conclude
that the beginning of the 1930s was a period of transformation for Coo-
maraswamy: it is just at this point that his relation to mediaeval Christian
thought changed from an enthusiastic but transient acknowledgment
of the value of Meister Eckhart in particular, to a permanent and scholarly
interest in the entire Scholastic tradition from its origins in St. Augustine
to its flowering in the thirteenth century. Coomaraswamy was led to
Scholasticism by Maritain's book, and later made use of Gilson's works
on Augustine and Bonaventura,[19] but he was critical of Maritain's inter-
pretations. He followed the advice that historians always give to younger
students: he went back to the sources. In 1935 he included *Art et scolas-
tique* in the bibliography appended to a major work on mediaeval aes-
thetic, but called it "somewhat tendentious" and "tainted by modernism."[20]

[19] Etienne Gilson, *La Philosophie de St. Bonaventure* (Paris, 1924); *idem, Intro-
duction à l'étude de Saint Augustin* (Paris, 1928).
[20] AKC, "Mediaeval Aesthetic I. Dionysius the Pseudo-Areopagite and Ulrich En-
gelberti of Strassburg" (1935), p. 32.

On the other hand, he had also written in the same year that "the Indian rejection of Buddhism was normative, in the same sense that the 'Thomist revival' (considered apart from the bigotry of some of its exponents) is normative at the present day."[21] This is, of course, not a complete vote of confidence. "Normative," "normal," is one of Coomaraswamy's highest words of praise; it meant for him that some essential realities had been recognized and a human activity—a thinking, a making, a doing—had been affected by the recognition. But he had reservations about the Catholic church, which he was obliged to express more than once because he was naturally asked why he did not convert to Catholicism, since he had mastered Catholic doctrine and obviously accepted it as an authentic formulation of the truth. His answer to this question in a letter of 1942 is not only clear but also vibrant: it has the very specific taste of Coomaraswamy's individuality.

A fundamental reason why I could not possibly do so is the Catholic claim to *exclusive* possession of truth. Other religions, or rather metaphysical traditions, claim to teach *the* truth but do not claim exclusive possession of it. Christianity has other weaknesses, notably the reliance upon the historicity of Christ. I could say, "I know that my Redeemer liveth," but could not say, "I know that he was actually born in Bethlehem." It is only Christ's "eternal birth" that really interests me. . . . I am of far more use to Catholics as a defender of their truths (e.g. of the doctrine of one essence and two natures) than I should be as a convert![22]

To return briefly to Coomaraswamy's debt to Maritain: it was certainly acknowledged in the very first words of his first published article on Scholasticism, "Meister Eckhart's View of Art,"[23] which begins with a citation from *Art et scolastique*. On the other hand, the article itself is based on his own understanding of sources, which he read in the original. Maritain, like Guénon, helped raise Coomaraswamy's potential "to the sparking point," but Coomaraswamy had his own tasks and cannot be considered a disciple either of the great Catholic thinker or of the great Traditionalist. They were participants in the same world, in the same "universe of discourse," to use a term in which Coomaraswamy found

[21] AKC, "The 'Conqueror's Life' in Jaina Painting," p. 139.
[22] AKC, letter to S. E., 26 February 1942, private collection.
[23] AKC, "Meister Eckhart's View of Art," in *The Transformation of Nature in Art*, ch. II.

delight and nourishment.[24] The actual geometry of their relationship, however, cannot be fitted to an equilateral triangle: Coomaraswamy and Guénon were close to each other and kept personally in touch; Coomaraswamy and Maritain both lived in North America during the 1930s and '40s, but were not particularly close (Maritain was in Toronto after 1933); and Guénon and Maritain had met at a seminar in France in the 1920s, where they found that they did not have very much to say to each other. The dialogue between Neo-Scholastic thought and Guénonian thought went on fruitfully in Coomaraswamy's writings, if not at the conference table.

This, then, constitutes all the available material relating to the most important transition in Coomaraswamy's life; and we have already begun to hear the language of Coomaraswamy's mature writings. It seems necessary now to recall that in spite of all the changes in Coomaraswamy's concerns, he was in 1932 and thereafter still an art historian, an incomparably better historian, who was now prepared to examine traditional religious art, whether Indian or Christian, from a point of view "in agreement with the innermost nature and eloquence of the exhibits themselves."[25] In 1937, he formulated his considered criteria for what the practice of art-historical scholarship should be. His words provide a bridge to the next section of this biography, and also evoke the long course that he traveled:

One can in fact only be said to have understood the work, or to have any more than a dilettante knowledge of it, to the extent that he can identify himself with the mentality of the original artist and patron. The man can only be said to have understood Romanesque or Indian art who comes very near to forgetting that he has not made it himself for his own use; a man is qualified to translate an ancient text when he has really participated in, and not merely observed, the outer and inner life of its time, and identified this time with his own. All this evidently requires a far longer, more round about, and self-denying discipline than is commonly associated with the study of the history of art.[26]

[24] His best discussion of this term appears in "Does 'Socrates is Old' Imply that 'Socrates Is'?" SP II, 409–410, 414, 417 ff.
[25] AKC, "Why Exhibit Works of Art?" p. 20.
[26] AKC, "Is Art a Superstition, or a Way of Life?" (1937), included in *Why Exhibit Works of Art?* (1943), where it appears as ch. III. This passage, p. 75.

XIII. The Writings of 1932–1947:
A Critical Survey

Professor Erwin Panofsky (1892–1968) saved a charming smile for the moment in his seminars when he introduced his bibliography of ancient and modern works on iconography. It took him at least eight classroom hours to transmit his bibliography, eight hours of titles and comments while students tried vainly to keep up. In retrospect, after using the bibliography, students understood that it was probably Panofsky's most valuable offering, aside from his good nature—intellectual, charismatic but gentle, the nature of a St. Jerome who left his lion at home.

A complete study of the bibliography of Coomaraswamy's writings in his best period would be so elaborate that no smile could justify it, but a selective outline of his concerns and his outstanding articles is worth the reader's time, and will provide the occasion for certain kinds of commentary that might otherwise never find a place. It is just during these years that his *biography* becomes plain. In the section following this one, we shall speak of his comings and goings; there are hardly any. He had friends and dined with them, corresponded with scholars at a distance, wrote a very great deal; he kept one kind of garden at Needham and another kind outside his camp in Maine; he fished and learned to drive an automobile; he grew gray but stayed strong, then he weakened. He died at seventy, an age at which one is really not obliged to die, but he had just finished a book on *Time and Eternity* and it was a reasonable moment to study their relationship experientially. To follow his life during these years we have to follow him into his writings, which were its center.

The year 1932 has been identified as the beginning of Coomaraswamy's best period, not only because he began in that year to publish works devoted purely to metaphysics and religion (for example, "Mahā-Pralaya and Last Judgment") but also because his writings on art have a new density and sense of purpose. His "Introduction to the Art of Eastern Asia," a 31-page pamphlet with a minimum of illustrations, is of a kind

that he had often written, but of a very different quality. It is an intro-
duction for the *understanding*, not for any other organ—eye, curiosity,
or whatever. Almost wholly lacking in references to specific works of
art, it prepares the reader for a more complete experience of Asian art
than merely "liking" or "disliking" it, primarily by introducing him to
Indian and Chinese criteria for quality in works of art and quality in
experiencing art. The "connoisseur," no less than the artist, must agree to
training, in his view of things. This particular essay established a mode
that he used often in the next fifteen years: it is didactic, close to sources
such as Sanskrit texts on rhetoric, yet winning, energetic, imaginatively
written. It is a mode of essays on art that hardly require an illustration
because they deal with ideas. Other essays of this type are *Asiatic Art*
(1938) and "The Christian and Oriental, or True, Philosophy of Art"
(1939), to mention but two.

In 1933, Coomaraswamy published *A New Approach to the Vedas: An
Essay in Translation and Exegesis,* and thereafter he regularly brought
out longer and shorter studies of the Vedas and Upaniṣads, which ought
some day to be collected in a single volume in association with similar
studies of Buddhism. A passage in the introduction to *A New Approach*
describes its plan at the same time that it evokes a method he used in
the metaphysical studies of the next fifteen years:

> It is very evident that for an understanding of the Vedas, a knowledge
> of Sanskrit, *however profound*, is insufficient. Indians themselves do
> not rely upon their knowledge of Sanskrit here, but insist upon the
> absolute necessity of study at the feet of a *guru*. That is not possible
> in the same sense for European students. Yet Europe also possesses a
> tradition founded in first principles. That mentality which in the
> twelfth and thirteenth centuries brought into being an intellectual
> Christianity owing as much to Maimonides, Aristotle, and the Arabs
> as to the Bible itself, would not have found the Vedas "difficult." . . .
> What I have called here "a new approach to the Vedas" is an exposi-
> tion of Vedic ideas by means of a translation and commentary in
> which the resources of other forms of the universal tradition are
> taken for granted. . . . I have simply used the resources of Vedic and
> Christian scriptures side by side. An extended use of Sumerian, Tao-
> ist, Ṣūfī, and Gnostic sources would have been at once possible and
> illuminating, but would have stretched the discussion beyond reason-
> able limits. As for the Vedic and Christian sources, each illuminates

the other. . . . Whatever may be asserted or denied with respect to the "value" of the Vedas, this at least is certain, that their fundamental doctrines are by no means singular.[1]

Explicit in this passage is Coomaraswamy's conviction that a common metaphysical basis underlies the traditional religions of East and West. To this he generally applied the well-established term *Philosophia Perennis*. *A New Approach to the Vedas*, like the "Introduction to the Art of Eastern Asia," is important as a stylistic model in Coomaraswamy's oeuvre. Here for the first time he began to append a great many footnotes to his main text; this would seem to be a small matter, hardly worthy of notice, but in fact as time went on he allowed the footnotes of his more erudite articles to become literally an independent text. No one familiar with Coomaraswamy needs to be reminded of the impossibility of reading some of his articles as a continuous whole.

A New Approach was a stylistic model in a positive sense, too, in that for the first time he tried in it to make accurate, evocative translations of Vedic and Upaniṣadic texts through the use of Scholastic language and archaic or composite words. The problem of translating Hindu and Buddhist metaphysical terms, recently discussed in a most interesting way by Agehananda Bharati in his book *The Tantric Tradition*,[2] is in part the problem of improving on the somewhat vague, Romantic translations of the period of Max Müller, the Sanskritist and student of mythology to whom the very long series, *The Sacred Books of the East*, is due. Bharati's solution to this problem is to use the terminology of modern analytical philosophy, in which terms are exceedingly carefully defined. Thus, for example, where the standard translation of the term *jñāna* is "wisdom," "knowledge," or "intuition," he prefers the translation "analytical appreciative understanding" and is prepared to differentiate and justify each element of this translation.[3] Coomaraswamy represents an earlier phase of reexamination of the problem of translation, and he felt himself to be nearly alone in his recognitions. In the year that *A New Approach* appeared, he published two articles dealing with the problem, "On Trans-

[1] Pp. vii–ix.

[2] Agehananda Bharati, *The Tantric Tradition* (2nd ed., New York, 1970, paperback; 1st ed., 1965).

[3] *Ibid.*, p. 16. AKC translated *jñāna* as *gnosis*, which he took to be its "etymological and semantic equivalent" (AKC, letter to Walter Shewring, 27 February 1938, family collection).

lation: Māyā, Deva, Tapas," and "Versions from the Vedas," and he reviewed a work by the literary critic and philosopher, I. A. Richards, which concerned itself with translation. This was Richards' *Mencius on the Mind: Experiments in Multiple Definition* (London, 1932). On the same occasion, Coomaraswamy also reviewed a book of which Richards was coauthor with C. K. Ogden, *The Meaning of Meaning* (London, 1923, with later editions). "On Translation" proposes three *suggestions raisonnées,* as he called them, for new translations of Sanskrit *māyā, deva,* and *tapas;* the discussions of each term are meant to be models of the intensive reflection that should precede a choice of equivalents.

> Mistranslation is not to be attributed to a lack of assiduity, nor to an inadequate mastery of Oriental languages on the part of scholars, but much more to their inadequate use of English. . . . [The Western scholar's] purely scientific outlook and special education will almost inevitably preclude in him a knowledge of Christian metaphysics, theology, and mystical literature where only is to be found the English terminology required for adequate translation. Such terms as unground, unknowing, abyss, procession, Spiritus, spiration, essence, nature, substance, hypostasis, regard, magic, angel, consonantia, comprehensor, are entirely unknown to him in their technical significance. Oriental translators, having acquired their vocabulary and point of view mainly from the published works of European scholars, are similarly limited. . . . The importance cannot be exaggerated of rendering "the holy heathen books" not merely with grammatical accuracy, but as to specific terms in their context, with a precise awareness of their real meaning. . . . We ought not to hesitate to make over all existing translations that are not from this point of view entirely competent, remembering that translations are not made as ends in themselves, but to be read, marked, learnt, and inwardly digested.[4]

The second article, "Versions from the Vedas," exemplifies not the process of understanding specific terms but the character of a translation when it is, as he says, "designed to fulfill the requirements." In his brief introduction to the versions, there is an interesting comment: "Unfamiliar or archaic English words are employed advisedly: for in the first place

[4] AKC, "On Translation: Māyā, Deva, Tapas," pp. 74–75, 87.

modern colloquial English is actually inadequate to the end in view, a more precise, expressive, and intellectual vocabulary being needed; second, the unfamiliar term forces the reader to supply a new content, where a colloquial term might only serve to inhibit thought."[5] Coomaraswamy displays a certain attitude toward mental processes in this passage: he has the blend of confidence and mistrust that is often true of persons who use their minds a great deal and obtain good results, but know that the mind is full of inconveniences. The laws governing its operation are discouragingly close to the laws of physics. Inertia is a problem, momentum is another, paths of least resistance make it difficult to find paths of reason, and so on. Coomaraswamy is not so much blaming the reader for intellectual laziness as acknowledging his acquaintance with the problem. He, in fact, delighted in colloquial English—what is it but delight in plain talk that made him entitle one of his best essays "What is the Use of Art, Anyway?" On the other hand, in his own writings as in his translations, he often sacrificed colloquial, communicative style for the sake of a "more precise, expressive, and intellectual vocabulary" and the inclusion of as much data as possible. By the time of his 1935 article in the same series as those we have been discussing, "Two Vedantic Hymns from the *Siddhāntamuktāvalī*," he was able to make a lucid statement of views on translation that caps quite remarkably the earlier statements we have quoted. There is never any doubt when Coomaraswamy has made up his mind.

> We have not hesitated to employ the technical terms of scholastic philosophy in their proper context; we maintain, indeed, that the content of Indian religious or philosophical texts cannot be conveyed in any other way; and that the propriety of this procedure will be apparent to anyone precisely to the extent that he is familiar with both Hindu and Christian scholastic method. It is not intended that the result make for easy reading; on the contrary, the modern reader, accustomed to the use of words in vague or much degraded senses, and to the making of hasty assimilations, must be faced with the necessity of establishing for himself the content of unfamiliar references, which is even more essential here than it would be in the analogous case of the study of the Latin hymns of the Middle Ages. It will therefore be understood that the translation is a technical one, and to be taken accordingly. We believe at the same time that by these means the formal beauty and clarity of the original are better

[5] AKC, "Versions from the Vedas," p. 20.

preserved than would be possible in an easier, vaguer, and more sentimental wording.[6]

Our discussion of Coomaraswamy's approach to the translation of traditional texts is of wider significance because many of his writings are essentially *translations* of traditional ideas: reconstitutions of a network of doctrines, symbols, and visual representations. They do not "make for easy reading"; it is altogether characteristic of Coomaraswamy that he used this down-to-earth phrase in the course of acknowledging the difficulty of some of his work.

We must return briefly to Coomaraswamy's view of the work of I. A. Richards and C. K. Ogden. I. A. Richards, literary critic, linguist, philosopher, and sometime poet on the faculty of Harvard University, is a thinker the significance of whose work spreads beyond his fields of specialization. Coomaraswamy found in Richards the intellectual rigor that he himself tried to maintain, as well as a love of the text to be translated, which led to a more resourceful and appropriate translation. Richards' book with C. K. Ogden, *The Meaning of Meaning*, became part of the substance of Coomaraswamy's intellectual life. Its understanding of symbols in the context of language and literature applied equally well to the symbols of religion, metaphysics, and visual art, and was in no way contradictory to the understanding that Coomaraswamy found in Hindu, Buddhist, and Christian texts of a much earlier period. Coomaraswamy heard an echo in Richards and Ogden of his own will to create a new kind of scholarship, one that would concern itself with meaning and be vulnerable to its own discoveries. He often quoted C. G. Jung on this point, doing so for the first time in his review of *The Meaning of Meaning*. Jung had written in 1931: "So-called scientific objectivity . . . fears and rejects with horror any sign of living sympathy . . . partly because an understanding that reaches the feelings might allow the contact with the foreign spirit to become a serious experience."[7] What Coomaraswamy found in Richards and Ogden is suggested by a phrase from their book that has the ring of a slogan or aphorism: "Symbols cannot be studied apart from the references which they symbolize";[8] for Coomaraswamy

[6] AKC, "Two Vedantic Hymns from the *Siddhāntamuktāvalī*," p. 91.

[7] Richard Wilhelm and C. G. Jung, *The Secret of the Golden Flower: A Chinese Book of Life* (New York, 1931; rev. ed., New York, 1962). In the revised edition, Jung's comment will be found on p. 81.

[8] C. K. Ogden and I. A. Richards, *The Meaning of Meaning*, edition of 1930, p. 20. These words were used by AKC as an epigraph to his *Elements of Buddhist Iconography* (1935).

this principle was a guiding light that led away from "iconographic" studies toward what Panofsky in his studies of Western art called "iconology."[9]

I. A. Richards lived in Cambridge, near Harvard University. He and Coomaraswamy became friendly in the 1930s. The only letter that remains in Coomaraswamy's correspondence indicates that in 1940 Coomaraswamy was urging Richards to read René Guénon and Richards was urging Coomaraswamy to read Coleridge—certainly civilized acts of persuasion.[10]

The diversity of Coomaraswamy's interests is well represented by a series of articles that appeared in 1934, concerned respectively with the metaphysical content of certain Indian mathematical terms, an iconographic theme that can be traced from Islamic art to a Sumerian origin, and a twelfth-century Sanskrit treatise on painting.[11] But the event in 1934 that most deserves attention is the collection of essays published by Harvard University Press, *The Transformation of Nature in Art*. It was composed of seven essays, three of which—"The Theory of Art in Asia," "Meister Eckhart's View of Art," and "Parokṣa," the latter a study of the Indian theory of symbolism—were new. *The Transformation* brought Coomaraswamy's mature thought to the general public for the first time. It was reviewed rather widely. These reviews were well characterized by Professor Rudolf Riefstahl in a letter to Coomaraswamy written a few months after they began to appear (Riefstahl taught Islamic art and the history of textiles at New York University, and had been a close friend of Coomaraswamy's since the 1920s): "I saw a few of the reviews. They were all of one type: a dim feeling that something is going on which is to overthrow much of accredited ideas. The consciousness that this something finds here an adequate expression; and yet a lack of real understanding, perhaps also fear of destroying thoughts whose rut pleases. Hence the dull lukewarmness."[12]

Certainly in this book Coomaraswamy had reached the height of his powers—not a height from which he would quickly fall, but rather a plateau that he would occupy securely for the remainder of his career.

[9] Cf. Erwin Panofsky, *Studies in Iconology: Humanistic Themes in the Art of the Renaissance* (New York, 1939; reprinted, with new preface by the author, New York, 1962).

[10] Cf. I. A. Richards, letter to AKC, 8 January 1940, family collection.

[11] Biblio. Nos. 435, 436, 437 in the *Working Bibliography*.

[12] Rudolf Riefstahl, letter to AKC, 13 March 1934, Princeton Collection.

Although Riefstahl spoke of intellectual revolution, it is a very quiet book with no quality of polemic, concerned with Asian and Western mediaeval concepts of art: the artist's practice, the spectator's practice, the purposes of art, and some problems of content and style. On the other hand, many topics that Coomaraswamy expounded here in a scholarly manner, quoting sources and technical terms at every step, reappear later in definitely polemical essays and lectures.

One such topic has to do with the traditional artist's conception of his work. Both in this book and in later writings, from "The Technique and Theory of Indian Painting" (1934) and "The Intellectual Operation in Indian Art" (1935), on to one of his latest papers, "Athena and Hephaistos" (1947), he was concerned to gather as much material as possible relating to the *intellectual* work of the artist that normally precedes the actual production of a work of art. In the Indian context, this preliminary work included understanding the patron's requirements, knowing established methods and iconographies, and interiorizing the iconography through a mental visualization that was closely akin to one of the practices of Hindu and Buddhist worship. In Chinese and Japanese culture, a similarly deliberate preparation of the artist can be described from literary sources. Coomaraswamy collected and expounded material of this kind in the first place as a contribution to knowledge, but also *in the first place*, it is fair to say, as a contrast to the practice of the great majority of modern Western artists. Knowledge of traditional practices was his basis for criticizing the contemporary. In one form or another, much of Coomaraswamy's knowledge passed along this route. What could be understood about religious tolerance from studying the example of Ramakrishna, who espoused in turn the practices and doctrines of Islam and Christianity at certain periods in his life, became the point of departure for an article on religious tolerance specifically intended to influence Indians, with their violent Hindu-Muslim animosity, and Westerners with their own set of prejudices.[13] What could be understood about the Hindu concept of the self through intricate studies of Vedic mythology and Upaniṣadic formulae found its way into such brief readable articles as "On Being in One's Right Mind" (1942), or "Who is 'Satan' and Where is 'Hell'?" (1947). These comments should not imply that Coomaraswamy believed in sweetening or watering his scholarly findings for the sake of a popular audience: his popular writings and such things as

[13] AKC, "Śrī Ramakrishna and Religious Tolerance," SP II.

a series of radio broadcasts given in 1935–1936 under the auspices of the Boston Museum are always thorny, critical, uncompromising.[14] He was often enough criticized by fellow scholars for his polemical attitude, his aggressiveness, all the military activity associated with a man who has something to say—who else but Coomaraswamy would have closed an essay with a word or two about "the museum militant"?[15] There is no rebutting this criticism; it is true. It nonetheless fails to take into account the great number of purely scholarly works, such as *The Transformation of Nature in Art*, in which the polemics are grounded.

Coomaraswamy recognized these two aspects of his work, the scholarly and what he called "the literature of indictment"; ultimately, he valued the former over the latter. In a letter of 1944 to his friend Marco Pallis, the author of several accounts of first-hand experience in Tibet, Coomaraswamy sorted them out:

> I am rather appalled by your suggestion of *my* writing a book of the nature of a critique of Occidentalism for Indian readers. It isn't my primary function (dharma) to write "readable" books or articles; this is just where my function differs from Guénon's. All my willing writing is addressed to the professors and specialists, those who have undermined our sense of values in recent times, but whose vaunted "scholarship" is really so superficial. I feel that rectification must begin at the reputed "top," and only so will find its way into schools and text books and encyclopedias. In the long run the long piece on the "Early Iconography of Sagittarius" on which I have been engaged for over a year, with many interruptions, seems to me more important than any direct additions to the "literature of indictment."[16]

This passage reflects perfectly well that he could not avoid indictment: in the very act of explaining why he will not write a full-length critique of the West, he indicts Western scholarship for superficiality and mistaken values. The bibliography of 1932–1947 has an abundance of the two aspects: scholarship and fiercely argued conviction. They are generally kept separate, although occasionally in a footnote to an intricately reasoned study of some aspect of Indian metaphysics, there can be found a knifing comment on the Western belief in Progress, art historians' con-

[14] For example, Biblio. Nos. 459, 461, in the *Working Bibliography*.
[15] AKC, "Why Exhibit Works of Art?" p. 22.
[16] AKC, letter to Marco Pallis, 20 August 1944, family collection. The article mentioned is an unpublished fragment.

cern for "aesthetics" rather than meaning, and other features of the West with which he never made peace.

We have distinguished scholarship from polemic; one further distinction ought to be made. Coomaraswamy often wrote that the ideas he expressed were not "his own": they were nothing but the Christian and Oriental philosophy of art, expressed anew. He found a marvelously disputative way of putting this by asserting the opposite of what could be expected: "I should like to emphasize that I have never built up a philosophy of my own or wished to establish a new school of thought. Perhaps the greatest thing I have learned is never to think for myself; I fully agree with André Gide that 'Toutes choses sont dites déjà,' and what I have sought is to understand what has been said."[17] It is true of him. Nonetheless, in the course of expressing anew the old ideas and in bringing them to bear on the contemporary situation, he created an oeuvre that could not be mistaken for that of any other person in respect to its themes, emphases, and rhetoric. And to this individuality must be added a further one, the frequent passages where in fact the idea *is* "his own." He was more original, in the ordinary sense of the word, than his principles allowed him to admit. On the other hand, it was an originality nourished by traditional thought and in harmony with it. Coomaraswamy once expressed his sympathy for an element in the literary history of several traditional cultures that is usually taken to be an example of self-serving deception: authors who gain wider circulation for their writings by attributing them to an earlier, better-known figure, even to a saint. The outstanding example in the Christian tradition is a fifth-century Eastern theologian whose works were attributed, apparently from the very beginning, to Dionysius the Areopagite, a disciple of St. Paul. These works, now ignobly described as the writings of Pseudo-Dionysius, are among the central texts of mystical theology in both the Eastern and Western churches. Coomaraswamy's insistence that the ideas he expressed were not "his own" has its analogy, although not a perfectly exact one, in the deception of Pseudo-Dionysius.

A series of works of which we have already seen the beginning in *A New Approach to the Vedas* continued on through the years 1932–1947: translations and studies of particular passages and motifs in early Indian scripture. These were often arduous studies, published in a variety

[17] AKC, talk at his Boston dinner (22 August 1947); cf. text as printed in Ch. XVII of this study.

of American, Indian, and European journals. Coomaraswamy felt in-
debted to the president of the American Oriental Society, Professor
W. Norman Brown, and to the editors of the society's journal, for pub-
lishing his work in spite of its unusual character, which had more in
common with the works of Pseudo-Dionysius than with standard Sanskrit
studies.[18] He also found a dependable publisher in the *Harvard Journal
of Asiatic Studies*, which would give over nearly an entire issue to a long
paper such as "Some Pāli Words" (1939). This article, in form a con-
tribution of new definitions of early Buddhist terms that he believed in-
sufficiently treated in the Pali Text Society dictionary, is in fact a series
of short exercises in metaphysical thought that shed as much light on
Hindu thought as on early Buddhist. Other publications that welcomed
Coomaraswamy's metaphysical writings were *Études traditionelles*, the
French journal guided by René Guénon, and the *Indian Historical Quar-
terly*. Some of the outstanding articles in this series are "Angel and Titan:
An Essay in Vedic Ontology" (1935), *The Darker Side of Dawn* (1935),
"The Idea of 'Eternal Creation' in the *Ṛg Veda*" (1936), and a series in
the late 1930s bearing titles such as "Vedic Exemplarism," "Vedic 'Mono-
theism,'" and "The Vedic Doctrine of Silence." The difficulty of the
majority of these papers is redeemed by writings of another kind—not,
however, redeemed in the sense that their difficulty is unjustified; it is
rather the reader who feels redeemed when he encounters Coomaraswamy's
more accessible studies of the same material, of which the two best exam-
ples are the published version of a lecture given at Wellesley College, "The
Vedānta and Western Tradition" (1939), and the published version
of lectures given at the Jewish Theological Seminary in New York, *Hin-
duism and Buddhism* (1943). The requirements of the lecture format had
an excellent effect on Coomaraswamy, similar in nature to the effect on
certain German scholars of their forced migration to America in the
1930s: he was obliged to make more synthetic statements than in research
papers, and was obliged to hold an audience.

Coomaraswamy's late works on the Vedas, well represented by his
paper of 1942 on the Vedic sacrificial rite, "*Ātmayajña*: Self-Sacrifice,"
often strike one, because of their technicality and staggering completeness
of reference, as blueprints or precedents for the rites of a new culture.
He gives the impression of having determined to record everything pos-
sible concerning the Vedic sacrifice, in case anyone or any group in con-

[18] So he remarked in the anniversary talk, *ibid.*

temporary society decided to reinstitute some sort of sacrifice. His writings would both discourage such a group from "inventing," and illustrate most encouragingly the depth of thought and understanding that can be coded into a rite.[19] Coomaraswamy's writings have been very justly contrasted with those of Śrī Aurobindo in his later days: whereas Śrī Aurobindo permits himself dreams of cosmic dimensions and works out a schema for the eventual transformation of human consciousness on a world scale, Coomaraswamy expounds the details of traditional thought and cultural forms rather pessimistically, simply because he finds doing so fruitful for his own understanding, and perhaps helpful for some readers as well.

Some of Coomaraswamy's closest friends used to needle him about the difficulty of his writings on Indian metaphysics; since most of them were leaders in their own scholarly fields and not opposed to intricacies, it is interesting to hear their comments. Lucien Scherman, a refugee scholar on the Harvard faculty who had been the director of the Ethnographic Museum in Munich, became a close friend of Coomaraswamy's in the 1940s. Correspondence between them confirms the statement in the Coomaraswamy *Memorial Volume* that Scherman acquired an interest in metaphysics from Coomaraswamy and pursued its study seriously.[20] Early in 1943, Scherman wrote to Coomaraswamy, "You know it requires time to attain total comprehension of the way you are treating so difficult topics. I have again learnt a good deal from your newest article. . . . True, several of your sentences approach nearly what we call in German 'Spitzfindigkeiten.' Nevertheless you help the reader as a teacher of the 'Philosophia Perennis' to analyze carefully such terms as *manas, amanībhāva, . . .* etc. and their equivalents."[21]

George Sarton, the Harvard historian of science who first met Coomaraswamy in 1912, and later became one of his closest friends when they

[19] AKC had thought specifically about this image of a "blueprint" and rejected it, in point of fact. In a letter of 23 February 1938, addressed to the editors of *Apollo*, the English art journal in which a review accusing him of taking a "mediaevalist" attitude had appeared that month, he wrote: "We are not using the Middle Ages or the Orient as a blueprint for a new society; we use them to point our moral, which is that you cannot gather figs of thistles." AKC's letter was never published, since *Apollo* had no regular correspondence page. The critical review, initialled H.R.W., appeared in *Apollo*, XXVII, No. 158 (1938), 100. Letter in the family collection.

[20] Dr. Robert von Heine-Geldern in *Memorial Volume*, p. 55.

[21] Letter of Lucien Scherman to AKC, 17 January 1943, Princeton Collection.

found themselves together in Boston, acknowledged reception of an offprint of Coomaraswamy's study on "Ornament" (1939) with the following not so kind note: "Many thanks for 'Ornament.' I am substantially in agreement with you, but am overpowered by your massive notes!"[22] In another letter a few years later, Sarton thanked him for a copy of *Spiritual Authority and Temporal Power*, his book on the Indian theory of government (1942): "Your excessively learned memoir on 'Spiritual Authority' was received."[23] "Excessively" can serve as a straightforward word of praise, but Sarton often demonstrated in his extensive and bright correspondence with Coomaraswamy that he knew the uses of irony.

Coomaraswamy's European friends did not spare him an occasional comment, either. C.A.F. Rhys Davids, president of the Pali Text Society, acknowledging by letter Coomaraswamy's appreciative review of something she had written, could not resist making the remark that Coomaraswamy heard from Sarton: "I appreciate the honour in your article on Reinterpretation of Buddhism, and thank you for that on *Ākiṃcaññā*. I regret here that you have made footnotes equal to a number of little articles. I feel murderous overwork so arranged (or not arranged)."[24] I. B. Horner, Rhys Davids' successor as president of the Pali Text Society and Coomaraswamy's collaborator for an anthology of Buddhist texts that appeared a year after he died,[25] had much the same thing to say— just a little more gently: "I have not yet read the Transmigrator—a pleasure to come (and hard work!)."[26] Horner was referring to "On the One and Only Transmigrant" (1944), Coomaraswamy's most condensed expression of his understanding of the doctrine of reincarnation. The difficulty of some of Coomaraswamy's work only occasionally discouraged editors, but once in a while he had to face a rejection slip. When a Festschrift volume was planned for George Sarton, Coomaraswamy sent a long, intricate study, "On the Indian and Traditional Psychology, or Rather Pneumatology," to its editor, M. F. Ashley Montagu, the well-known anthropologist, who was also a good friend of Coomaraswamy's. Montagu apologetically returned the article with a note that it was "too long" and "perhaps a little too heavy."[27] Coomaraswamy responded by

[22] George Sarton, letter to AKC, Whitsunday 1940, Princeton Collection.

[23] *Idem*, 19 September 1942, Princeton Collection.

[24] C.A.F. Rhys Davids, letter to AKC, 27 January 1941, Princeton Collection.

[25] AKC and I. B. Horner, *Gotama the Buddha* (London, 1948).

[26] I. B. Horner, letter to AKC, 12 March 1944, Princeton Collection.

[27] M. F. Ashley Montagu, letter to AKC, 4 October 1943, Princeton Collection.

sending another article, "Symplegades," which was equally difficult.[28] The article on psychology, an important one in his late oeuvre, went unpublished and will only appear in the Bollingen edition of Coomaraswamy.

One or two further comments seem necessary regarding the difficulty of some of Coomaraswamy's late works. Metaphysics is by nature difficult. Who expects to read metaphysical exegesis "without tears"? Still, one has the impression, now confirmed by Coomaraswamy's colleagues, that he made little effort to organize certain essays in the best possible way, which is to say, for the most efficient possible communication. His wife, Doña Luisa, commented in 1951 that in his practice as a writer, "more often than not, the first outline was the final copy."[29] In a letter some years later, she made a comment to a friend that also supplies a clue: "The style is not really Western, it is in a very real sense Upanishadic. . . . It wants much patience."[30] It is true that his exegesis has much in common with traditional exegesis, in which a line of scripture (whether *Bhagavad Gītā* or *Old Testament*) is the occasion for an incomparably longer commentary; it is also true that he worked quickly, and apparently felt that it was more important to gather the material of his studies than to present it in an agreeable form. But there are clues throughout Coomaraswamy's writings that suggest an additional psychological explanation of this element in his writings. Coomaraswamy himself detested "psychological explanations," principally because he found them reductive, but he was the first to admit, and lament, that everyone has a psychology, by which he meant an egotistical personality.

Irritation is a leitmotiv in Coomaraswamy's writings from the very beginning. Irritability and anger are the other side of the coin of idealism in a world immersed in passivity, indifference, and hostility to change. Coomaraswamy came to this pass often in his work on social reform in Ceylon and India, and later he felt something of the same irritation when he considered the apparently unbridgeable gap between traditional culture and the culture of the modern West. Western ignorance of the very things that seemed most valuable, perennially valuable to him, led him to write in a major essay in 1938:

[28] AKC, "Symplegades," SP I.

[29] Doña Luisa Coomaraswamy, "Some Recollections and References to Dr. Ananda Coomaraswamy," *Kalāmanjari*, I:1 (1950–1951), p. 21.

[30] *Idem*, letter to Mr. and Mrs. R., 20 July 1968, Princeton Collection.

Throughout this essay I shall be using the very words of the Middle Ages. I have nothing new to propound; for such as I am, the truth about art, as well as about many other things, is not a truth that remains to be discovered, but a truth that it remains for every man to understand. I shall not have a word to say for which I could not quote you chapter and verse. These pages are littered with quotation marks. Many of the citations are from the *Summa* of St. Thomas; many from Augustine, Bonaventura and Eckhart."[31]

Littered with quotation marks?—it is a strangely angry phrase, a phrase that implies, "Look what your ignorance of tradition obliges me to do!" It may be, then, that Coomaraswamy did not make his difficult essays easier because he really did not want to. On the contrary, every now and then he tries to defeat the reader. The reader must do his own work if he wishes to achieve an integrated understanding of some aspect of traditional knowledge. Coomaraswamy supplies the raw material for this most generously—his scholarship has this quality of generosity. It is a gift of knowledge for which one can see that he himself paid dearly by years of work and reflection. One also sees that he wishes the reader to pay.

Professor Mircea Eliade, the historian of religions now at the University of Chicago, with whom Coomaraswamy maintained a warm correspondence from the 1930s when Eliade was still in Europe, has analyzed the taste for difficulties and obscurities in modern art and literature as an unconscious nostalgia for initiatory experience.[32] One of his examples is the work of James Joyce. The fascination of penetrating the obscurities in Joyce's late work, the mystery that surrounds its meanings, the promise of discovery, is taken by Eliade to be analogous to initiation in many cultures—not a parallel to initiation, but an unrecognized substitute. This speculation sheds light on Coomaraswamy's most intricate essays. Coomaraswamy cannot be said to have had an *unconscious* nostalgia for spiritual initiation; he explicitly looked upon his research and writing as "intellectual preparation" for a spiritual initiation that was unfortunately unavailable in the West. In 1939, he wrote to his ex-wife Stella: "Intellectual preparation—not mere scholarship of course—is necessary for spiritual progress. Intellectual preparation is all that one can do here, far from teachers in whom any tradition is still alive (except that I judge it

[31] AKC, "The Philosophy of Mediaeval and Oriental Art" (1938), SP I, 45.
[32] Cf. Mircea Eliade, "Sur la Permanence du sacré dans l'art contemporain," *XX Siècle*, No. 24 (1964), pp. 3–10; *idem*, "L'Initiation et le monde moderne," in C. J. Bleeker, ed., *Initiation* (Leiden, 1965), pp. 1–14.

may be so amongst some American Indians, particularly the Navajo)."[33] Hence it is not the content of his writings that can be described as unconsciously related to the wish for an ultimate test and blessing, an initiation, but rather, perhaps, the form of his most difficult essays. Their division into nearly two texts (main text and long notes), their meticulous references to original Hindu and Buddhist terms, their countless brief citations from Indian scripture, their extremely detailed descriptions of mythic patterns, have quite a specific effect on the reader: it is like being beaten by the elders, hooted at from behind a terrifying mask, if we take the analogy of primitive initiations; or, to take the example of the sometimes gentler initiations of India, it is like sitting at the feet of a teacher who has so much to say and such vast scriptural and personal authority for saying it that the student eventually doubts himself and is thrown back on his own powers of reflection—which in some cases is the very thing sought by the teacher. It is reasonable to speculate that Coomaraswamy let some of his writings be "murderous overwork," in Rhys Davids' phrase, because he felt more or less consciously that there was something appropriate in that—perhaps not appropriate to his reader's mind, which grows impatient with so much detail, but appropriate to the reader's heart, which needs to be made to feel that knowledge is vast and one is always at the beginning, always out of one's depth. It would be going too far to suppose that Coomaraswamy thought out the question in these terms, and there is no justification for forcefully imputing to him motives that he did not himself acknowledge. All we can say is that he did write a good number of articles in such a way that the unspecialized reader is put through the experience just described. Coomaraswamy himself may only have felt a certain irritation and littered his work with quotation marks in an effort to acquaint his reader with traditional thought.

We might conclude these comments on the challenge of the late writings with two passages from early Buddhist literature that Coomaraswamy translated and discussed appreciatively in the course of his article "Some Pāli Words." In the first, the Buddha described his teaching method as follows: "When the analytical factors of the meaning have been verified both as regards what is laid down and what is elaborated, I then explain them by many alternative-formulae, teach and illuminate them, make them comprehensible, open them up, dissect and spread them out."[34]

[33] Letter of AKC, 15 November 1939, private collection.
[34] AKC, "Some Pāli Words," SP II, 315–316 (Pāli terms given by AKC in this passage are excluded).

The quality of intellectual resourcefulness evoked in this passage can fairly be taken to have been Coomaraswamy's ideal; this particular passage, with its concept of "alternative-formulae" is one that meant a great deal to him and entered into his understanding of the relation between communication through visual art and communication through the written word.

Another passage in Pāli literature, again words attributed to the Buddha, represents a further ideal of Coomaraswamy's, to whose more complete realization he intended to devote his years of retirement. "At the close of my discourse I compose and settle my heart, focus and synthesize it, in accordance with the former fashion of my interior synthesis in which assuredly I abide when and whenever I will."[35] Coomaraswamy realized the first ideal of resourceful communication, but the second, the ability to alternate between perfect composure and perfect discourse, was more elusive.

Up to this point, we have discussed Coomaraswamy's translations and commentaries on early Indian scripture, his first book of mature essays on art, the place of polemic in his writings, and the character of his more difficult metaphysical writings. We should now follow three strands in his writings from 1935 onward: scholarly works on Indian art, similar works on Western mediaeval art, and popular essays and lectures on art. As regards this latter category, it is difficult to know where to draw the line. Coomaraswamy was thoroughly integrated into the academic art-historical community, as has already been indicated. He occasionally lectured at the College Art Association meetings; he published rather frequently in its various journals. The *Art Bulletin* has always been reserved for scholarly articles, and Coomaraswamy's contributions to it in the 1930s were of this nature. The now-defunct journal *Parnassus,* also sponsored by the College Art Association, was more popular and topical in nature. He contributed to it such articles as "An Approach to Indian Art" (1935), which has the typical structure of his "introductions to Indian art," in that it deals primarily with the principles of Indian art and culture. He also contributed to *The College Art Journal*, a professional "trade" journal in which often it is not the frontiers of research that are in question but simply common problems of teaching, equipping departments of art history and small museums, and so on. This journal began publication only in the 1940s. Typically, Coomaraswamy contributed to it a short *mise en*

[35] *Ibid.,* pp. 299, 321 (Pāli excluded).

question of the standard concerns of college art history departments, titled "Symptom, Diagnosis, and Regimen" (1943). Works such as those that appeared in *Parnassus* and *The College Art Journal* cannot really be called popular; they were addressed to a professional audience, although written in Coomaraswamy's attractively colloquial style, the style of his lectures. Writings in this mode also derived from lectures given at various American colleges. Wheaton College in Massachusetts organized a symposium in 1936 around the theme of "Patron and Artist, Pre-Renaissance and Modern," at which the speakers were Coomaraswamy, his friend the artist and essayist A. Graham Carey, and John Howard Benson, a printer and stone carver well known in New England. The lectures were supplemented by demonstrations of various arts and crafts. Coomaraswamy spoke on "The Normal View of Art"; it was later published with other talks given at the conference.[36] Often dogmatic and marred by exaggerations that helped to make points more strongly, in several places it still seems utterly fresh, saying things that he had never said before or never said so well. The construction of this lecture—including a segment of "the Christian and Oriental philosophy of art" that none could express so well as he, a segment of virulently negative views on modern art redeemed by neither much compassion nor much understanding, and a segment of entirely fresh observations on art, aesthetics, and human values—is characteristic of a good many of Coomaraswamy's popular writings in the late period. The talks in his radio broadcasts of 1936–1937, later published in various forms, fit into this category: "The Love of Art" and "The Appreciation of the Unfamiliar Arts" of 1936, followed in 1937 by "What is the Use of Art, Anyway?"

Coomaraswamy's art-historical publications, after the first edition of *The Transformation of Nature in Art*, continued in various directions. A large monograph on early Buddhist sculpture at Bodhgayā appeared in 1935 in the *Ars Asiatica* series, to which he had already made two contributions,[37] and his *Elements of Buddhist Iconography* was published by Harvard University Press in the same year. The latter must be counted among his most important later works. It is a sustained demonstration of the fruitfulness of an erudition that has the particular balance of Coomaraswamy's: knowledge of the external features of Indian iconography, knowledge of the entire religious and metaphysical tradition under-

[36] 1936.
[37] AKC, *La Sculpture de Bodhgayā. Ars Asiatica*, No. 18 (1935).

lying the iconography, knowledge of the corresponding traditions in Islam and Christianity. In works such as this one, Coomaraswamy's thought is always essentially complex. The new thought that he is creating, for the sake of which his book is written, emerges as a result of detailed textual, iconographic, and comparative studies in which a very large universe of discourse is taken into account. *Elements* is a demonstration of the characteristics of a universe of discourse that includes the metaphysics, phraseologies, and iconographies of Hinduism, Buddhism, Christianity, and Islam. Within this universe the particular region under examination is the early iconography of Buddhist art, whose source is in still earlier Vedic and Upaniṣadic conceptions, and for which illuminating parallels can be found in the non-Indian traditions. The particular aim is to demonstrate the complex inner content of certain principal Buddhist symbols, the Tree of Life, the Earth-Lotus, the World-Wheel, and the Lotus-Throne.

Something of the originality of this study appears in its opening words, which forewarn the reader that a shift in perspective has taken place. Whereas iconographies are generally studied because their representation at a given time and place is beautiful and because the ideas and other cultural data they transmit are stimulating, in this work iconographies are studied out of a need to reconstitute the traditional world-view and to experience what effect it can have on modern temperaments.

It is proposed to treat those fundamental elements of Buddhist symbolism which predominate in the earlier aniconic art, and are never dispensed with in the later imagery, though they are there subordinated to the "human" icon. In neither case is the symbol designed as though to function biologically: as symbol (*pratīka*) it expresses an idea, and is not the likeness of anything presented to the eye's intrinsic faculty. Nor is the aniconic image less or more the likeness of Him, First Principle, who is no thing, but whose image it is, than is the "human" form. To conceive of him as a living Tree, or as a Lamb or Dove, is no less sound theology than to conceive of Him as Man. . . . Any purely anthropomorphic theology is to that extent specifically limited; but He takes on vegetative, theriomorphic, and geometrical forms and sounds just as much and just as little as he dons flesh. So the Bodhisattva vows that he will not be Utterly Extinguished until the last blade of grass shall have reached its goal.[38]

[38] AKC, *Elements of Buddhist Iconography*, p. 3.

For most readers, such a passage moves in an unfamiliar universe of discourse. It can be apparent from a first reading that Coomaraswamy feels sufficiently at home in it to be able to speak with vivacity, even wit ("just as much and just as little as he dons flesh"). One can see that he seems to have retrieved certain traditional icons such as the Lamb and the Dove from the particular settings where they are appreciated by the faithful but regarded with indifference by the greater number. One can see that this retrieval of old forms is not done from within any single tradition for the sake of reanimating it, of calling the flock back together, but from another point of view. Data from all of the fallen traditions are gathered in order to understand them as parts of a single universe of discourse and in order to reconstitute that universe of discourse. The impulse is religious, but ecumenical in the largest sense: Coomaraswamy said lightly on one occasion, "I am too catholic to be Catholic,"[39] and rather more seriously remarked on another occasion that it is quite possible to describe oneself as "orthodox" without adding anything further such as "orthodox Christian" or "orthodox Jew."[40] But if the impulse is religious, is it not perhaps to the same degree lacking in scholarly impartiality?

There is no doubt that Coomaraswamy's writings are tendentious: tending toward God, in works such as *Elements*; tending toward a culture in which manufactured goods have spiritual significance both for their maker and user, in more popular writings. It is a question whether this tendentiousness blinded Coomaraswamy or, on the contrary, allowed him to see more, or blinded him in some respects and made him clear-sighted in others. Coomaraswamy's colleagues were not all of one opinion on this question. For each person like Lucien Scherman or Benjamin Rowland, Jr., there were other equally eminent scholars on the attack. One of Coomaraswamy's correspondents was John Clark Archer, professor of comparative religion at Yale University, expert in a subject upon which Coomaraswamy drew very heavily in *Elements* and other studies. Professor Archer acknowledged reception of a metaphysical paper in the spring of 1936 with the following letter, to which Coomaraswamy added a brief postscript before filing it:

I wish to thank you most heartily for your article on Vedic Exemplarism. . . . Its erudition, close documentation and "exemplary" parallels

[39] Katharine Gilbert in *Memorial Volume*, p. 85.
[40] AKC, review of Theodor Haecker, *Schönheit: Ein Versuch* (1937).

command the closest attention from the reader. I myself find it diffi-
cult to associate so intimately the Rigveda, Plotinus and St. Thomas,
for example. But a mystical sense disregards time and space, I know!
Your article drips secretions of the mystical. I am myself somewhat
more realistic in my reading of the Rigveda, and of the Upanishads,
also.[41]

Coomaraswamy added at the bottom: "pour rire—sinon pour pleurer!"
It would be easy to affirm that Coomaraswamy's religious intellectuality
is the very type of spirit to which humanistic scholarship owes the re-
ligious monuments, both literary and plastic, that are so often the object
of its study. But this would be to close the question of his differences
with more "realistic" scholars decidedly in Coomaraswamy's favor. He
himself liked to keep the question open: why else did he send his paper
to Professor Archer for comment? Coomaraswamy was self-conscious
because of his differences from other scholars around him, and often
made remarks directly concerned with the nature and purpose of scholar-
ship. He was to some extent embattled, but not really on the defense.
He had friends, admirers; important publishers welcomed his writings.
He had also built his reputation as a "standard" art historian since the
early years of the century, and he continued to the very end to produce
works of standard scholarship; his last published work, which appeared
a full nine years after his death due to the difficult circumstances of post-
war Europe, was an irreproachable monograph on a major monument of
early Buddhist sculpture, Bhārhut.[42] Under these conditions, he can be
fitted neither into the category of brilliant eccentrics nor into the category
of men ahead of their times who go unappreciated by their contemporaries.
In the years 1936-1938, Coomaraswamy's Indian studies dealt predomi-
nantly with metaphysics, but three articles on Indian art stand out: a very
closely reasoned piece on "The Part of Art in Indian Life" (1937), a fiery
defense of his scholarly method published in the same year ("The Rape
of a Nāgī"), and the long introduction on "The Nature of Buddhist Art"
contributed to a portfolio on wall painting in India and Ceylon whose
principal author was Benjamin Rowland, Jr. (1938).
More surprising is his continuation of the mediaeval studies that began
with the chapter on Meister Eckhart in *The Transformation of Nature
in Art*. In 1935 he published a translation and commentary on texts rele-

[41] John Clark Archer, letter to AKC, 29 April 1936, family collection.
[42] AKC, *La Sculpture de Bharhut* (Paris, 1956).

vant to aesthetic theory in the works of Pseudo-Dionysius and the thirteenth-century theologian, Ulrich Engelberti of Strassburg. This was followed in 1938 by a second installment: a translation of Thomas Aquinas or Dionysius, with commentary as before, followed by a long note on "the scholastic thesis of the essentially intellectual quality of beauty."[43] In his introduction to the first article, Coomaraswamy pointed out the importance of knowing material such as this in spite of its difficult and even alien point of view. There were very few previous works on the subject in English, and the texts themselves, having little in common with modern thought, are most extraordinarily alien. Coomaraswamy nevertheless argued for "the intrinsic charm of the material," and went on,

No one who has once appreciated the consistency of the Scholastic theory, the legal finesse of its arguments, or realized all the advantages proper to its precise technical terminology, can ever wish to ignore the patristic texts. Not only is the mediaeval aesthetic of universal application and incomparably clear and satisfying, but also, at the same time that it is about the beautiful, beautiful in itself.

The modern student of "art" may be at first inclined to resent the combination of aesthetic with theology. This, however, belongs to a point of view which did not divide experience into independently self-subsistent compartments; and the student who realizes that he must somehow or other acquaint himself with mediaeval modes of thought and feeling had better accommodate himself to this from the beginning.[44]

There is, then, a challenge. Coomaraswamy did not have a mastery of Western mediaeval monuments and iconography comparable to his mastery of their Indian counterparts, but at places where Indian and Christian art tended to coincide, such as in aesthetic theories, he could work with confidence and even do work that it had not occurred to others to do. His knowledge of Christian theology had been a tool for the illumination of early Indian thought; it could also function independently or turn

[43] AKC, "Mediaeval Aesthetic: I. Dionysius the Pseudo-Areopagite and Ulrich Engelberti of Strassburg" (1935), and "Mediaeval Aesthetic: II. St. Thomas Aquinas on Dionysus, and a Note on the Relation of Beauty to Truth" (1938), where this brief passage appears on p. 22. These articles were published together as "The Mediaeval Theory of Beauty" in *Figures of Speech or Figures of Thought* (1946); the reader will find this unified version in SP I.

[44] AKC, "The Mediaeval Theory of Beauty," SP I, 189–190.

back into the Christian artistic tradition. It was always his thesis that traditional religious cultures, even ones as separate from each other as the Western mediaeval and the Indian, have more in common with each other than they do with the modern West. It is also true that in his approach to Indian iconography he had benefited from the work of Émile Mâle on Christian iconography. The comprehensiveness and warmth that characterize Mâle's work, Mâle's respect for traditional thought, which gave conviction and eloquence without vitiating scholarship, were certainly models for what Coomaraswamy tried to do in his own field. Coomaraswamy failed to be the Morris of the East, as he might have wished, but he easily wins title to having been the Mâle of the East.

It was only to be expected that in addition to his articles on mediaeval aesthetics, there would be some on iconography. He generally took up themes for which he had found interesting parallels in Indian art or knew an overlooked theological doctrine that helped to explain its features. Such were the Tree of Jesse, an image of the Virgin suckling St. Bernard, and the type of the icon of Christ in which the eyes seem always to rest on the observer, no matter where he stands.[45] In his Western studies, Coomaraswamy occasionally blundered (as also in his Eastern studies—this has always been the prerogative of scholars). In an article published in 1944 on "The Iconography of Dürer's 'Knoten' and Leonardo's 'Concatenation,'" which brought together a great variety of interesting material on the interlace motif and the symbolism of weaving and threads, he made a glaring error of fact regarding mediaeval church labyrinths. Professor Panofsky, the great Dürer scholar, called attention to this in his monograph on Dürer.[46]

Coomaraswamy could work in harmony with mediaevalists: for an exhibition of mediaeval art arranged in 1940 at the Boston Museum by Dr. George Swarzenski, yet another German scholar of international repute who had been obliged to leave his country, Coomaraswamy wrote a brief introduction on "The Nature of Mediaeval Art." He could also work more or less out of harmony with mediaevalists: probably his most perspicacious critic throughout the 1930s and 1940s was Professor Meyer Schapiro, much of whose work has been in mediaeval art. The point of departure for Professor Schapiro's criticism was a genuine friendship, but

[45] AKC, "The Meeting of Eyes" (1943), SP I.
[46] Erwin Panofsky, *Albrecht Dürer* (3rd ed., Princeton, 1948); Vol. II, "Additions to the First Edition," No. 360, p. 165.

there seems to be no other scholar of his quality who so thoroughly questioned Coomaraswamy's views, with the exception of Sir Herbert Read, less scholar than critic. Coomaraswamy never found himself writing, "Pour rire—sinon pour pleurer!" on Schapiro's letters. On the contrary, he sought out Schapiro's company.

We have had reason several times to mention Coomaraswamy's appreciation of the idea of "alternative-formulae," an idea most clearly stated in Buddhist writings. The theology, socio-religious order, and art of the mediaeval West were understood by Coomaraswamy as valid alternative formulations of their counterparts in India. A good many of his essays on art use mediaeval and India data in parallel, to establish a single "traditional" point of view on a given subject. For example, in a commentary on a famous principle enunciated by an architect of Milan cathedral ("Ars sine scientia nihil," 1943), Coomaraswamy was able to illustrate one of the key doctrines of Indian art theory without any straining of his texts. A third alternative formulation to which Coomaraswamy gave equal weight is the Platonic, with its extensions into later thinkers such as Plotinus and Augustine. His article on "Ornament" (1939), for example, is an etymological study of the terms for ornament in Sanskrit, Greek, Latin, and English. "The Christian and Oriental, or True, Philosophy of Art" (1939) is a parallel reading of Christian and Indian philosophy. It is one of his most important longer essays, polemical to be sure, but full of ideas that can be found in the writings of no other scholar.

In 1939 Coomaraswamy also published his first short study of primitive art; it first appeared in French in *Études traditionelles* under the title "De la 'Mentalité primitive',," and only later in English. The traditional culture and arts of so-called primitive peoples appeared to him to offer a further alternative formulation of everything that concerned him. All the artifacts of primitive cultures expressed fragments of their world view at the same time that they served a specific purpose; and all actions, from planting to woodcarving, were understood as both physical and metaphysical in content. Coomaraswamy also discovered that the fate of many African and South Pacific cultures, upon contact with the white man, differed little from the fate of traditional Indian and Ceylonese culture: the destruction was even more complete because only small, easily damaged populations were involved. This discovery resulted in the renewal of his protest against industrialism and commercialism in such articles as "Notes on Savage Art" (1946). His "discovery," of course, is a funda-

mental fact that every anthropologist must acknowledge at some point in his career.[47]

In pursuit of knowledge of primitive culture, Coomaraswamy was reading Boas, Schmidt, Lévy-Bruhl, Margaret Mead, conversing with Leyland Wyman in Boston, corresponding with members of the United States Bureau of Indian Affairs. He was reading specialized monographs on South Pacific peoples, American Indian religious and social forms, and aspects of folklore. Little by little finding its place in relation to what he already thought about traditional culture, all of this came to expression in articles that followed on "Primitive Mentality," which constitute a strong, characteristic portion of his late writings.[48]

One aspect of folklore that he investigated especially thoroughly is folk- and fairy-tale motifs. He found in the world-wide distribution of many folk motifs, such as the perilous bridge or the moving gate by which the hero must pass, a great body of material that preserved and dramatized the fundamental doctrines of traditional thought. As he previously made comparative studies in metaphysical and religious thought, which already required a comparative approach to myth, in the 1940s he did a number of studies of the content and transformations of folklore motifs. Perhaps the most fascinating of these is "Symplegades," (1946), dealing with the whirling or pulsating gate through which the folk heroes of many cultures are obliged to pass. They succeed, but always leave behind a little something: a bit of their horse's tail gets caught in the gate, or a bit of themselves. The transformations of motifs did not interest him *per se*, but only insofar as they indicated various aspects of a common content. He was moved and astonished by the distribution of comparable motifs among cultures that had apparently nothing in common historically.

We have outlined an accumulation of new interests in Coomaraswamy's intellectual life that would be nothing more than an accumulation were they not united by a single point of view, the "traditional" point of view (we should continue to put this word in quotation marks occasionally until we have carefully examined its content; for now, it must be considered suspect). All of these new interests were represented in the two

[47] Cf. Claude Lévi-Strauss, "Anthropology: Its Achievement and Future," *Current Anthropology*, VII (1966), 126.

[48] Biblio. Nos. 462, 514, 523, 577, 586, 593, 595, 602, 605 in the *Working Bibliography*.

collections of essays made in the 1940s: *Why Exhibit Works of Art?* (1943), and *Figures of Speech or Figures of Thought: Collected Essays on the Traditional or "Normal" View of Art* (1946). At the beginning of the first collection, he indicated on the copyright page that there was to be no copyright: "quotations long or short may be made without express permission." Three years later, he found a much more daring formula for the copyright page of *Figures*: "No rights reserved." To this was added that quotations of "reasonable length" could be made without written permission—which sounds rather as though his publishers, the excellent Luzac and Company, had put their foot down. Coomaraswamy's conviction that there is no property in ideas lay behind this departure from convention. In practice, there was an inconvenience in the gesture: it later exposed his works to publishers' reprints that did not always bring financial benefit to his family to the degree that a copyright would have assured.

If it is true that Coomaraswamy in these late years created a new form of thought and brought back into the universe of discourse a quantity of traditional material that had been lost, it is also true that he recognized the need for something like a manual of study that would permit others to recapitulate his progress. He suggested in the preface to *Figures* that whoever makes use of that book, as well as of *Why Exhibit Works of Art?* and *The Transformation of Nature in Art* "*and* of the sources referred to in them will have a fairly complete view of the doctrine about art that the greater part of mankind has accepted from prehistoric times until yesterday."[49]

Several of the articles in the two later collections deserve comment. The title article of *Why Exhibit Works of Art?* was originally a lecture delivered in the spring of 1941 to The American Association of Museums. Gordon Washburn, a leading museum director at that time connected with the Albright Art Gallery of Buffalo, invited Coomaraswamy to be the principal speaker at the meeting because, as he wrote in his letter of invitation, he had just finished reading "Primitive Mentality" and wanted to bring Coomaraswamy's way of thinking to the attention of museum colleagues. "Unfortunately, most museum people in this country do not yet know your writings nor understand your point of view. Here at last I have an opportunity to present you before the largest gathering of them

[49] AKC, *Figures of Speech or Figures of Thought*, p. 5.

which is ever held. . . . It provides an opportunity to shake them up in a very real way."[50] A few days after his lecture at the meeting, Coomaraswamy briefly described his experience there in a letter: "Recently I expounded 'my' view of art and its bearing on museums to the Am. Assoc. of Museums Convention and was surprised to find it welcome. I said the educational effect of a museum exhibit should be philosophical, not aesthetic."[51] Coomaraswamy's pessimism about the modern world, not so deep that he was closed to pleasant surprises, not so well founded that he ever failed to find an audience for his ideas, is apparent in his remark. The lecture in its published form is his best single discussion of the function of museums.

In the second collection of essays, the title essay is his most complete continuous exposition of the traditional philosophy of art in Plato's terms; other traditions are cited only after a close reading of Plato on art and its role in society. Another remarkable essay, "*Saṃvega*: Aesthetic Shock," is a discussion of art appreciation in which, against a background of Buddhist texts, he gives an account of what it is when the appreciation of art becomes a "serious experience."

> samvega . . . refers to the experience that may be felt in the presence of a work of art, when we are struck by it, as a horse may be struck by a whip. It is, however, assumed that like a good horse we are more or less trained, and hence that more than a merely physical shock is involved; the blow has a *meaning* for us, and the realization of that meaning, in which nothing of the physical sensation survives, is still a part of the shock.[52]

In this essay, Coomaraswamy found a middle way through the dangers that threaten aestheticians: he described what it is to be moved by a work of art without recourse to a technical philosophical vocabulary, which so often in works on aesthetics places the thought at a discouraging distance from experience; he described the experience psychologically without creating an atmosphere of subjectivity or speaking a private language— on the contrary, his analysis gives the impression of an objective cycle of inner experience to which the viewer's experience corresponds more or less. And yet by his description he did not destroy the experience or

[50] Gordon Washburn, letter to AKC, 2 April 1941, family collection. Quoted by courtesy of the author.

[51] AKC, letter to S.E., 27 May 1941, private collection.

[52] AKC, "*Saṃvega*: Aesthetic Shock" (1943), SP I, 183.

reduce the reader's appetite for aesthetic experience—on the contrary, the essay has something of the nature of an appeal:

> I have myself been completely dissolved and broken up by [Gregorian chant], and had the same experience when reading aloud Plato's *Phaedo*. That cannot have been an "aesthetic" emotion, such as could have been felt in the presence of some insignificant work of art, but represents the shock of conviction that only an intellectual art can deliver, the body-blow that is delivered by any perfect and therefore convincing statement of truth.[53]

Coomaraswamy very rarely introduced himself in the first person into his essays. That he did so here is a sign of his concern, which moved him to break with his own custom. Professor I. A. Richards, thinking back recently to what he knew of Coomaraswamy, remarked that Coomaraswamy wrote some of his essays "in a white heat."[54] "*Saṃvega*" qualifies, not because it is merely passionate—Coomaraswamy subscribed in his way to William Butler Yeats's lines, "The best lack all conviction, while the worst / Are full of passionate intensity"—but because it is of a profoundly cultured intensity.

A few articles and books require some commentary in what remains of Coomaraswamy's bibliography. Since the early 1930s, Coomaraswamy had been following the writings of C. G. Jung with interest. It was evident that Jung had helped to introduce in the West certain classics of Eastern thought, such as *The Secret of the Golden Flower*, and that Jung's psychological commentaries on both Chinese and Indian thought represented an assimilation of Eastern culture on the highest level. Furthermore, Jung's work on archetypal symbolism, myth, and religious art was very close to what Coomaraswamy had been doing from another point of view. Coomaraswamy occasionally sent Jung offprints of articles that he thought would interest him, such as "The Inverted Tree" (1938), a study of the significance and transformations of a very ancient symbol. To this paper, Jung replied: "Your paper about 'The Inverted Tree' has been an exceedingly welcome gift to me. This is exactly the kind of thing we need most, namely monographs on symbolic motives. For us it is chiefly a very practical question since we are concerned with such symbolism in our daily psychological work with patients. The tree is one of the most frequent symbols."[55] Coomaraswamy's interest in Jungian

[53] *Ibid.*, p. 184.

[54] Conversation with Prof. Richards. AKC said as much of himself (see Appendix, p. 291).

[55] Princeton Collection.

thought extended beyond his relation with Jung himself; the Jungian analyst, Dr. John R. Layard, was among his frequent correspondents in the 1940s, and the use of a Jungian approach to symbols caught his attention—and occasionally later his comments—in works of anthropology, psychology, and literary criticism. Several articles in Coomaraswamy's bibliography reflect this interest, particularly "Primordial Images" and "On Hares and Dreams."

Two works of Coomaraswamy's last year, 1947, bring us to the close of this *bibliographie raisonnée*. During the Second World War, he began once again writing essays on social problems and the tension between East and West. He had predicted on a few occasions well before the war that if industrialization and Westernization continued in the East, the West would very likely find itself fighting its own style of total war with an Eastern power. The coming of the war reanimated in him the wish for tolerance between East and West. His commentaries were not directly on the war, but on misunderstandings that would continue after the hostilities and require solution. Lectures and essays of this character were collected in a volume, *Am I My Brother's Keeper?* (New York, 1947). As so often, the title chosen for the volume has a plain English eloquence that belies how complex his language could be in writings on metaphysics. One of the best of the lectures on the theme of mutual understanding was given too late to be included in the volume. It was his Kenyon College Conference address of 1946, "For What Heritage and to Whom Are the English-Speaking Peoples Responsible?" In that year, when the machinery for granting independence to India was grinding to its dénouement, he reexamined Anglo-Saxon attitudes and acts in India and pleaded both for greater understanding of Eastern culture and for greater understanding of the West's own heritage. This general reexamination of Anglo-Indian relations attracted the attention of the national press; résumés appeared in *The New York Times* and elsewhere.

The last metaphysical writing to appear in his lifetime was *Time and Eternity*, a study with chapters on Hindu, Buddhist, Greek, Muslim, Christian, and modern concepts of time. It is a very difficult book, not in this case in respect to its organization, but because of the thought itself. It can be assimilated only very slowly by readers without special training in metaphysics; it is the fruit of a very slow assimilation in the course of Coomaraswamy's intellectual life. Perhaps half of the book is citations, passages from authors who represent the best of each tradition. Coomaraswamy's relation with these ancient authors and certain of their

modern commentators is well represented by his closing paragraph, in which for the first time in any writing he adopted the Indian convention of ending a study of sacred doctrine with a prayer. He used to say, in the 1940s, that as he grew older he became more Indian; this had the flavor of a boast when he put it in letters, but the boast originated in a true perception of himself, better reflected here.

We have traced, according to ability, the history of the meanings of the concepts of time and eternity: the one, in which all things come and go, and the other, in which all stand immutable. We can only accept these established meanings without question, if the integrity of communication is to be preserved; except for those who elect to live in a merely existential world without meaning, they have always been, and will always remain an integral part of human experience. For "non-spatial and non-temporal intuition is the condition of the interpretation of the spacetime world itself"; "all states of being, seen in principle, are simultaneous in the eternal now . . . (and) he who cannot escape from the standpoint of temporal succession so as to see all things in their simultaneity is incapable of the least conception of the metaphysical order"; and in the "unified experience of reality the whole process of creation from the Primal Covenant to the Resurrection is a single timeless moment of Divine self-manifestation."

OṂ NAMO ANANTĀYA KĀLĀNTAKĀYA![56]

Why invent a drama where there is none? Yet it is fair to say that Coomaraswamy seems to slip away in this passage. He confers the privilege of closing his book on other authors—respectively Wilbur Urban, a philosopher whom he knew as a personal friend, René Guénon, and R. A. Nicholson, whose translations and commentary on Rūmī he had been using for years; and instead of taking the opportunity to make his own final comments, after these trusted contemporaries have been given their due, he writes an ancient prayer. This is the sign of further changes in his life, changes that can be understood by returning to the intersection of time and eternity where we left his biography some pages ago.

[56] "Oṃ! Reverence to the ever lasting destroyer of time!" Translation through the courtesy of Professor W. Norman Brown, letter to the author.

XIV. 1932–1947: The World of a Scholar

Plato, who is the father of European metaphysics, teaches that to know reality one must separate as far as possible the soul from the body, but that having done so one must not remain on that height in literal isolation but *descend again into the cave to play a part in the life of the world*, for which one is thus, and thus only, truly qualified. (He uses the word "play" just as Indian *līlā*).

Coomaraswamy, letter to S.E., 1941

Coomaraswamy knew as a scholar and loved as a man such maps of life as this one from Plato's writings. He considered that an individual's place on such a map is "strictly speaking a secret between himself and God."[1] He lived the latter part of his life against a background of such maps.

New England tried periodically to size up the stranger. The Lowell, Massachusetts, *Morning Citizen* described Coomaraswamy in 1931 as "the most prolific New England author of today,"[2] which was perhaps true but delightfully incongruous. The author of a series in the *Boston Herald* in 1933, "Talking It Over with Unusual Bostonians," preferred to think of him as remote: "Dr. Coomaraswamy is a tall man, slow-spoken, slow to smile; he has an incisive mind, an ironic sense of humor. His sparse grey beard, thick straight iron-grey hair, and keen, steady dark eyes beneath a round, smooth, hairless brow lend his face a rare distinction. It is neither an open face nor a secret one, but it is the remote face of a scientist and scholar."[3] Eric Schroeder recorded what Brahmin Boston thought of him: "He was too famous and too odd to be ignored; but a superstitious or vulgar respect for him as a "distinguished" figure was the usual way of regarding him. It was generally realized that he had something important to say, and that it would be wise to give him a hearing; but very few thought it was wise to take him seriously."[4] In professional circles there existed a similar division of feeling. It is

[1] AKC, "Mahātmā" (1939), p. 4. [2] Clipping, family collection.
[3] *Ibid.* [4] Appendix, p. 287.

reflected in a letter sent to Coomaraswamy in 1947 by the book review editor of a professional journal, who remarked that in trying to find a reviewer, he had the problem of choosing between Coomaraswamy's co-workers, who would inevitably review the work favorably, and the mass of other readers, whose approach was too narrow to do Coomaraswamy justice.[5]

But it is not by any division into opposed camps nor by any single statement that Coomaraswamy in these years can be understood, which means not so much *described* as *seen* moving in his world, disturbed by some things and delighted by others. What seems to have been most important, aside from his work, was conversations: by letter, in person, it mattered little. From the sum of these conversations, as we can know them now, there emerges a picture full of nuances.

Coomaraswamy's day-to-day life was simple enough. He had adopted a heavy schedule of work. He generally rose at five A.M. and worked in his study until nine; then he drove some twelve miles into the city to the museum for the rest of the daylight hours.[6] As Fellow for Research in the Asiatic Department, he had few curatorial responsibilities and seems also to have taken less responsibility than was expected. He worked quietly at a desk in the department offices on the ground floor, his window overlooking the big rectangular space framed by the wings of the museum building. He did not welcome interruptions while he worked, but at lunch he enjoyed conversations with staff colleagues. He was actually a discreet presence in the museum during these later years; his direct contribution to its prestige had been solidly and abundantly made in the 1920s, and now his writings, listed annually in the museum's *Annual Report*, were a source of pride.

Coomaraswamy's working method was quite individual. When he had finished an article, he often kept it (in the published version) close at hand and added afterthoughts in longhand as they occurred to him (Figure 30). These were his "desk copies," growing and changing with the years. His intention seems to have been in part to improve the articles for later republication in a collection, and in part simply to record re-

[5] Letter to AKC, 14 October 1947, family collection.

[6] In 1937, AKC wrote in the course of a Vedic commentary: "The light of Dawn is at once a beauty and a call to action, setting all things to work." Besides expressing his appreciation of the early hours of day, this brief passage expresses his view that beauty is always *for* something—it works its attractions for the sake of something beyond it. The passage is from "Beauty, Light, and Sound" (1937), 53, note 3 (published to date solely in French; cf. Bibliography).

Each and every part of a picture seen in dhyāna,
each word of a mantra that has been 'found' or 'heard',
is indispensible and necessary, in the same sense
that in a mathematical equation, that a solution would
be impossible if any single symbol were removed. It is
therefore impossible to eliminate any part of the picture,
or any word of the Ṛg Veda as "irrelevant"; no solution it
is the business of the speculator to find the locus of the
equation, but he cannot do so by eliminating a
disagreeing any symbol that he does not understand. To
arrive at a solution, every symbol must be read in
its place.

 or that may be distasteful.
 The erotic passages , and the 'Frogs', for
example are not by one iota less an integral part
 nor any lover in whatever level of reference
of the Vedic theology than are any of the more
'acceptable' hymns to Varuṇa or Dawn.

Figure 30. A page from Coomaraswamy's notes.

lated material in a form that he found convenient. He would cut some articles into separate pages and paste them on large sheets so that he could literally surround the original with additions and revisions. At the close of a day of research and writing in the museum, where the library was a necessary resource, he would return to his home and perhaps take care of the garden, which was of absorbing interest to him. A photograph of Coomaraswamy at about age fifty-five, taken in the garden,[7] gives the impression of a man in a remarkable state of health. His body has a quality of sturdiness still unthreatened by the aging which has begun to line his face. His garden had particular significance for him. Like any serious gardener, he knew the botany of what was growing, but it was not this that engaged him. In a short article on Chinese landscape paintings exhibited at the museum in 1944, he wrote: "The conception of kinship is . . . profound . . . it is the 'soul of the soul,' or 'spirit,' that is one and the same undivided life or light in all living things 'down to the ants.' . . . The whole creation is . . . a family; and whoever is unresponsive to the innermost nature of an animal or a tree is unresponsive to his own Inner man."[8] Words like these reflect an experience of nature that is available to everybody and goes beyond everybody's words. Coomaraswamy's garden was not a place where he "distinguished himself" in any way, but rather a place where he "extinguished himself," allowed the author, historian, philosopher, and all his other *personae* to take their place in the scheme of things. His garden was also a place, perhaps one of the very few, where he could experience that blend of childish wonder and adult contemplation that is often a resource or refreshment of creative people. He once ordered, for example, quite a series of cacti from California and bothered a good number of people whom he knew in that state, simply because those apparently dry and hostile forms astonished him.

The garden cared for, he would work on until dinner in his study. Often Mrs. Coomaraswamy did the entertaining alone when there were guests, until dinnertime. During these years they received a great variety of people, from Indian students—usually doing sciences at various institutions in Boston—to scholars in every field. Anecdotes from the dinner table are still in circulation, for example of the time when a young graduate student in Classics at Harvard came for dinner and found himself faced with a conversation in Latin.

[7] This photograph appears as the frontispiece to SP II.
[8] AKC, "Chinese Painting at Boston" (1944), SP I, 313.

Summers were spent in Maine in a small hillside cabin, where friends visited. Dr. Robert von Heine-Geldern, among others, recounts his visit in the *Memorial Volume*:

> It was a unique experience, after roaming through the immense forests, to sit in that lonely and rustic home, high up on a hill, listening to my hosts' tales of their life in India and discussing with them questions of mythology and of traditional metaphysical lore. Somehow, the situation reminded me a little of the atmosphere in which the Upanishads must have been born. Although by no means voluble and by nature and principle inclined to silence and restraint, Coomaraswamy, like the religious teachers of ancient times, felt the urge to communicate his ideas. "Nobody will ever stop me from talking metaphysics," he once told a mutual friend of ours.[9]

By 1938, when Heine-Geldern paid his visit, Mrs. Coomaraswamy had spent more than two years in India, on her husband's suggestion and following her own bent, studying Sanskrit and traditional lore. She served as his secretary during the years after her return from India, in addition to providing a home life that suited him exceptionally well.

Scholars tend to correspond a great deal with each other. Coomaraswamy never had the opportunity to meet certain scholars whom he counted among his closest friends, thanks to the letters they exchanged. Among the younger Orientalists—the generation that followed his own—there were a certain number of this kind. It is the first circle of friends that deserves to be described—leaving gaps, inevitably—in order to evoke Coomaraswamy's place in the world and to understand him better by the reflected light of friends.

Dr. Hermann Goetz, a German art historian who has long occupied an important rank in scholarship, first wrote Coomaraswamy in 1923, to say that his books had helped him to persevere in serious study of Indian art in spite of general indifference to it among German Orientalists.[10] The relationship, thus started under the signs of debt and gratitude, quickly became an exchange between equals. Goetz made the German translation of Coomaraswamy's *History of Indian and Indonesian Art* and kept close watch over its publication. He worked in the fields of Rajput and Moghul painting for many years after Coomaraswamy had

[9] *Memorial Volume*, p. 56.
[10] Hermann Goetz, letter to AKC, 6 September 1923, Princeton Collection.

abandoned original research in it. A landmark in their relation is Goetz's contribution to the Coomaraswamy Festschrift, the collection of papers offered him on his seventieth birthday. In "Rajput Art: Its Problems," Goetz began with an homage to Coomaraswamy but rewrote the history of Rajput painting in the light of research done since Coomaraswamy's work. Like several other authors, he took the occasion of the Festschrift to differ with Coomaraswamy.

Goetz had written to Coomaraswamy in 1946, using essentially the same words that we find in his contribution to the *Memorial Volume*, in which he took Coomaraswamy to task for recognizing so little of value in the modern world. He knew both how to criticize Coomaraswamy's position and how to understand it:

> his own preoccupations with Eastern philosophy and history should have told him that the cycle of life cannot be halted, that youth and maturity, birth and disintegration are integral, inevitable aspects of life, that the rationalized technical civilization for the nations of hundred millions is as necessary as the primitive virginity for tribes of some thousands. . . . He lived in a world which implicitly believed in the progress of the gadgets, or rejected it in romantic archaism. And though he found a number of prominent companions in his spiritual venture, he had settled in the country where the cult of the gadget had reached its very apogee. This, and the bitter opposition which every pioneer encounters, drove him into a vehement reaction, a one-sided glorification not only of the Middle Ages, but of India and of the whole of Asia, an idealization which refused to see also the other side of life.[11]

In his letter to Coomaraswamy, Goetz had spoken of the Kali Yuga, that age which for Indian cosmology is the very opposite of the Golden Age. It is the age we are currently living. In a letter of early 1947, Coomaraswamy's response to Goetz's criticism picks up at this point:

> I fully agree that the Kali Yuga is a necessary phase of the whole cycle, and I should no more think it could be avoided than I could ask the silly question, "Why did God permit evil in the world?" (One might as well ask for a world without ups and downs, past and future, as ask for one without good *and* evil.) On the other hand, I feel under no obligation whatever to acquiesce in or to praise what I judge

[11] Hermann Goetz, *Memorial Volume*, pp. 325 ff.

to be evil, or an evil time. Whatever the conditions, the individual has to work out his own salvation; one cannot abandon judgment, and be overcome by popular catchwords. I feel therefore at liberty to describe the world as it is, to mark its tendencies. I see the worst, but I need not be a part of it, however much I must be in it; I will only be a part of the better future you think of, and of which there are some signs, as there must be even now if it is ever to come.[12]

The difference between Goetz's and Coomaraswamy's attitudes is the difference between intelligent compromise and prophetic wrath.

Goetz was one among many German intellectuals for whom scholars in America were severely worried after 1933.[13] Coomaraswamy was from time to time oppressed by this order of concern, which of course became graver with the outbreak of war. Goetz found his way by 1940 to a good position in India as curator of the Baroda Museum, but not before an anxious correspondence with Coomaraswamy and others in America concerning the possibility of emigrating there. Heinrich Zimmer, who had been a leader in Indian philosophical studies since the 1920s, was also obliged to pass through the scholarly underground; he spent his last years in America (d. 1943) and quickly won a place in American intellectual life through his books. Coomaraswamy played a role in seeing to it that Zimmer found some degree of well-being in America; he thought Zimmer to be an ideal scholar, at the same time erudite and creative, able to gather material rigorously but also able to see its significance.[14] Zimmer wrote Coomaraswamy from his home in New Rochelle in the suburbs of New York City: "I need not say how much it means to me to have met you personally. Your inspiring way of dealing with Hindu art and religion has, since I became a student, been one of the main elements of my initiation into this revelation of truth."[15]

A younger European scholar, the historian of religions Mircea Eliade, was in correspondence with Coomaraswamy from the 1930s on, as we have already had occasion to mention. Working in Bucharest until the outbreak of war, he had diplomatic missions to Lisbon and elsewhere during the war itself, but found himself in bad straits after 1945. Coomara-

[12] AKC, letter to Hermann Goetz, 17 January 1947, family collection.

[13] Cf. Donald Harnish Fleming and Bernard Bailyn, ed., *The Intellectual Migration: Europe and America, 1930–1960* (Cambridge, Mass., 1969).

[14] Cf. AKC, "Henry R. Zimmer" (1943); also review of Zimmer, *Myths and Symbols in Indian Art and Civilization* (1947).

[15] Heinrich Zimmer, letter to AKC, no date, Princeton Collection.

swamy once again pulled strings in the scholarly community to find something for Professor Eliade in America, who had written in summer 1947 that he needed nothing short of an "incipit vita nova."[16] After finding a tentative—and completely unsuitable—engagement for him in an Arizona preparatory school, Coomaraswamy did not live to see Eliade join the faculty of the University of Chicago and find a "vita nova" entirely suited to his qualities as a scholar.

Eliade was thirty years younger than Coomaraswamy, but from the beginning of his work in the early 1930s he had much in common with the Coomaraswamy of the 1930s and 1940s. He had the custom of addressing Coomaraswamy as "cher maître" in his letters; in French it is a straightforward term, acknowledging the preeminence of an older person in a field of knowledge. In a letter that Coomaraswamy received less than two weeks before his death, Eliade distinguished the use of "maître" in this sense from one of its other primary senses, that of spiritual master. "C'est avec le plus grand interêt que j'ai lu *Symplegades*, reçu aujourd'hui même. Le travail me semble décisif. . . . Vous avez admirablement mis en valeur la multivalence du mythe, et l'analyse finale—le dépassement de la condition humaine à travers toutes les polarités—est digne d'un 'maître.' "[17]

Eliade's distinction between a masterly work of scholarship and a concluding passage where Coomaraswamy spoke with the voice of a spiritual master is a fundamental one to be made; there will be more material for doing so later in this section. The Hasidic Jews of Eastern Europe admired a rabbi who could speak or read Torah exceptionally well, but they admired even more a rabbi who could "be Torah." The distinction interested Coomaraswamy very much.

Another European relation of Coomaraswamy's—another friend whom he never met—was the Assyriologist Walter Andrae. Andrae first came to Coomaraswamy's attention with the publication of *Die ionische Säule: Bauform oder Symbol?* (Berlin, 1933), which Coomaraswamy reviewed in the *Art Bulletin*, describing it as an example of new tendencies in

[16] Mircea Eliade, letter to AKC, 10 August 1947, family collection. Quoted by courtesy of Professor Eliade.

[17] *Idem*, letter to AKC, 26 August 1947, Princeton Collection. Quoted by courtesy of Professor Eliade. Tr.: "It is with the greatest interest that I have read *Symplegades*, received this very day. The work seems decisive to me. . . . You have admirably presented the multivalence of the myth, and the concluding analysis—the transcendence of the human condition by means of passing through all the polarities—is worthy of a master."

archaeology: "Here and there within the last few years a disconcerting wind has stirred the dry bones, to the alarm of orthodox scholarship, which fears nothing so much as a stirring up of life amongst the relics that have been so neatly catalogued and put away in our archaeological mortuaries."[18] Andrae's examination of the early history and significance of the Ionic column interested Coomaraswamy, but he was even more struck by the afterword to Andrae's book, where the author expressed his convictions about the spiritual significance of ancient symbols. Coomaraswamy "read into the Congressional Record," so to speak, these few pages by including a nearly complete translation in his *Art Bulletin* review (in the 1946 collection of essays, *Figures of Speech or Figures of Thought*, he included Andrae's text under the title "The Life of Symbols"). Andrae had been able to express "poetically"—which is to say, in a language drawing in equal measure upon thought and feeling— certain shared convictions that Coomaraswamy had never been able to express so well. Characteristically, Coomaraswamy assimilated Andrae's expression and often quoted it, but he never allowed it simply to dissolve into his thought. He kept it intact as a source, in the same way that he kept passages from much earlier authors intact, to be cited as needed.

An infrequent but significant correspondence developed between Coomaraswamy and Andrae. The latter lived and worked in Berlin when he was not excavating in the Near East. He was the director of the Near Eastern Department of the Staatlichen Museen; in 1928, he had published with Heinrich Schaefer a general work, *Die Kunst des alten Orients*, in the famous *Propyläen Kunstgeschichte* series. He was thus a prominent archaeologist who could "stir the dry bones" of orthodox scholarship with equanimity. Coomaraswamy sent Andrae his *Art Bulletin* review and some articles on the R̥g Veda. Andrae replied, thanking him and adding: "I see . . . that you participate inwardly in the recovery of a Way that we Western men must seek, while Eastern man has always followed it and, I believe, still does. This similarity of perspective encourages and cheers us."[19]

This friendship is interesting because it shows the operation of a certain destiny: Coomaraswamy was attracted by the works of a European scholar of whom he knew nothing personally, only to find that he was a student

[18] AKC, review of Walter Andrae, *Die ionische Säule: Bauform oder Symbol?* (1935), SP I, 342. For further information on Andrae, cf. his autobiography, *Lebenserinnerungen eines Ausgräbers* (Berlin, 1961).

[19] Letter to AKC, 30 July 1935, Princeton Collection; tr. by the author.

of Indian philosophy and Anthroposophy (the latter, a spiritual move-
ment founded by Rudolf Steiner in the early years of the century, is per-
haps better known in America for its secondary and high schools than
for its philosophy). Coomaraswamy would very probably have been
suspicious of Anthroposophy, had he read its primary texts. He would
have found some expression such as "syncretistic" or "tainted with
modernism" to describe it; but he acknowledged the insight of a scholar
who had learned from Anthroposophy. In view of Coomaraswamy's quite
rigid division between "traditional" and "modern," one is glad to see him
occasionally fooled—fooled by the quality of persons who benefited from
contemporary thought outside of his own list in which *nihil obstat.*

Coomaraswamy's connections with younger Orientalists are often sur-
prising. Many of the great contemporary scholars, whose debts to prede-
cessors have dissolved in their own mature work, seem upon closer ex-
amination to have benefited greatly from Coomaraswamy's influence.
Paul Mus, a French scholar who is remembered both for his work on
Borobuḍur[20] and Southeast Asian art and for his attempts to further a
peaceful conclusion to French imperialism in Indochina, wrote to
Coomaraswamy in 1932 that he accounted him "the one among his teach-
ers whose works have most humanly opened to him the generous and rich
thought of India, which one never forgets once one has known its taste.
. . . Your thought is so penetrating and nourishing that your students find
themselves completely saturated with it, and when they try to work for
themselves it is still a little through your eyes that they see questions
upon which you have so deeply left your imprint."[21] Mus found that his
own work often moved in the same direction as Coomaraswamy's; in
1936 he mentioned this, not for the first time, in a letter, and added:
"This agreement is precious to me, I would even say indispensable, in
order to continue an order of research which is not always very enthusi-
astically encouraged by the leaders of Indian studies in France."[22]

Coomaraswamy's innovations in Oriental scholarship, such as *Elements
of Buddhist Iconography* (mentioned by Mus in the second letter), bore
fruit at a great distance. Dr. Stella Kramrisch, another scholar in Mus's
generation who worked for years in India before coming to the United
States in the 1950s, also found in Coomaraswamy's work elements for the
foundation of her own. In a doubtless unintentional echo of Coomara-

[20] Cf. AKC, review of Mus, *Barabuḍur* (1937).
[21] Paul Mus, letter to AKC, 11 June 1932, family collection; tr. by the author.
[22] *Idem,* letter to AKC, 1936, family collection; tr. by the author.

swamy's 1910 outline of what he thought necessary in Indian art studies, nearly forty years later she wrote: "The more energy one has to put into it, the more one becomes aware of a work which like no other has given to Indian studies the direction of the Indian mind."[23] When Dr. Kramrisch published her important study, *The Hindu Temple*, in 1946, it was described by a reviewer as the fulfillment of Coomaraswamy's wish for an Indian art history that would give due importance, and above all due understanding, to the meaning of forms. Again, one is struck by the minor significance of actual meetings among these scholars. Coomaraswamy met Kramrisch once, but no more.

Coomaraswamy was more or less close to a number of younger Orientalists in America: Benjamin Rowland, Eric Schroeder, Langdon Warner, Murray Fowler, Richard Ettinghausen, Arthur Upham Pope, John Ellerton Lodge, among others. In each of these relationships there is a story worth telling, yet a line must be drawn somewhere, passing among all the good stories and excluding some. Coomaraswamy joined Ettinghausen in 1934 as a consulting editor of the new publication *Ars Islamica*, for which Ettinghausen was principally responsible. Ettinghausen, although a master of orthodox scholarship in Islamic studies, appreciated Coomaraswamy's work on the philosophical and religious content of art, as well as his criticism of contemporary art-historical scholarship. Ettinghausen put to Coomaraswamy a question that the latter heard from many other sources; to what extent is it proper to interpret works of Islamic art as symbols? Coomaraswamy's tendency was to view all traditional art as either consciously or unconsciously symbolic. In the second case, he believed that traditional forms and ornaments were used simply because they were a standard, inherited repertoire, but that if one could follow them back to their source, one was likely to discover that they were originally significant. Ettinghausen asked:

I often wonder how you evaluate Persian Art because so much of it does not come in the circle of traditional art. Many pieces seem to be created only for entertainment or to please the eye. I am thinking of the many inlaid bronzes or of the so-called mina'i pottery with their over-glazed painted decorations. Their decorations seem to be ornament in the modern sense and not "originally meant to endow the objects with its necessary accidents with a view to proper operation."

[23] Stella Kramrisch, letter to Doña Luisa Coomaraswamy, 20 April 1946, family collection. Quoted by permission of Professor Kramrisch.

I cannot see that they represent "a polar balance of physical and metaphysical."[24]

The answer to this letter is not available, but in 1947 the two scholars met each other for the last time at a Near Eastern conference at Princeton University: Coomaraswamy mounted the podium after Ettinghausen's address on the state of Islamic studies and gave a lecture on the philosophy of Persian art—which covered just the question Ettinghausen had asked several years earlier.[25]

Ettinghausen's regard for Coomaraswamy took practical form. In a letter of 1942, he asked Coomaraswamy to consider whether he would like to have a bibliography of his writings drawn up, and he proposed to put the resources of *Ars Islamica* to work on the task, provided that Coomaraswamy would help where necessary. The bibliography, conceived as a sixty-fifth birthday gift, appeared in *Ars Islamica* IX (1942), and was for many years the single most useful tool for students of Coomaraswamy's writings.

Another circle of friends comprised a number of scholars teaching in universities in the northeastern United States. They were in a variety of fields, reflecting Coomaraswamy's various interests. We have already discussed his friendships at Harvard with I. A. Richards, George Sarton, Lucien Scherman, Eric Schroeder, and Benjamin Rowland, Jr. The resources of the Harvard community were certainly great in the 1930s and 1940s; but there is little evidence of Coomaraswamy's connections aside from one remarkable expression of indebtedness[26] that links Coomaraswamy to Professor James Woods, a scholar of Sanskrit and Pāli, some years Coomaraswamy's senior, who retired from the university in 1934 and died a year later. It seems very likely that Coomaraswamy's learning in these fields owed a great deal to Professor Woods. Coomaraswamy was by no means working in a cultural vacuum, however much he raged against the vacuum lying just outside his own milieu. Within his world there were not only senior people such as Professor Woods, but extremely acute contemporaries such as I. A. Richards, and younger men like Schroeder and Rowland, who were his students on an informal basis. For questions of Greek philology and philosophy, Coomaraswamy corresponded with Werner Jaeger and occasionally dined with him. When

[24] Richard Ettinghausen, letter to AKC, 8 July 1943, family collection. Quoted by permission of Professor Ettinghausen.

[25] AKC, "Note on the Philosophy of Persian Art" (1951), SP I.

[26] AKC, talk at his Boston dinner; as published in this study, p. 252.

he needed to discuss questions of sociology, he could address himself to one of his closest friends in these later years, Pitirim Sorokin, who occupied the Chair of Sociology at Harvard from the time of its creation in 1930. Conversation about education could proceed very well with Robert Ulich of the Graduate School of Education, who was among Coomaraswamy's intimates.

Outside his Boston milieu, Coomaraswamy was particularly fond of Meyer Schapiro of Columbia University, as already mentioned. They met in the late 1920s and argued, in an atmosphere of mutual respect, for the next twenty years. At the end of the twenty-year dispute, Professor Schapiro, perhaps better than anyone else, expressed what was irreplaceable in Coomaraswamy's scholarship.[27]

Coomaraswamy had friends in Catholic milieus both in America and abroad. His way of traveling the boundaries of his world was to send offprints of his articles out to people in the hinterlands whom he may only have known through their writings or reputation. Thus he sent a series to the Archbishop of Quebec, and on another occasion to Cardinal Cushing, Boston's late well-known prelate.[28] With professors in Catholic universities he found an interesting dialogue. He was, as we have seen, extremely close to the Catholic intellectual tradition, but the exclusivity of Catholicism troubled him. He had a splendid collection of passages from the Early Christian fathers where a genuine tolerance of other spiritual traditions was expressed. To Paul Dinkins, of Texas Christian University, he wrote the following in 1944:

> You doubtless understand that I do say to you "Yours is the true religion," only not italicising "the." Papal infallibility (*ex cathedra*) is no difficulty; one only wonders, Why should *only* the Pope be infallible? As Aristotle says, "*Nous* is never wrong": and there *should* be more than one person "led by the Holy Ghost" in the Christian fold and, because so led, infallible. To me "conversion" means turning around from facing the world to face God. But it is an "accident" whether we refer to Him as Jehovah (*noster Deus ignis consumens*) or to Him as Agni.[29]

This exemplifies the tone of much of his correspondence with Catholic intellectuals. Coomaraswamy's greatest friend among them was Walter

[27] Cf. epigraph to Chapter XVI.
[28] Acknowledgments in the Princeton Collection.
[29] AKC, letter to Paul Dinkins, 1 August 1944, family collection.

Shewring, an English friend of Eric Gill's, with whom he had a fruitful correspondence in the last ten years of his life. The conversation with Shewring ranged over many subjects, but always returned to Christianity. In 1936, for example, Coomaraswamy wrote:

> A Catholic friend of mine here who has been writing articles on extremism—urging a *no compromise* relationship between the Church and the world, tells me that I (who am not formally a Christian!) am the only man who seems to see his point! What I am appalled by is that even the Catholics who *have* the truth if they would only operate with it wholeheartedly, are nearly all *tainted by modernism*, leaving speculation and factibilia to the profane Mammon. Christianity is nowadays presented in such a sentimental fashion that one cannot wonder that the best of the younger generation revolt. The remedy is to present religion in its intellectually difficult forms: present the challenge of a theology and metaphysics that will require a great effort even to understand at all.[30]

The renewal of interest in religion has happened in another way in the last decade, but Coomaraswamy's suggestion of the necessary mood was prophetic: an idea of the *difficulty* of understanding seems to be present in many of the forms of religious renewal in contemporary America.[31]

Coomaraswamy was at his best in his conversations with Catholic thinkers. Usually taken to be doctrinaire himself, in relation to Catholics who were unable to accept his equal respect for other religious traditions, he suddenly appears to be supple, expert at intellectual karate: "You are doubtless right in saying that I have 'missed something' in my understanding of Christianity. I am sure I have missed much in my understanding of other confessions also. Is it not inevitable that we all should have 'missed something' until we reach the end of the road?"[32]

His veneration for Hindu and Buddhist scripture was matched by his suspicion of modern Hindus and Buddhists in Europe and America who professed to teach. Partly through the influence of Heinrich Zimmer, he had come to accept Ramana Maharshi, the Indian sage, as a genuine saint and teacher, but, as he wrote to Dr. Layard, the Jungian analyst and cultural anthropologist with whom he corresponded in the 1940s, "There

[30] AKC, letter to Walter Shewring, 4 March 1936, family collection.
[31] Cf. Jacob Needleman, *The New Religions* (New York, 1970, with later editions).
[32] AKC, letter to S.L.G., 21 July 1943, family collection.

is nothing better than the Vedānta—but I know of no Śrī Ramana Maharshi living in Europe. I do not trust your young English Vedantist, nor any of the missionary Swamis; though there may be exceptions, most of them are far from *solid*. I would not hastily let anyone of them have the chance. . . . Not even Vivekānanda, were he still alive. Were Rāmakrishna himself available, that would be another matter."[33]

Coomaraswamy corresponded with Aldous Huxley and Gerald Heard during the war years, when they were directing a "little college, ashram, or religious house"[34] at Trabuco Canyon, California. Huxley and Heard valued his books and essays. Of *Hinduism and Buddhism*, for example, Huxley wrote to him: "I have been rereading your little book and would like to tell you again how much I admire it for depth and compact density of substance and for a kind of gnomic quality of expression. It is unmatched in its class."[35] Coomaraswamy was interested in his correspondence with these two men, both authors of repute and serious Western students of Eastern thought; their complimentary letters to him could not help but elicit a reply. Nonetheless, he maintained a certain reserve, taking the occasion of his letters to point out what troubled him in Huxley's Orientalism and adherence to the Perennial Philosophy.[36] On one occasion, he wrote to Huxley, "I do not approach the great traditions, as you seem to do, to pick and choose in them what seems to me to be 'right'."[37]

He was critical of *gurus*, and had no wish to be considered one. For Eric Schroeder, he was "the wizard and awakener, the teacher of my adult life"; Dr. Kramrisch once wrote of him as a *guru*; and a young Ceylonese living in Malaya, S. Durai Raja Singam, spoke of Coomaraswamy as his *guru* and produced the *Memorial Volume* of tributes as a labor of love for his *guru*. But all of this was largely a figure of speech—or figure of thought, if you wish—because Coomaraswamy felt himself to be just a *samaṇa*, a toiler on the way. Only days before the end of his life, he found himself obliged to write a letter to an old friend in Europe who had suffered a spiritual breakdown and was deep in despair. His friend had asked advice and offered to raise enough money to come to visit him in America, if Coomaraswamy thought it useful. Coomara-

[33] AKC, letter to John Layard, 11 August 1947, family collection.

[34] Gerald Heard, letter to AKC, 5 July 1943, Princeton Collection.

[35] Aldous Huxley, letter to AKC, 22 February 1944, family collection.

[36] Cf. Aldous Huxley, *The Perennial Philosophy* (1944; 2nd ed., Cleveland and New York, 1962).

[37] AKC, letter to Aldous Huxley, 28 September 1944, family collection. Quoted by permission of the Estate.

swamy concluded his long reply: "I do not think you should try to come to USA. I have not reached the end of the road myself, and am only your fellow-traveller, though possibly better equipped with route-maps."[38]

What Coomaraswamy *knew* was extraordinary: Eastern and Western religious thought and metaphysics were second nature to him, but in a way that he fully recognized, they were not yet "first nature." He did not yet perceive himself and all of life from the center of a fully awakened Self, although he believed this possible and knew in extraordinary detail how each tradition traces the way to the Self. Such was "intellectual preparation," and it is what he offered to Schroeder and others. When Coomaraswamy was asked by younger persons to "teach," on occasion he suggested that they see Guénon in Cairo or the circle of Guénon's co-workers in Europe. He believed that these persons were closer to practical teachings than himself, thanks to their links with Sufism in Morocco and Egypt.

At times he ran into trouble with the younger Orientalists in whom he was trying to inculcate a knowing love of the spiritual traditions. Helen B. Chapin, a scholar in Far Eastern studies, once lost patience with him and sent an ultimatum: "Please forgive me for saying this, but it must out. I had rather have someone like Hui-Neng, the sixth patriarch, for my *guru* than one who knows all literature. I am swamped by meaningless words all day long. Can I read all night meaningful words and understand them? I need to chop wood all day and cook the refectory meals or something like that."[39] But three days later, abject, she sent an apology: "Obeisance to my guru! Obeisance to my guru! Obeisance to my guru! Now it seems to me that things cannot be done by halves. . . . How could I have asked my Manjusri for a *guru* and accepted an unlettered one—Manjusri, whose *samaya* form is a book."[40] These letters and what we can imagine as Coomaraswamy's reply have a joyful taste: the word *guru* enters into a little drama played out between Coomaraswamy and one of his favorite colleagues.

Coomaraswamy's circle of friends among artists was small in his later years. He appealed to certain Catholic artists in Europe, and to a few American artists interested in the Orient. The only English artist with whom he retained ties after leaving England for good in 1917 was Eric Gill. Their correspondence continued, always spirited. Gill sent Coomara-

[38] AKC, summer 1947, family collection.
[39] Helen B. Chapin, letter to AKC, 25 October 1945, family collection.
[40] *Idem*, letter to AKC, 28 October 1945, family collection.

swamy a note from Jerusalem in 1934, where he had gone to fulfill a commission for sculpture. He had just written a brief book of his own and had taken Coomaraswamy's *The Transformation of Nature in Art* along in his luggage:

> I hope to God you'll approve of my little book—far, far away though it is from yours in excellent and dignified statement and depth of thought. My game however is a different one from yours and as a working stonecarver I've not the opportunity (even if I had the wit) to study the roots of the matter—I can only write a pamphlet and hope for the best, i.e. hope that my instincts, intuitions and whatnot are not too wide of the mark. I live and talk and walk with Christ all day long but I misunderstand what he says or perhaps I'm inadvertent and perverse (and, as you know, to keep a balance between —but *balance* isn't the right word—a balance between the realities of love and thought, the actualities of the loveliness of a woman's bottom and the actuality of the loveliness of the mind—too difficult to express—all things seem one loveliness and yet and yet. . . . However, you know the difficulties).[41]

Coomaraswamy loved Gill's rough-and-tumble style. Given the opportunity in 1944 to write the introduction to a posthumous collection of Gill's essays,[42] he produced something rough-and-tumble himself.

Among French Catholic artists, Coomaraswamy was particularly related to Albert Gleizes, the well-known Cubist painter who in 1927 founded a community for agriculture and artisan work in the Midi. The question of what is sacred art was central to the community; it was part of their more general concern for the renewal of Christianity. By 1935, Coomaraswamy and Gleizes were in contact with each other, although they never met, and after the war they continued their interrupted correspondence. Coomaraswamy admired Gleizes's writings, from *Vers une Conscience plastique: la forme et l'histoire* (Paris, 1932), to his book of 1947, published in English as *Life and Death of the Christian West*. Gleizes's letters gave Coomaraswamy the taste of a sophisticated French artist's reflections on the artistic and spiritual life around him:

> I am rereading at the moment, and very seriously, your *Transformation of Nature in Art*. I am learning from it quantities of admirable

[41] Eric Gill, letter to AKC, 27 May 1934, Princeton Collection.
[42] AKC, introduction to Eric Gill, *It All Goes Together*.

things and verifying my modest observations as a painter, made in the course of studio work over many years. It is rather strange that my research, without specific guidance, has led me to the terrain of tradition. I was led to it without knowing that it existed. I thank Heaven for having introduced me to these regions and having permitted me to find there men like you and René Guénon. Your works give me great joy. And I would like to see them translated and published in France. I am sure that a certain number of anxious and disinterested minds would find in them both direction and certitude. There are so many unfortunate people around us who no longer know where to turn and who are reduced to following bad guides or their own, individualistic tendencies.[43]

We read these words perhaps with skepticism, with an unvoiced question: show us the fruits of this certainty and sense of direction that some have and others have not. But the whole question of modern sacred art is at stake, and it is a question to which Coomaraswamy was not particularly close. He supplied elements of value to religious artists, which they used as they wished.[44]

The only well-known American artist whose contact with Coomaraswamy has been recorded—aside from Georgia O'Keeffe, Stieglitz's wife, who apparently kept an eye out for his essays on art as they appeared—was Morris Graves. Graves visited Coomaraswamy in Boston before he left for the Far East in 1946; he had already read a good deal of Coomaraswamy's work prior to their meeting. In Selden Rodman's *Conversations with Artists* (New York, 1957), something of what Graves and Coomaraswamy discussed is recalled,[45] but better sources are the catalogue that Graves wrote for his 1948 Willard Gallery exhibition in New York and a statement written for the director of the Henry Gallery in Seattle, at the time of an exhibition in 1950. The Willard Gallery catalogue was prefaced by a passage from *Elements of Buddhist Iconography*, and Graves' comments on each painting in the catalogue owe much to Coomaraswamy. Graves' statement for the Henry Gallery is very close to Coomaraswamy in its understanding of three different spaces. Graves wrote:

[43] Albert Gleizes, letter to AKC, 5 November 1945, family collection; tr. by the author.

[44] Cf. Jean Chevalier, "Travail d'artiste et travail d'artisan," *Témoignages*, XXI (April 1947), 165 ff. Jean Chevalier is another French artist of the Gleizes circle whose working philosophy owed something to Coomaraswamy.

[45] Pp. 12–13.

The observer must be mindful of the simple fact that there are three "spaces": PHENOMENAL space (that is the space "outside" of us). MENTAL space (that is the space within which dreams occur and the images of the imagination take shape).

The third "space" is the SPACE OF CONSCIOUSNESS (that is the space within which is "revealed"—made visible upon subtle levels of mind—the abstract principles of the Origin, operation, and ultimate experience of consciousness).

It is in this SPACE OF CONSCIOUSNESS from which come the universally significant images and symbols of the greatest of religious works of art. . . . The observer is only cheating himself out of the fullest *enjoyment* and *information* of a painting if he makes the foolish demand that the painting function within a "space" from which it did not originate.[46]

Graves drew his schema both from a passage in *The Transformation of Nature in Art*,[47] and from his talk with Coomaraswamy. There is no reason to judge critically either Graves' or Gleizes's reception of Coomaraswamy's ideas; it is, however, interesting to compare Graves' excited, visionary understanding with Gleizes's doctrinaire, workmanlike understanding.

Our discussion of Coomaraswamy's relation to modern artists can be concluded with a report on a dispute—disputes were as much Coomaraswamy's natural element as the inner calm of the Inner Man whose rights and possibilities he defended. At the end of his life, Coomaraswamy had planned to go to Baltimore as the principal speaker at the annual meeting of the American Society for Aesthetics. It was to take place late in September 1947; he died on the ninth of that month. But he had a taste of what was in store for him at Baltimore through an exchange of letters with Hilla Rebay, director of the Museum of Non-Objective Painting in New York City (later the Guggenheim Museum). A mutual friend of Rebay's and Coomaraswamy's advised her to send Coomaraswamy some material on the museum's collection. His initial reply has not been preserved, but it could not have been very different from his published views on abstract art. Coomaraswamy was well enough known for such expressions as these:

[46] A copy of the Henry Gallery statement has been seen by the author thanks to the kindness of Mrs. LaMar Harrington, assistant director of the gallery. For further information, cf. Fredrich S. Wight, *et al.*, *Morris Graves* (Berkeley and Los Angeles, 1956), pp. 32, 43–44.
[47] Pp. 6 and 174–175, n. 3.

just as the modern artist is neither a useful or significant but only an ornamental member of society, so the modern workman is nothing but a useful member and neither significant nor ornamental. It is certain that we shall have to go on working, but not so certain that we could not live, and handsomely, without the exhibitionists of our studios, galleries, and playing fields.[48]

Our artists are "emancipated" from any obligation to the eternal verities, and have abandoned to tradesmen the satisfaction of present needs. Our abstract art is not an iconography of transcendental forms, but the realistic picture of a disintegrated mentality.[49]

Rebay *did* interpret nonobjective painting as "an iconography of transcendental forms." Her reply to Coomaraswamy was a mixture of mysticism and insults: "To give up adoration for matter leads the feeling to the rhythm of the In-between, which is the Tao. Its cosmic vibrations are the secret of all soul appeal and influence, inherent only to non-objective paintings. . . . Due to lack of opportunity to see creative Art, you may have lacked a great aesthetic experience. Yet without that experience, you missed your epoch—and so what can you have to say to the Aesthetics at Baltimore?"[50] Coomaraswamy must have been interested in her defense of the most modern art on the grounds of its spirituality. He returned to his typewriter and sent off a reply:

It *is* rather a shame if after thirty years of Curatorship in the MFA (apart from previous experience) I have had "no opportunity to see creative art"!

No one is more than I aware that "the realities of our existence are non-objective." This has always been the traditional doctrine; and I have cited so much in my books regarding its application to art that I shall only refer here to Plato, *Rep.* 510 D, E, *Laws* 931 A, *Tim.* 51 E, 92, and the well known passage on mathematical beauty in *Philebus*, all to the effect that what true art "imitates" is never itself a visible form. But this does not mean that the work of art was to be looked at merely as an aesthetic surface, provocative of feelings; it had to satisfy both mind *and* body. Some of the modern abstract works are, no

[48] AKC, "A Figure of Speech or a Figure of Thought?" (1946), SP I, 28–29.
[49] AKC, "Symptom, Diagnosis, and Regimen," SP I, 316–317.
[50] Hilla Rebay, letter to AKC, 18 August 1947, Princeton Collection.

doubt, "pleasing"; but that is not enough for a whole man, who is something more than a merely "aesthetic" animal.[51]

It was not Coomaraswamy's writings on Oriental art and metaphysics that estranged him, insofar as this was the case, from the community of art historians, critics, and enthusiasts; it was rather his general philosophy of art and culture and his disdain for modern art and modern values. There was something in what he wrote that was not quite cricket, a certain insistence on transcendental values and a stubborn rejection of modernity that got in the way of doing business. As Goetz rightly remarked in his memoir, Coomaraswamy insisted too much, in reaction to what he considered to be the extreme superficiality of modern times, and it was just this "too much" that lost him friends. On the other hand, he had friends near and far whose conversations and letters supported him, both in his exaggeration and in his incontestable genius.

> You are, so far as I know, the only scholar in the field (of art history) to recognize the importance of First Principles. At least you are the only one to say so.

> It is a curious thing to me that so many fine minds seem content to function without what I shall call primary direction. The detachment of science, splendid as a means, is disastrous when taken as an end. The objective end of detachment is not detachment, but Truth![52]

Such a message as this from Frank Sieberling, Jr., an editor of the *Art Bulletin*, received at a moment when Coomaraswamy was engaged in a controversy in the *Bulletin's* pages over whether or not he was simply an archaist who wished to "turn back the clock," is perhaps all that Coomaraswamy needed by way of encouragement to be able to continue to engage all comers.[53]

Coomaraswamy's personal "worlds" are now familiar, but his America, his attitudes toward America as a whole, is still another dimension. He loved certain elements in the American past, and they represented ideals with which he hoped America could again come to terms. One such element was the American Indian, whose culture he first came to know

[51] AKC, letter to Hilla Rebay, 29 August 1947, Princeton Collection.

[52] Frank Sieberling, Jr., letter to AKC, 17 October 1938, Princeton Collection.

[53] Cf. Richard Florsheim, review of AKC, *Is Art a Superstition or a Way of Life*, in *Art Bulletin*, XX (1938); and AKC's reply, "Note on Review by Richard Florsheim," *ibid.*, p. 443, reprinted in *Christian and Oriental Philosophy of Art*.

during early trips to the Western states. Coomaraswamy had no direct contacts with American Indians in later life, but in a most unexpected way he had an emissary among the American Indians in the person of a young anthropologist, Joseph Epes Brown. It may be that Brown was one of the young Americans whom Coomaraswamy sent to Guénon; in any case, he adopted the traditional point of view common to Coomaraswamy and Guénon, and his letters to Coomaraswamy indicate that he knew Guénon personally. In the summer and fall of 1947, Brown was living with the Oglala Sioux Indians in North Dakota and working with an interpreter to record the words of Black Elk, an old Holy Man who wished to make an account of the main rites of his tribe and their significance, both as a message to his own people and to white America. This book was published as *The Sacred Pipe*; it has become one of the texts that supports the serious new effort to understand American Indian culture taking place in recent years.[54] While he was in North Dakota, Brown heard of Coomaraswamy's death. He sent a letter to the widow, part of which should be quoted here. Through it we get a sense of a world with unexpected connections:

I am only sorry that your husband was not able to know of the stimulus and comfort his works have now brought to the North American Indian whom he always loved so. Parts of his work are now being read by, or translated to those few Holy Men of the following nations which I have visited: Sioux, Assimboine, Gros Ventre, Cree, Blackfeet, Arapaho, Shoshone, Crow, and Cheyenne. Our main work is with the Sioux, and due to the stimulus and encouragement of your husband, Schuon, and R. Guénon, a whole culture is coming to life. The Holy Men here are now mending the broken threads, reestablishing rites, insuring that the Spiritual Transmission be carried on until, or better, through the end of our age. We are hoping that the same shall be the case with the Hopi and Navajo in the S. W. in whom your husband was especially interested. I thought you would be glad to know of this—to know that your husband is in the hearts of many of these venerable men—men whom I love to be with, for in every way they remind me so much of your husband.[55]

[54] Joseph Epes Brown, *The Sacred Pipe: Black Elk's Account of the Seven Rites of the Oglala Sioux* (Norman, Oklahoma, 1953), reprinted 1971.

[55] Joseph Epes Brown, letter to Mrs. Ananda K. Coomaraswamy, 14 November 1947, family collection. Quoted by permission of Professor Brown.

Much as one might feel that there can be no direct connection between the spiritual traditions of the East and the traditions of the American Indian, the fact seems to be that an anthropologist animated by a knowledge of Eastern tradition was able to earn the respect of American Indian sages and in some way communicate a new impulse to them.

Coomaraswamy was also touched by the history and artistic productions of the Shakers, the Christian monastic sect that flourished in some northeastern and central states in the nineteenth century. In 1940, Shaker history was just becoming "history," so to speak, through the all-embracing scholarship of Edward Deming Andrews, whose works on the history, religion, music, dance, and crafts of the Shakers were being written and published during those years, at the same time that the Shaker sect itself had dwindled to just a few communities of aged persons. Coomaraswamy and Andrews, who lived in Western Massachusetts, became good friends after Coomaraswamy reviewed the latter's book, *Shaker Furniture: The Craftsmanship of an American Communal Sect* (New Haven, 1937).[56] Coomaraswamy appreciated the Shaker workshop where, instead of Workmen's Compensation Laws pinned to the door, there might be such a saying as "Every force evolves a form." The penetration of the spirit into all "secular" activity is the common element in American Indian life, which covered the continent, and in Shaker life, which involved only small rural communities for a relatively brief period. But each is the very type of "alternative culture" to which some young Americans are drawn nowadays, and to which Coomaraswamy in his day found himself looking.

If he loved the "alternative cultures," what then did he think of the "culture," the American way of life? When he first came to America, and during his Roaring Twenties, he rather liked it. In a radio broadcast on "The Relation of Art to Life in India" given in 1929, he said:

[In India] those who were not professional craftsmen never thought of making art an amateur accomplishment—the normal man's interest in art was much more like that of a worshipper who lights a candle at an altar, an American who is a connoisseur of the lines of a motor car, a housewife with her domestic machinery, a woman following the fashions, a capitalist building a new skyscraper, than like that of the very few people who nowadays go to picture gal-

[56] AKC, review of E. D. Andrews and F. Andrews, *Shaker Furniture* (1939), SP I.

leries or museums, or buy "works of art," or pose as "lovers of art" or "critics." Indians had the same normal interests and needs as everyday Americans who are not aesthetes; and if they created a great art, it was for the same reasons and in the way that Americans are creating a great architecture and a world of exquisitely articulated mechanical devices."[57]

Coomaraswamy's good opinion of the "anonymous" popular arts of America and his appreciation of the ordinary man continued into his later years, but he was of course adamantly opposed to the extreme industrialism of America, with its associated materialism, quantitative rather than qualitative standards, and condemnation of large parts of the population to boring, repetitive work. He had no plan for changing things, only a vision of the horror of the present situation and the suggestion that America needed to "somehow get back to first principles."[58] In 1939, a few months after the beginning of war, when the question of military conscription had come up, he wrote, as was his custom, a letter to the editor of *The New English Weekly*, the socialist journal headed by Philip Mairet (who had by then been married for years to Coomaraswamy's first wife): "we are inured to membership in industrial societies that are not organic structures but atomic aggregates of servile units that can be put to any task that may be required of them by a deified 'nation': the individual, who was not 'free' before the war, but already part of a 'system,' is not now 'free' to stand aloof from it."[59] He wished for a "complete transformation of our way of living," but while he could not resist calling for it on the scale of the nation, in fact he believed that "complete transformation" in this day and age—the Kali Yuga, as he said with Goetz—is possible only for individuals. He often stated that it would be necessary to lower the standard of living:

[57] AKC, "The Relation of Art to Life in India" (1929).
[58] AKC, "Note on Review by Richard Florsheim."
[59] AKC, letter to *The New English Weekly*, 14 December 1939, p. 139. AKC enjoyed warm relations with Mr. and Mrs. Mairet and was able to publish his views in the correspondence column of *The New English Weekly* as often as he wished. During the war years, AKC's letters were often extremely philosophical in content with no reference whatsoever to the war. Their welcome in the *NEW* suggests that the continuation of intellectual life in England was as much a fact as was physical destruction. I. B. Horner, his close friend at the Pali Text Society in England, had written to AKC in 1944: "One is not creative with flying bombs about," but she had, in fact, been trying to continue her work and the publication program of the *PTS*.

Of course there is good being done in Russia. But I am not convinced by the *ideal*: it seems to me only another form of what has been called "the insane asylum approach to social problems," viz. "make the inmates as comfortable as possible." Here we cannot liberate the chain-belt worker and the miner etc., unless we are willing to *lower* our (material) "standard of living."[60]

We cannot pretend to culture until by the phrase "standard of living" we come to mean a *qualitative* standard. . . . Modern education is designed to fit us to take our place in the counting house and at the chain-belt: a real culture breeds a race of men able to ask, What kind of work is worth doing?[61]

Coomaraswamy's unshakable ideal was a spiritualized culture in which not everybody is a priest, but every kind of work is potentially a teacher —and every worker potentially a learner. Given the distance between his ideal and the ambient reality, it is not surprising that he occasionally lost his temper.

More than a physical well-being is necessary for felicity. An Indian peasant's face has neither the vacancy of the grinning apes and whores that are the ideal of the American advertiser, nor the expression of anxiety that marks the American "common man" in real life.[62]

In a brave new world the cultural domination of America is even more to be dreaded than that of England: for these United States are not even a bourgeoisie, but a proletarian society fed on "soft bun bread" (these words are those of a well-known large scale baking company's advertisement of its product), and thinking soft bun thoughts.[63]

Coomaraswamy's America: it was the elite environment of Harvard and the Boston Museum, it was the Rocky Mountains and the fishing grounds of Maine, it was the universities and colleges where he lectured and where his friends taught—and it was also a kind of nightmare: a vast society of anxious common people alongside a small elite that had time for "culture," but whose culture was often more like self-indulgence

[60] AKC, letter to S.E., 1941, private collection.
[61] AKC, letter to *The New English Weekly*, published 1 April 1943.
[62] *Ibid.*
[63] AKC, letter to *The New English Weekly*, published 4 October 1945.

than work. And so he both loved and hated America. At the end of his life, he was still hoping that America could play the new role in Asia thrust upon it by the outcome of the Second World War with more wisdom than had England in its years as the "paramount power": "There is a sense in which most Europeans have never, even in imagination, crossed the Suez Canal—even to have been born on the other side could not make of Kipling an *in*sider. It may be that Americans can go farther, and that to do so is a responsibility that their present position in the world demands of them."[64]

[64] AKC, review of John Archer, *The Sikhs* (1947), p. 70.

XV. The Two Selves

"The Gods entered into man, they made the mortal their house." His passible nature has now become "ours": and from this predicament he cannot easily recollect or rebuild himself, whole and complete. We are now the stone from which the spark can be struck, the mountain beneath which God lies buried. . . . "You" and "I" are the psycho-physical prison and Constrictor in whom the First has been swallowed up that "we" might be all He in whom we were imprisoned is now our prisoner; as our Inner Man is submerged in and hidden by our Outer Man. It is now his turn to become the Dragon-slayer; and in this war of the God with the Titan, now fought within you, where we are "at war with ourselves," his victory and resurrection will be also ours, *if* we have known Who we are. It is now for him to drink us dry, for us to be his wine.[1]

Coomaraswamy's late years were a time of eloquence: *e-loquence*, he would have been apt to write, in order to emphasize that words come out from a source. Out of what did he speak? In the passage taken from *Hinduism and Buddhism* as the epigraph to this section, it is apparent that the ideas, myths, and images of many traditional cultures circulate around a center. Coomaraswamy is like a magician who has worked them all into a single long scarf or temple banner and swirls them in the air before the reader. If we ask which ideas or images were most important to him, which are the ones that he worked into the banner with particular care, we may be able to fill in an important part of his biography: his search for self-knowledge. It is just this that can be identified as his "center": a search. If we fail to understand at least something of this inmost element of his biography, we run the risk of being rather indifferent spectators at the end of his life, when this element became more important than any other. The easy way for both author and reader would be to suppose that all one must do is read certain essays and books in which Coomaraswamy most clearly expressed his understanding of the meaning and purpose of

[1] AKC, *Hinduism and Buddhism*, pp. 8–9.

human existence: read *Hinduism and Buddhism* through, "*Ākimcaññā*: Self-Naughting," "The Vedānta and Western Tradition," "*Svayamātṛṇṇā*: Janua Coeli," "Who is 'Satan' and Where is 'Hell'?" and other essays where the traditional psychology is discussed.[2] The hard way—in fact an impossibility—would be to review the whole of traditional psychology as Coomaraswamy assembled it from Eastern and Western and, as he would say, Northern and Southern sources. Between the easy and the impossibly hard there must be an appropriate path to follow—and so our discussion of his search becomes itself a search.

Coomaraswamy recognized himself in the psychological, metaphysical, and religious ideas of his traditional texts far more than in the great ideas of twentieth century psychology. He made the equation: "traditional philosophy = metaphysics = ontology = theology,"[3] and to these could be added the terms "psychology, or rather pneumatology" that figure in the title of his paper: "On the Indian and Traditional Psychology, or Rather Pneumatology." With this distinction between psychology and a science of the spirit (*pneuma*) we plunge into his thought, which was both a careful reexpression of traditional thought and a series of reflections about himself. This double perspective is important. For example, the struggle of the God and the Titan is a myth that he recounted in several different contexts—Vedic and Greek among others—but it also signified something for him in the context of himself, for he was "at war with himself," to paraphrase the passage. It should again be said at this point that Coomaraswamy's thought went beyond his experience, and that a man's inner experience is "a secret between himself and God." He no more demanded of his readers that they at once experience the struggle of the God and the Titan in themselves than he demanded it of himself; what he wished was to expound very richly this traditional psychology, which is also a metaphysic and a myth, in order to prepare both his own mind and the reader's for a subsequent "verification." He often used the term "verification" in preference to "realization," probably on the one hand because "realization" had become a *mot-clef* of popular Orientalism, and on the other because this term expressed his conviction that the inner life has to be approached intentionally and actively, as much in a scientific spirit as in a spirit of prayer.

[2] All of these works, with the exception of *Hinduism and Buddhism*, are included in SP I and II. To the list should be added "On the Indian and Traditional Psychology, or Rather Pneumatology," published for the first time in SP II.

[3] AKC, letter to S.E., 20 February 1941, private collection.

The traditional doctrine that seems to have been primordial in Coo-
maraswamy's thought is the idea of Two Selves.

> Our whole metaphysical tradition, Christian and other, maintains
> that "there are two in us," this man and the Man in this man. . . .
> Of these two "selves," outer and inner man, psycho-physical "per-
> sonality" and very Person, the human composite of body, soul, and
> spirit is built up. Of these two, on the one hand body-and-soul (or
> -mind), and on the other, spirit, one is mutable and mortal, the other
> constant and immortal; one "becomes," the other "is," and the exist-
> ence of the one that is not, but becomes, is precisely a "personification"
> or "postulation," since we cannot say of anything that never remains
> the same that "it *is*." And however necessary it may be to say "I"
> and "mine" for the practical purposes of everyday life, our Ego in
> fact is nothing but a name for what is really only a sequence of ob-
> served behaviours.[4]

Coomaraswamy returned many times to this doctrine, expounding it first
in the terms of one tradition, then in the terms of another. He pointed
out in general the important role of repetition in traditional cultures:
people in them wish to be reminded again and again of essentially the
same things, either of ideas that are never well enough understood, among
intellectuals, or of a relation with divinity that is never pure enough,
among worshippers (a category that by no means excludes intellectuals, as
Coomaraswamy liked to illustrate through the example of Śaṅkarācārya-
rya).[5] When he made a joke about the repetitions in his own writings,
he called them "the same old stuff," but in fact it was a serious occupa-
tion for him to reformulate fundamental truths many times over.

> In the words of Eckhart, "Holy scripture cries aloud for freedom
> from self." In this unanimous and universal teaching, which affirms
> an absolute liberty and autonomy, spatial and temporal, attainable
> as well here and now as anywhere else, this treasured "personality"
> of ours is at once a prison and a fallacy, from which the Truth shall
> set you free: a prison, because all definition limits that which is de-
> fined, and a fallacy because in this ever changing composite and cor-

[4] AKC, "Who is 'Satan' and Where is 'Hell'?", SP II, 24–25.
[5] Cf. AKC, "The Origin and Use of Images in India" (1929), reprinted in *The
Transformation of Nature in Art*.

ruptible psycho-physical "personality" it is impossible to grasp a constant, and impossible therefore to recognize any authentic or "real" substance. In so far as man is merely a "reasoning and mortal animal," tradition is in agreement with the modern determinist in affirming that "this man," so-and-so, has neither free will nor any element of immortality. . . . Tradition, however, departs from science by replying to the man who confesses himself to be only the reasoning and mortal animal that he has "forgotten who he is" (Boethius, *De Consol.*, prose vi), requires of him to "Know thyself," and warns him, "If thou knowest not thyself, begone" (*si ignoras te, egredere*, Cant. I.8). Tradition, in other words, affirms the validity of our consciousness of being but distinguishes it from the so-and-so that we think we are. . . . Liberation is not a matter only of shaking off the physical body—oneself is not so easily evaded—but, as Indian texts express it, of shaking off all bodies, mental or psychic as well as physical.[6]

In some passages, Coomaraswamy seems to be saying that the "little self" is a danger and delusion from which searching people wish to be totally free: "Freedom is from one's self, this 'I' and its affections. He only *is* free from virtues and vices and all their fatal consequences who never became anyone; he only *can* be free who is no longer anyone; impossible to be freed from oneself and also to remain oneself."[7]

In the war between Self and self, between the purposes of the Spirit and the purposes of body and psyche, Coomaraswamy seems often, as we said, to have declared total war: the "self-naughting" of which he wrote—which would permit the greater Self to live more in the open—must be carried very far, carried out very seriously, in his view of things. When one has felt the truth of such a saying as this from the *Enneads*: "Other than that single, all-inclusive Life, all other life is darkness, petty, dim and poor,"[8] how does one live from that point on, and in what frame of mind? Coomaraswamy was not under the impression that he was living in a way that would permit him to admit "that single, all-inclusive Life"

[6] AKC, "*Ākimcañña*: Self-Naughting," SP II, 89–90, 93. The sources cited in this text, in AKC's abbreviated manner, are Boethius, *The Consolation of Philosophy*, H. F. Stewart, Cambridge and London, 1918 (Loeb Classical Library), and the *Song of Songs* in the Latin Vulgate translation.

[7] AKC, *Hinduism and Buddhism*, p. 17.

[8] Plotinus, *The Enneads*, VI.6.15, quoted by AKC, "On the Indian and Traditional Psychology, or Rather Pneumatology," SP II, 371.

into his everyday life, but he was preparing for that day, and the preparation itself already had some of the practices, some of the results, and quite thoroughly the point of view of the later stage. He was preparing a house for himself, so to speak, and although not yet living in it, perhaps only passing through it to add this and that necessary feature, he looked forward to moving in and could reasonably expect that he would find things in order and at the place where he had seen them during preliminary visits.

How is the Victory to be won in this Jihād? Our self, in its ignorance of and opposition to its immortal Self, is the enemy to be convinced. The Way is one of intellectual preparation, sacrifice, and contemplation, always presuming at the same time guidance by forerunners. In other words, there is both a theory and a corresponding way of living which cannot be divided, if either is to be effective. . . . Our end will have been attained when we are no longer anyone. That must not, of course, be confused with annihilation; the end of all becoming is in *being*, or rather, the source of being, richer than any being. . . .

There can be no greater sorrow that the truly wise man can feel, than to reflect that "he" is still "someone" (*Cloud of Unknowing*, Ch. 44). To have felt this sorrow (a very different thing from wishing one had never been born, or from any thought of suicide) completes the intellectual preparation. The time has come for action. Once convinced that the Ego is "not my Self" we shall be ready to look for our Self, and to make the sacrifices that the quest demands. We cannot take up the operation in its ritual aspect here (except, in passing, to stress the value of ritual), but only in its application to daily life, every part of which can be transformed and transubstantiated. Assuming that we are now "true philosophers," we shall inevitably begin to make a practise of dying. In other words, we shall mortify our tastes, "using the powers of the soul in our outward man no more than the five senses really need it" (Meister Eckhart, Pfeiffer, p. 488); becoming less and less sentimental ("sticky") and ever more and more fastidious; detaching ourselves from one thing after another. We shall feed the sensitive powers chiefly on those foods that nourish the Inner Man; a process of "reducing" strictly analogous to the reduction of fleshly obesity, since in this philosophy it is precisely "weight" that drags our Self down, a notion that survives in the use of the word

"gross" = sensual. Whoever would *s'eternar, transumanar,* must be "light hearted."[9]

Better than any other, this passage suggests Coomaraswamy's view of his own way of life in later years. His closest friends knew that this was the inner form of his life, and at least one even cautioned him not to take the practice of self-naughting beyond certain limits. George Sarton wrote him a brief note "*re* self-naughting. It can not be done permanently *in* the world; there are various sayings of Christ confirming this. And even in India a man must become a *saṃnyāsin* in order to carry self-naughting to perfection."[10] Coomaraswamy had thought about this question and had several responses to it, the first being something in the nature of a retort, a direct response, and the second a refinement of his understanding of the war between the higher and lower parts of human nature. His direct response was as follows:

It will be seen that in speaking of those who have done what was to be done, we have been describing those who have become "perfect, even as your Father in heaven is perfect." There will be many to say that even if all this holds good for the all-abandoner, it can have no meaning for "me" who, *en étant un tel* am insusceptible of deification and therefore incapable of reaching God. Few or none of "us" are yet qualified to abandon ourselves. But so far as there is a way, it can be trodden step by step. . . . A long stride has been taken if at least we have learned to accept the idea of the naughting of self as a good, however contrary it may be to our "natural" desire, however *äller menschen fremde.* For if the spirit be thus willing, the time will come when the flesh, whether in this or in any other ensemble of possibilities forming a "world," will be no longer weak. The doctrine of self-naughting is therefore addressed to *all,* in the measure of their capacity, and by no means only to those who have already formally abandoned name and lineage.[11]

It is interesting in this passage to find Coomaraswamy insisting on a certain measure of self-discrimination, a certain measure of noncooperation

[9] *Ibid.,* pp. 372–375. Citations are from *A Book of Contemplation the Which is Called the Cloud of Unknowing, in the Which a Soul is Oned with God,* ed. Evelyn Underhill, London, 1912, and from *Meister Eckhart,* ed. F. Pfeiffer, 4th ed., Göttingen, 1924.

[10] George Sarton, postcard to AKC, 30 November 1940, family collection.

[11] AKC, "*Ākimcaññā*: Self-Naughting," SP II, 105–106.

with the lower forces in man as an intelligent way to live, at the same time that he takes evident delight in exercising his eloquence and his command of traditional ideas and imagery. The ultimate aim is to know that "I am that," to know in an utterly simple way, as these words suggest, that I am not different from God (taking the word "I" to mean the inmost part of each man); but meanwhile there is a lot of living to do. Coomaraswamy's delight in his métier, in the exercise of his powers *as a man*, is all the evidence that we need to recognize that his self-naughting was not totalitarian in practice. He in fact lived much of the time *between* Self and self: it is at the in-between place that he naturally took up his station, although he longed very deeply to be through once and for all with the trivial and destructive Outer Man. This understanding of something in-between came into his writings time and again, and tended to humanize his ascetic impulse towards self-naughting. We are "archetypal inwardly and phenomenal outwardly,"[12] as he wrote. Is it possible to be both voluntarily, to enlarge inner experience, which is certainly the more lacking of the two, without destroying the Outer Man?

> What follows when the lower and the higher forms of the soul have been united? This has nowhere been better described than in the *Aitareya Āraṇyaka* (II.2.7): "This Self gives itself to that self, and that self to this Self; they become one another; with the one form he (in whom this marriage has been consummated) is unified with yonder world, and with the other united to this world." . . . The Agathos and Kakos Daimons, Fair and Foul selves, Christ and Antichrist, both inhabit us, and their opposition is within us. Heaven and Hell are the divided images of Love and Wrath *in divinis*, where the Light and the Darkness are undivided, and the Lamb and the Lion lie down together. In the beginning, as all traditions testify, heaven and earth were one and together; essence and nature are one in God, and it remains for every man to put them together again in himself.[13]

The passage evokes wholeness: man is not called to deny entirely any part of his nature, but to bring higher and lower, essence and nature, into harmony. It is worth remembering that Coomaraswamy often wrote of the needs of the "whole man" in his works on art and aesthetics. The

[12] AKC, "*Kha* and Other Words Denoting 'Zero,' in Connection with the Metaphysics of Space" (1934), SP II, 225.

[13] AKC, "Who is 'Satan' and Where is 'Hell'?", SP II, 32. Cf. also "On the Pertinence of Philosophy" (1936), 131.

whole man: not a superhuman Self that has no need of works of art, since nothing can be reflected of which it is not already aware, nor the "psycho-physical vehicle" that needs only functional efficiency in works of art, but a *whole* man who instinctively wishes a "polar balance of physical and metaphysical" in the objects that make up his environment. In framing this conception, Coomaraswamy was both reporting on a quality that he found in traditional art and appealing to his contemporaries to take another look at their own manufactures and "supports of contemplation" (paintings, sculptures, and so on).

But having found the idea of "reintegration" in Coomaraswamy's thought, we should not be tempted to underestimate his will to understand in what way man is fooled by his own nature, fails to recognize all his constituents because he sees only those that "appear." The "chariot," the vehicle, is an excellent thing, but he insisted on distinguishing it from the unnoticed Person who uses it to go around. These are the terms of a Buddhist simile that he used quite often.

> The chariot, with all its appurtenances, corresponds to what we call our self; there was no chariot before its parts were put together, and will be none when they fall to pieces; there is no "chariot" apart from its parts; "chariot" is nothing but a name, given for convenience to a certain percept, but must not be taken to be an entity (*sattva*); and in the same way with ourselves who are, just like the chariot, "confections." The Comprehensor has seen things "as they have become" (*yathā bhūtam*), causally arising and disappearing, and has distinguished himself from all of them.[14]

Coomaraswamy's term, "the Comprehensor," a translation of Sanskrit *evaṃvit*, is another word that designates the Self. He defined it carefully in *Hinduism and Buddhism*; it evokes his aspiration toward an inner *activity*, an activity of understanding that would be logically prior although not necessarily temporally prior to acts of any other kind. In his definition, we can recognize the direction in which he wished to go and must already have gone to a considerable degree: "When the Indians speak of the Comprehensor (*evaṃvit*) of a given doctrine, they do not mean by this merely one who grasps the logical significance of a given proposition; they mean one who has "verified" it in his own person, and is what he knows; for so long as we know only *of* our immortal Self, we

[14] AKC, *Hinduism and Buddhism*, p. 59; cf. pp. 72–73.

are still in the realm of ignorance; we only really know it when we become it; we cannot really know it without being it."[15]

Another passage expressing his understanding of activity can help us to recognize that his ideal was not some form of idle intelligence. In his furthest speculation concerning the destiny of the divine part of man, a speculation that *seems* to follow it in a peregrination outside of the mortal body—which was only its prison but not its tomb—he describes its nature as both restful and active, wholly detached and wholly involved: "Impossible . . . to think of an identification with the Divine Essence that is not also a possession of both its natures, fontal and inflowing, mortal and immortal, formal and informal, born and unborn. An *ablatio omnis alteritatis* must imply a participation in the whole life of the Spirit, of 'That One' who is 'equally spirated, despirated' (RV X.129.2), eternally 'unborn' and 'universally born.' "[16] Otherworldly as this may sound, it reflects in absolute terms how Coomaraswamy wished to be in this life, not because this double condition of involvement and detachment is "better" or much admired by traditional sagacity, but because it appeared to be in fact his condition, to be recognized and experienced insofar as his faculties would permit.

With this passage, we have gone far enough to have the taste of Coomaraswamy's search for self-knowledge. What still needs to be emphasized, however, is the importance to him of the idea of death. If there is warfare between Self and self, there must also be deaths.

If, indeed, "the kingdom of heaven is within you," then also the "war in heaven" will be there, until Satan has been overcome, that is, until the Man in this man is "master of himself," *selbes gewaltic*. . . . But this is not only a matter of Grace; the soul's salvation depends also on her submission, her willing surrender; it is prevented for so long as she resists. It is her pride, . . . the Satanic conviction of her own independence (*asmi-māna, ahaṃkara, cogito ergo sum*), her evil rather than herself, that must be killed; this pride she calls her "self-respect," and would "rather die" than be divested of it. But the death that she at last, despite herself, desires, is no destruction but a transformation.[17]

[15] *Ibid.*, p. 65.
[16] AKC, "The Pilgrim's Way" (1937), pp. 5–6. n. 3.
[17] AKC, "Who is 'Satan' and Where is 'Hell'?", SP II, 28, 31–32.

The battle will have been won, in the Indian sense and the Christian wording, when we can say with St. Paul, "I live, yet not I, but Christ in me" (Gal. II:20); when, that is to say, "I" am dead, and there is none to depart when body and soul disintegrate, but the immanent God. Philosophy is, then, the art of dying. "The true philosophers are practitioners of dying, and death is less terrible to them than to any other men . . . and being always very eager to release the Soul, the release and separation of the soul from the body is their main care" (*Phaedo* 67D, E). Hence the injunction "Die before you die" (Rūmī, *Mathnawī*, VI.723 f., and Angelus Silesius, *Cher. Wandersmann*, IV.77). For we must be "born again"; and a birth not preceded by a death is inconceivable.[18]

Coomaraswamy had a marvelous collection of traditional references to the "death in life." The two most shocking were drawn from Eckhart and Rūmī: the Christian said that "the kingdom of God is for none but the thoroughly dead"; the Muslim spoke of a "dead man walking."[19] When Coomaraswamy cited texts such as these, he was not only using them for his purpose at a given moment, but inviting the reader to go back to the texts themselves. The image from the *Mathnawī*, for example, which he often cited, is so shocking that many readers will eventually go to the trouble of looking it up in context, and by doing so they are better able to measure its significance than they can through Coomaraswamy's brief allusions. We might do this just once here, as a sample of the kind of reading that Coomaraswamy urged. The *Mathnawī* text is as follows:

> O seeker of the mysteries, if you wish to see a dead man living—
> Walking on the earth, like living men; yet he is dead and his spirit is gone to heaven;
> One whose spirit hath a dwelling-place on high at this moment, so that if he die, his spirit is not translated,
> Because it has been translated before death: this mystery is understood only by dying, not by using one's reason;
> Translation it is, but not like the translation of the spirits of the

[18] AKC, "On the Indian and Traditional Psychology, or Rather Pneumatology," SP II, p. 000. Citations are from St. Paul's *Letter to the Galatians*; the *Phaedo* of Plato; Reynold A. Nicholson, *The Mathnawi of Jalālu'ddīn Rūmī*, translation and commentary (new ed., London, 1968); and Angelus Silesius (Johann Scheffler), *Cherubinischer Wandersmann* (new ed., Munich, 1949).

[19] Cited by AKC in "*Ākimcaññā*: Self-Naughting," SP II, 92, and elsewhere.

vulgar: it resembles a removal during life from one place to another—

If any one wishes to see a dead man walking thus visibly on the earth,

Let him behold Abu Bakr, the devout, who through being a true witness became the Prince of the Resurrected.

In this earthly life look at the Siddiq Abu Bakr, that you may believe more firmly in the Resurrection.

Mohammed, then, was a hundred spiritual resurrections here and now, for he was dissolved (naughted) in dying to temporal loosing and binding.

Aḥmad (Mohammed) is the twice-born in this world: he was manifestly a hundred resurrections.[20]

We may constate right away that to go back to the text raises more questions than it answers: the unfamiliar atmosphere of Islam is in this passage, as well as a good number of ideas and images to which even very serious Western readers will be unaccustomed. Nonetheless, we learn something from it; we begin to see that if "true philosophers are practitioners of dying," they are also practitioners of being reborn. The "dead man walking," Abu Bakr, turns out to be anything but a *memento mori*. He is an exemplary man, to whom all can turn for evidence of the resources in human nature.

For Coomaraswamy, then, the idea of death was very close; death entered into the creative inner process of "self-negation and self-realization," as he once described it,[21] and he was not prepared to say that "death in life" is just a literary analogy to the real and final death of the psychophysical vehicle. Something indeed dies, just as it would later, but the peculiar human opportunity seems to be that to die in life permits a birth of still more life. For many years before his own death, Coomaraswamy had reflected about the meaning of death, both the final one that everyone recognizes, and the inner one toward which the texts point. He was absolutely confident of the presence in human beings of a part that never dies because it was never born, an immortal part. Because of this, he had little fear, at least little imaginary fear. "I do not know whether the empirical psychology has ever attempted to deal with man's natural fear of death; the traditional psychology affirms that one who

[20] Nicholson, *Mathnawī of Jalālu'ddīn Rūmī*. This passage, Book VI, II.742–751. Editorial apparatus excluded from the passage as quoted here.

[21] AKC, "Ṛgveda 10.90.1: *átyatiṣṭhad daśāṅgulám*" (1946), p. 161.

has known his own, immortal, and never-aging Self, cannot fear (AV X.8.44)."[22] Knowledge of traditional doctrine was not a means of self-defense against a particular incident feared in the future, but rather an element in a complete circle of doctrines that concerned itself with life *and* death. In fact, Coomaraswamy had the insight that any kind of looking ahead would be a distraction from the acts of understanding necessary just where he was. In a study of "The Symbolism of Archery,"[23] he expressed this most clearly.

> The actual release of the arrow, like that of the contemplative, whose passage from *dhyāna* to *samādhi, contemplatio* to *raptus,* takes place suddenly indeed, but almost unawares, is spontaneous, and as it were uncaused. If all the preparations have been made correctly, the arrow, like a homing bird, will find its own goal; just as the man who, when he departs from this world "all in act" (*kṛtakṛtya, kataṃ karṇīyam*), having done what there was to be done, need not wonder what will become of him nor where he is going, but will inevitably find the bull's eye, and passing through that sun door, enter into the empyrean beyond the "murity" of the sky.[24]

These lines come very close to being a piece of practical advice. In a certain way, the validity of traditional doctrine must be judged in part by the appearance of insights: if a philosophy, even the venerable philosophy that Coomaraswamy studied, does not foster individual insights that are both in harmony with itself and recognizably individual, then there must be something wrong.

An element often missing in Coomaraswamy's intentional expositions of "self-naughting" is some indication of how interesting it can be, but in this comment on the arrow, which suggests that one must really take care of one's life when it is in one's hands, and really trust when it is no longer in hand, we can see that "self-naughting" must have been of absorbing interest. Which self to naught? the one that in this world is too lazy to "do what there was to be done"; in the other world, the one that tends to fear, that is helpless and anxious instead of helpless and open.

[22] AKC, "On the Indian and Traditional Psychology, or Rather Pneumatology," SP II, 372n. The reference is to *Atharva Veda,* ed. W. D. Whitney and C. R. Lanman (Cambridge, Mass., 1905).
[23] AKC, "The Symbolism of Archery" (1943).
[24] *Ibid.,* p. 119.

We have already mentioned Coomaraswamy's paper on "The Vedānta and the Western Tradition." In the second part, he represented through an extensive use of the symbolic properties of the circle the inward voyage that can be made from the outermost circumference, where man thinks of himself as "so-and-so," progressively past concentric fences, to the common center where his consciousness is not different from that of the "Spectator, the Universal Man" enthroned there, who has been watching his progress inward from the beginning. In itself, this description is not particularly rare. It is true that as an art historian who learned the lessons of his field, Coomaraswamy was able to represent this symbolism in such a way that the reader can visualize it—one has the impression of a Renaissance landscape, peculiarly drained of color, but still carefully detailed and eminently habitable. But aside from this small triumph, the representation of an inward voyage through the divisions of a *maṇḍala* is the stock in trade of popular Orientalism, which he merely practiced better than most when the opportunity came up. Perhaps it is unfair to speak of the article in this way, but these are thoughts that come to mind while reflecting on a passage toward the end, where he describes a transition in consciousness that would be hard to find in another author. It is a passage where something entirely distinctive in Coomaraswamy can be recognized.

"No man cometh to the Father save *through* me." We have passed through the opened doorways of initiation and contemplation; we have moved, through a process of a progressive self-naughting, from the outermost to the innermost court of our being and can see no way by which to continue—although we know that behind this image of the Truth, by which we have been enlightened, there is a somewhat that is not in any likeness, and although we know that behind this face of God that shines upon the world there is another and more awful side of him that is not man-regarding but altogether self-intent—an aspect that neither knows nor loves anything whatever external to itself. It is our own conception of Truth and Goodness that prevents our seeing Him who is neither good nor true in any sense of ours. The only way on lies directly *through* all that we had thought we had begun to understand: if we are to find our way in, the image of "ourselves" that we still entertain—in however exalted a manner—and that of the Truth and Goodness that we have "imagined" *per excellentiam*, must be shattered by one and the same blow. "It is more

necessary that the soul lose God than that she lose creatures . . . the soul honors God most in being quit of God."[25]

Certainly a powerful song, perhaps above all in its evocation of the "other side of God." Through this passage we can taste once more Coomaraswamy's sense of the drama of inner life—not so much the ups and downs, peripaties and denouements of falling in and out of love or in and out of good fortune, which he knew perfectly well from his younger days—but the drama of the search for God, a movement toward some things, away from others. In his later years, Coomaraswamy was trying to free himself from his biography.

[25] AKC, "The Vedānta and Western Tradition," SP II, 19–20.

XVI. AKC's Last Days

He was one of the luminaries of scholarship, from whom
we all have learned. And by the immense range of his studies
and his persistent questioning of the accepted values, he gave
us an example of intellectual seriousness, rare among schol-
ars today.

Meyer Schapiro, September 12, 1947[1]

Coomaraswamy moved into his late sixties with the usual number of
works in progress and reasonably good health. At the end of 1939 he had
some illness and was laid up for a while, but he caught his stride again.
By 1947, however, he had aged considerably (Figure 31). He described
himself in a letter to a friend as "far from well . . . obliged to work less
strenuously and to avoid any physical strains, but may last a long time if
I act wisely."[2] His book on *Time and Eternity* was published in that year;
meanwhile he continued work on a long account of the early iconography
of Saggitarius, a still longer account of the Sphinx, a study of reincarna-
tion, and smaller projects which, unlike these three, were completed and
published either during his lifetime or shortly after. His correspondence
was as interesting as ever, full of engaging questions and answers, light-
ened from time to time by irreverent friends: "the Persian double dome
has a post in the center, with radiating spokes, but don't please, give them
mystical meanings."[3]

His house was by no means haunted by the fear that his health would
fail him. On the contrary, the approach of his seventieth birthday had
given friends and admirers the impulse to celebrate very elaborately, and
he himself was making plans for retirement that promised to be anything
but a cessation of activity. In 1945, Coomaraswamy heard from a young
Indian scholar, K. Bharata Iyer, who proposed to edit a Festschrift in his

[1] Meyer Schapiro, letter to Mrs. Ananda K. Coomaraswamy, family collection.
Quoted by courtesy of Professor Schapiro.

[2] AKC, letter of 7 July 1947, family collection.

[3] M.B.S., letter to AKC, 2 March 1947, Princeton Collection.

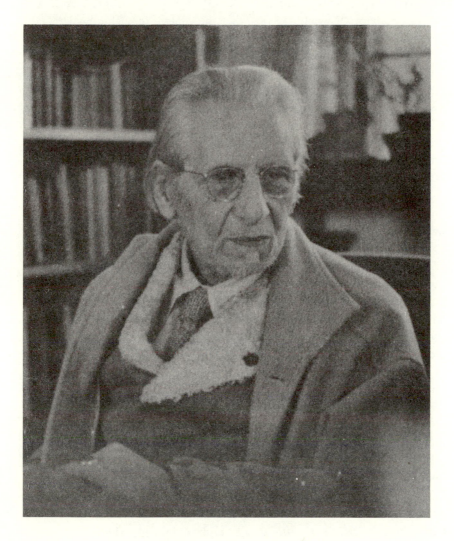

Figure 31. Coomaraswamy at home in the 1940s.

honor. Coomaraswamy liked the idea and sent Iyer a list of scholars in a variety of fields who he thought would wish to be included, adding a word of advice: "I would say this, that the content of such a book as you have in mind ought not to be restricted to the field of the arts; I have little doubt that my later work, developed out of and necessitated by my earlier work on the arts and dealing with Indian philosophy and Vedic exegesis, is really the most mature and most important part of my work."[4] Begun well in advance of his seventieth birthday, the volume progressed without undue difficulty; it acquired the title *Art and Thought*. When fully assembled, it contained forty articles by as many authors, representing the fields of art history, Sanskrit studies, psychology, sociology, Traditionalist thought, history of religions, and metaphysics; it was perhaps the first, and still the only book in which the essentially anti-academic but by no means ill-informed Traditionalist commentators on art rubbed shoulders with a number of outstanding university professors of art history.

While Iyer was preparing *Art and Thought*, another Eastern admirer, S. Durai Raja Singam, proposed to edit a volume of tributes and memoirs written by friends, colleagues, and public figures who knew and valued Coomaraswamy's writings. Raja Singam was teaching school in Malaya at a great distance from most of the people whose contributions he sought, but by late 1947 he had managed to assemble quite an extraordinary collection of memoirs, ranging from the reminiscences of persons who knew Coomaraswamy as a schoolboy to a message from the governor general of India.

Raja Singam's *A Garland of Tributes*, as the first edition of his book was entitled, and Bharata Iyer's *Art and Thought* were presented to Coomaraswamy on the occasion of a birthday dinner arranged for him at the Harvard Club in Boston by a number of close friends to which the whole circle of Coomaraswamy's friends and colleagues was invited. That dinner on the evening of August 22nd, 1947, was remarkable not just because of what was offered to Coomaraswamy, but because he offered something in return, an after-dinner address in which he spoke simply and sincerely of what he had done and of what he still wished to do.

He had been thinking for several years about his retirement. In 1945, in a letter to his first wife, Ethel, he had written, "I, too, hope to live a number of years more; at the same time I do prepare for death, as far as possible, in the Platonic manner. In a few years more we plan to go home to

[4] AKC, letter to K. Bharata Iyer, 19 March 1945, Princeton Collection.

India (northern) permanently, where I will in a certain way retire, rather than dying in harness; that is, I want to contact and realize more immediately the actuality of the things of which my present knowledge is more 'intellectual' than direct."[5] This formulation of his plan had already been in his mind for some time. To his close friend Marco Pallis, the explorer of Tibet, he had written a year earlier: "When I go to India, it will be to drop writing, except perhaps translation (of Upaniṣads, etc.); my object in 'retiring' being to *verify* what I already 'know.' "[6] The formulation made its way with him through the next few years, as did so many: his was the kind of mind that finds an expression and stays with it, reinvestigating its content, changing it slightly, but abandoning it only slowly or never. By the time of the birthday address of late August 1947, he had brought it to term:

> I have not remained untouched by the religious philosophies I have studied and to which I was led by way of the history of art. "Intellige ut credas!" In my case, at least, understanding has involved belief; and for me the time has come to exchange the active for a more contemplative way of life in which it would be my hope to experience more immediately, more fully at least a part of the truth of which my understanding has been so far predominantly logical.[7]

He had been occupied during the previous fifteen years with recovering traditional knowledge in a surprising number of fields—art and aesthetics, government, metaphysics, religion—but it had left him little time for himself. In 1936 he had admitted to Walter Shewring, the English Catholic writer with whom he had much in common: "I am so occupied with the task that I rarely have the leisure to enjoy a moment of personal realization. It is a sort of feeling that the harvest is ripe and the time short."[8] It is an informal expression, yet one that reflects his everyday life. Not only was time lacking, but also the practical indications of a trusted teacher. We have seen that Coomaraswamy was unwilling to place his *sādhana*, his work of verification, under the guidance of any of the Hindus or Buddhists he had met in the West. Even Vivekānanda would not have sufficed. Perhaps the only price that he paid for emigrating to America was that he more or less cut himself off from India, where there lived a

[5] AKC, letter to Ethel Mairet, 1 June 1945, family collection.
[6] AKC, letter to Marco Pallis, 20 August 1944, family collection.
[7] AKC, talk at his Boston dinner; as published in this study, p. 254.
[8] AKC, letter to Walter Shewring, 4 March 1936, family collection.

certain number of teachers whom he trusted, Śrī Ramana Maharshi the best known among them. On the other hand, this did not overly trouble him; he did not think it proper to exaggerate the importance of finding a *guru*. The teacher-pupil relationship was traditionally considered a necessity, but the anxious search of some people around him for a teacher, before they knew clearly why a teacher is needed, did not seem quite right. He also trusted the wisdom literature; he had found that it changed him and was more than an ineffectual outline. As he wrote during the summer of 1945 to a friend in difficulty:

> You say "the written word" is of little use to you and that you need a personal contact. And it is true that everyone needs to find their Guru. At the same time it is generally vain to *search* for one; the right answers will come when we are ready and competent to ask the right questions, not before; and so with the Guru. There is a necessary "intellectual preparation." This is why, in spite of your rejection of the written word, I feel you may perhaps not have found the written words you need, and why I suggest that you lay aside the sources you are most familiar with and plunge into a study of the traditional sources, Greek, Islamic, and Indian and Chinese.[9]

Coomaraswamy himself had many things to do before setting aside a life devoted primarily to intellectual research. Working in relative isolation in Boston, he was nonetheless much more than a man who "knows" some truth but violates it day in and day out through unconcern or lack of a personal discipline. His work was his discipline. He can be compared to the Zen potters in Japan who never sit in meditation, apparently because their craft is sufficient support for whatever inner search they undertake. Coomaraswamy was indeed "under fire," in a state of *tapas* or *tapasya*, through his later years. On the evidence of his writings, it can fairly be said that even in his relative isolation, moved only by the love of the truth and of the traditional texts where he believed he found it, he acquired more being than do many others who have the opportunity to sit at the feet of masters. His intended return to India was not an acknowledgment of superficiality in the life that he had led, but simply the next step. The four stages of life in traditional Hinduism include a third stage in which the older couple, having raised their family and settled their affairs in the world, go into semiretirement for the sake of experiencing "more

[9] AKC, summer 1947, family collection.

immediately, more fully at least a part of the truth of which [their] un-derstanding has been so far predominantly logical"—Coomaraswamy's statement describes what was customary among seriously religious people in India since the writing of the *Laws of Manu*. It would be incorrect to imagine Dr. and Mrs. Coomaraswamy taking up residence in an ashram, even that of Ramana Maharshi. The plan to live in retirement was a genuine one; whatever conversations he wished to have with spiritual guides would doubtless have been landmarks in a solitary work of realization.

Coomaraswamy was clear about the nature of the undertaking he had in mind. A passage from an article on Mind written in 1940 expresses this:

"Thither neither sight nor speech nor intellect can go; we neither 'know' it nor can we analyze it, so as to be able to communicate it by instruction" (*anuśiṣyāt*, Kena Upanishad 1.3). The realization of the corresponding state in which the Intellect does not intelligize, which is called in our text "the Eternal Mystery" and in KU vɪ.10 "the Supreme Goal" and which "cannot be taught," is the ultimate "secret" of initiation. It must not be supposed that any mere descrip-tion of the "secret" such as can be found in scripture (*śruti*) or in exegesis, suffices to communicate the secret of "de-mentation" (*ama-nībhāva*) or that the secret has ever been or could be communicated *to* an initiate or betrayed to anyone or discovered by however much learning. It can be realized only by each one for himself; all that can be effected by initiation is the communication of an impulse and an awakening of latent potentialities, the work must be done by the initiate himself. . . . We make these remarks only to emphasize that whatever can be said *of* it, the secret remains inviolable, guarded by its own essential incommunicability.[10]

It would be difficult to find another such lucid but passionate statement of the essential solitariness of initiation—the solitariness toward which he was at last moving in 1947, more than seven years after these words were written.

The birthday dinner in Boston gathered together a great many friends, although not all. George Sarton, for example, the obstinate historian of science who used to date his letters to Coomaraswamy according to the

[10] AKC, "*Manas*" (1940), SP II, 213–214. KU = *Kaṭha Upaniṣad*.

Christian festival cycle—"Whitsunday," "Shrove Tuesday," "St. Agnes' Eve,"—sent a note that he could not make it, but pleaded: "Does my mind not spend every one of your birthdays with yours?"[11] However, most minds invited came to the gathering. Telegrams were received from friends at a distance. A cable arrived from Colombo informing Coomaraswamy of a celebration there:

> Large representative distinguished gathering assembled Thursday evening Ceylon University including scholars, legislators, Supreme Court judges, knights, bishops, heads Buddhist Sangha, eminent ministers all religions, leaders all walks civil and official life, representatives learned societies, heads foreign consulates and government delegations, newspaper editors; passed with acclamation resolution felicitating your attainment seventieth birthday, wishing you long life, happiness, expressing Lanka's pride in unparalleled distinction achieved by you in realm of scholarship, bringing glory your native land. . . . Your portrait by distinguished artist unveiled at meeting.[12]

And so in the peculiar language of telegrams, he learned that Ceylon had not forgotten him. After dinner and the reading of messages sent for the occasion, Coomaraswamy gave the brief talk that follows. It is included here because it is an integral part of his biography, indeed the only extensive public remarks about himself that he ever made.

> I am more than honoured—somewhat, indeed, overcome—by your kindness in being here tonight, by the messages that have been read, and by the presentation of Mr. Bharatha Iyer's Festschrift. I should like to recall the names of four men who might have been present had they been living: Dr. Denman W. Ross, Dr. John Lodge, Dr. Lucien Scherman, and Professor James Woods, to all of whom I am indebted. The formation of the Indian collections in the Museum of Fine Arts was almost wholly due to the initiative of Dr. Denman Ross; Dr. Lodge, who wrote little, will be remembered for his work in Boston and Washington and also perhaps for his aphorism, "From the Stone Age until now, quelle dégringolade"; I still hope to complete a work on Reincarnation with which Dr. Scherman charged me not long before his death; and Professor Woods was one of those teachers who can never be replaced.

[11] George Sarton, letter to AKC, summer 1947, family collection.
[12] Family collection.

More than half of my active life has been spent in Boston. I want to express my gratitude in the first place to the Directors and Trustees of the Museum of Fine Arts, who have always left me entirely free to carry on research not only in the field of Indian art but at the same time in the wider field of the whole traditional theory of art and of the relation of man to his work, and in the fields of comparative religion and metaphysics to which the problems of iconography are a natural introduction. I am grateful also to the American Oriental Society whose editors, however much they differed from me "by temperament and training," as Professor Norman Brown once said, have always felt that I had a "right to be heard," and have allowed me to be heard. And all this despite the fact that such studies as I have made necessarily led me back to an enunciation of relatively unpopular sociological doctrines. For, as a student of human manufactures, aware that all making is "per artem," I could not but see that, as Ruskin said, "Industry without art is brutality," and that men can never be really happy unless they bear an individual responsibility not only for what they do but for the kind and the quality of whatever they make. I could not fail to see that such happiness is for ever denied to the majority under the conditions of making that are imposed upon them by what is euphemistically called "free enterprise," that is to say, under the condition of production for profit rather than for use; and no less denied in those totalitarian forms of society in which the folk is just as much as in a capitalistic regime reduced to the level of a proletariat. Looking at the works of art that are considered worthy of preservation in our Museums, and that were once the common objects of the market place, I could not but realise that a society can only be considered truly civilised when it is possible for every man to earn his living by the very work he would rather be doing than anything else in the world—a condition that has only been attained in social orders integrated on the basis of vocation, "*svadharma*."

At the same time I should like to emphasize that I have never built up a philosophy of my own or wished to establish a new school of thought. Perhaps the greatest thing I have learned is never to think for myself; I fully agree with André Gide that "Toutes choses sont dites déjà," and what I have sought is to understand what has been said, while taking no account of the "inferior philosophers." Holding with Heraclitus that the Word is common to all, and that Wisdom is to know the Will whereby all things are steered, I am convinced

with Jeremias that the human cultures in all their apparent diversity are but the dialects of one and the same language of the spirit, that there is a "common universe of discourse" transcending the differences of tongues.

This is my 70th birthday, and my opportunity to say: Farewell. For this is our plan, mine and my wife's, to retire and return to India next year; thinking of this as an "*astaṃ gamana*," "going home." There we expect to rejoin our son Rama, who after travelling with Marco Pallis in Sikkim and speaking Tibetan there, is now at the Gurukula Kangri learning Sanskrit and Hindi with the very man, Pandit Vagishvarjī, with whom my wife was studying there twelve years ago. We mean to remain in India, now a free country, for the rest of our lives.

I have not remained untouched by the religious philosophies I have studied and to which I was led by way of the history of art. "Intellige ut credas!" In my case, at least, understanding has involved belief; and for me the time has come to exchange the active for a more contemplative way of life in which it would be my hope to experience more immediately, more fully at least a part of the truth of which my understanding has been so far predominantly logical. And so, though I may be here for another year, I ask you also to say "goodbye,"— equally in the etymological sense of the word and in that of the Sanskrit "*Svagā*," a salutation that expresses the wish "May you come into your own," that is, may I know and become what I am, no longer this man So and so, but the Self that is also the Being of all beings, my Self and your Self.[13]

It does not require commentary. He gave a balanced picture of himself: art historian, metaphysician, social philosopher, and, in the last words, a man who had made the Quest—which so often seems grand but a little artificial—simply his own affair.

Soon after he had finished speaking, Coomaraswamy suddenly seemed to grow pale. He felt quite ill. His wife drove him home without further ceremony and he quickly recovered from whatever had disturbed him. The next few weeks flowed without incident. On the morning of September 9, Coomaraswamy was upstairs in his study, finishing a revision of *The Dance of Shiva* for a new edition, while Mrs. Coomaraswamy

[13] AKC, talk at his Boston dinner (1947); also published in SP II.

was down in the garden doing some pruning with a Harvard student who had come to help.[14] She called to her husband to come down and see the progress. He left what he was doing right in the middle of a sentence, as seems to have been his habit, and chatted for a while with his wife and the student, Robert W. Bruce. It was an easy, summertime conversation. Coomaraswamy had his eyes on a bull-frog in the goldfish pond—a device of the Lord's for catching flies and astonishing children. Mrs. Coomaraswamy and Bruce went around to the other side of the house to get the young man's paintings out of his car to show Coomaraswamy. A few minutes later Coomaraswamy followed them. He told his wife that he felt dizzy. She had him sit down and reached for the pills in his vest-pocket that he carried for such moments. He said, "Yes," leaned against his wife and seemed to faint. Mr. Bruce ran into the house for some water to throw in his face, but he did not regain consciousness. A doctor and ambulance were called, but it was already too late. He had died of a heart attack at the beginning of his seventy-first year.

Mrs. Coomaraswamy had his body laid out in the guest room of their house. She telephoned several of her husband's closest friends. Benjamin Rowland came as quickly as he could; he found Coomaraswamy, as he said, lying "like a dead eagle" in his temporary place of rest.

It is a very strange moment when a man of this kind dies. He had spent much of his time "placing" death, understanding its role in the life of the world and the life of man, investigating all ideas concerning what part of man inevitably returns to dust and what part inevitably returns to the Lord, what the various conditions of a soul can be as it separates out from the body and moves, like an arrow released, towards the murity of the sky. He had tasted, tested all these symbols and ideas, and doubtless also tasted the intuitions from which they proceed. He had asked those around him not to mourn when he died. And yet when a man dies there is mourning, no matter how much he insisted on reticence. All who knew him well were in a strangely double situation—just the kind that he valued: impossible to mourn him like any other man, false to mourn him only with high philosophical words that failed to recognize the reality of grief. They found themselves threading their way through contraries. In a letter of condolence to Mrs. Coomaraswamy, the anthropologist Joseph Epes Brown recalled his last conversation with Coomara-

[14] This account is based on the correspondence of Mrs. Ananda K. Coomaraswamy in the family collection and on the account of Robert W. Bruce in *Memorial Volume*, pp. 148ff.

swamy and found himself weighing against his own feeling of loss a passage on death that Coomaraswamy had translated and annotated.

I remember on my last visit to you, our conversation was almost completely on death, mostly the real death, not the apparent "death" which comes when the vehicle dissolves and returns from whence it was borrowed. At that time I copied a translation your husband had made from Apollonius, *Epistle to Valerius* (Ep. 58) on death. You probably saw it—but perhaps not and so I shall copy some of it here.

"There is no death of anyone save in appearance only, even as there is no birth of anyone, but in appearance only. For when anything turns away from its Essence to assume a nature there is the notion of 'birth,' and in the same way when it turns away from the nature, to the Essence, there is the notion of a 'death,' but in truth there is neither a coming into being nor a destruction of any essence, but it is only manifest at one time and invisible at another."

"This manifestation and invisibility are due respectively to the density of the material assumed on the one hand, and to the tenuity of the essence on the other." (Note by AKC.)[15]

Professor Brown's letter epitomized the reaction of friends as the news of Coomaraswamy's death circulated. He had written from the plains of North Dakota. In Cairo, René Guénon spoke of "our regretted collaborator who was, for years, one of the best artisans of the renewal of traditional ideas in the West."[16] The difficulty of mourning Coomaraswamy is suggested by the note he added to his translation of Apollonius, as well as by other passages of the same kind in his published writings: not only the clarity of its thought, but also the crispness of the wording, the certainty of conception, made it difficult to avoid feeling that Coomaraswamy's spirit was simply passing through the clear divisions of a cosmos that he had studied.

The funeral was held at noon Friday in the garden. Mrs. Coomaraswamy had decided to invite a Greek Orthodox father whom she knew to perform the ceremony, because the Eastern Church seemed to her the most orthodox form of religion available where they lived. The service at

[15] Joseph Epes Brown, letter to Mrs. Ananda K. Coomaraswamy, 14 November 1947, family collection. Quoted by courtesy of Professor Brown.
[16] René Guénon, in *Études traditionelles*, XLVIII (1947), 280.

Needham was thus the Greek one, while Coomaraswamy's son, at school in India, arranged for Hindu rites. A good many people attended, including the local shopkeepers and artisans, with whom Coomaraswamy often had good relations. Professor Robert Ulich spoke the eulogy.[17] Later in the day, Coomaraswamy's body was cremated and the ashes placed in a brass bowl that a Japanese colleague in the Museum of Fine Arts, Kojiro Tomita, had chosen for this purpose, thus repeating a forgotten gesture of many years before, when Coomaraswamy's intimate, John Ellerton Lodge, had wrapped the body of William Sturgis Bigelow in Buddhist robes. Years later, when Mrs. Coomaraswamy could finally make a voyage to India, she had a portion of the ashes "given back" to the Ganges, as was the custom in his family, while the other portion was given to members of his family in Ceylon for immersion there. There was, then, no resting place and no epitaph, although he had written one in 1942 that can be understood as what he would have wished for himself. It was written from the heart of his rebellion against the trivial, greedy, and unenlightened self that he had recognized within himself and could not help but see in other men:

> The Hindu of any caste, or even a barbarian, can become a Nobody.
> Blessed is the man on whose tomb can be written, *Hic jacet nemo*.[18]

[17] Cf. Robert Ulich in *Memorial Volume*, pp. 1–7.
[18] AKC, *Hinduism and Buddhism*, p. 30.

XVII. Coomaraswamy and William Morris:

The Filiation

> But if Abanindra Nath Tagore and his followers stand in
> this art revival of ours, to a certain extent in the place oc-
> cupied by the Pre-Raphaelites in the history of English art,
> where is our William Morris?
>
> Coomaraswamy, 1910[1]

Had the admirers of William Morris done a book in his honor, it would
never have occurred to them to give it the title *Art and Thought*. They
might well have called it *Art and Society*. Here lies the greatest difference
between William Morris and Coomaraswamy who, although almost un-
recognized in the role, carried Morris's thought into the mid-twentieth
century. Nowadays, few people read William Morris. He has, it is true,
been assigned a place of honor in the early history of modern design by
Nikolaus Pevsner, Herbert Read, and others;[2] he is acknowledged as a
late Romantic poet; he is remembered as a Victorian socialist; his memory
has recently been revived by a good new biography, specialized studies
of his art, and the republication of his *Collected Works*.[3] But it remains
true that an educated person is only supposed to know his name. It is,
then, a surprise to read Morris's prose works and find in them an under-
standing of the problems of the artist in industrial society, a fiery humani-
tarian socialism, and a sustained eloquence that little by little may con-
vince one that he was not only a great individual, but also an unrecognized

[1] AKC, *Art and Swadeshi*, p. 52.

[2] Pevsner, *Pioneers of Modern Design*, early chapters; Herbert Read, *Art and In-
dustry*.

[3] Cf. Philip Henderson, *William Morris: His Life, Work and Friends* (London,
1967); Asa Briggs, *William Morris: Selected Writings and Designs* (Harmonds-
worth, 1962); May Morris, ed., *The Collected Works of William Morris* (London,
1910–1915, reprinted New York, 1966); May Morris, *William Morris: Artist, Writer,
Socialist* (London, 1936, reprinted New York, 1966); and other recent publications,
among which Eugene D. Lemire, ed., *The Unpublished Lectures of William Mor-
ris* (Detroit, 1969), is of special interest.

ancestor of the "alternative culture" or "counter-culture" that occupies so many minds today. The theme of Coomaraswamy's relation to Morris has hung back, waiting for a time when it could be fully evoked. The relation between the two men does not fit into the sequence of Coomaraswamy's life as just another element: it is a precondition of the sequence, a first orientation that provided direction throughout. On the other hand, in order not to exaggerate Morris's influence, it should be said immediately that Morris had almost nothing to do with Coomaraswamy's interest in religion, metaphysics, and their expression in works of art. Morris declared himself "careless of metaphysics and religion,"[4] and his definition of art, like Ruskin's, was nothing more than "man's joy in his work," visibly expressed.[5] *Art and Thought*, so true a reflection of Coomaraswamy's point of view, says nothing about Morris, who would have been in his workshop experimenting with indigo dyes or tapestry-weaving techniques while Coomaraswamy was reading a scripture or working out the content of a symbol.

"Coomaraswamy was one of Morris's people, he even looked it—the flowing hair, the old clothes. . . ." This remark by one of Coomaraswamy's closest friends in later years, Eric Schroeder, suggests very well both the visible and the subtle mark that Morris made. To be "one of X's people" implies a freedom, but also an adherence: it is the stage beyond adoration or discipleship. We have already seen a good deal of the earlier stage in their relation; when Coomaraswamy was young he engaged in something that can justly be called the Imitation of William Morris. Morris (1834–1896) was forty-three years old at Coomaraswamy's birth and nearing the height of his career; Coomaraswamy was nineteen when Morris died. There is no evidence that they met, but all through the years of Coomaraswamy's English upbringing and education, Morris was everywhere apparent in England as a craftsman and designer, a reformer of taste, an enemy of industrial manufacture, a socialist lecturing throughout the country, a poet, a fine printer. During the 1890s, years in Coomaraswamy's life for which there is hardly any documentation, the young man must have absorbed nearly the whole range of Morris's concerns as his own. When Coomaraswamy began to write on Ceylonese art and society in 1905, he was already a Morris person through and through. We do not need to read in *The Ceylon National Review* of May 1908, that he was then printing his works "on the press used by the late William Morris, ever

[4] Briggs, *William Morris*, p. 36. [5] *Ibid.*, pp. 140 ff.

to be revered by lovers of arts and crafts, of whom Dr. Coomaraswamy is a devoted follower," to take the measure of his devotion. It is difficult, too, to imagine Coomaraswamy acquiring his love of Morris *after* he had reached Ceylon, in 1902. He must have taken it with him from his school and college days, just as Morris acquired his love of Ruskin and Carlyle from his college days. Coomaraswamy had no father, in the sense that he never really knew his father; his father was an example about whom he heard and a stirring in his blood, but nothing more. Morris was just as much his father, although since it was a relation in spirit and not in flesh, it seems better to think of it as a filiation, a genealogy by attraction. The example of Morris was many-sided and virile: he was a man of action, a doer and organizer, and an artist who could experiment unsparingly with techniques, without losing his delicacy and lightness as a designer. Nothing left him cold, and yet he always took thought. If one was scanning the horizon in the 1890s for a model, one could hardly have found a better.

The idea of a concordance suggests itself for summarizing the relation between Coomaraswamy and Morris: there are so many principles, interests, and kinds of activity in common that the whole question could nearly be dismissed with two parallel columns relating things in the life of each. Even as we describe their common points in a less schematic way, the idea of a concordance cannot help but underlie it. In 1905, Coomaraswamy published a translation of the *Völuspa*, a small portion of the Icelandic Elder Edda. He had a first edition printed in Ceylon; later, during his years with the Essex House Press, he brought out a finely printed small edition.[6] Nothing could seem more incongruous on the part of a half-Ceylonese patriot than to translate a northern saga and go to the trouble of having it printed at Kandy, in the central highlands of Ceylon. But this was only an aspect—perhaps the only incongruous aspect—of the young Coomaraswamy's Imitation of William Morris. Morris had devoted much effort to the translation of northern literature, working in collaboration with an Icelandic gentleman, Eirikr Magnusson. The northern epics such as *Sigurd the Volsung* seemed to Morris to be the equivalent of the Homeric epics and undeservedly less well known. Coomaraswamy sought out Morris's Icelandic collaborator, in the first years of the century, and worked with him in much the same way, although on a much shorter text—the complete *Völuspa* required only

[6] Biblio. Nos. 30, 103, in the *Working Bibliography*.

twelve printed pages. It was not Coomaraswamy's calling to revive interest in Icelandic myths, but the impulse he acquired here carried on. *Myths of the Hindus and Buddhists* of 1913, and *Buddha and the Gospel of Buddhism* of 1916, are in part a transposition of Morris's impulse to retell and revive the most ancient myths.

This transposition from Morris's England to Coomaraswamy's Ceylon and India is only one of many. Among Coomaraswamy's first public appeals in Ceylon was an "Open Letter to the Kandyan Chiefs," concerned in part with the problem of the treatment of ancient buildings. In the year of Coomaraswamy's birth, 1877, Morris had founded The Society for the Protection of Ancient Buildings. It quickly became known as "Anti-Scrape," and was a far from negligeable force in English life. In the society's manifesto, Morris had written:

> It is for all these buildings, therefore, of all times and styles, that we plead, and call upon those who have to deal with them, to put Protection in the place of Restoration, to stave off decay by daily care, to prop a perilous wall or mend a leaky roof by such means as are obviously meant for support or covering, and show no pretence of other art, and otherwise to resist all tampering with either the fabric or ornament of the building as it stands.[7]

In his 1905 letter, Coomaraswamy simply adapted the ideas and even the language of Morris to a new setting:

> The ruinous state of ancient buildings and their scandalous neglect might also be written on. It is not restoration they need, but more preservation, a few tiles or a new beam, and protection from white ants. Instead of this, the most ancient buildings in the remoter districts are simply rotting away, and often used as cattlesheds; very occasionally they are unjudiciously and unwisely "restored" and thereby absolutely ruined as works of art and beauty.[8]

The similarity of the language in these two passages is striking, although they are neither great Morris nor great Coomaraswamy. Coomaraswamy's ear for language was tuned by Morris's works more than by those of any other writer. Morris wrote *English*, not Latinate English, Romantic English, or inattentive English: his prose works exercise a rich but never obscure vocabulary, and there is instinctive good design in their sound.

[7] May Morris, *William Morris: Artist, Writer, Socialist*, I, 111.
[8] AKC, "Open Letter to the Kandyan Chiefs" (1905).

The heart of the concordance between Coomaraswamy and Morris was their view of society and the significance of the artist and craftsman. Morris's attitude towards Britain's commercial policies in her colonies exemplifies his views:

> So far-reaching is this curse of commercial war that no country is safe from its ravages: the traditions of a thousand years fall before it in a month; it overruns a weak or semi-barbarous country, and whatever romance or pleasure or art existed there, is trodden down into a mire of sordidness and ugliness; the Indian or Javanese craftsman may no longer ply his craft leisurely, working a few hours a day, in producing a maze of strange beauty on a piece of cloth: a steam-engine is set a-going at Manchester.[9]

It must have been with a mind already prepared by such passages as this that Coomaraswamy went to Ceylon. Morris's desperate vision included England, of course:

> Apart from the desire to produce beautiful things, the leading passion of my life has been and is hatred of modern civilization.[10]

> There are matters which I should have thought easy for [Science]; say, for example, teaching Manchester how to consume its own smoke, or Leeds how to get rid of its superfluous black dye without turning it into the river. . . . However it be done, unless people care about carrying on their business without making the world hideous, how can they care about art?[11]

Morris's solution was a return to simplicity in living, to craft production, and patience while these changes improved the quality of people and material culture. Utopian Socialism is the term that Engels applied to Morris's point of view,[12] but it would be too easy to dismiss this outbreak of the will to live well with a word or two.

> I hope that we shall have leisure from war—war commercial, as well as war of the bullet and the bayonet; leisure from the knowledge that darkens counsel; leisure above all from the greed of money and the craving for that overwhelming distinction that money now brings;

[9] May Morris, ed., *Collected Works*, XXIII, 8.
[10] Briggs, *William Morris*, p. 36.
[11] *Ibid.*, p. 103.
[12] Henderson, *William Morris*, p. 277.

I believe that as we have even now partly achieved LIBERTY, so we shall one day achieve EQUALITY, which, and which only, means FRATERNITY, and so have leisure from poverty and all its griping, sordid cares.[13]

Just as one senses in Coomaraswamy's early work the very purest manifestation of social idealism, so one senses it here. There is something immensely strong in Morris's appeal, and yet it is weak: it is strong because it comes from conscience, but it is weak because it appeals to nothing in other men aside from conscience. Individuals like Morris have more conscience than the great majority of those to whom they address themselves. Coomaraswamy absorbed this characteristic, with its strengths and weaknesses. He must have felt that what Morris had done and thought was *right* and gave life, even if it failed to influence the mass of men; Coomaraswamy much preferred to be right and to feel that his conscience was alive, than to compromise; we have already seen this through his exchange with Hermann Goetz. A French graphologist who recently examined Coomaraswamy's handwriting without any knowledge of the writer, noted: "La volonté n'est pas bien integrée au réel" (the will is not well integrated with reality).[14] This was a trait that Coomaraswamy shared with Morris with respect to their social idealism, which was far more a political poetry and an expression of awakened conscience than a down-to-earth program. Philip Henderson, in his recent biography of Morris, made the necessary comment: "Morris felt that he had only to project his vision of the good life sufficiently clearly for all men to desire it. But in this he was mistaken, as he came reluctantly to realize because, as a matter of fact, for the average worker the good life was represented by the kind of life led by the average capitalist—the sort of life which Morris himself abhorred."[15]

Morris had a vision of the former estate of art and of its deterioration since the destruction of popular culture by the changes in living that accompanied industrialization. For him, art was not respectable when it was the toy of a small circle of leisured men; it must either be present throughout a society in all things made, as he believed it had been in the Middle Ages and in the unchanging peasant culture that survived to the eighteenth century, or it was of no real significance. It is no exaggera-

[13] Briggs, *William Morris*, p. 104.
[14] The study was made through the resources of Cabinet Pierre Leconte, Paris, a psychological testing firm.
[15] Henderson, *William Morris*, p. 250.

tion to say that Coomaraswamy never ceased to adhere to this point of view, even in his late writings.

Morris very much regretted the distinction between fine art and applied, decorative, or utilitarian art. In the periods that he admired, particularly the Middle Ages, all arts were honored. He blamed the Renaissance for creating a division between artist and craftsman: "as . . . art sundered into the greater and the lesser, contempt on one side, carelessness on the other arose. . . . The artist came out from the handicraftsmen, and left them without hope of elevation, while he himself was left without the help of intelligent, industrious sympathy."[16] Morris's successful revival of craft in the late nineteenth century and Coomaraswamy's fascination with the crafts of Ceylon are both rebellions against the division between fine art on the one hand and artless industrial production on the other. As with everything that Coomaraswamy had from Morris, the impulse continued throughout his life: in the 1930s, for example, it was Coomaraswamy who immediately welcomed Edward Deming Andrews' work on Shaker craftsmanship, reviewed it in the widely read *Art Bulletin*, and sought out the friendship of Andrews himself.

No matter how far we wish to carry the comparison between Morris and Coomaraswamy, we find new evidence of filiation; the father's mark went deep. Coomaraswamy was a professional museum man throughout much of his life; how is it, then, that he could speak of "objects displayed in the glazed coffins of our gallery,"[17] or write that "we are proud of our museums, where we display the damning evidence of a way of living that we have made impossible"?[18] This vision of museums is none other than Morris's, expressed already in 1877 in such lines as: "nor can I deny that there is something melancholy about a museum, such a tale of violence, destruction, and carelessness, as its treasured scraps tell us."[19]

And so it is that part of what strikes one as surprising in Coomaraswamy's writings—what strikes one as not the work of an art historian but of some other kind of man, is due to the influence of William Morris. Coomaraswamy's life and ideas, from the days of the Ceylon Social Reform Society to his description of himself in his seventieth birthday address as a "student of human manufactures," were woven through with Morris's example.

[16] Briggs, *William Morris*, p. 89.
[17] AKC, "Understanding the Art of India" (1934), p. 21.
[18] AKC, "Am I My Brother's Keeper?" (1947), p. 7.
[19] May Morris, ed., *William Morris: Artist, Writer, Socialist*, II, 17.

XVIII. Tradition: An Introduction to

the Late Writings

There is only one mythology, one iconography, and one truth,
that of an uncreated wisdom that has been handed down
from time immemorial.

Coomaraswamy, 1944[1]

THE IDEA OF TRADITION

In his later years, Coomaraswamy was often interested to show that if
an idea once had the power to be considered a dogma, indisputable truth,
then it is still likely to yield understandings for the modern mind. By
reading in the dogmas of a particular culture a more universal set of re-
lationships, he was able to make articles of faith seem again to be what
they doubtless were at origin: expressions of metaphysical truth. Such a
dogma as the Virgin Birth in Roman Catholic thought, to outsiders simply
untenable, was understood by Coomaraswamy to refer to the inexhaus-
tibleness of divine creativity: "Indian tradition . . . knows a virginity of
the Mother. . . . An ultimate 'virginity' of both parents is indeed a meta-
physical necessity, for the twin poles of being, the unmoving centres of the
Principial and World Wheels, act only by their presence and not by local
movements: 'He' is undiminished by his largesse, 'She' by her parturition."[2]
Through resourceful comparison and a knowledge of what he called "First
Principles" (simple, axiomatically true, ancient ideas about the plan of
the world), Coomaraswamy thus managed to reanimate a conception that
may have seemed useless and isolated. Dogmas must be *penetrated* in this
way—such is the implicit teaching of his method. His purpose, of course,
was not to encourage conversions to Roman Catholicism or Hinduism,
but to regain understandings that exist in many traditions and could exist
in the modern mind—not as interesting fragments, he would have hoped,
but as elements in a generally changed point of view.

[1] AKC, "A Lecture on Comparative Religion" (1944).
[2] AKC, *Elements of Buddhist Iconography* (1935), p. 72, n. 45.

265

In the first part of this chapter, we shall try to penetrate one of Coomaraswamy's own dogmas, the idea of Tradition. It is the central idea of his later years. It implies a very specific vision of nearly everything, and it is a fundamental idea that cannot be used "a little," because it implies so many values and criticisms. It is a rather fixed idea—a content to be understood, not a content in evolution—but it does take on the coloring of its user, so that one can find oneself quarreling inwardly with a particular author or passage without doubting the idea itself. For the twentieth century, it is a largely untried idea. A form of it was popular in the nineteenth century through every sort of mediaeval revival, but it went underground after World War I and experienced further development in a much wider context of thought, evolving from mediaevalist nostalgia to an elaborate and detailed knowledge of premodern cultures, particularly of the metaphysical and religious ideas upon which they were founded. These ideas had so much in common, whether they appeared in sophisticated or primitive cultures, that it became customary for certain authors, among them Coomaraswamy, to speak of "traditional" ideas without adding "traditional Indian" or "traditional American Indian."

"Traditional" signified something precise and important without further explanation, just as the word "modern" signified something precise and important. "Traditional" described cultures which, whatever their historical faults, were founded on an understanding of the spiritual nature of man and the world; "modern" described cultures that have forgotten many truths of the spirit, no matter how brilliantly they exercise particular faculties of the spirit. "Modern" cultures were described as antitraditional: they emerged by rejecting and forgetting tradition, and they tend to destroy traditional cultures around them both by competition and attraction. "Traditional" became a word of praise, guaranteeing that a given entity (an idea, a social form, a practice) was true or fitting in itself and related to a larger whole. What was not "traditional" had deviated from the only real *norm*; it was antitraditional, that is, modern, and either evil or only accidentally good. This concept of Tradition was presented dogmatically and soon became a rigid means of parting the Cursed from the Blessed. It became so, not because the proponents of traditional thought were by nature narrow-minded, but because the vision of a modern world with little or no true spirituality, torn by vast wars, living under a reign of quantity, provoked a powerful reaction in those

who believed that they knew of something better that once existed and now is lost.

The hallmark of Tradition, according to its twentieth-century expositors, was a dependence upon God, or Truth. Even in surviving traditional societies of the present day, they found a great many ideas, artistic traditions, and customs in general circulation that keep the relation between man and his world rich with a sense of the sacred. To aver that a given entity is "traditional," according to their new understanding, is to say immediately that it has links upward and downward with many other entities, and horizontal links with entities of a kind similar to itself. At the very top of this traditional universe is God, or whatever sacred force is said to have generated the universe, and no idea, act, or thing fails to be connected ultimately with Him. The lack in "modern" cultures of this sense of the sacred struck them as outrageous and ominous. In their own lives, they sought to know the sacred, and in their writings they appealed to those with eyes to see and ears to hear to recognize that the modern world is one of "impoverished reality."[3]

For Coomaraswamy and the writers closest to him, Tradition is obviously a charged word. It is full of hope, because it implies that substantial truths have been embodied in certain ways of doing things, certain works of art, certain doctrines. But it is also full of despair because we are "moderns," and it is not at all obvious, even if we agree that modern life is impoverished, how we are to go about making a relation with Tradition, or if traditional forms are the only source of spiritual health. In the best of hands, and when traditionalist thinkers are truest to their own ideas, the idea of Tradition can give modern people the wish to seek a new quality in their own lives without giving the impression that the details of past solutions are currently valid.

This description of Tradition is in many respects new; it is proper to the twentieth century and can easily be considered one facet of the self-doubt that came over the West during and after the Great War. It is Western and modern in its formulation, for while a concept of tradition exists in each traditional culture, the new version is based upon a broad view, encompassing all of these, which would not have been possible

[3] This expression, often used by AKC after 1942, he owed to Professor Iredell Jenkins, whose article, "The Postulate of an Impoverished Reality," *Journal of Philosophy*, XXXIX:20 (1942), 533 ff., struck AKC as a just critique of Western thought since the eighteenth century.

prior to modern means of travel and communication. Furthermore, the study of Tradition is not conceived as an historical exercise but as a means of increasing discrimination and strengthening the will to live well and "know well" in modern times. Knowledge is reorganized, subjects grouped in characteristic ways, and the values placed upon them by modern thought are often modified or reversed.

Coomaraswamy occasionally made lists of cultures that he considered traditional, in the sense of the word that has now begun to be established. He once listed: "the normal and long-enduring types of civilization . . . Indian, Egyptian, early Greek, mediaeval Christian, Chinese, Maori, or American Indian, for example."[4] It would be difficult to situate all of these cultures in a single category were there not the idea of Tradition. They become a unity if we accept at least provisionally that First Principles or first truths order them all in one way or another; and it becomes an urgent matter to study them if we entertain at least provisionally the assertion that these truths are either missing in the mainstream of modern culture or present only in fragmentary and emptied forms.

For Coomaraswamy, India was the epitome of traditional civilization. A knowledge of Indian thought—metaphysics, spiritual disciplines, iconographic and symbolic repertoire, aesthetics, social theory, and so on—provided him a touchstone when he studied other traditional civilizations, and seems also to have served in this fashion for René Guénon, to whom must be principally attributed the new idea of Tradition. Others, younger than Coomaraswamy and not as closely related to him as was Guénon, clearly owe more to Islamic civilization (to which Guénon in later years was also integrated as a professed Muslim).[5]

These reflections raise the question of the origin of the new idea of tradition, which has so far been sketched only impressionistically. Its history could be written at length; a summary has indeed been written, which traces it from a reaction in the Renaissance to Scholastic rationalism through nineteenth-century French traditionalists such as Joseph de

[4] AKC, "Is Art a Superstition, or a Way of Life?" (1937). As published in *Christian and Oriental Philosophy of Art*, this passage appears on p. 84.

[5] Cf. works by Frithjof Schuon, Titus Burckhardt, Marco Pallis, and Martin Lings, as well as the English quarterly, *Studies in Comparative Religion*, which in many ways is the successor of *Études traditionelles*. None of these authors has restricted himself to Islam: traditionalist thought is frequently comparative. Their writings are anthologized in Jacob Needleman, ed., *The Sword of Gnosis* (Baltimore, 1974).

Maistre, whose traditionalism had as much to do with conservative politi-
cal convictions as with the recovery of a lost vision of man.[6] It would
be useful, short of attempting a complete history of the idea, to look at its
history within Coomaraswamy's milieu and in his own changing use
of it. This, too, will be only piecemeal, neglecting such themes as the
contribution of Theosophy to the evolution of the idea and the influence
of Western secret societies, such as the Freemasons. Such societies and
organizations influenced Guénon in his youth and, although he turned
away from them definitively and mounted a serious attack on what he
considered to be their pseudo-knowledge and pseudo-traditions, he un-
doubtedly learned from what was sound in them.[7]

Sir George Birdwood, the late nineteenth-century connoisseur of Indian
crafts, described Indian art in 1880 as "a traditional art still fresh and
pure,"[8] and thirty years later, at that historic meeting of the Royal Society
of Arts that Birdwood chaired, E. B. Havell put the whole of Indian
culture under the sign of Tradition: "Art still survives throughout the
length and breadth of India, a part of a great traditional culture, intimately
bound up with the religion and daily life of the great mass of the Indian
people."[9] By 1910, Coomaraswamy was accustomed to this use of the
term "tradition" and was adrift in nostalgia for the nearly lost traditional
life of Ceylon and India. Writing of Kandyan artists, for example, in
1906, he said that "they were guided by tradition, in it they lived and
moved and had their artistic being."[10] For a little while, in this early
period, he would make up florid phrases to suggest the value of traditional
civilization; he would speak of the good that could come from "a suffi-
ciently serious, religious and aesthetic culture";[11] or of a "religious, heroic
and aesthetic culture";[12] or of "the permanent ground of epic tradition,
devotional faiths and the common life."[13] In *The Message of the East*,
he invoked "the gospel of tradition,"[14] while his friend, the architect C. R.

[6] Cf. Jean Thamar, *Études traditionelles* (1951).

[7] Cf. early works of René Guénon, *Le Théosophisme, histoire d'une pseudo-re-
ligion* (Paris, 1921), and *L'Erreur spirite* (Paris, 1923).

[8] Birdwood, *The Industrial Arts of India*, p. 384.

[9] Havell, *Journal of the Royal Society of Arts*, 4 February 1910, p. 274.

[10] AKC, "Kandyan Art: What It Meant and How It Ended" (1906), p. 3—bor-
rowing from St. Paul, Acts 17:28.

[11] AKC, *Burning and Melting: Being the Sūz-u-Gudāz of Muhammad Rizā Nauʾī
of Khabūshan* (London, 1912), p. 7.

[12] AKC, "Sati: A Vindication of the Hindu Woman" (1913), p. 1.

[13] AKC, "Rajput Painting" (1919), p. 49.

[14] AKC, *The Message of the East* (1908), p. 26.

Ashbee, wrote of what it is "to build well, *i.e.*, according to tradition."[15] These quotations represent an early stage in the evolution of the idea of tradition, for Coomaraswamy and his circle.

The next stage is marked by the year 1921, when Guénon published his first major work, *Introduction générale à l'étude des doctrines hindoues.*[16] Coomaraswamy may have known nothing of this book, which presented the new concept of Tradition in quite complete form, until perhaps 1930. Whatever gestation the concept experienced in the period before Guénon published, by 1921 he had written a chapter, "What is Meant by Tradition," in which he recognized that he was establishing a new definition:

> In the foregoing pages we have constantly had occasion to speak of tradition, of traditional doctrines or conceptions, and even of traditional languages, and this is really unavoidable when trying to describe the essential characteristics of Eastern thought in all its modalities; but what, to be exact, is tradition? . . . Etymologically, tradition simply means "that which is transmitted" in some way or other. . . . As far as the East is concerned, . . . the identification of tradition with the entire civilization is fundamentally justifiable. . . . As for Western civilization, . . . it is on the contrary devoid of any traditional character, with the exception of the religious element, which alone has retained it. Social institutions, to be considered traditional, must be effectively attached in their principle to a doctrine that is itself traditional. . . . In other words, those institutions are traditional which find their ultimate justification in their more or less direct, but always intentional and conscious, dependence upon a doctrine which, as regards its fundamental nature, is in every case of an intellectual order.[17]

Guénon's later works never failed to add new elements to the understanding of tradition established by this earliest book.

The growing influence of the idea can be measured by following the history of the French periodical, *Études traditionelles*, to which Guénon contributed since about 1929; by the mid-1930s it had become the major

[15] Ashbee, "The Guild of Handicraft, Chipping Campden," *The Art Journal* (1903), p. 149.

[16] Cf. René Guénon, *Introduction to the Study of the Hindu Doctrines* (London, 1945).

[17] *Ibid.*, pp. 87–89.

journal of traditional thought. It was born in 1893 as *Le Voile d'Isis*, further described as a "revue . . . d'études ésoteriques, psychiques et divina- toires."[18] The title as a whole is Theosophical in tone—*Isis Unveiled* was the title of a major Theosophical work of the end of the century. In 1929, its descriptive subtitle was "revue mensuelle de Haute Science,"[19] and its purpose was described as "l'étude de la Tradition et des divers mouve- ments du spiritualisme ancien et moderne."[20] By 1932, its subtitle had drawn closer to Guénon's thought: "la seule revue en langue française ayant pour objet l'étude des doctrines traditionelles tant orientales qu'oc- cidentales, ainsi que des sciences qui s'y rattachent,"[21] and it spoke fur- ther of "LA TRADITION PERPÉTUELLE ET UNANIME, révélée tant par les dogmes et les rites des religions orthodoxes que par la langue universelle des symboles initiatiques."[22] This formulation expresses noth- ing short of the complete intellectual program of twentieth-century tradi- tionalism. In 1934–1935, the journal acquired the subtitle "*Études tradi- tionelles*," and by 1937, and thereafter to the present day, the phrase *Le Voile d'Isis* disappeared, along with every trace of the *fin de siècle* oc- cultism that originally made it appropriate.

Coomaraswamy's transformation in the period around 1932 corresponds to the transformation of *Le Voile d'Isis* under Guénon's influence. Just in this period, the "time" of the idea of Tradition had come, at least for a small number of persons. At intervals through the 1930s, articles by Guénon directly concerned with one or another aspect of the idea of Tradition would appear in the journal: "Tradition et traditionalisme," "Les Contrefaçons de l'idée traditionelle," "Tradition et transmission,"[23] among others. Concurrent with these articles appeared Coomaraswamy's own studies of aspects of traditional Indian thought. A school of thought had come into existence, sometimes militantly, sometimes compassionately at odds with the greater part of academic thought on its specialized sub-

[18] Michel Valsân, in his introduction to René Guénon, *Symboles fondamentaux de la science sacrée* (Paris, 1962), has also given a brief history of the periodical and commented on the significance of its changing titles.

[19] "Monthly journal of Higher Science."

[20] "The study of Tradition and the diverse movements of ancient and modern spirituality."

[21] "The only journal in French having as its object of study the traditional doc- trines of East and West, as well as the sciences dependent upon them."

[22] "THE PERPETUAL AND UNANIMOUS TRADITION, revealed by the dogmas and rites of the orthodox religions, no less than by the universal language of initiatic symbols."

[23] Respectively appearing in October 1936, November 1936, and January 1937.

jects: traditional thought and its application to all aspects of human life. For the adherents of this school, traditional civilization was the peerless alternative culture.

In a country such as Morocco, which is both traditional and modern, there are often two schools in large cities: the first is a modern university with Western curricula, the second is a *madrasa*, a traditional school that offers a range of traditional Islamic learning—scriptural studies, history, law, and so on. Coomaraswamy and Guénon can be thought of as bringing the knowledge of the *madrasa* to the attention of the university; but this analogy errs slightly. In the first place, Guénon avoided the universities. Coomaraswamy was very much a part of them and always felt that the most interesting conversation was to be had with trained minds that could gradually open to a new perspective, the traditional perspective; but Guénon kept his distance, addressing himself only very generally to the Western intelligentsia. He mistrusted the academic mind and received abundant mistrust in return. In the second place, traditional thought is hierarchically structured, and all parts of it did not occupy Coomaraswamy and Guénon in equal measure. It is true that Coomaraswamy devoted a book to the traditional Indian theory of government,[24] but he did not really offer the complete curriculum of a *madrasa* or old Sanskrit school. He was primarily interested in art, metaphysics, and theology. Moreover, he attained a knowledge of art and sacred writings in relationship, which was undoubtedly unique: he and the other traditionalists represent much more a new center of learning than a Western offshoot of something that exists more fully in the East.

Guénon did not like to be categorized as a "traditionalist"; he found that the term had been already over-used to designate critics of modern society who "only have a sort of tendency or aspiration towards tradition without really knowing anything at all about it."[25] Coomaraswamy did not mind the term; he wrote without hesitation of the *traditionalist* point of view. To use the term is inevitable.

Traditionalist thought, as we have already observed, was not just a peaceful analysis of a complex and harmonious world description; it was a challenge to the modern world, a complete withdrawal from the secular, positivistic point of view and a defiant critique of what it left behind.

[24] AKC, *Spiritual Authority and Temporal Power in the Indian Theory of Government* (New Haven, 1942).
[25] René Guénon, *The Reign of Quantity and the Signs of the Times*, p. 252. Cf. also *Études traditionelles* (1940), p. 38.

Was this touch of violence necessary? The question arises far more in relation to Guénon than to Coomaraswamy. Coomaraswamy never ceased being a scholar, a man of books and colloquia and subscriptions. Guénon was a great theoretician of traditional thought, but also in certain books what the French would call *un violent*—formidably intolerant of a Western world that he literally left when he took up residence in Cairo. But his violence was only of words, and only to convince; nobody died on his account; many have lived more richly. His message was put in an uncompromising form that could not easily be misunderstood.

When they faced the modern world, Coomaraswamy and Guénon opposed it, but when they devoted themselves to study of traditional ideas and symbols, they were at peace: they were like desert cacti, thorny and hostile on the outside, sweet on the inside. In Coomaraswamy's notes, a fragment expresses this sweetness in few words: "the point of view from which I recommend 'searching the scriptures' is that of *Chandogya Upaniṣad* VII.26.2: 'from taking hold of the traditional-teachings there is release from all the knots (of the heart).' "[26] If they were warriors, it was not to introduce new conflicts, but to remind their readers of categories of experience that are beyond conflict.

Surprisingly, Coomaraswamy devoted no single essay to the idea of Tradition. In the spring of 1944, Langdon Warner, the historian of Japanese art, wrote to a friend that he had seen Coomaraswamy recently and that he may well have persuaded him to write "a short essay on the word and subject tradition,"[27] but such an essay never appeared.

Coomaraswamy's friend, Eric Schroeder, by no means exaggerated when he spoke of "AKC's praise of 'Tradition' as he found and beautified that component of history."[28] In Schroeder's comment there is an obvious element of skepticism: Coomaraswamy's idea of Tradition, he implies, was marvelous but not wholly true. As long a study could be devoted to breaking down the distinction between traditional and modern as to establishing it. The anthropologist Mary Douglas in a recent work has pointed out that *traditional* does not always mean *religious*; according to her, every type of society from the most secular in spirit to the most religious can be found in the tribal world.[29] Social scientists can show

[26] Unpublished note, Princeton Collection.
[27] Langdon Warner, in Theodore Bowie, ed., *Langdon Warner through His Letters* (Bloomington and London, 1966), p. 165.
[28] Eric Schroeder, letter to the author, 2 June 1970.
[29] Mary Douglas, *Natural Symbols: Explorations in Cosmology* (New York, 1970).

that modern social structures such as large business corporations have elements of traditional order, while traditional society shows elements generally associated with modernity.[30] As a corrective to Coomaraswamy's "beautification" of tradition, one need only read Daniel Lerner on *The Passing of Traditional Society: Modernizing the Middle East* (New York, 1958), an excellent study in which the author's sympathies are all with the new. Yet in spite of such correctives and qualifications, the distinction between traditional and modern that Guénon and Coomaraswamy proposed has had staying power.

The Truth of Tradition

Perennial Philosophy, or *philosophia perennis*, is the term often used by Coomaraswamy to refer to a line of thought passing through the great traditional civilizations, as well as through certain rare individuals living in Europe after the Renaissance. It is posited as the essential intellectual formulation of traditional man's view of himself and his world. Coomaraswamy's most complete discussion occurs in "The Vedānta and Western Tradition":

> The Vedānta is not a "philosophy" in the current sense of the word, but only as the word is used in the phrase *philosophia perennis*, and only if we have in mind the Hermetic "philosophy" or that "Wisdom" by whom Boethius was consoled. . . . We do not envisage, as does the *philosophia perennis*, the possibility of knowing the Truth once and for all; still less do we set before us as our goal to become this truth.

> The metaphysical "philosophy" is called "perennial" because of its eternity, universality and immutability; it is Augustine's "Wisdom uncreate, the same now as it ever was and ever will be"; the religion which, as he also says, only came to be called "Christianity" after the coming of Christ. What was revealed in the beginning contains implicitly the whole truth; and so long as the tradition is transmitted without deviation, so long in other words as the chain of teachers and disciples remains unbroken, neither inconsistency nor error is possible. On the other hand, an understanding of the doctrine must be perpetually renewed; it is not a matter of words.[31]

[30] Cf. Lloyd I. Rudolph and Susanne Hoeber Rudolph, *The Modernity of Tradition* (Chicago, 1967).
[31] AKC, "The Vedānta and Western Tradition" (1939), SP II, 6–7.

For Coomaraswamy, the study of traditional thought and art disclosed a metaphysic which is not only a series of ideas that can be memorized and repeated but an invitation to a life-long search. The fact that traditional cultures were saturated with this metaphysic created his loyalty to them. He believed that it must be distinguished from every particular religious or philosophical system in which it is expressed:

> While there can be only one metaphysics, there must be not merely a variety of religions, but a hierarchy of religions, in which the truth is more or less adequately expressed, according to the intellectual capacities of those whose religions they are. Nor do I mean to deny that there can be heterodox doctrines, properly to be condemned as heresies, but only that any and every belief is a heresy if it be regarded as the truth, and not merely as a signpost of the truth.[32]

> What are philosophy and religion? . . . For the traditional East, philosophy does not mean either a mere epistemology or the mere history of "what men have believed," but much rather an all embracing metaphysics or science of first principles and of the true nature of reality. Religion, from this point of view, differs from philosophy only in the same way that art differs from pure science: the philosophy, or rather metaphysics, representing a theory or *vision*, and the religion a *way* to the verification of the vision in actual experience.[33]

Because it permits a thoroughgoing interest in every mode of traditional thought but requires no particular adherence to any one, the idea of a perennial philosophy or metaphysic is characteristically modern. It implies a new approach to the whole question of religious belief and practice, as well as to the literature and art that express and support religions, an approach that asks the mind to attune itself to underlying principles. It does not ask the student and scholar to be "a good Hindu" or "good Catholic" except provisionally: the way to understand Hindu art and scripture is to be "a good Hindu" *in part*, principally through creative imagination, but it reserves the student's right to withdraw, to compare data from other studies, to build little by little not an independent system of thought bearing the ponderous title Perennial Philosophy, but rather an attitude of mind and a shape of heart in harmony with the religions of the past. It is a working hypothesis, supported perhaps privately by intuition, but for purposes of public discussion only by long comparative

[32] AKC, "Śrī Ramakrishna and Religious Tolerance" (1936), SP II, 38.
[33] AKC, "A Lecture on Comparative Religion."

study. It encourages specialized study of the details of distinct artistic and literary traditions while suggesting that specialized insights can be linked together in a common "universe of discourse." Coomaraswamy believed this necessary for a correct contemporary education.

According to what principles should the links be fashioned? This question interested him. He said, fundamentally, that the links are already there: "There is a science of theology, of which Jewish, Christian, Hindu and Muslim theology are only special applications. It is just as if we were to discuss mathematics with an Oriental scholar; we should not have in mind the mathematics of white or colored men as such, but only mathematics itself. In the same way, it is not about *your* God or *his* God that you must learn to talk with the Oriental theologian, but about God himself."[34]

When Coomaraswamy's blows are well placed, our typical modern contempt for religions as absurdly sectarian ways of thinking is to some extent dislodged: "To those who think that Agni, Buddha, Christ, are the names of persons of entirely different nature (for example, physical, human, and divine respectively) we may remark with Eckhart that 'He to whom God is different in one thing from another and to whom God is dearer in one thing than another' (e.g., by one name rather than another), 'that man is a barbarian, still in the wilds, a child.' "[35] The clear proposal in this passage is not to believe in any one of these persons, but to think about the significance of all such persons. Coomaraswamy wrote with particular eloquence about the meaning of *iconoclasm*, in various essays;[36] he was iconoclastic in the sense that he studied traditional "images" but affirmed again and again, following the orthodox line, that all images are only the shadow or projection of their prototypes. The prototype can be understood through the shadow, and in the achievement of this more general understanding lies something of more value for modern Western inquirers than acquiring an emotional attachment to any image. Restoring the traditional universe of thought does not require revival of worshipful belief in Christ or Agni, but rather a recognition of the *place*

[34] *Ibid.* Cf. also *The Religious Basis of the Forms of Indian Society* (1946), pp. 3–4.

[35] AKC, "Uṣṇīṣa and Chatra: Turban and Umbrella" (1938), p. 13, n. 2.

[36] Cf. AKC, "The Origin and Use of Images in India," and "Meister Eckhart's Theory of Art" in *The Transformation of Nature in Art*; also "The Nature of Buddhist Art," SP II.

of such a person in any traditional universe; it may be that at a later time the reader will become Christian or Hindu, but for the moment, as "intellectual preparation," Coomaraswamy wanted to give his reader the shock of recognizing a general structure in place of the unrelated, sectarian systems likely to be seen in the various old religions. He never fabricated anything like an abstract of all traditional expressions of a given idea, which he believed could lead only to "a mechanical and lifeless monstrosity . . . a sort of religious Esperanto." Rather, he progressed by a comparative method, collating the formulae of one tradition with another, which kept in view the likelihood that all religions have a common source. He did not particularly admire the attempt of Aldous Huxley, in *The Perennial Philosophy* (New York, 1944), to make a sort of primer of traditional religious thought. Each formulation, each symbol, each personage whether mythical or historical, is best studied first in its own context, and only thereafter compared, set into the larger traditional universe. Studies of this kind are integrated at first by nothing more than the spirit of inquiry, and later by a knowledge of general structures and "First Principles," which can properly be called the perennial philosophy.

It is a question whether perennial philosophy is, after all, the best term for what Coomaraswamy intended. It reflects the formality of tradition but seems rather "cold," unable to imply or call one's innate vitality. Guénon himself once questioned the term in the course of a résumé of an essay by Coomaraswamy; he suggested that *Sophia Perennis* made more sense than *Philosophia Perennis*. Be that as it may, Coomaraswamy put this term to work; he believed that without a grasp of the perennial philosophy, it is impossible to study most premodern cultures appreciatively:

The jargon of the Perennial Philosophy has been called the only perfectly intelligible language; but it must not be overlooked that it is as much a technical language as is the jargon of Chemistry. Whoever would understand Chemistry must learn to think in the terms of its formulae and iconography; and in the same way whoever would understand the Perennial Philosophy must learn, or rather relearn, to think in its terms, both verbal and visual. These are moreover, those of the only universal language of culture, the language that was spoken at the Round Table before the "confusion of tongues." . . . Whoever cannot use this language is excluded from the ancient and

common universe of discourse of which it is the *lingua franca*, and will have to confess that the history of literature and art, and the cultures of innumerable peoples, past and present, must remain for him closed books, however long and patiently he may read them.[37]

While the idea of a perennial philosophy is able to guide study and reflection down a most creative course, for the majority of us it can be only a preparatory or companion concept. It is not itself the Path, but rather the theory of Paths, genuinely invaluable as such. Coomaraswamy came to this conception by way of many years of Hindu and Buddhist studies, to which were joined, little by little, studies of mediaeval Christianity and Islam, Platonism, Neoplatonism, and tribal thought. His guide was always Indian thought; the others were "alternative formulations" of intense interest, not quite as important to him *personally*. In the same way, students of traditional thought or traditional art only rarely flourish without a personal commitment, either to a contemporary expression of traditional truth or to an ancient one still well taught today.[38] Finally, we should recognize that Coomaraswamy does not try to *prove* the truth of tradition. Although he does not conceal his own adherence to traditional philosophy, it is part of the etiquette of this mode of thought that no proofs by argument are offered: "We are not . . . concerned to prove any doctrine whatever dialectically, but only to exhibit its consistency, and therewith intelligibility. The consistency of the Philosophia Perennis is indeed good ground for 'faith' (i.e., confidence, as distinguished from mere belief); but as this 'Philosophy' is neither a 'system' nor a 'philosophy,' it cannot be argued for or against."[39] Laying down his arms with one hand, he picks them up with the other. Granted that the truths of traditional philosophy cannot be proven but only "exhibited," it must also be admitted, as is briefly asserted in the above passage, that they cannot be disproven by argument:

All tradition proposes means dispositive to absolute experience. Whoever does not care to employ these means is in no position to deny that the proposed procedure can lead, as asserted, to a principle that is precisely *aniruktam*, no thing and no where, at the same time that it is the source of all things everywhere. What is most repugnant

[37] AKC, "Gradation and Evolution, II" (1947), p. 93.
[38] Cf. a discussion that relates to these observations in AKC, "Paths that Lead to the Same Summit," p. 39.
[39] AKC, "*Akimcaññā*: Self-Naughting" (1940), SP II, 90n.

to the nominalist is the fact that granted a possibility of absolute experience, no rational demonstration could be offered in the classroom, no "experimental control" is possible.[40]

COOMARASWAMY's great confidence in traditional thought has now been sufficiently evoked. One final question: are these not, after all, ideas of a philosophical and theological nature, offering little to students of art? It is true that this philosophy and theology developed in Coomaraswamy as a consequence of art studies, but what links the concern for perennial truth with the problems of the analysis and many-sided appreciation of works of art? In answer, it must be said that this point of view generates a certain *kind* of art history, overlapping other kinds but possessing characteristics of its own. Meyer Schapiro once asked Coomaraswamy his opinion of Max Dvořák's book of the mid-1920s, *Kunstgeschichte als Geistesgeschichte* (*The History of Art as History of the Spirit*). Coomaraswamy replied by saying that he did not know this particular book, but in any case he preferred "Kunstgeschichte *ist* Geistesgeschichte"— art history *is* the history of the spirit.[41] Art studies were for him a means of recovering and experiencing truth; after all the work of making archaeological finds, of cataloguing, of differentiating styles and periods, of identifying iconographies and artists, there remains the most essential task:

it is not the function of a museum or of any educator to flatter and amuse the public. If the exhibition of works of art, like the reading of books, is to have a cultural value, i.e., if it is to nourish and make the best part of us grow, as plants are nourished and grow in suitable soils, it is to the understanding and not to fine feelings that an appeal must be made. In one respect the public is right; it always wants to know what a work of art is "about." . . . Let us tell them what these works of art are about and not merely tell them things about these works of art. Let us tell them the painful truth, that most of these works of art are about God, whom we never mention in polite society. Let us admit that if we are to offer an education in agreement with the innermost nature and eloquence of the exhibits themselves, that this will not be an education in sensibility, but an education in philosophy, in Plato's and Aristotle's sense of the word, for whom it means ontology and theology and the map of life, and a wisdom to be applied to everyday matters. Let us recog-

[40] AKC, "Nirukta = Hermeneia" (1936), SP II, 261n.
[41] AKC, letter to Meyer Schapiro, 30 April 1932, Princeton Collection.

nize that nothing will have been accomplished unless men's lives are affected and their values changed by what we have to show.[42]

And so, nearly everything of value lay within the world of Tradition. Illustrated by traditional works of art, structured by scripture and commentary, this world and its values can be understood by modern inquirers. He liked to warn his readers that they were setting out on a voyage from one world to another; he sincerely hoped that the wind would be favorable—in fact, the Gale of the Lord—so that they would go far.

I ought perhaps to warn you, that if you ever really enter into this other world, you may not wish to return: you may never again be contented with what you have been accustomed to think of as "progress" and "civilization."[43]

[42] AKC, "Why Exhibit Works of Art?" (1941). As published in *Christian and Oriental Philosophy of Art*, this passage appears on p. 20–21.

[43] AKC, "The Philosophy of Mediaeval and Oriental Art" (1938), SP I, 46–47.

APPENDIX

Memories of the Person

By Eric Schroeder

<div>

 I sat upon the shore
Fishing, with the arid plain behind me
Shall I at least set my lands in order?
London Bridge is falling down falling down falling down
 falling down. . . .

Datta. Dayadhvam. Damyata.
 Shantih shantih shantih
 T. S. Eliot, *The Waste Land*

</div>

I had occasionally seen the figure of Coomaraswamy in the years between 1931 and 1936 walking swiftly through one of the Museum galleries on his way to the Library, or taking his seat at some lecture hall in Boston, noticeable as he was, lofty, already rather haggard, with a head like a tomahawk. When I was told, "that's Coomaraswamy," I recalled a book of essays—*The Dance of Shiva*—which I had read and which had not struck me, the writer being very much of an advocate and the reader in this case not ready to be convinced, as being entirely honest. To a stranger's eye the first impression was of great theatrical distinction, and of an outer manner guarded and secretive. What secret was guarded there I was too callow to wonder much; and the half-formed suspicion of a possibly untrustworthy person was, I think, my only prepossession when I went to work as a volunteer in the Boston Museum.

Certain cautious gestures of hospitality when I was introduced, the finding of a place for my table, the offering of cigarettes, and the willingness of a man who was obviously and really busy to talk and help, began to dissipate this predilection simply by making me at home with him. Most of my first day was spent down in a cellar storage among dusty unexhibited objects; but when I emerged at the end of the darkened winter afternoon to speak to Mr. Tomita, the Curator of the Asiatic Department, Coomaraswamy walked into Mr. Tomita's office and sat down to

listen. Some of the antiquities had interested me; and I was expatiating upon them with enthusiasm. Mr. Tomita, who disapproved of Dr. Coomaraswamy's negligence in his purely curatorial functions, observed pointedly that it would be a very good thing if someone would put that storage in proper order, for it had long been a disgrace. There was a short silence. Then Dr. Coomaraswamy's rather mumbling tones emerged from the shadow beyond the lamplight.

"Perhaps one of these days I ought to take a run down and have a look at the old place," he said, like a London stockbroker remembering after the lapse of many years the ivy-mantled home of his ancestors.

What irony! It was not only the sublime detachment from what other people expected of him which delighted me, but rather the incongruity of this efflorescence, this perfectly aimed quotation from Edwardian conventionality, from the surface of a personality so unconventional and so unsentimental. Laughing, I looked toward the speaker. The lenses of his large spectacles gleamed, and his cigarette-end glowed; I could more dimly see, through the thin beard, lines of laughter drawn about his painfully fastidious mouth. He was sitting back, his legs crossed with the elegance only possible to the very thin; and his head was tilted in the cock of a connoisseur as he enjoyed the effect of his humor. In that moment I knew that whatever I thought about him I should like him.

Thus began a ten years' friendship which was both an intimacy and a running fight, in which he was finally the victor. Our days at the Museum were strenuously spent, for he was pouring out articles in the full spate of his matured metaphysical understanding. He read on at night, and worked in the early morning, so that his Museum hours were only a part of his day. Behind a long table drifted deep with journals, books, and papers his labor proceeded. From the window at his back a light which was generally cold fell upon the figure which became infinitely familiar: the long iron-gray hair, the characteristic brooding pose, and the movements of his very beautiful fingers as he pushed or turned his books. When he wanted a reference, he would rise, and stand for a moment with sunken head, then comb back his gray locks with his hands and go prowling off along the bookshelves with a loose hound-like walk peculiarly his own. The most vivid impression of his physique can be had of an anecdote: he was once walking, he told me, along Commonwealth Avenue with his dog, of some slender long-haired breed, an Afghan, I think, or a Saluki, when he heard the voice of one of the many

to whom unconventionality is offensive, demanding sarcastically at his back: "Which is which?"

Another vivid image is of an intolerably hot muggy afternoon in summer. We were trying to work, but our brains were steamed. Suddenly he stood up and muttered: "This is no good"; then, slinking into the Asiatic Department safe, he lay down, drew up his knees, and fell asleep. I looked in on him after a while; lying gaunt on his inhospitable couch, with the dusty gilt paraphernalia of Asiatic religions calm above him, he presented in a pathos not easy to define the physical appearance of an anchorite at rest. But this was exceptional. His only normal breaks from work were conversations with his visitors, or the sharing of some good incident. I would hear his voice interrupt me with "Listen to this . . ."; and he would regale me with some precise correspondence of formulation, or some incandescent sentence—"O Eloquence the more mighty that it is unadorned! O Axe cleaving the Rock!" Such things continued to shape his mind, I think, or to temper it. I remember well the piety with which he communicated Bede's great saying about Heaven: "Nullum ibi honoris desiderium pulsat"; and the fastening of it in him was a stage, I suppose, in his mental pilgrimage.

In those days we were constantly engaged in argument; for I was trying to revive the art historian who had become extinct in the philosopher, and he was determined to evoke the philosopher in an immature art historian. Time was on his side, perhaps; it was certainly not on mine. Though he was perfectly generous and communicative on historical questions, he was not interested in them any more. He felt interest in present history, the industrialist rape of Asia and the prostitution of Western intellect to the contingent, but his *delight* was in metaphysics. All the waves of historical argument beat upon him in vain; persistently, persistently he diverted history into the eternal categories which alone he was willing to admit. Why he was not exasperating is a nice question, but he was not; and I began to regard as things personally valuable the high sloped forehead, the hawk-like and magisterial nose, the eye, often veiled and cold, which suddenly became affectionate as he invited one to a joke, or gleamed with command as he stated meaning.

His concern with Museum objects and their history, with dating and attribution, was now slight, though his memory retained astonishingly much of his old great learning in this respect. Taste and expository ingenuity in the galleries he called "window-dressing" and left to others

who cared more than he. These others were, very properly in a Museum, a majority; and they tolerated Ananda's philosophic dogmatism unconvinced. One day at lunch we were going at it hammer and tongs, Ananda maintaining the essentially metaphysical character of artistic production and I asserting the frequent and significant predominance of moral and natural motive, he citing texts and I adducing works and circumstances, he pointing out the continuity in all traditional cultures of metaphysical reference in symbols, I challenging him to explain on any such grounds so characteristic a form as for instance the panegyric in Mediaeval Persia. Our table-companions at last found a spokesman in the Director of the Museum. "I don't want to hurry you," he said politely, "but when you two have *quite* finished splitting that *particular* hair, will you take time out to pass me the salt?"

As I came to know him more intimately, at home as well as at work, his individuality gave me increasing pleasure. He had a specially *English* coziness, which was rather surprising in so relentless a critic of English national motives, but which was quite unmistakable, a certain appropriateness to old tweeds, a handsome relaxation and tact in the enjoyment of a fireside armchair, a slight but aristocratic taste in personalities, and an English literary wit. He rested in the pleasantness of good things, liked good and disliked bad food, discussed quite earnestly the problem of getting good clothes in America, and gave me the name of an excellent hatter. The difference between a "gentleman" and another was surprisingly real to him. And indeed I began to notice inconsistencies in him as a character which for a while interrupted the growth of trust, though it never affected liking. It was odd, I thought, that one who extolled as normal the anonymity of the right craftsman should be concerned with his own reputation. Yet he still took unashamed pleasure in what he called his fan mail; and he had done, I found, working over Museum material, even stranger things in the past, defending, for instance, his early dating of the great Ragmala paintings against Goetz's criticism by arguments which when examined appeared, to say the least, disingenuous. His marital career was inappropriate to a man who wrote of marriage as a sacrament, and some of his financial dealings seemed no less incongruous with the views of right livelihood which he expounded. And yet he had spent practically all his substance for what I could see to be a consecrated end, the publication of his work. And he had had, by worldly standards, great possessions. I was puzzled.

One day we had gone out to lunch at a restaurant near the Museum.

Ananda produced a letter from his pocketbook. "I would like you to read this," he said; "in a way it's a very personal letter; but I'd like you to read it." And he passed over a sheet covered with the strong and delicate handwriting of Eric Gill. I read the message, an expression of the English craftsman's love and gratitude, a testimony of kindred. Whether it was intended as an indirect rebuke to me I hardly know; but I felt the embarrassment of rebuke. My betters thought better of my friend than I did. It began to appear that I had been wrong in paying attention to my instructor's inconsistencies when I should have been attending to his consistency. For the consistency mattered, and to me; the inconsistencies were his own concern, and it was not certain that they really mattered.

Not long after this he said "If I had known always what I know now, I think I would have tried to make my practice more like what I have preached." This really should have clarified everything, although I did not immediately understand at the time how very much he meant by what he said. His belief in salvation by knowledge was entire. In much the same way as by bodily habit he disposed his standing weight utterly on one leg and stood in *contrapposto*, or as a monopode, propped on his lecture-desk or against a wall with one leg hooked up, or as, when his shoelace came loose, he dropped swiftly on to one knee, feeling apparently more at home concentrated upon half his natural support, he lived habitually in his intellect in a much greater degree of concentration than other men. As that was perfected, other things fell away. This made the personality exciting and memorable, and *edifying* in a sense in which the character, the whole psychic complex, was not. In the environment of Boston, where the character is regarded as the man and the personality as a mask, it was impossible that he should be esteemed. He was too famous and too odd to be ignored; but a superstitious or vulgar respect for him as a "distinguished" figure was the usual way of regarding him. It was generally realized that he had something important to say, and that it would be wise to give him a hearing; but very few thought it was wise to take him seriously.

Yet he was an exemplar, or in the radical sense a martyr. By the time that I came to know him the deliberate was predominant in him, and the personality was actually inspiring as being consciously directed by the intellectual will. Passionate desire for a better social order had almost yielded to a contemplative recognition of the working of cause and effect, and to a purer benevolence. The aesthetic and erotic to which he was once addicted had been discarded. The Charioteer now held the reins,

and all the perceptions of a fierce and learned mind were turned, easily now, to the service of conviction. What relation his earlier writings bore to earlier circumstance I do not know. But in the last ten years of his life he saw with surpassing clearness how much thought has been muddied by the pervading materialism of our time, and foresaw the chaos into which "progress" is plunging. And something masterful, for in him then one should not call it ambitious, dedicated his life to an attempt to dominate this materialism by exposing it as what it was, and by stating opposite truth. The purpose was noble. The will that served it was noble, and the intellect which fulfilled the will was noble.

In earlier essays his genius for emphasis had tempted him into assertions not always just in my opinion; and his attack on ephemeral particulars, though serious and generally very effective, partook of the limitations of its opposite. But in later years his adversary was world-wide and perennial—Man's ignorance of What he is. His weapons were the Scriptures, the words of the holiest thinkers; and in these years it may be said that his work sanctified him. Our last conversations made me aware of a partial approach to sanctity in Ananda. He still dramatized his conviction: he was still, I think, conscious of me as audience when once, leaning back and looking askance at the granite facade of the Museum visible, with heavy clouds rolling above it, through his window, he said "You know, all this is to me as if it wasn't there." But I had now the feeling that although conscious of his interlocutor he was perfectly serious, and that his attention to myself was a cool but perfectly serious concern not for my agreement but for my well-being. When, in our early acquaintance, he asked me what of his work I had read, and I mentioned *The Dance of Shiva*, he said "I have come a long way since that, you know." He had.

At the end of one summer my wife and I went up to stay with the Sage, as we called him, in his forest house near the Canadian border of Maine. Evening was just darkening into night when we left our car at the foot of the steep ascent and walked up a rough road through trees to the knoll on which it stood, humped and black, with faint yellow light in the windows. Our knocking roused footsteps, and Ananda opened the door, a wilder silhouette than we expected, very rough in the jacket, very baggy in the knickerbockers, his long shanks ending in boots like boats. Behind him in the room half-lit appeared the timbers of an open roof, with an old pair of trousers hung up in the gloom like a regimental banner in the nave of a church. A table near the door with tools and fishing tackle; a battered axe by the fireplace; and in the far corner the curtains of a great bed partly drawn.

Our arrival had something of a new meeting; again I felt a flattering *cortesia* in the deliberateness of his cautious hospitality. His handshake was always accompanied by a curious raising and shrinking of the shoulders, as if he expected one's grip to be too firm; but the ordeal over was generally followed by some gesture of complete relaxation. My prowling round the room had revealed much in the way of implements for dealing with rocks and wood, with flowers and fishes, little in the way of art beyond a gramophone, and an admonitory poverty of books. The last he proceeded, when questioned, mumblingly to explain, with some little apparent distaste; and then he led the way to the kitchen, where he set about making supper.

This kitchen was the scene of high old times. Ananda used to throw fuel into the stove in the attitude of one who, only too conscious that he was playing with fire, expected it to spit back at him; but he was expert in what cookery we did. The staple of our diet was pancakes—"Aunt Jemima." This was mainly because we liked Aunt Jemima, but partly also because the only bread in the house was very good bread, too good to be thrown away, but very tough bread, too tough to be conveniently cut—a huge old loaf with a crust as obdurate as tortoise shell. On occasion, when somebody felt the absolute necessity of bread, Ananda would approach this loaf, where it lay upon the counter, with a large hunting-knife, and rising on to the toes of his boots would rock forward with all his weight upon the enemy. The blade entered the crust with an agonizing squeak, but a few minutes' hard work produced the fragment called for, which he bore solemnly back to the table.

There was in the cupboard the remains of a bottle of Apricot Brandy, laid in some time before, and probably for medicinal use: our host did not care for alcohol, which gave him a headache. But on the last night of our visit we were clearing things up, since Ananda was going to drive back to Boston with us. It was felt that the hilarious festivities of the kitchen should have a climax, and the bottle be finished. After supper, accordingly, it was uncorked and poured; we raised our glasses and drank. I could hardly believe my palate. All alcohol had long been evaporated, and what remained was a simple syrup, precisely the juice of canned apricots. I looked at the others. My wife evidently tasted what was wrong —she looked amused and disappointed. But not so the Sage: catching but misinterpreting my astonished gaze, he raised his eyebrows in grave appreciation and murmured in a voice of awe, "Very smooth!"

Innocent indeed he was in many matters. He was not what is called a man of the world, and would have made a poor rogue. He was pure in

many loves. The visionary sunlight of William Morris's romances delighted him; and his affection for plants was apparently a simple appreciation of loveliness or character, without a tinge of sentimentality or egoism. He had made a large rock-garden in Maine with his own hands, and had a quite elaborate garden at his Needham house in which he toiled with his wife. These places were not settings for himself (though all who saw him there would remember him there), but simply homes for his plants. He did not pose in them, but worked doggedly, or if he had visitors led them swiftly about, standing to point out inconspicuous beauties, or dropping on one knee to pull a new-grown weed or make some rough place smooth with his likable fingers.

The arrangements in Maine were comfortable but very simple. There was, for instance, no bath. "When it becomes unbearable," he explained, "we go down to the lake." Profoundly unlike his American neighbors, who devote immense moral energy to being practical, he was yet startlingly practical in his own way. At lectures, for instance, he would sometimes with the same simplicity compose himself for sleep, confident that if the lecture were to prove worth listening to it would keep him awake. He had, of course, a sufficient sense of decorum, and would tell me to wake him up if he should begin to snore.

Of all personal images perhaps the most significant is the figure of the fisherman. He was expert in this rather un-Buddhist pastime. "If you want to learn to fish," his Maine neighbors agreed, "you couldn't have a better teacher; he's the top." He used the best English tackle, from Hardy's, and possessed a great variety of flies, though he regarded the gaudier confections with some contempt. The wily and patient process of his fishing really began in the neighbourhood of the proposed pond, with a questioning of the innkeeper or some other fisherman upon recent "takes," conducted in a tone of hypocritical indifference. And then he would sit hour after hour in his boat, or stand upon the shore, quiet as the incarnate destiny of all fishes; hour after hour his line would whistle forth and drop on the water, as he waited, the breeze stirring the long hair beneath a weatherbeaten hat speckled with spare flies, his fell profile enjoining silence as he lifted his face in a fresh cast, or watched through lowered lids the drag of the fly.

On the last afternoon of the fishing season we went down to fish in the river. It was too bright for much luck; but with his usual patience Ananda cast on and on, the late sun gilding his thin brown cheek as it gilded the faded woods behind him. At last he got a bite, and landed his

fish—it was a young and foolish trout too small to keep. The fisherman wet his hand, took him off the hook, and looked at him, with a face in which the formidable expression of his fishing had altered to gentleness. For a moment or two he seemed to enjoy the little creature's all-seeing stare and golden side, then tossed him back to his element, and watched the bright ripples of his track as he made for deep water. "Well," he said, "that's the end of the year."

The figure of the fisherman is lasting in my mind because he was a fisher of men. However uncompromising his rhetoric, he wanted to persuade. What response meant to him appeared from his pleasure in the Festschrift which was being prepared for his birthday; and he was profoundly moved to catch an echo in a notable mind, like Gill's or Guénon's. Even in small matters he used a fisherman's patient reiterative insistence. Once he and Mrs. Coomaraswamy took my wife to a flower-show. He was at this time greatly interested in cacti; cacti live in waste lands where other plants cannot, and exemplify organic life where the inorganic seems to prevail. He had a winter garden in his conservatory of those armored plants which put forth the most surprising of all flowers. My wife told me how he kept leading her back as if by accident to the stall where cacti were sold until at last she succumbed and bought one. She knew what he was at, but only resisted up to a certain point. On me he plied the same cunning of reiterated temptation, persistently diverting my interest in the beauty or history of human works to what was scriptural in them. After I had left the Boston Museum, and saw him less often, he kept a pull on me by periodic postcards in his neat back-sloping hand, calling my attention to some book or article.

Probably his own intellectual achievement had taken its original spring from *emotion*: a *feeling* for the disorder of our times, our art and politics, was, I guess, the birth of his life purpose, and his technique of emphasis was still at its most effective long afterwards in a piece like "Am I My Brother's Keeper?," written, as he told me, "at white heat." But though he passed from one emphasis to another, even to infidelities he was indifferent; for *he was moving on*. His being was directed not to a blending of the elements of personality, but Platonically and hierarchically to the domination of one right-chosen element, intellect. However he fell short in external action, his life, seen from this point of view, was a triumph.

In our personal relationship the fisherman was quietly determined that I should move away from emotion in the same direction, and he was artful in preventing other motions. Once, when I was pleased with

a couple of articles I had written for a journal emphasizing with material from Persian sources the consciously aesthetic approach of Persian artists to their problem, he said "I saw your articles in *Parnassus*—they were very *smart*; I should call them *smart*," using an adjective well calculated to rouse my own disgust for something which he knew I probably fancied as sound and well-written. On another occasion he could coax no less obliquely. He saw at my house a painting I had just finished, the symbolism of which was more in line with the traditional symbolism he cared for than that of any previous work of mine. When I saw him a week or two later in the Museum, he reverted to the picture: "I keep thinking of that painting of yours—the horse's skull: it was very well painted. I'd hardly expected you to paint so well." I have a strong suspicion that he was flattering my technical prowess with the indirect object of having me continue to paint symbols which he recognized as serious.

Our long tug-of-war ended in my being pulled across the mark. The unruly fish came in. He won. The heron figure will always stand there, the wizard and awakener, the teacher of my adult life. He himself disclaimed any role beyond that of Transmitter, and rightly: though I loved the person, gratitude for what he taught is in a way even more personal than affection. He more than any other taught me to read the eternal content in human works: he taught me to read Scripture, and his gift seems to me the greatest gift one person can give another in our days.

Now that he has lived his life, and his gifts have become bequests, the metaphysic which he drew from the deepest human wells and poured abroad, meaning after meaning, will, I expect, water what is to come. As the disasters which he anticipated overtake the generation he addressed, it is at any rate sure that an antithetical wisdom like his own will here and there be purified to the semblance of what he was accustomed to summon from times and regions remote, the human witness of Asia and of the age of Western piety. That he should become his printed words will certainly accord with his living desire. But we do not wrong him in recalling the loved personality now extinct, in which the Artificer assembled materials both precious and ironical, but from which a rising will of great purity constructed at the last a material Image to all who saw it unmistakable, the Image of a master theologian, the bodily shape of the Comprehensor, in which intellectual positiveness had become visibly one with knowledge, leaving as if printed by the foot of God Absconded the absolute authority of his face in death.

Select Bibliography of the Writings of
Ananda K. Coomaraswamy

In the following bibliography, there are only two standard abbreviations:

SP I, SP II: *Coomaraswamy*, edited by Roger Lipsey, Princeton University Press, Bollingen Series, 1977. Vol. I, *Selected Papers: Traditional Art and Symbolism*. Vol. II, *Selected Papers: Metaphysics*
MFA Bulletin: *Bulletin of the Museum of Fine Arts, Boston*

In the notes to this book, there are frequent references to the Princeton Collection (= the Ananda K. Coomaraswamy Papers in the Princeton University Library). This is an extensive collection of the scholar's research notes, drafts, and correspondence that accompanied the bequest of his Oriental library, now owned by the Princeton University Library. A full account of this collection will be found in my article, "The Coomaraswamy Bequest at Princeton University," in *Ananda Coomaraswamy: Remembering and Remembering Again and Again*, ed. S. Durai Raja Singam (Kuala Lumpur, 1974), pp. 64–65.
The other large collection of correspondence, photographs, and memorabilia upon which I have drawn, the family collection, is owned by AKC's son, Dr. Rama P. Coomaraswamy.

1904

"Report on Thorianite and Thorite." Colombo (published with *Report on the Occurrence of Thorium-Bearing Minerals in Ceylon*, ed. Wyndham R. Dunstan).

1905

Borrowed Plumes. Kandy, Ceylon.
"Open Letter to the Kandyan Chiefs," in *Ceylon Observer*, 17 February 1905, pp. 5–6.
"Unfamiliar Kandyan Literature," in *The Kandyan*. Ceylon.

1906

"Anglicisation of the East." *Ceylon National Review* (Colombo), I, 181–195.

Handbook to the Exhibition of Arts and Crafts in connection with the Ceylon Rubber Exhibition. Colombo.

"Kandyan Art: What It Meant and How It Ended." *Ceylon National Review*, I, 1–12.

1907

The Deeper Meaning of the Struggle. Broad Campden: Essex House Press.

1908

"The Aim of Indian Art." *Modern Review*, January, pp. 15–21.

The Influence of Greek on Indian Art. Delivered at the Fifteenth International Oriental Congress, Copenhagen (1908). Broad Campden: Essex House Press.

Mediaeval Sinhalese Art. Broad Campden: Essex House Press.

The Message of the East. Madras: Ganesh Press.

"The Relation of Art and Religion in India." In *Transactions of the Third International Congress for the History of Religions*, II. Oxford, 70–74.

"The Village Community and Modern Progress." *Ceylon National Review*, II, 249–260.

1909

Essays in National Idealism. Colombo: Colombo Apothecaries Co. Ltd.

The Indian Craftsman. Foreword by C. R. Ashbee. London: Probsthain.

1910

Domestic Handicraft and Culture: A Lecture Read before the Association of Teachers of Domestic Science, 28 May 1910. Broad Campden: Essex House Press.

"Indian Bronzes." *Burlington Magazine*, XVII, 86–94.

Indian Drawings. Printed for the India Society at Essex House Press, London.

1911

Art and Swadeshi. Madras: Ganesh Press.

"Education in Ceylon." In *Art and Swadeshi.* Madras.

"The Modern School of Indian Painting." *Catalogue to the Festival of Empire and Imperial Exhibition, Indian Section,* London.

1912

Burning and Melting: Being the Sūz-u-Gudāz of Muhammad Rizā Nau'ī of Khabūshan. Translated (with Mirza Y. Dawud). London.

Indian Drawings: 2nd Series, Chiefly Rajput. Printed for the India Society, London.

"Rajput Cartoons: A Criticism after Nietzsche." *Rajput Herald* (London), June, pp. 21–25.

"Rajput Painting." *Ostasiatische Zeitschrift*, I, 125–139.

1913

The Arts and Crafts of India and Ceylon. Edinburgh: Foulis. Reprint: New York, 1964.

(With Sister Nivedita.) *Myths of the Hindus and Buddhists.* London: Harrap, 1913, and New York: Holt, 1914. Reprint: New York, 1967.

"Sati: A Vindication of the Hindu Woman." Read before the Sociological Society, London, November 1912. *Sociological Review*, VI:2, 117–135.

1914

"Bronzes from Ceylon, Chiefly in the Colombo Museum." *Memoirs of the Colombo Museum*, ser. A., no. 1. Ceylon: Colombo Museum.

"Indian Aid." *New Age*, 15 October 1914, p. 580.

"Notes on Jaina Art." *Journal of Indian Art*, XVI, 81–97.

"The Religious Foundation of Life and Art." In *Essays in Post-Industrialism: A Symposium of Prophecy*, edited by A. K. Coomaraswamy and A. J. Penty, London: Foulis.

"The Royal Palaces of Rajputana." *Rajput Herald* (date uncertain), pp. 230–240.

Viśvakarma: Examples of Indian Architecture, Sculpture, Painting, Handicraft, First Series: One Hundred Examples of Indian Sculpture. Introduction by Eric Gill. London: Luzac, 1912–1914.

"A World Policy for India." *New Age*, 24 December 1914, pp. 192–193.

1915

"The Hindu View of Art." *The Quest* (London), VI:3, 480–498.

"Love and Art." *Modern Review*, May, pp. 574–584.

1916

Buddha and the Gospel of Buddhism. London: Harrap. Reprint: New York, 1964.

"The Cave Paintings of Ajanta." *Vanity Fair* (New York), September, p. 67.

Rajput Painting: Being an Account of the Hindu Paintings of Rajasthan and the Panjab Himalayas from the Sixteenth to the Nineteenth Century Described in Their Relation to Contemporary Thought. London and New York. Reprint: New York, 1975.

1917

The Mirror of Gesture: Being the Abhinaya Darpana of Nandikeśvara. Translated from the Sanskrit of Nandikeśvara by A. K. Coomaraswamy with Gopala Kristnayya Duggirala. Cambridge, Mass. 2nd ed. with new introduction: New York, 1936.

"Oriental Dances in America." *Vanity Fair*, VIII, 61.

1918

The Dance of Śiva: Fourteen Indian Essays. New York. Reprint: Introduction by Romain Rolland, New York and London, 1924; New York, 1957.

"Rajput Painting." *MFA Bulletin*, XVI, 49–62.

1919

"Rajput Painting." *MFA Bulletin*, XVII, 33–43. (Continuation of "Rajput Painting," 1918.)

1920

Twenty-Eight Drawings. New York.

1921

"Notice sur l'entité et les noms de Çiva." In *Sculptures çivaïtes* (with A. Rodin, E. B. Havell and V. Goloubew). *Ars Asiatica*, No. 3. Paris.

1922

"Śaiva Sculptures. Recent Acquisitions: Umā-Maheśvara Groups and South Indian Bronzes." *MFA Bulletin*, XX, 15–24.

1923

"The Appreciation of Art" (with Stella Bloch). *Art Bulletin*, VI, 61–64.

Catalogue of Indian Art. Pt. 1: *General Introduction.* Boston: Boston Museum of Fine Arts.

Catalogue of Indian Art. Pt. 2: *Sculpture.* Boston: Boston Museum of
Fine Arts.

"Indian Art in Boston." *The Arts,* III:2, 36–46.

"Photographs in the Print Department." *MFA Bulletin,* XXI, 79.

*Portfolio of Indian Art: Objects Selected from the Collections of the Mu-
seum.* Boston: Boston Museum of Fine Arts.

1924

Catalogue of the Indian Collections in the Museum of Fine Arts, Boston.
Pt. 4: *Jaina Paintings and Manuscripts.* Boston: Boston Museum
of Fine Arts.

"A Gift from Mr. Alfred Stieglitz." *MFA Bulletin,* XXII, 14.

1925

Bibliographies of Indian Art. Boston: Boston Museum of Fine Arts.

1927

Catalogue of the Indian Collections in the Museum of Fine Arts, Boston.
Pt. 5: *Rajput Painting.* Boston.

History of Indian and Indonesian Art. Leipzig, London, and New York.
Reprinted New York, 1965.

"The Origin of the Buddha Image." *Art Bulletin,* IX, 287–317.

1928

"Indian Architectural Terms." *Journal of the American Oriental Society,*
XLVIII, 250–275.

Yakṣas [I]. Washington, D.C.: Smithsonian Miscellaneous Collections,
LXXX:6.

1929

*Les Miniatures orientales de la collection Goloubew au Museum of Fine
Arts de Boston.* Foreword by Victor Goloubew. *Ars Asiatica,* No. 13.
Paris.

"The Origin and Use of Images in India." *International Studio,* XCIII:
384, 21–26, 94. Also in *The Transformation of Nature in Art.* Cam-
bridge, Mass.

"The Relation of Art to Life in India." *Forward* (New York), 27 January.

1930

Catalogue of the Indian Collections in the Museum of Fine Arts, Boston. Pt. 6: *Mughal Painting.* Boston.

1931

Yakṣas, II. Washington, D.C.: Smithsonian Institution Publication 3059. (Includes addenda to *Yakṣas, I,* 1928.)

1932

"Introduction to the Art of Eastern Asia." *The Open Court,* XLVI, 185–215. SP I.

"Mahā-Pralaya and Last Judgment." *Cultural World* (Los Angeles), III:4, 14–16.

1933

A New Approach to the Vedas: An Essay in Translation and Exegesis. London.

"On Translation: Māyā, Deva, Tapas." *Isis,* XIX:55, 74–91.

"Versions from the Vedas." *Indian Art and Letters,* VII:1, 19–26.

Review of C. K. Ogden and I. A. Richards, *The Meaning of Meaning,* and I. A. Richards, *Mencius on the Mind. Journal of the American Oriental Society,* LIII, 298–303.

1934

"*Kha* and Other Words Denoting 'Zero,' in Connection with the Metaphysics of Space." *Bulletin of the School of Oriental Studies* (London), VII, 487–497. SP II.

"Meister Eckhart's Theory of Art." In *The Transformation of Nature in Art.* Cambridge, Mass.

"The Technique and Theory of Indian Painting." *Technical Studies,* III, 59–89.

"Understanding the Art of India." *Parnassus,* VI:4, 21–26, 30.

1935

"Angel and Titan: An Essay in Vedic Ontology." *Journal of the American Oriental Society,* LV, 373–419.

"An Approach to Indian Art." *Parnassus,* VII:7, 17–20.

"The 'Conqueror's Life' in Jaina Painting." *Journal of the Indian Society of Oriental Art,* III, 127–144.

The Darker Side of Dawn. Washington, D.C.: Smithsonian Miscellaneous Collections, XCIV:1.

Elements of Buddhist Iconography. Foreword by Walter E. Clark. Cambridge, Mass.

"The Intellectual Operation in Indian Art." *Journal of the Indian Society of Oriental Art*, III, 1–12. SP I.

"Mediaeval Aesthetic: I. Dionysius the Pseudo-Areopagite and Ulrich Engelberti of Strassburg." *Art Bulletin*, XVII, 31–47. Cf. SP I, "The Mediaeval Theory of Beauty."

"Sacred and Profane Science." Translated from the French of René Guénon. *Viśva-Bharati Quarterly* (Calcutta), I, 11–24.

La Sculpture de Bodhgayā. Ars Asiatica, No. 18. Paris.

"Two Vedantic Hymns from the *Siddhāntamuktāvalī*." *Bulletin of the School of Oriental Studies* (London), VIII, 91–99.

"Walter Andrae's *Die ionische Säule: Bauform oder Symbol?* A Review." *Art Bulletin*, XVII, 103–107. SP I.

1936

"The Appreciation of the Unfamiliar Arts." Radio Broadcast of the Museum of Fine Arts, Boston, Second Series, January 9, 1936. *Viśva-Bharati Quarterly*, II, 17–21.

"L'Idée de 'création éternelle' dans le Rig-Veda." *Études traditionelles*, XLI, 13–17.

"The Love of Art." *Parnassus*, VIII:4, 22–23.

"Nirukta = Hermeneia." *Viśva-Bharati Quarterly*, II, 11–17. SP II.

"The Normal View of Art." Lecture delivered at Wheaton College. In *Patron and the Artist, Pre-Renaissance and Modern* (with A. G. Carey). Norton, Mass., pp. 7–38.

"On the Pertinence of Philosophy." In *Contemporary Indian Philosophy*, edited by S. Radhakrishnan. London, pp. 113–134.

"Śrī Ramakrishna and Religious Tolerance." *Prabuddha Bharata* (Mayavati, India), XLI, 268–274. SP II.

"Vedic Exemplarism." *Harvard Journal of Asiatic Studies*, I, 44–64; addenda and corrigenda, p. 281. SP II.

"Vedic 'Monotheism.'" *Journal of Indian History*, XV, 84–92. (Revision of "Vedic Monotheism." *Dr. S. Krishnaswami Aiyangar Commemoration Volume*. Madras, 1936, pp. 18–25.) SP II.

1937

"Beauté, lumière et son." *Études traditionelles*, XLII, 51–60.

"Is Art a Superstition or a Way of Life?" in *Why Exhibit Works of Art?* London, 1943.

"The Part of Art in Indian Life." in *Cultural Heritage of India*. Calcutta. Vol. III, 485–513. SP I.

"The Pilgrim's Way." *Journal of the Bihar and Orissa Research Society*, XXIII, 452–471.

"The Rape of a Nāgī: An Indian Gupta Seal" (pts. 1 and 2). *MFA Bulletin*, XXXV, 38–41 (pt. 1); 56–57 (pt. 2). SP I.

"The Vedic Doctrine of 'Silence.' " *Indian Culture*, III, 559–569. SP II.

"What Is the Use of Art, Anyway?" in *The Majority Report on Art*, John Stevens Pamphlet, no. 2 (with A. Graham Cary and John Howard Benson).

Review of P. Mus, *Barabuḍur*. *Journal of the American Oriental Society*, LVII, 336–343.

Review of Theodor Haecker, *Schönheit: Ein Versuch*. *Criterion*, XVI, 739–741.

1938

Asiatic Art. Chicago.

"The Inverted Tree." *Quarterly Journal of the Mythic Society*, XXIX, 111–149. SP I.

"Mediaeval Aesthetic: II. St. Thomas Aquinas on Dionysius, and a Note on the Relation of Beauty to Truth." *Art Bulletin*, XX, 66–77. Cf. SP I, "The Mediaeval Theory of Beauty."

"The Nature of Buddhist Art." Introduction to *The Wall-Paintings of India, Central Asia, and Ceylon*, by Benjamin Rowland, Jr. Boston, pp. 3–38. SP I.

"Note on a Review by Richard Florsheim of 'Is Art a Superstition or a Way of Life?' " *Art Bulletin*, XX, 443.

"The Philosophy of Mediaeval and Oriental Art." *Zalmoxis* (Paris), I, 20–49. SP I.

"Uṣṇīṣa and Chatra: Turban and Umbrella." *Poona Orientalist*, III, 1–19.

1939

The Christian and Oriental, or True, Philosophy of Art. John Stevens Pamphlet (Newport, R.I.). Reprinted in *Why Exhibit Works of Art?*, London, 1943.

"De la 'mentalité primitive.'" *Études traditionelles*, XLIV, 277-300. (Translation of "Primitive Mentality" in *Quarterly Journal of the Mythic Society*, XX [1940], 69-91). SP I.

"Mahātmā." *Calcutta Review*, LXXI, 1-4. French translation in *Études traditionelles*, XLIV (1939), 82-86. Also in *Mahātmā Gandhi—Essays and Reflections on His Life and Work*, edited by S. Radhakrishnan, London, 1939.

"Ornament." *Art Bulletin*, XXI, 375-382. SP I.

"Some Pāli Words." *Harvard Journal of Asiatic Studies*, IV, 116-190. SP II.

Review of, E. D. Andrews and F. Andrews, *Shaker Furniture*. *Art Bulletin*, XXI, 200-206. SP I.

"*Svayamātṛṇṇā*: Janua Coeli." *Zalmoxis*, II, 3-51. SP I.

"The Vedānta and Western Tradition." *American Scholar*, VIII, 223-247. SP II.

1940

"*Ākiṃcaññā*: Self-Naughting." *New Indian Antiquary*, III, 1-16. SP II.

"*Manas*." In *A. C. Woolner Commemoration Volume*, Lahore, pp. 53-60. SP II.

"The Nature of Mediaeval Art." In *Arts of the Middle Ages*. Boston: Boston Museum of Fine Arts.

1941

"Why Exhibit Works of Art?" *Journal of Aesthetics and Art Criticism*, I, 27-41 (title essay of *Why Exhibit Works of Art?* London, 1943). Reprinted as *Christian and Oriental Philosophy of Art*, New York, 1956.

1942

"*Ātmayajña*: Self-Sacrifice." *Harvard Journal of Asiatic Studies*, VI, 358-398. SP II.

"On Being in One's Right Mind." *Review of Religion*, VII, 32-40.

Spiritual Authority and Temporal Power in the Indian Theory of Government. New Haven.

1943

"Ars sine scientia nihil." *Catholic Art Quarterly*, VI, 12-14. SP I.

"Eastern Wisdom and Western Knowledge." *Isis*, XXXIV:3, 359-363.

Henry R. Zimmer (obituary). *Review of Religion*, VIII, 16–18.

Hinduism and Buddhism. New York.

"The Meeting of Eyes." *Art Quarterly*, VI, 322–324. SP I.

"*Prāṇa-citi.*" *Journal of the Royal Asiatic Society*, pp. 105–109.

Review of J. Layard, *The Lady of the Hare: A Study in the Healing Power of Dreams. Psychiatry.* VIII, 507–513. Also published as "On Hares and Dreams," *Quarterly Journal of the Mythic Society,* XXXVII, 1 (1947).

"*Saṃvega*: Aesthetic Shock." *Harvard Journal of Asiatic Studies*, VII, 174–179. SP I.

"The Symbolism of Archery." *Ars Islamica*, X, 104–119.

"Symptom, Diagnosis, and Regimen." *College Art Journal*, II:4, 121–124. SP I.

Why Exhibit Works of Art? London: Luzac. Reprinted, New York: Dover, 1956, under the title *Christian and Oriental Philosophy of Art.*

1944

"Chinese Painting at Boston." *Magazine of Art*, XXXVII, 94–99. SP I.

"The Iconography of Dürer's 'Knots' and Leonardo's 'Concatenation.'" *Art Quarterly*, VII, 109–128.

"A Lecture on Comparative Religion." Unpublished as such, typescript in the Princeton Collection; cf. "Paths That Lead to the Same Summit" (1947), which contains much of the lecture.

Recollection, Indian and Platonic; and On the One and Only Transmigrant. Journal of the American Oriental Society, LXIV, Supplement no. 3. SP II.

"Sir Gawain and the Green Knight: Indra and Namuci." *Speculum*, XIX, 104–125.

1945

"Understanding and Reunion: An Oriental Perspective." In *The Asian Legacy and American Life*, edited by Arthur E. Christy. New York, pp. 215–230; notes, pp. 269–270.

1946

"A Figure of Speech or a Figure of Thought?" title essay of *Figures of Speech or Figures of Thought*. SP I.

Figures of Speech or Figures of Thought: Collected Essays on the Traditional or "Normal" View of Art (Second Series). London: Luzac

(n.b. "Second Series" is AKC's indication that he viewed this volume as the sequel to his first collection of essays, *Why Exhibit Works of Art?* [cf. entry for 1943]).

"Notes on Savage Art." In *Figures of Speech or Figures of Thought.*

"Primordial Images." *Papers of the Modern Language Association,* LXI:2, 601–602.

The Religious Basis of the Forms of Indian Society; Indian Culture and English Influence; East and West. New York.

"*Ṛgveda* 10.90.1: *atyatiṣṭhad daśāṅgulam.*" *Journal of the American Oriental Society,* LXVI:2, 145–161.

"Symplegades." In *Studies and Essays in the History of Science and Learning Offered in Homage to George Sarton on the Occasion of His Sixtieth Birthday,* edited by M. F. Ashley Montagu. New York, pp. 463–488. SP I.

1947

Am I My Brother's Keeper? New York.

"Am I My Brother's Keeper?" Title essay of *Am I My Brother's Keeper?* New York, 1947.

"Athena and Hephaistos." *Journal of the Indian Society of Oriental Art,* XV, 1–6.

"Dr. Coomaraswamy's Talk at His Boston Dinner." *Journal of the Indian Society of Oriental Art,* XV, 10–12. SP II.

"For What Heritage and to Whom Are the English-speaking Peoples Responsible?" Address given at the Kenyon College Conference of 1946. In *The Heritage of the English-speaking Peoples and Their Responsibility.* Gambier, Ohio: Kenyon College, pp. 48–65.

"Gradation and Evolution, II." *Isis,* XXXVIII:111–112, 87–94.

"Paths that Lead to the Same Summit." In *Am I My Brother's Keeper?* New York, 1947.

Time and Eternity. Artibus Asiae, Monograph Series. Ascona, Switzerland.

"Who Is 'Satan' and Where Is 'Hell'?" *Review of Religion,* XI, 36–47. SP II.

Review of J. Archer, *The Sikhs in Relation to Hindus, Moslems, Christians, and Ahmadiyyas. Journal of the American Oriental Society,* LXVII, 67–70.

Review of H. Zimmer, *Myths and Symbols in Indian Art and Civilization. Review of Religion,* XI, 285–290.

1948

The Living Thoughts of Gotama The Buddha. With I. B. Horner. London.

1951

"Note on the Philosophy of Persian Art." *Ars Islamica,* XV–XVI, 125–128. SP I.

1956

La Sculpture de Bharhut. Annales du Musée Guimet, Bibliothèque d'Art, n.s. 6. Paris.

1977

"Does 'Socrates Is Old' Imply That 'Socrates Is'? " SP II.
"On the Indian and Traditional Psychology, or Rather Pneumatology."
SP II.

Index

Library of Congress Cataloging in Publication Data

Coomaraswamy, Ananda Kentish, 1877–1947.
Coomaraswamy.

(Bollingen series; 89)
Includes index.
CONTENTS: v. 1. Selected papers, traditional art,
and symbolism.—v. 2. Selected papers, metaphysics.—
v. 3. His life and work.
1. Art—Addresses, essays, lectures. I. Lipsey,
Roger, 1942– II. Series.
N7445.2.C68 1977 700'.8 76–41158
ISBN 0-691-09931-6 (v. 3)